ANDY HOWELL
ART, SKATEBOARDING & LIFE

by Andy Howell with Amely Greeven

Andy Howell Art, Skateboarding & Life
by **Andy Howell** with **Amely Greeven**

Art Direction: **Paul Hutchison and Andy Howell**
Design: **Paul Hutchison**
DVD Direction: **Ted Newsome**
Photography Direction: **Ted Newsome**
DVD Interviews: **Ted Newsome and Laban Pheidias**
Additional thanks: Sharon Harrison, Justin Tyler Clark

Published in the United States of America

SECOND PRINTING
Gingko Press, Inc. in Association with Untitled Publishing, llc

Gingko Press, Inc.
5768 Paradise Drive, Suite J
Corte Madera, CA 94925, USA
Phone (415) 924 9615 / Fax (415) 924 9608

email: books@gingkopress.com
www.gingkopress.com

Hardcover edition:
ISBN: 1-58423-221-8
ISBN 13: 978-1-58423-221-6

Paperback edition
ISBN: 1-58423-261-7
ISBN 13: 978-1-58423-261-2

Printed in Hong Kong
© 2005 Untitled Publishing, LLC

Untitled Publishing, llc
7660 Fay Avenue, Suite H
La Jolla, CA 92037

email: connect@untitledpublishing.com
www.untitledpublishing.com

FOREWORD

On Andy Howell

If you can say one thing about Andy Howell, it's that he's a man ahead of his time-to a fault.

If he had only waited a few years to launch his hip-hop-inspired skate-clothing company or his pre-Roxy girls' label, or if he hadn't gotten bored with running the Underworld Element skateboard brand and stuck with it instead of following his instincts elsewhere, or migrated to California like every other skater seeking a pro career instead of staying in his hometown of Atlanta, he might be an industry mogul instead of watching others cash in on his ideas.

But that's the tragedy of the artist, isn't it? He does what he does because it feels right, whatever the cost and despite the logic (or lack thereof). Andy has always followed his instincts, and while they haven't made him wealthy, he's rich in spiritual currency.

Andy is a man making his way toward enlightenment through creative experiences. Some of those experiences we get to see in the form of his artwork. A multi-media expressionist, Andy has been putting paint to canvas and creating other physical pieces that have been shared and appreciated at galleries and on scratch pads. But I know Andy best as a skateboarder. I'm lucky to have ridden with him and seen him ride in his prime.

In 1991 I traveled from the skate capital of the known world, Southern California, to Atlanta, Georgia to interview and photograph the man who helped launch one of the industry's new upstart companies, The New Deal. A professional skater with sponsors and the perfect year-round skate weather at his disposal in California, Andy felt more at home where he was. So there he stayed.

He moved to Atlanta from Virginia Beach, I learned, to go to art school. Atlanta grew on him, so he refused to leave, even though he had obligations to produce artwork and provide creative direction to the new company he was building out west. In the era of proto-desktop computers, Andy would transmit ten-by-30-inch high-resolution artwork via a 28.8 kpbs modem from his studio in the Deep South to New Deal HQ in Costa Mesa, California. Needless to say, these transmissions were sent overnight and usually took all night to send. In the cool-today-lame-tomorrow world of early '90s skate graphics, this was an insane way to work. But it worked for Andy. It had to, because his instinct led him (or kept him) away from the So Cal skate brothel.

Most companies at the time were churning out remarkably similar artwork, or just blatant rip-offs. Or they would import some fresh young skater or artist from some far-away land (or state) who after a year or so would sink into and be consumed by the morass of the skateboard industry, its pressures, and the trends that marched through it. The thought of supporting a branch office, one so remote and one that represented the creative heart of a brand, was a totally new idea, and it was the result of an East Coast skater insisting on remaining what he was-and what presumably made him famous: being a talented skateboarder and artist from a place outside California.

That week we spent together in Atlanta was memorable for a number of reasons. It was remarkable, firstly, because we managed to shoot an entire interview in one city and in some fairly typical East Coast summer monsoon-like weather. I was having trouble coping with it, and all I had to do was sit with my camera and wait for Andy to skate.

But more impressive than his work rate was his approach to skating. It was his craft-or rather, one of his crafts. He wanted each trick we shot to say something about his skating, and the set of shots to form a portrait of his style. He wasn't trying to outdo what was going on across the country-although he did-and he insisted that he skate with his crew of locals. Despite the magazine photographer (me) sitting like a white elephant next to the rail or stairs or whatever we were skating, he wanted to be in his natural environment and skate like he normally skated.

At the time, I should note, everything was shot on film. That meant that every attempt to shoot a sequence was a half roll of film. Most tricks at the time were very technical and required several attempts to land clean. This put immense pressure on skaters, but Andy usually hit it in a few rolls of film, which is remarkable. And thinking back, he was getting up early, doing his New Deal work, on the phone with Costa Mesa, and drawing/sketching/coloring board graphics and designing ads before I even got up. Then we hit the streets and he skated for me. I wasn't used to that. Skateboarding wasn't used to that.

As the interview revealed, Andy was also one of the most articulate skaters of his day. I learned that, as important as skateboarding was to him, it was really just one of the brushes in his toolbox. And unlike the paintings, graphics, and other two-dimensional work that survives to the present, his skating had to be witnessed first-hand to be appreciated, even if photos and videos hint at the essence of the events they capture. In Andy's case, his skating speaks volumes, but still only manages to scratch the surface of the man. I learned that as soon as I turned on my tape recorder that summer in Atlanta. As he spoke about his skateboarding, and I glanced around the apartment at his other artwork, and listened to his eclectic collection of music, I wondered where he would be in ten years. And I remembered hoping that he didn't become a typical skate-company owner who ran the organization but ceased to have any real direction. I hoped that he would still be creating and searching and sharing, because I imagined he would have evolved his crafts to an incredible level of refinement. And he has. And he's still evolving.

One of us may capitalize on something he's done (and moved on from), but what's the real value of experience? What can we gain from our actions? How do we grow as individuals, and not just as corporations? What's really the point in doing what we do? I have no idea. But I'll bet anything that Andy does.

-Miki Vuckovich

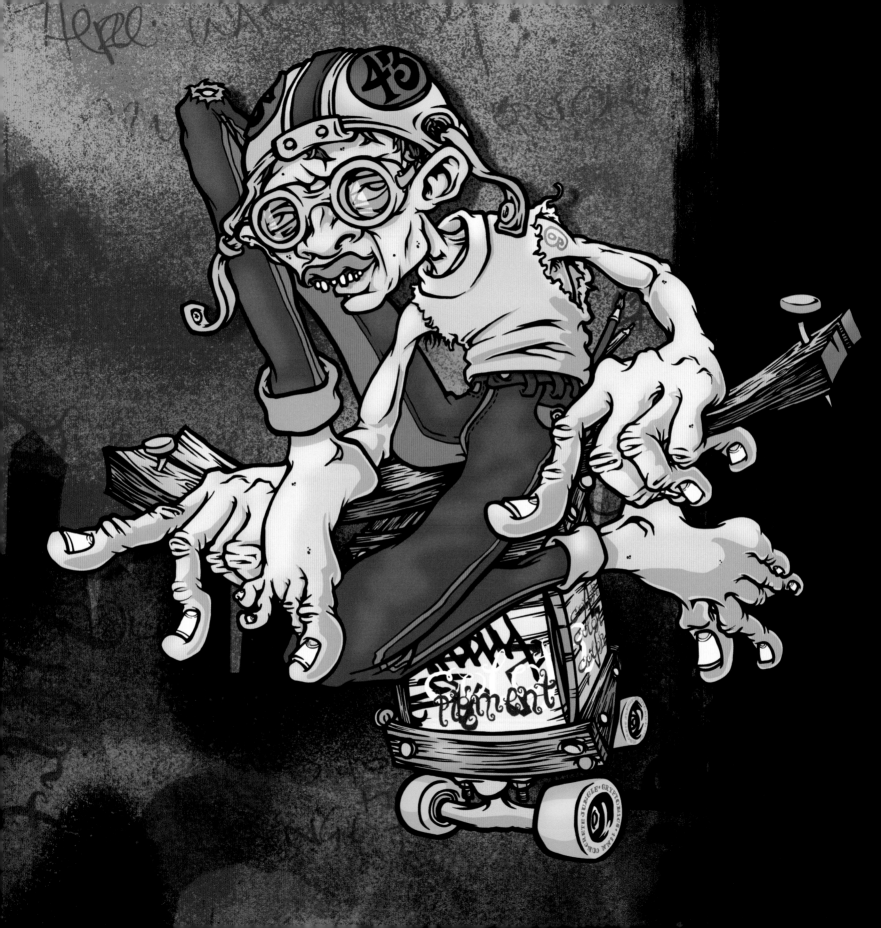

iNTRO

Hello, my name is…Andy Howell.

Since I was a boy I have dreamt I was flying, starting with long strides across the beach at Kitty Hawk, the sand squeaking beneath my feet. As I move faster and the time between the squeaks of my feet on the sand increases, I start to fly higher and higher until I am gliding above the same stretch of beach where I grew up. My abilities once airborne aren't refined though, even after all the times I have flown. I miscalculate distances, turn with a different technique and style every time. Sometimes my flights are long and graceful, sometimes short and erratic. Every trip I go on is a different experience.

My flying machine is my imagination, an old winged paintbox with Indy trucks and soft urethane wheels and homemade wings. I keep my tools in my back pocket, a brush, a pencil, a camera, and a mouse. Inside the paintbox are colors and pictures and sounds, an ever-changing collage of the things that inspire me, the things that drive me.

I feel most alive when lost in the right side of my brain, that creative space where I can be completely free. I find myself somewhere between today and tomorrow, in a world partly known and partly my own experiment in knowing. I wonder at the intricacies of mediocrity, the simplicity of the fantastic, and I continue to wake up each day with the same intention. Create something new.

I call it the zone of the in-betweens.

When I was asked to make this book, I began to collect as many elements as I could find and to work on writing the story. As the experiences of my life began to come together in one place, it became clear to me that in writing my own story I was telling pieces of the stories of the other people who have touched my life as well. I decided to contact a bunch of them and ask if they would contribute to the book in written form. I was amazed at the response. Their stories helped to make mine complete, as their impact on me helps make my life complete. So the book is written along the timeline of my experiences, with the generous contribution of added stories and pictures from the people who have influenced my life in one way or another.

Inspiration has been the primary driving force in my life for as long as I can remember. The world seems to make sense when I am inspired, and life becomes clear and meaningful. So many people have inspired me in so many different ways over the years, and I continue to be inspired every day. Hopefully I have in turn passed that inspiration along to others. So, thank you, and enjoy.

CHAPTER 1
VIRGINIA BEACH:
ILLEGAL CRUSADE

Illegal Crusade *Virginia Beach*

Glenda Holcomb, Andy Howell's mother *One time when Andy was about seven or eight months old, I waded out to a sandbar off the beach to meet some friends. I was holding him in my arms. When we headed back to land, I suddenly hit deeper water. A wave came, and it was awful. I got dragged to the bottom, and I really thought Andy would drown in my arms or I that would drown, or I'd lose my hold. It scared the sheepsharkey out of me. I can hardly think of it without crying. But Andy came up giggling and spluttering and laughing. He wasn't scared at all.*

Andy Howell When I was about eight years old I got a Logan Earth Ski with OJ Superjuice wheels and Tracker Full Tracks for Christmas. I thought I was the shit. I was too little to go to the skatepark right then, but later these neighborhood hesh rocker guys would take me and my childhood friend Steve Solomon there. We'd ride tandem catamaran-style down the middle of the snakeruns and try to slalom down to this quarterpipe at the end, which was about eight feet tall. To us it felt like 35 feet tall with ten feet of vert. We were too scared to do much, so we'd just roll up and down the ramp 'til we'd finally stop. All the skaters hated us.

Courtney Harbison, Andy's younger sister Everything he liked to do made a lot of noise. Once he woke up, the whole house had to wake up.

Glenda Holcomb He was all boy. He loved sports, he was very curious, and he found is way into everything—from the medicine cabinet to the pots and pans in the kitchen. There's no doubt from the get-go that when he knew what he wanted, he just went for it. He was crawling when it started.

Andy As a small kid I was more into fishing than skating. My dad taught me to fish off the beach at five years old, and it's been a part of my life ever since. I used to get up and go to the lake near us at five in the morning before school. I'd just sit and think for a couple of hours. I loved animals, and used to know every kind of lizard and snake and fish from the Golden Book Series by heart. My parents got me a subscription to *Bassmaster* magazine, and from then on my main goal in life was to get my parents to buy me a Bassmaster boat to go with it.

I started surfing at around age eight, my first surfboard was a blue-and-yellow Lightning Bolt Gerry Lopez that my parents bought me. I began to recognize surfing styles in the magazines and movies, and noticed that some people had a more fluid motion than others on a board. I'd try to emulate Lopez and Mark Richards, who had by far my favorite styles in surfing. And I loved the fact that Gerry Lopez just seemed to be a free-spirited explorer too. But I didn't really pursue skateboarding. Everyone started getting those wider skateboards, and I had this really ghetto old skateboard. I was embarrassed.

Glenda Holcomb I remember him out on the beach with a catch of fish and a knife at six years old, investigating their innards. And of course like every mother I thought, "Oh good! He's going to be a surgeon!" A few years later, he somehow or other got the neighbors to let him go fish on their property. I remember the day Andy brought home a large-mouth bass. He was around ten. I was in the kitchen, cleaning, and he came through the front door yelling, "Look what I got! Look what I got!" And of course here was this fish, gasping for breath. I oohed and ahhed over it, and he said he wanted to kill it, stuff it, and hang it over his bed. I convinced him to put it back in the lake. I never asked if he actually did it.

Andy There was a kid who had recently moved in next door named Pat McMichael. He skated past us down the street one day wearing checkered hightop Vans and a torn-up jean vest with punk patches all over it. I was like, "Who is *that?*" He just looked like this rad-ass punk, and my friends avoided him. But the next day I went up to him and started talking to him about his skateboard, an Uncle Wiggley with a plaid design on the bottom. We quickly became friends and he got me into skating. I wanted to learn everything, and instantly adopted the punk culture, which was a sure fit for my attitude.

Glenda Holcomb We just lived in a middle-class neighborhood, nothing fancy, but he went to the private school where I taught English. It was the kind of place where it was considered fine form to put on your little white outfit and play tennis. Skateboarding was not the "in" thing to do, by any stretch.

Andy One day Pat asked me to hitchhike across town with him to go skate this huge ramp, and he said this guy called Robert Tugman was going to be there, a total ripper. This terrified me because I was Mr. Good Kid who knew better than to stray outside the boundaries. But I went. Tugman was at the ramp doing all these amazing tricks, while we were just trying to fakie at the bottom and yank little frontsides. But we skated it.

And from the moment I experienced the feeling of doing what I wasn't supposed to, from the moment I started going for it and learning tricks, I was hooked because it felt so innovative. It wasn't just the fun of doing a physical activity—that was the third or fourth thing down the list. The first thing was that it was super creative, the second thing was that it was so challenging to do the tricks people were doing that I was constantly pushing myself to do better all the time, and the third thing was that I could actually create what was next.

I was about fourteen when I realized that I just had to skate every day, all day. Skateboarding had become the first and foremost thing in my life. There were maybe ten kids in my neighborhood who were all the same age, and we all started skateboarding together. In the next neighborhood were a few more, including Allen Midget, who were starting to learn tricks on transitions. Al and I started skating together

every day, and were always neck and neck at learning tricks. When Al learned a backside air, I had to learn it the same day. We really pushed each other to get better.

Alyasha Owerka-Moore, designer, founder of Alphanumeric and FiberOps For any of us who got into skating the draw was that it was this independent mode of expression. It wasn't necessarily a team sport. It's not like, hey you didn't pass me the ball so we didn't make the goal.

Anthony Yamamoto, Design Director, Quiksilver The appeal of skating is that it enabled us to break out of the mold. It forced us think for ourselves and made us really independent 'cause you don't have to rely on anyone else. The only thing you have is your board—skate or surf. I think that strength is what enabled a lot of skateboarders to do their own thing in every area of life.

Steve Douglas, pro skateboarder, co-founder of New Deal, Element, and 411 Video Magazine Skating was for me about doing something where I wouldn't let anyone else down. If I were on a team I might let people down—but skating I had only myself to blame, and I often did. I think that's what a lot of skaters have in common, they don't want to be part of a "team."

Shepard Fairey, artist, creator of the Obey propaganda phenomenon When you discover at age thirteen that instead of going to put on a soccer jersey to play with the other kids you don't like much, you can go skate, it's totally empowering.

Glenda Holcomb Andy was always organizing the local kids. They just tended to follow what he did. Before it was skating, it was lacrosse. A lot of them didn't even know what a lacrosse stick was, but soon enough he had everybody in the neighborhood buying lacrosse sticks.

Courtney Harbison He was not the real grungy skate type. I guess he was in between the preppy Polo type and the skater. Andy made a name for himself early on; he was pretty much known as the artist and the skateboarder and I think everyone pretty much respected him. But he didn't really fit in with the guys at school.

Andy At that time, around '83 or '84, if you had a skateboard, you'd either get beat up by the jocks at your school or get heckled when you walked down the street. Total outcasts, really. People didn't understand it. But you could walk down the street with a pair of Vans on and see some kid who was not even from your town with a pair of Vans on, and you'd just be like, "Right on, let's hang out." Skaters were so few and far between, that you could instantly become friends, because it was so refreshing to actually meet someone who was into the same things. And minutes later you'd be skating with this total stranger, and you'd

probably skate together every day thereafter. Often before we'd go skate, my friends and I would shave mohawks into our heads with electric clippers in the driveway so our parents wouldn't know. At least not until after the session.

There were no city-funded skateboard ramp parks in the country yet, so we built ramps in every backwoods illegal spot we could. We'd cut down trees in random woods around town, clear some space. Then we'd steal wood like it was going out of style. We'd sneak into construction sites and grab two pieces of plywood and surf back with them balanced on our skateboards—I'm talking at eight o' clock at night, not 2.00 a.m., 'cause of course we had to be home in bed early on a school night. Eventually it got to the point where we'd go steal entire cases forty sheets high. Building and skating ramps was the raddest feeling—how we didn't get caught I just don't know. We'd spend six or seven days in a row making one ramp and could never wait 'til it was done to skate it. We'd grind across eight-foot gaps where it hadn't been sheeted, totally eating shit and hurting ourselves. Then like a month later the cops would find it and chain it up. So we'd go do it again. And again. At the time it felt like a crusade, but in retrospect it was definitely illegal.

Shepard Fairey When I was a kid in Charleston, if I saw a skateboarder I'd practically run up and hug him. Immediately I'd want to hang out and ask if he knew where any ramps were, like, "You skateboard: we have something in common. It's us versus the world." One time when I was fourteen I was skating at this parking garage trying to figure out how to clear these stairs, and this kid came up and said, "You're not gonna make it. Do the math. Do the geometry." And I said, "I think I can make it." And I did. And he goes, "Okay. You're radical enough for me to tell you where the vert ramp is." It belonged to Blaize Blouin. I took the bus out there by myself and found twenty other kids skateboarding. I was like, "Holy shit, it's mecca!" And from that, skateboarding became a billion-dollar industry.

Andy Eventually there were so many ramps in people's yards in Virginia Beach it was like an epidemic hit. All the "good citizens" clamped down because they saw the ramps as eyesores and the city outlawed skating. So a bunch of us skate kids got together and started petitioning the city to build us a local skatepark. We got all the parents of skateboarders to sign it, got a court hearing, and finally got the city to fund the first-

ever, city-funded skatepark in the country. The land it was built on was called Mount Trashmore because it was basically a big landfill that had been covered in grass and turned into a public park. Fitting, I thought.

Trashmore had one of the biggest ramps ever built at that time, 32 feet wide, ten and a half feet high, with a nine-foot transition and three-foot channel. It was so rad. I mean, there'd be city employees coming in city uniforms to replace sheets of plywood as we stood up on the decks drinking water between runs! We were stoked, and everyone started to improve really fast. Eventually the whole pro circuit came to our city, and the National Skateboard Association added us to the pro contest circuit. Suddenly, all the pros came to our town—including Tony Hawk, who I met for the first time there—and Stacy Peralta, who came to film his team. We were stoked when our ramp showed up in the next Bones Brigade video. The VB skaters just made it happen, because we wouldn't accept the fact that the city had outlawed skating. Eventually the city ended up funding three or four more ramps in the area too.

Glenda Holcomb I guess I knew he was building illegal ramps in the woods. But I think you teach kids what's right, and then if they make a mistake they have to deal with it. Too many parents come with the safety net too often.

Andy There were no videos when we started skating, so the only thing we had to see how a trick was done was a photo sequence in a magazine. And of course we thought that if those guys were pros, that meant they made every trick every single time. So we pushed ourselves ultra hard to learn every trick. We'd see pictures of these guys upside down, eight feet out of a bowl, and we'd sit on the flatbottom of the ramp in my friend John Fudala's backyard with the magazine open, posing airs and trying to figure out how you'd have to move your body to do that. So our skating didn't even look like the skating in California—the styles and everything were completely different. We were doing it our own way, and that became a big difference between East and West Coast skating.

Steve Douglas It was an exciting time in vert skating because Virginia Beach had a great scene there. To see all those guys was incredible for me and my friend Bod Boyle. We'd moved from the U.K. to the U.S. thinking that British skaters were part-time skaters 'cause they only skated twice a week. And funny thing, the second time I visited Virginia Beach from California, I asked someone, "Where's Andy?" And they said, "Oh, we don't see so much of Andy anymore, he only skates five times a week." We were like, "Five days a week is slacking off?" So we left back to Cali going, "Man, we need to skate every day cause those guys in Virginia Beach are skating every day."

Andy Trashmore was insane, people started coming from all over the world to skate our new super ramp, and we all skated together pretty

much every day. As my Virginia Beach friends and I improved at skating as ams, we were traveling like crazy and had these insane shop sponsorships from the local surf shops, one called 17th Street and one called WRV. There really weren't even any skate shops in the area at the time. We started to get a reputation around the East Coast and Midwest. People knew if the VB boys were coming to your contest, watch out because we were all placing in the top ten. Allentown, Pennsylvania; Ocean City, Maryland; Greenville, South Carolina; Atlanta, Georgia; Jacksonville, Florida—we made our way everywhere. Of course, somebody's mom or big brother would have to take us, 'cause we didn't drive yet.

Glenda Holcomb Our living-room den was full of kids much of the time, sleeping on the floor, watching TV. Very polite, well-behaved kids. That's why I allowed it, I thought, "I'll get to know who they are." I must admit I wanted Andy to go to Princeton or Yale. His dad was a dentist, and I wanted him to enter the medical profession. I thought skateboarding was just a passing fancy, "Go knock yourself out."

Courtney Harbison I loved having big brother's friends over. I had a blast. Some of them were kind of, oh god, pretty grimy, but some were pretty cute. A big deal around here was that Andy made T-shirt designs for 17th Street Surf Shop. I was so proud about it. I'd be all, "My brother made that design." I was pretty much known as Andy's little sister all the time, everywhere I went. It was neat.

Andy It ended up that like ten people just from my city turned pro. This was a time when 95 percent of pros were from the West Coast. Our crew of skaters was led by Henry Gutierrez, who later became a pro skater for Vision, his brothers Glenn and Eddie, Mike Crescini—Vision, Allen Midget—Schmitt Stix, Sergie Ventura—Hosoi Skateboards, Mike Conroy, Bushka Vidal, and a crew of others.

This was a time when skaters were called things like Load Warrior, Puker, Peanut, or Metalman. I remember one time when our 17th Street Surf Shop team took a road trip to Greenville for the MESS series contest. Our idol Buck Smith was there from Kona and all the Rancheros from Atlanta, who were these gnarly Southern vert guys. Tommy Kaye, Lenny Bird, Hughes, Load—all these cats who blew our minds. It was a bunch of sick older dudes ripping this thirty-foot-wide ramp. And it was one of the best days of our lives, because basically we were these little kids who were amazed to be so far from home. I think Paul Schmitt may have been there in his VW bus.

Once when I was fifteen we went to the Suburban Youth Ramp Jam in Allentown, Pennsylvania, a whole crew driven across three states in John Fudala's mom's station wagon. When we got there Geoff Graham's mom was already making this massive breakfast for the other twenty skaters who had showed up. This was a group of skaters from a number of isolated local ramp scenes around the Northeast, none of whom had met in person before, sharing a mutual

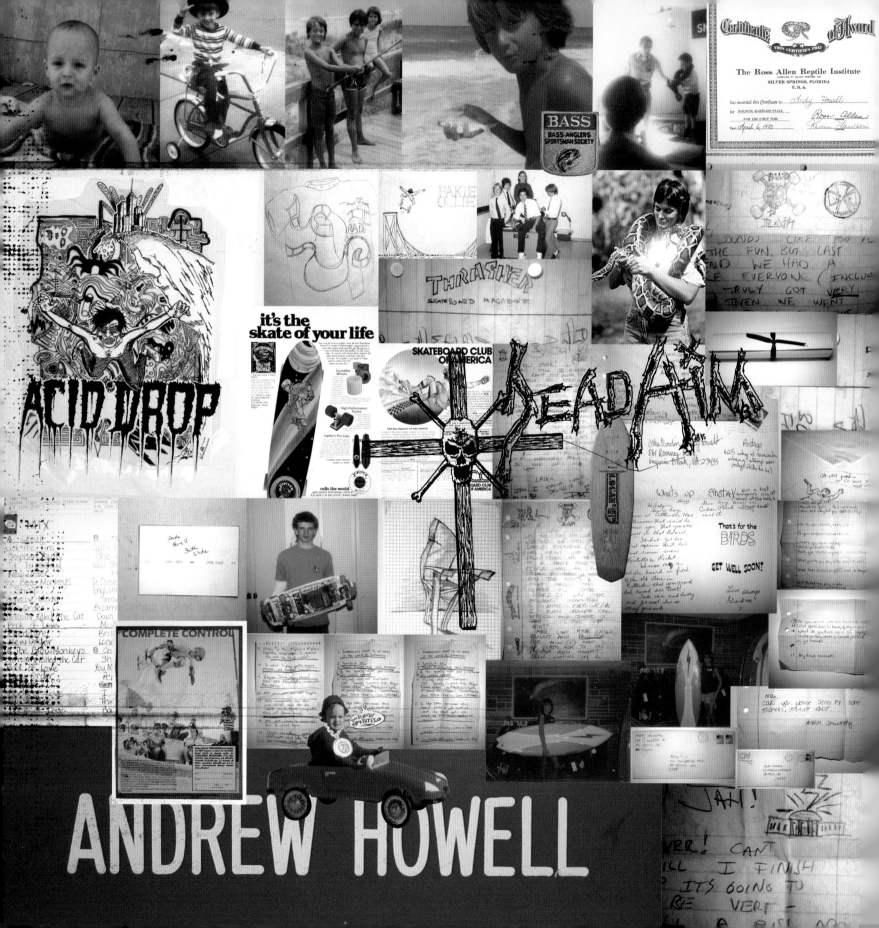

ANDREW HOWELL

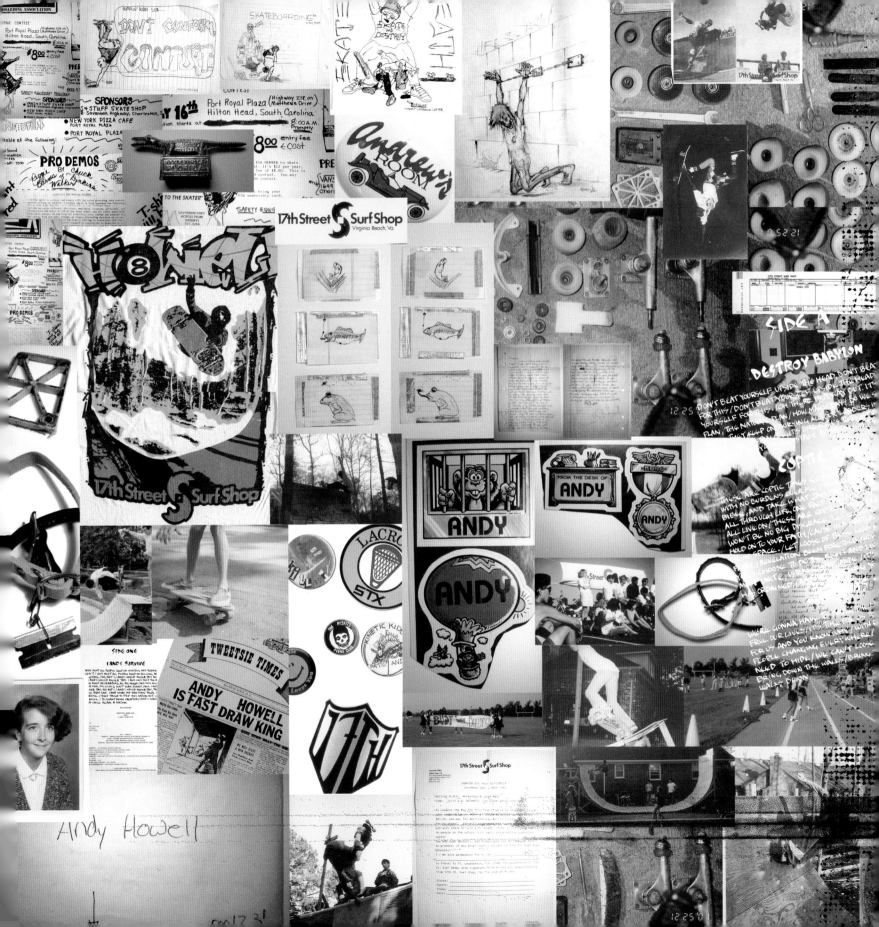

drive to skate—and an appreciation for a killer breakfast. Ramp contests at that time were self-organized jam sessions with no real prize for winning except a growing notoriety within the circulating skate 'zines from that area. It was the most amazing time, everyone became friends instantly and made plans to trade 'zines and meet again at the next contest.

Immediately when we got back from Allentown, we built a twelve-foot-wide ramp in my neighbor Ron Siegel's backyard. And I had what at the time was the highlight of my skate career there: We threw this contest called Ron's Ramp Jam, and everyone from the VB crew came over. I skated super good, because obviously I knew the ramp really well, and I won it with my newest tricks, including inverts, thrusters, and fakie ollies. All of my peers in skating at the time were there, all of the Windsor Woods guys. And miraculously, I beat Henry G., which was something I never dreamed would happen, so for a day I felt like a king. Ron's ramp was the first double-trick ramp in the area, with both walls the same height, and I had learned to do back-to-back tricks, which gave me the edge.

When I was about fifteen I had this crazy drive to get sponsored. Everyone was skating vert at the time, and Trashmore and the new Lynnhaven ramp were in full swing. There were no sponsor-me videos back then, so I got a friend to snap these really cheesy photos of me doing inverts and airs, and I put them in an envelope along with a handwritten list of how I had placed in local contests. I sent it out to Santa Cruz Skateboards, hoping for a miracle but knowing it was a pipe dream. My friends knew I was trying to get sponsored, so when I got a phone call from Rob Roskopp asking me what kind of boards I wanted to ride I was sure it was one of them fucking with me.

"C'mon, who the hell is this? Bushka? Charles? Dude, quit fucking with me! It's not cool!" I think Roskopp was a little shocked, but I was so certain it was one of my skate buddies. He must've thought I was being a little punk. He assured me it was really him and asked what kind of board I wanted again, and I replied sarcastically, "Yours, of course, dude!" Man, my song changed when I got a fat package a few days later filled with seven Roskopps, a shitload of Slimeballs, griptape, and a bag of stickers just begging to be tossed into the flatbottom of a crowded contest. I couldn't believe it, I was sponsored by Santa Cruz!

I skated in some vert contests, got my first picture in *Thrasher* doing a tuck-knee invert all flapped over, and I was stoked. Santa Cruz kept sending me free boards and I was one of about four or five kids sponsored in VB at that time. Our scene was exploding, and I had dreams of one day becoming a pro vert skater for Santa Cruz.

Paul Schmitt, founder of Schmitt Stix Skateboards and PS Stix manufacturing, co-founder of New Deal, Element, 411 Video magazine If anything, Andy wasn't the Virginia Beach flavor, he wasn't the party boy. Andy's wild in his own way. He's not wild like normal wild.

Andy When I was fifteen and riding amateur vert for Santa Cruz, my parents took the family to California on vacation. It was like a dream for me, but my mom and dad didn't like it at all. We stopped at the Santa Cruz factory in Soquel, and I finally got to meet Rob Roskopp and Keith Meek. They were like, "Dude, we're going to head down to Orange County and go skate some ramps." I was all, "Oh my

god, no way! MOM! DAD! PLEASE! PLEASE!" By some miracle they decided to let me go. Man, I was wide-eye amazed to be able to skate with these guys—they were my total heroes.

So we drove down to Long Beach and hooked up with Jeff Kendall and went to Fender's Ballroom and saw a huge punk-a-thon show with 7 Seconds and a slew of other sick punk bands. I was fifteen and in heaven. Then we went down to Huntington Beach to meet up with Marty Jimenez and skate some ramps. We got to one and Duane Peters was there. Then Mark Gonzales showed up. He was doing his big street boneless ones on the ramp and it looked insane. He was a natural on ramps just like the street. I didn't meet him there, but I got to watch him skate. My parents came down and picked me up, and I went back to VB totally blown away that I had actually been to California.

zero nine

Then tragedy struck at sixteen. I bottomed out on a backside air and went straight to my knees. One of them swelled up like a melon almost immediately. I was screwed, how was I gonna skate? I went to the hospital and they drained about a liter of fluid off my knee with a massive needle, then wrapped my leg in a soft cast, which gave me about ten degrees of mobility. I remember getting into my car to go home and wondering how I was going to get my pads on over my cast. I was completely obsessed, and immediately depressed.

So I was out of skating for a few months, and during that time I went crazy. I started making 'zines hardcore-style and printing shirts. I would race home from private school and drive over to the ramp just to sit on the basketball court next to the ramp and watch the sessions. I started to bring my board, and although I could barely move my leg, I would tic-tac around the court next to the ramp and pose sadplants on the flat ground with my stiff-casted front leg, while my friends stalled them out on vert. Something happened while I was dorking around in the parking lot—I began to learn to street skate.

My friends Bushka, Brad Marx, Brian Zentz, Charles Harmon, Otha Nowlin, Darren Jones, and I started to skate the streets together. We wanted to rip the streets, and we would boneless over or bomb-drop off of anything we could get onto. Tommy Guerrero came to town for a Powell demo, and we learned how to do slappies from him. We were doing vert tricks like blunts over curbs that we had taken from vert skating, while Tommy was a real street skater and someone we all looked up to, so we soaked up his style and finesse on street obstacles. We'd all go to the Trashmore parking lot and skate the curbs, then later when we were tired we'd have dork sessions doing tricks and arching our backs like Lance Mountain from the Bones vids. We were kind of getting known as the street skaters of VB, creating our own little scene. We pushed each other on the street like we had done on ramps, only now for me there was more creative freedom. Any obstacle on any street became a skatepark.

Tommy Guerrero, pro skater, musician, partner in Deluxe Distribution I was in Virginia Beach maybe for a contest, or more likely on tour doing demos. Andy says I taught him how to do slappies, but it's probably more like he taught me something. He was skating with his buddy Bushka and they were both super good. Andy is really creative and he's always approached things differently when it comes to skating—and usually in everything in his life as well. He always had a few tricks up his sleeve that made your head turn—"What the heck was that?" Those two were just as talented as any of the other skaters around, but not so known because all

the mags are located out West. Though *Thrasher* and *TransWorld* went out of their way to give coverage to anyone who ripped, everyone ended up coming to California—specifically Southern California. And since the magazines weren't flourishing financially, they often wouldn't send photographers around the country.

Andy When I turned sixteen our VB street crew took our first road trip to a contest in Wrightsville Beach, North Carolina. We weren't sure how far away it was by car, but my mom let me borrow our family's blue Wagoneer. We left really late on a Friday afternoon, in order to make the contest on Saturday morning, thinking it would only take four or five hours since my friend had given us a fuzzbuster to dodge radar. So I was driving about 80 in a 45 zone the whole way down there. It was completely stupid, and the stupidity was compounded with fear when a state trooper pulled us over on a windy road where we must have been going 90 miles per hour. In classic Southern cop form, he came up to the car with his hand on his gun.

He asked me, "Son where are you goin' in such a hurry?" I was terrified, but decided just to plead my case, "We're goin' to a skateboard contest at a roller rink in Wrightsville Beach." "No you're not son, you're goin' ta jail. Get out of the car!" My heart dropped right through my gut. "Oh please God," I thought, "Just get me out of this and I'll do anything you say. My mom is gonna kill me!"

But he didn't take me to jail, and he actually gave me a lesser misdemeanor ticket. Since I was a minor, however, my mom would have to come back down to this redneck town to bring me before a judge. I got back in the car to find Zentz and Charles and Bushka just laughing their heads off. I was pissed at them, adrenaline flowing from my encounter with the trooper. But Wrightsville Beach was only about four hours down the road, as far as I knew, so we could still make the contest. I'd deal with Mom *after* the contest.

We arrived at 3.00 a.m., and, knowing nobody in the area, we just pulled over in an abandoned parking lot. As would become the case in many road trips to come, we ate convenience-store food and crashed in the car. And tried not to wake up too stiff-necked to skate.

The course was amazing, and everyone was skating really well. Charles styled them to death with his plethora of Hosoi-inspired slides and smooth moves. Bushka got second place, and I got first—I skated to Iron Maiden's *Live After Death* album, to the song that starts with a Winston Churchill speech. We made new friends from the local Dog Bowl crowd, and we cruised home feeling stoked. I had to deal with my mom, but the trophy and the memories were well worth it.

Then Bushka, Charles, Zentz, and I planned our first solo trip out to Cali for the CASL street contest at Simi Valley. Sonja Catalano was running the show, and I remember we had to get our moms to talk to her to make sure we would be safe. I was so embarrassed. Sonja was like a den mother to all the skaters, only we weren't earning merit badges. We skated in the contest, and I placed third behind Scott Oster and Jim Thiebaud. I think I saw Julien Stranger skating there,

doing a big ollie off to the side of the contest between two jump ramps. I'd never seen anyone ollie off a jump ramp back then. Then we headed toward Oceanside, for the NSA Pro Am where Natas would slide the first handrail and Gonz would win the pro contest. I ended up placing fifth in the Sponsored Am contest, the biggest contest I had skated in to that date.

I'd met Blake Ingram the year before and we'd kept in touch, so he invited us back to Huntington again to stay after the contest. I think we couldn't stay at his mom's, so somehow we showed up at Marty Jimenez's house and he let us crash. That is where I met Mark Gonzales.

Blake Ingram, pro skateboarder, founder of Rorret Clothing Marty's house was like this place that every skater stopped at. It was the gathering point. It was kind of a flophouse, frankly, but everyone would end up there at some point in the day or night.

Andy At the time, Mark was living in a crate in Marty's living room. He wanted his own room, but Marty didn't have an extra room, so Mark just stuck four by eight sheets of wood together into a rectangular cube with a little sleeping bag inside and a hole in the top for a light bulb. He'd take all kinds of girls in there and turn his little light on and shut the door. It was so crazy. This was right at the time his first board came out— the '80s-looking graphic-design style one with the face and bright colors—and his first sticker had just been printed. I remember Mark talking about the colors of his new sticker, checking it out to see how he liked it.

Everyone else went back to VB, but I spent another week sleeping on the floor next to Mark's box. We'd wake up, eat, and go skate all day, meeting up with people like John Lucero, Ricky Barnes, Blake Ingram, and anyone who'd show up at the PO curbs. That whole week I got to watch the all-time master of street skating on every street terrain, from banks to benches to walls to curbs. I was totally stoked and trailed just behind him watching the way he approached objects on the street. I'd never seen anyone so graceful on the street, almost like he was floating or dancing over curb blocks, doing shifties and pivots and kickflips as if he was born with them. He would do backside 180 ollies kind of scooping his tail around, land in a backward manual, and then pivot all the way around 360. Never losing his momentum at all, he would flow into a frontside slider on a bench or a horizontal rail. We'd stop at Wimpie's for a burger on the way to ollie the chain gap under the HB Pier, where we'd run into Flea or Anthony from a new group that was just getting known in town called the Chili Peppers. Gonz taught me backside ollies to pivots on little blocks and frontside ollies to grinds on low benches. I learned how to flow down the street from him. It was pure street skating, and I was totally hooked. That week with Gonz inspired me more than any single thing ever inspired me in skateboarding.

I went back home, and a week later there was a street contest in VB. Everyone was there. And all of a sudden I was way ahead of anyone else at the contest.

Varials off the jump ramps, ollie to five-0 all the way across the curb block, 50-50s, while everyone else was doing slappies and boneless ones. I basically blew everyone away at the contest. All because I'd had the opportunity to learn from the best street skater in the world. That week with Gonz would change my whole life, it was like studying painting under Picasso. Completely off-the-wall and totally genius. I started trading in my Santa Cruz decks for Gonz ones, and I must have ridden over a dozen of those things in the next couple of years.

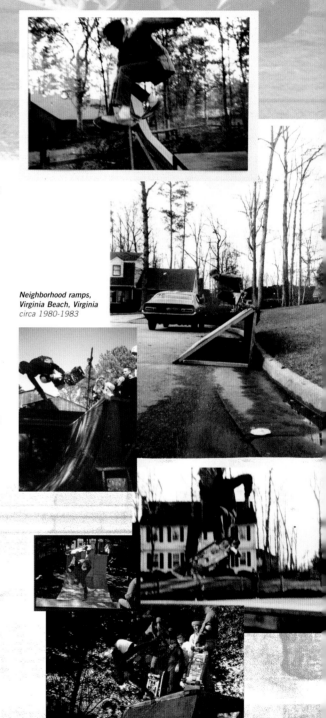

Neighborhood ramps, Virginia Beach, Virginia circa 1980-1983

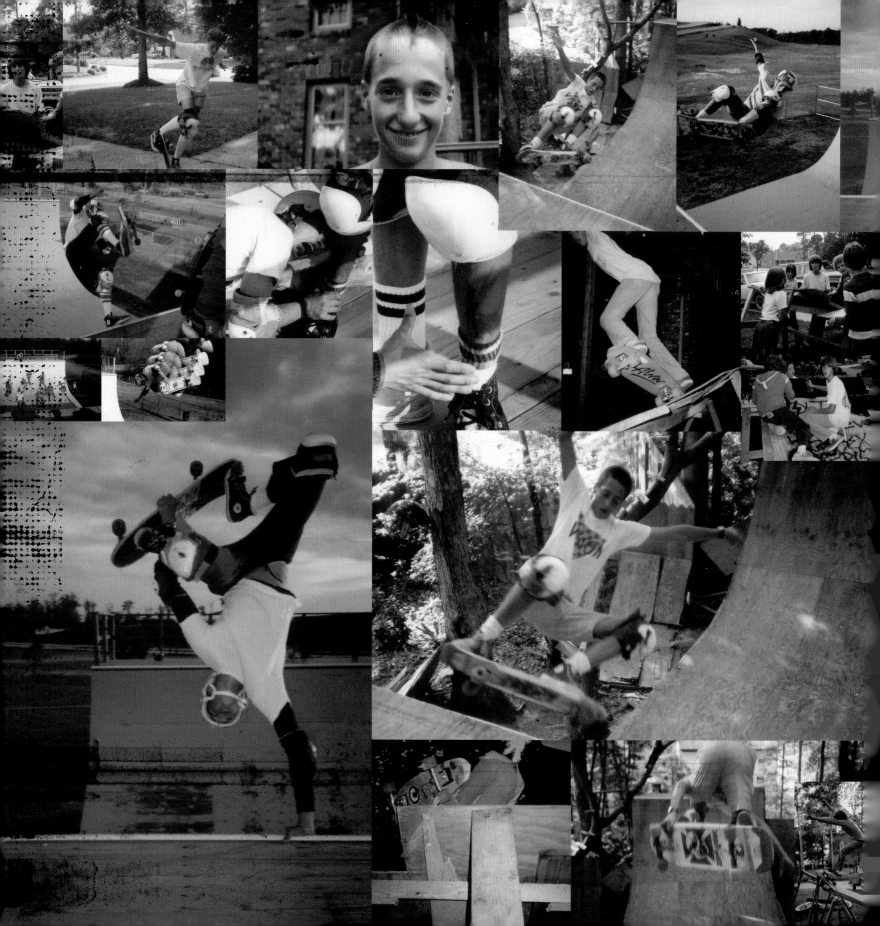

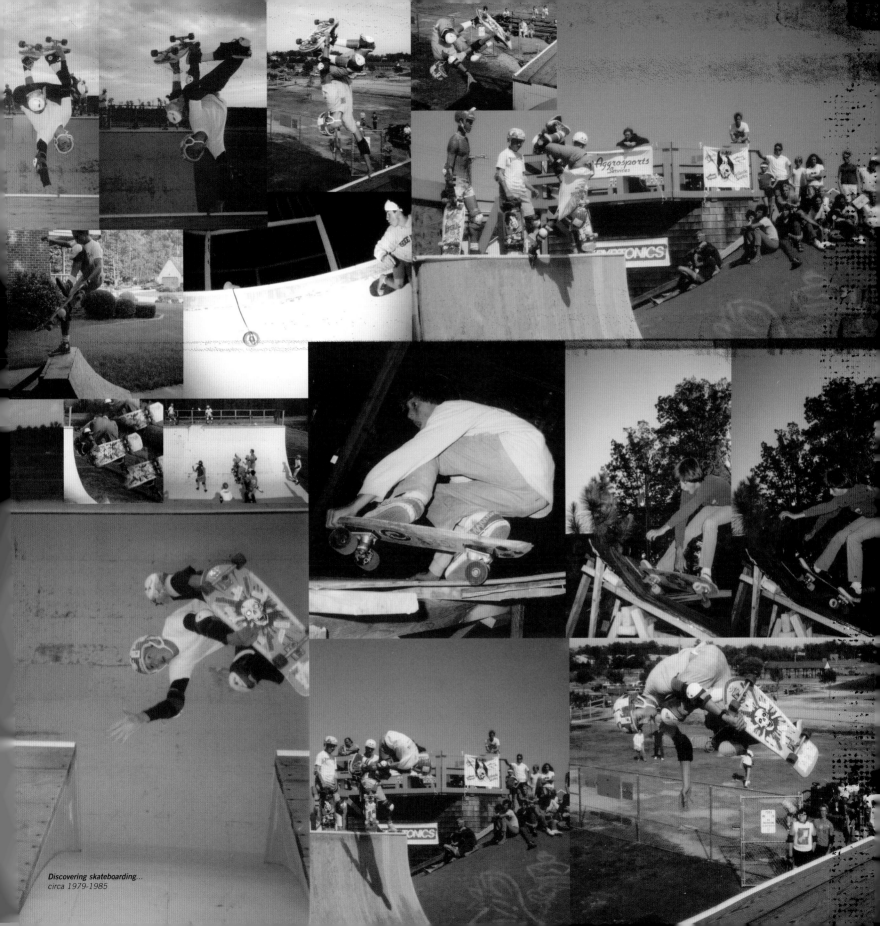

Discovering skateboarding...
circa 1979-1985

ANDY HOWELL

How-
seen
st all
many local ramps
is area. Andy,
a sophmore at
k Academy start-
mp skating only
year. Hopefully,
future will see
y entering and do-
ng well in area con-
tests because he def-
initely has the abil-
ity to skate with the
best of them. For now,
seeing is believing,
so take a good look at
these photos and
for yourself.

12
MIR

TH
54

CHAPTER 2
SiC NATURE

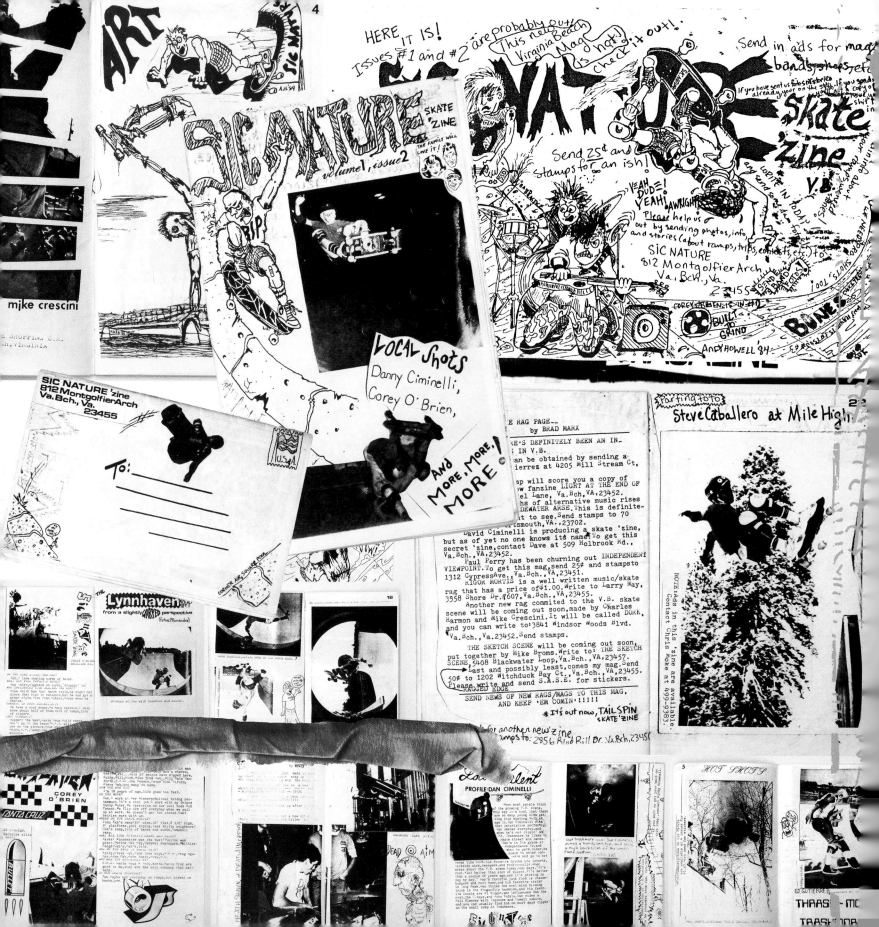

ART

mike crescini

SIC NATURE
volume 1, issue 2

RIP

THE FAMILY WILL LOVE IT!

LOCAL shots
Danny Ciminelli,
Corey O'Brien,
AND
MORE, MORE, MORE!

SIC NATURE 'zine
812 Montgolfier Arch
Va. Bch., Va.
23455

TO:
U.S.A.

CORNER AIR SQUARE POOL

HERE IT IS!
Issues #1 and #2 are probably out
This new Virginia Beach
Mag (is hot!)
check it out!

Send in ads for mag,
bands, shops, etc.

If you have sent us fotos or stories already, your on the staff. If you send a copy of issue or shirt.

SIGNATURE
SKATE 'zine V.B.

Send 25¢ and stamps for an ish!

YEAH DUDE! YEAH! AWRIGHT
Please help us out by sending photos, info, and stories (about ramps, trips, contacts, etc.) to:

SIC NATURE
812 Montgolfier Arch
Va. Bch., Va.
23455

BUILT TO GRIND
BONES
COREY O'BRIEN IN #1
ANDY HOWELL '84

Parting foto
Steve Caballero at Mile High

NO!! ads in this 'zine are available. Contact Chris Poke at 499-9383.

THE RAG PAGE--
by BRAD MARX

THERE'S DEFINITELY BEEN AN IN-
...an be obtained by sending a
...ierrez at 4205 Mill Stream Ct.
...ap will score you a copy of
...new fanzine LIGHT AT THE END OF
...el Lane, Va. Bch, VA, 23452.
...hs of alternative music rises
...DEWATER ARSE. This is definite-
...t to see. Send stamps to 70
...tsmouth, VA., 23702.

David Ciminelli is producing a skate 'zine,
but as of yet no one knows its name. To get this
secret 'zine, contact Dave at 509 Holbrook Rd.,
Va. Bch., VA 23452.

Paul Perry has been churning out INDEPENDENT
VIEWPOINT. To get this mag, send 25¢ and stamps to
1312 Cypress Ave. Va. Bch., VA, 23451.

RIGOR MORTIS is a well written music/skate
rag that has a price of $1.00. Write to Larry May,
3558 Shore Dr. #607, Va. Bch., VA, 23455.

Another new rag commited to the V.B. skate
scene will be coming out soon, made by Charles
Harmon and Mike Crescini. It will be called DORK,
and you can write to: 3841 Windsor Woods Blvd.
Va. Bch., Va., 23452. Send stamps.

THE SKETCH SCENE will be coming out soon,
put together by Mike Broms. Write to: THE SKETCH
SCENE, 5408 Blackwater Loop, Va. Bch., VA, 23457.
Last and possibly least, comes my mag. Send
50¢ to 1202 Witchduck Bay Ct., Va. Bch., VA, 23455.
Please write and send S.A.S.E. for stickers.
RAGGED EDGE
SEND NEWS OF NEW RAGS/MAGS TO THIS MAG,
AND KEEP 'EM COMIN'!!!!!

It's out now, TAILSPIN
SKATE 'ZINE

...for another new 'zine
...amps to: 2856 Blvd Rill Dr. Va.Bch, 23455

THE Lynnhaven RAMP
from a slightly WARPED perspective
(fotos) Hernandez

18

5
HOT SHOTS

Low Talent
PROFILE: DAN CIMINELLI

COREY O'BRIEN
SANTA CRUZ
BULLET

DEAD AIM

THRASH- MC
TRASH- OR

ED GUTIERREZ

Sic Nature
The Birth of a DIY Attitude

Andy Skateboarding and art always seemed to go hand in hand for me. In the seventh grade I'd get paid a dollar in school to draw tiger stripes on other kids' slip-on Vans. They'd see the designs I'd painted on mine with fabric markers my mom bought me, so I'd tell them to get the all-white ones and I'd paint them. That was the first design work I ever did for hire. Then one of my buddies and I had T-shirts printed from a Lacrosse drawing I'd done with a player throwing a goal and the words "Wing It" on it. I was so amazed

that something I had drawn could be reproduced. We sold about 50 of them. Only a few years later I would begin making designs for 17th Street Surf Shop, my skate sponsor.

Most people skipped art class, but I was a serious little kid, and I was serious about art. My mom sent me to the private school where she taught first grade so I had the same art teacher, Mrs. Adler, from the first grade to the eleventh. She was my mentor and pretty much taught me everything. The only adult to really encourage me in art, Mrs. Adler entered a painting of mine into the Virginia Year of the Child art contest when I was about eight, and I ended up winning. Elizabeth Taylor gave me the award. My mom was really hyped on that.

Glenda Holcomb The picture Andy painted was supposed to be an underwater scene. I took him up to Richmond for the awards ceremony. It was a pretty big deal, and he wore a coat and tie. Elizabeth Taylor was late, of course. She shook all the children's hands and gave them a little certificate. The picture was put on display in our local bank.

Andy Saturday-morning cartoons and after-school shows were probably my biggest influence as a kid. I knew every word to the *Schoolhouse Rock* shorts, and Bugs Bunny and Dr. Seuss were what educated me— they were more a part of shaping me than anything else. The Seals and Kroft shows like *Sigmund and the Sea Monster* and *The Land Of The Lost* also played a part in allowing me to live in fantasy worlds much of the time. Then when I was about fourteen and started skating and listening to punk, I developed a fixation on horror movies, too. *Nightmare on Elm Street* was

the first one I could sit all the way through, and I ended up watching it so many times I knew all the lines. As I got older, I got more into making cartoon drawings myself, and most of them became a combination of punk, skating, fantasy, and horror scenes.

My father had a drinking problem, so I was around this dysfunction all the time and didn't want to be in my house. I'd stay out way past dinnertime and dreaded going home. Art, just like skateboarding, was the perfect escape. It was one of those things I could do on my own. I could tuck myself away and do it by myself and nobody could tell me what was right and what was wrong. My mom told me much later that around that time things between her and my dad had gotten so bad that she'd just kind of checked out. She didn't care what was happening with anyone else in the family for a while—she had lost herself in trying to chase my dad down and stop him from drinking. Meanwhile I was in this private school, putting on a tie every day while all my skater buddies were wearing ripped up T-shirts and flip-flops to school. It totally and utterly sucked.

Everything that was getting crammed down my throat was the opposite of what I wanted. So I reveled in this punk fantasyland. I got turned on to the music—Minor Threat, Ramones, Sex Pistols, Corrosion of Conformity, DOA, Flipper, Black Flag, Dead Kennedys. The Bad Brains especially, because they were these full-on hardcore punks who were black and would break into reggae in the middle of punk songs. The raddest punk band was also the antithesis of punk rock—they were exactly what I was all about! They epitomized dichotomy, and I identified with that. I had this ultra-tweaked, weird side, but then also this good-student side making high grades. I was a punk skater living in a world of jocks and cheerleaders. The Bad Brains saved me. I listened to them every day. I still remember seeing the Destroy Babylon/Coptic Times/I and I Survive EP under the Christmas tree— my mom had actually gone out and found it for me.

Through all this my art took a turn into stuff that was subversive in society's eyes. I drew skeletons skating in pools, Pushead-style characters with the eyeballs falling out. Unreal pictures. It was a rebellion against everything. The drawing I did felt like the rush I got from listening to punk rock. Suddenly, oh my god, I can do anything, say anything, wear anything! And as long as I have my Vans on I'm still a skate kid. When I was about fifteen I used to sneak issues of *Heavy Metal* magazine into my room. They were filled with the kind of art I loved: horror, violence, fantasy, and really hot, sexy images that broke all the rules of illustration and pretty much bastardized the whole comics genre—kind of like what skateboarding was doing to mainstream athletics. I liked *Cheech Wizard* by Vaughn Bode, anything by Victor Moscoso, and another guy named Liberatore. He did an awesome comic called *Ranxerox*. It was so distorted, like a skateboard photographer's fisheye lens turned loose on the wholesome cartoons I'd grown up with. It was similar to what I was trying to do with my skeleton drawings, but these artists pushed it so much farther.

Being a virgin kid who didn't have sex 'til eighteen, I had this huge question mark in my head about sex all through my teenage years, which deeply influenced my art. My private fantasies were like out-of-body experiences which included real girls from my school or magazines mixed with cartoon girls and female comic book superheroes. Boris' girls and swamp dragons made cameos too, because I had one of his prints in my room right next to my Devo *New Traditionalists* LP poster. One time when I was about thirteen my mom walked in on me masturbating in the shower, and she just gasped and slammed the door. She never discussed it with me at all, which was the rule of thumb in my house, and so I developed a complex about my sexuality.

I kind of forced myself into this fantasy world because my sexual urges, which I assumed from her reaction must be wrong or evil, remained unrealized for many years after that. It didn't help that I went through puberty late, too. That was actually one of the reasons I started to stray away from team sports in school and became introverted. So although I was embarrassed and confused about sex, I was also a total pervert. Those fantasy magazines pulled me in because of their perversion in every way: perversion of society, of sex, of normalcy. Everything was blown out of proportion but to me it seemed to make perfect sense. So as an artist, I had kids' cartoons on one end of my influences and the complete debauchery of *Ranxerox* on the other, and I ended up making stuff that was really far out there. "Disney on drugs" *The Face* magazine later called my style, and they were right. The funny thing is I didn't touch drugs, didn't drink—I was a straight-edge punk kid. But I wore ripped-up plaid pants because Steve Caballero had them on in a picture in *Thrasher*, and I always had a shaved head or a mohawk.

When I was around fourteen I started making a Xeroxed 'zine and T-shirts with a ten-dollar Speedball screenprinting kit my mom bought me at a local arts and crafts store. I'd come home from school and disappear into my room and come out the next day, going, "Hey Mom, check out my new magazine." And I'd go to Roses department store with my mom and beg her to buy me three extra packs of white Hanes undershirts to use as blanks for my designs. It was just what I did to think about skating when I couldn't skate at night or during school. I loved to try to figure out how to get it out to lots of people. The result was that fine art and commercial art were meshed at a young age.

Shepard Fairey Skateboarding and punk rock made me feel like it's my world. I could do it "My Way," like the Sex Pistols if I was resourceful. It was all totally DIY, partly out of necessity. There were no punk-rock stores in Charleston, so if I wanted T-shirts and stickers, I had to make that shit myself. I started making paper-cut stencils for my board griptape, for T-shirts, and to put on ramps. That's also what started my whole young-entrepreneur thing. Sophomore year in high school, I made this T-shirt with a Sid Vicious print on it, and right away five kids at school wanted me to

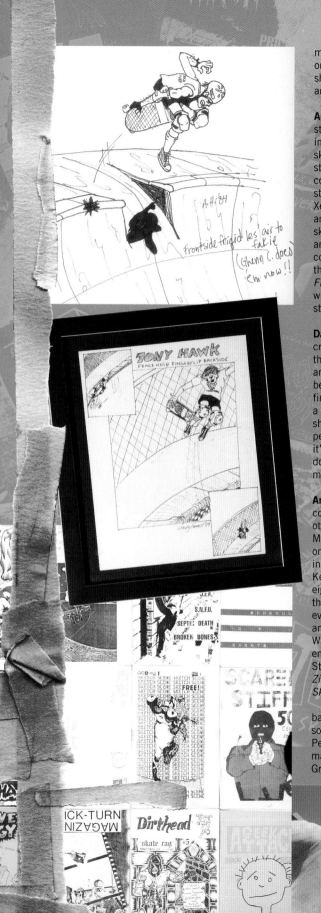

make them one. So the next time, instead of stealing one of my dad's undershirts, I bought a three-pack of shirts; printed them, sold two, kept one for myself, and made four dollars profit. It was awesome.

Andy My 'zine was called *Sic Nature*. I'd write my own stories, type them out on a bad typewriter, cut them into pieces, and paste them up with my drawings and skate snapshots. Then I'd take them to a photocopy store, Xerox them, and make a hundred 8 1/2 x 11 copies folded over. I'd stay up all night collating and stapling them with a saddle-stitch stapler and make Xeroxed crack-and-peel stickers to put in with them, and then I'd mail them to all the people who had skate 'zines in the country. *Thrasher* would list them and *TransWorld* would print the Zine Thing, the most comprehensive list of all the names and addresses of the skate 'zines everywhere. I did another one called *Fluid Motion* a bit later when I was at art school, which featured creative writing about skating with style-oriented photos.

David Choe, artist Punk music, comics, and graffiti created this do-it-yourself ethos because they were all things that seemed within reach. You see or hear them and think, "I could do that. Damn, I could do it better!" It's about never asking for permission. The first time you buy the paint and put it on the wall, it's a revelation: You don't have to go into a gallery and show your portfolio and get rejected by a million people. You just do it and get it out there. And then it's like, "Fuck, I can draw whatever I want, too. I can do all that taboo stuff they said I could never do. I'm my own boss!"

Andy The 'zines were the only tangible form of communication any of us had with other skaters in other scenes in other cities around the East Coast and Midwest. Skateboarding was still hardcore: Most towns only had a few skaters each. There were a few skaters in Allentown, Pennsylvania and some guys in Keystone, a few guys in Raleigh-Durham, and six or eight skaters total in Knoxville, Tennessee. And there'd be maybe five to eight times a summer when everyone from the East saw each other at contests, and besides that we'd all keep in touch by 'zines. What happened is that this web of skaters started to emerge. I'd send letters with my 'zine and drawings to Steve Caballero in San Jose for his mag called *Speeed Zine*, then to Gavin and Corey O'Brien who made *Skate Scene*.

Gavin and Cab were in The Faction, the first punk band made up of skaters. They became the soundtrack to our ramp sessions. In Allentown, Pennsylvania Rick Charnoski and Geoff Graham were making 'zines, Victor Koons' crew made *Geek Attack*, Gregg DiLeo made a 'zine with his friends called

Contort, Charles Harmon made *Dork Zine* and *Speed Wobble*, Brad Marx made *Ragged Edge*. I remember getting a 'zine from the Midwest with a really badly photocopied picture of Jeff Kendall. I mean he was so contorted on a Smithed out invert, it looked like his board was backward. Of course the quality was a terrible high-contrast photocopy, and it wasn't until a couple of years later that I actually saw him do it in person and could understand the photo I had seen in the 'zine. The reproduction quality of 'zines definitely left a lot to the imagination.

Dave Kinsey, artist, co-founder of BLK MRKT Visual Communications I had a 'zine called *Scene Zine* in Pennsylvania. It was art and skateboarding and poetry and stuff. I can still see the cover—I drew a city with graffiti on all the little buildings. I handwrote all the stuff 'cause I didn't have a typewriter. My last issue had a full feature interview with Matt Hensley and he was on the cover. My friend's dad worked at a photocopy place and he gave us the key one night and said, "Okay, do whatever you want." We went buck wild and used fifty reams of paper. I printed 200 copies and they sold in a second. That was rad.

Gregg DiLeo, founder of Division 23 Snowboards, co-founder of Forum Snowboards and Imagewerks Youth Culture Branding Agency Obviously there was no Internet and no cellphones. Communication came down to writing letters or calling from your home phone. So mostly we used the skate 'zines; those became our communication tools. In the early to mid '80s the big magazines like *Thrasher* and then later *TransWorld* only covered the California pro skate scene. They didn't really dip into what was going on in the rest of the country even though there were so may little pockets of really cool scenes, with a lot of good skaters. So we kept tabs on each other through 'zines instead. I lived in Boston and made a 'zine called *Contort*. I'd do road trips and go skate ramps in New Jersey or Pennsylvania and have instant friends cause we'd already traded 'zines by mail. It was really cool.

Andy At fifteen I saw a Bones Brigade promo video with this skater my age named Tony Hawk. He was tall and super skinny just like I was. He did a varial and an airwalk in a pool, super technical. He was so good, I was like, "I want to skate like that guy." So I wrote him a letter with questions for an interview and put an ad in my 'zine saying, "Coming next month, interview with Tony Hawk." Meanwhile a photographer came

and shot all these photos of me and my friends skating in Virginia Beach—there were about six of us who were really good at that point—and we got in *Thrasher*, which was like reaching nirvana. It turned out that the photographer who shot us lived right by Del Mar, so I asked him to shoot pictures of Tony Hawk with some rolls of film I gave him, so I could use the photos in my 'zine.

Tony Hawk, pro skateboarder, founder of Birdhouse Projects Skateboards One day I received my first "fan" letter. It had come from a random address on the East Coast into my mailbox, from some guy named Andy Howell. Skating had very little recognition in those days, so to receive a so-called fan letter was like getting a message from a long-lost brother. I don't remember exactly what it said, but it was more of a penpal correspondence than a letter of praise. I wrote back, excited to make new skating buddies and amazed that anyone outside the Del Mar Skate Ranch staff recognized my skills. As an aspiring amateur skater in the early to mid '80s, prospects were bleak. There was little interest in skateboarding, only one struggling magazine, sporadic events, and only one other skater in my high school. So even though I was sponsored, it was a title that didn't seem to hold much clout.

Andy Tony wrote back to me and answered all my questions for the interview. I was so stoked. A few weeks later, the photographer mailed me back the pictures. It was right when Tony Hawk and Mike McGill were trying to learn 540s—before anyone had done a 540 McTwist—so there was a sequence of him spinning this crazy trick in my 'zine which was just classic, because meanwhile the other pictures in the 'zine were of us skating vert and basically jumping over a curb. At that time we did the interviews by sending letters back and forth, snail-mail style.

Tony Hawk A few years later, after a surge in skateboarding popularity, I saw some pictures of a hot new street skater from the East Coast. It was Andy. Our passions were now allowing us both to live our dreams on opposite sides of the country. Neither one of us gave up—even through much doubt and ridicule along the way. About a decade later, after Andy turned his artistic sensibilities into a legitimate marketing business, Imagewerks, we had the chance to work together on various projects like video games and public-service announcements. And we're both still going strong. We'll always have a connection that runs deeper than just being "fellow pro skaters" at one point.

Andy All those years later, after working together on massive projects for Keep California Beautiful, launching Hawk shoes, and doing art for the *Tony Hawk's Pro Skater* video game series, Tony finally told me I sent him his very first fan letter ever. He said that since we were skating together in contests on a peer level for so long, he hadn't wanted to tell me that before. He'd waited almost twenty years after I had

sent him that letter, and then gave me a board that said, "For Andy, my number-one fan, literally. Thanks for everything." I was so honored, and for me, it was a full-circle thing, because we had both made a life out of being skateboarders. Making the 'zines for me was the first realization that I could do something on my own and reach so many people. Tony influenced me so much as a skater early on and the experience definitely planted a seed in me that continues to drive me to this day.

I was considered to be a complete dork in the private school. Everybody would say, "Oh wow, Andy's really good at art." But I wouldn't get invited to their parties, even though we all went to school together from age five. So by eleventh grade I was totally shut off. It was bullshit. I didn't want to talk to anyone. That's one of the reasons I didn't do drugs. Going to this private school where every kid had a BMW and the parents were completely absent, and seeing these kids my age just flipping out on drugs, I was so not into it. Neither were my skater friends. I think it was because I witnessed this elite group of what I considered to be completely hypocritical people doing that stuff.

Sometime in eleventh grade, a lady came to my school and did a presentation on the Art Institute of Atlanta. I was—very reluctantly—thinking I had to go to University of Virginia and study business and play lacrosse, 'cause that was the kind of thing kids from my school did and it was what my parents wanted. I loved my parents, but didn't feel like they understood me, or even really tried too. Now I know that they only wanted what they thought was best for me. But in that presentation by the Art Institute rep, I discovered for the first time that you could actually be an artist. Art could be your job and you'd get paid. I'd never known that before! I went right home and said, "Mom, Dad, two things: I'm going to be a skateboarder, and I am going to art school. Oh yeah, and I'm going to public school from now on."

Glenda Holcomb By the time Andy got to eleventh grade he just seemed to hate school. All the teachers said that he was becoming sort of reclusive; he came to class but wasn't putting in the effort he always had before. He was so miserable that I asked the father of a boy in my class, a psychiatrist, if he'd talk to Andy privately. And what he told me was this: "Glenda, I don't think Andy has a problem with what he wants to do with his life. He's determined. He knows what he wants to do. You're the one that has the problem."

Chris Miller, pro skateboarder, founder of Planet Earth Skateboards, co-founder of Rhythm Skateboards, Adio Shoes, Hawk Shoes When I was a kid there wasn't an awareness of "skateboard art" or personal expression within skate art. Board graphics were pretty straightforward typography or graphic art like stripes or checkers. It wasn't until the late '80s that Neil Blender started doing his own graphics for his own pro model that I realized the opportunity. I don't remember any other pro skater using their skate graphic as a form of personal expression before him.

Though I always drew and kept sketchbooks as a personal outlet as a teenager, and though I was skating and was already pro by seventeen, I didn't realize the opportunity to combine these interests until later on in my career.

Andy At Bayside Public High School, all of a sudden I was a superstar, because the culture I was into was revered. There, the jocks were the outcasts, and the surfers and skaters were the shit. Every cheerleader wanted to go out with me. Of course I was a total dork, going, "Uh, I don't know what to do with girls." But after a few months I started to catch on. When I finally *did* have sex for the first time that year, it wasn't at all like the fantasies that filled my head growing up. But then again, it wasn't half bad, and I ended up having a great time with the girls at Bayside. I hated my mom for keeping me in private school so long—this was so much better. It was racially mixed, and for the first time since my sister and I had memorized Sugar Hill Gang's "Rapper's Delight" as kids, I was introduced to rap music. A kid in my art class named Corey Baines would bust rhymes as my skate buddy Otha would tap out beats on the desk.

Corey and I became good friends, he was such a poet, and he inspired me to get into writing rhymes. I remember one time in English composition class he wrote a birthday rhyme for my teacher Mrs. Stefansky, who had always pushed us both creatively, and he stood up and rapped the entire thing. His two-minute birthday rap had captivated the whole room, and when he finished our teacher was almost in tears and everyone in the class was screaming "Whoa-oa!" I was awestruck—and that's the moment when I got into hip-hop. It was 1985. My mom was always so paranoid about Bayside, and there were definitely some bad elements in there, gangs and white hesher drug-dealer kids, but I was past the point of being influenced by peer pressure. I'd hang with kids who were into it and I'd stand out 'cause I'd be like, "Nah, I don't do drugs or smoke pot." And they'd be like, "What? That's crazy! Everybody's into it!"

Blake Ingram After meeting Andy in California when we were both fifteen or so, I'd go back to the East Coast from time to time and end up connecting with him. We'd go skate together and go on trips. One time in 1985 we were skating on this University campus, and Andy was riding this marble bench. He was ollieing up five-0 but somehow missed the bench; his board fell away and his shins rolled along the edge of the bench and his skin rolled up in a kind of swirl. I had a shocked look on my face and Andy started yelling, "What are you laughing at?" I wasn't laughing though. His face was dead white, all the blood had rushed from it. It was pretty bad. We ended that session and a few days later went to Nags Head and did some surfing and fishing together. I got a call from him a couple of weeks later, he was in hospital and had developed this incredibly serious infection from the injury.

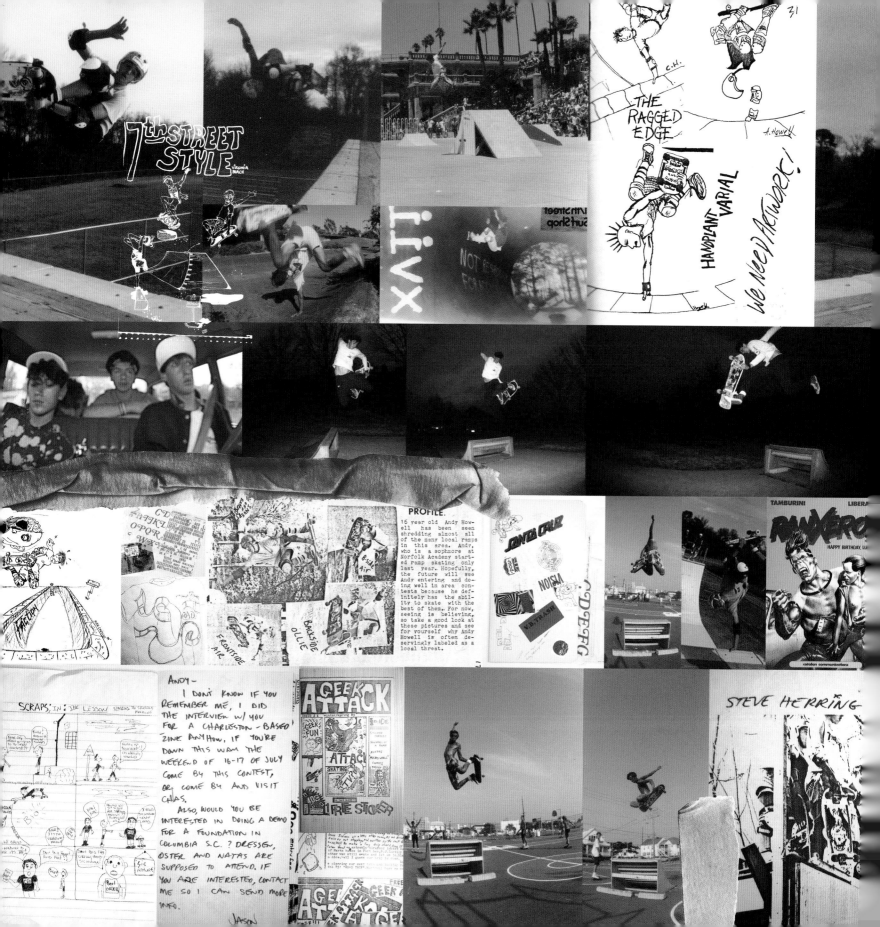

7th STREET STYLE
VIRGINIA BEACH

THE RAGGED EDGE

C.H.
A. Howell

HANDPLANT VARIAL

WE NEED ARTWORK!

PROFILE.

16 year old Andy Howell has been seen shredding almost all of the many local ramps in this area. Andy, who is a sophomore at Norfolk Academy started ramp skating only last year. Hopefully, the future will see Andy entering and doing well in area contests because he definitely has the ability to skate with the best of them. For now, seeing is believing, so take a good look at these pictures and see for yourself why Andy Howell is often deservingly labeled as a local threat.

SANTA CRUZ
NOISIA
V.B. TRASH

TAMBURINI LIBERA

RANXEROX

HAPPY BIRTHDAY, LU

FRONTSIDE AIR
B-SIDE AIR
BACKSIDE OLLIE

FACTION

catalan communications

SCRAPS IN THE LESSON

ANDY—
I DON'T KNOW IF YOU REMEMBER ME, I DID THE INTERVIEW W/ YOU FOR A CHARLESTON-BASED ZINE ANYHOW. IF YOU'RE DOWN THIS WAY THE WEEKEND OF 16-17 OF JULY COME BY THIS CONTEST, OR COME BY AND VISIT CHAS.
ALSO, WOULD YOU BE INTERESTED IN DOING A DEMO FOR A FOUNDATION IN COLUMBIA S.C.? DRESSEN, OSTER AND NATAS ARE SUPPOSED TO ATTEND. IF YOU ARE INTERESTED, CONTACT ME SO I CAN SEND MORE INFO.

JASON

GEEK ATTACK
winter/spring 85
INSIDE
GEEK FUN
ATTACK
SKATING TIPS
FREE STICKER

STEVE HERRING

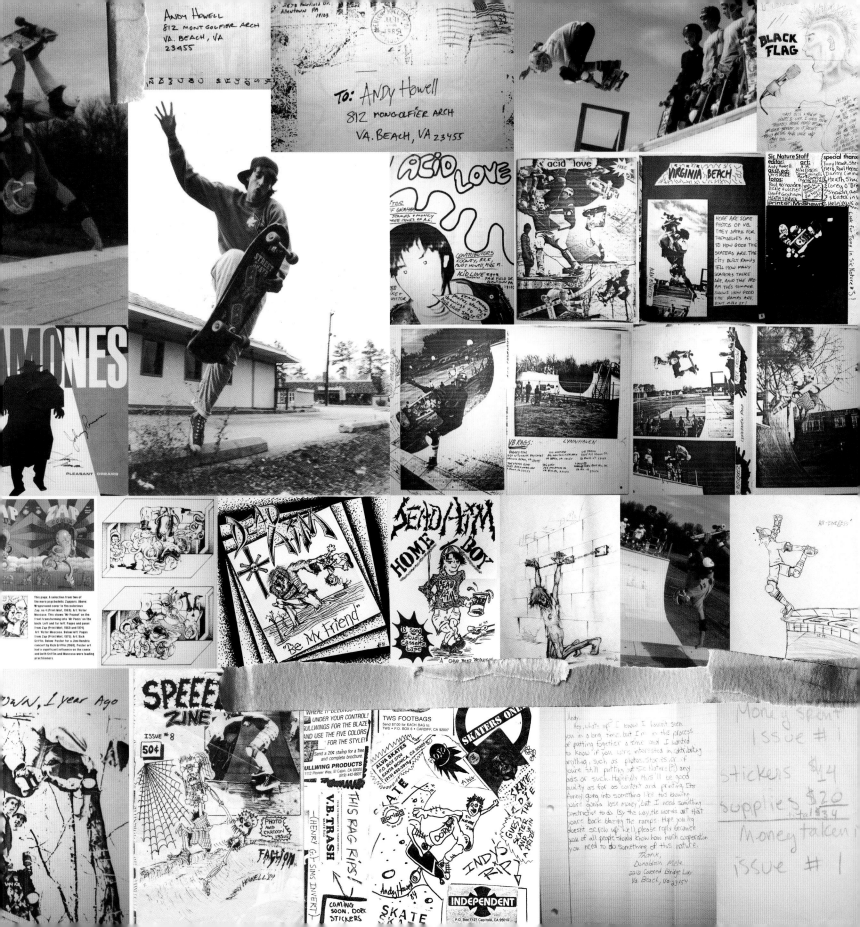

Glenda Holcomb Sending Andy off to art school the first time was so hard. Two weeks before he was supposed to go, he was hospitalized because a shin scrape from skateboarding had gotten reinfected through surfing, and bacteria got in. It got serious, and the surgeon said the infection was so close to the bone I had to sign a release form giving permission for them to amputate his leg if necessary. Luckily, that didn't happen. But he was supposed to be on an IV drip for a month. I drove him to school for his first semester with this IV pole dragging behind him. He didn't want to go and kicked up a fuss, but I said, "You're going, and that's that." I'm sure when he arrived at college people thought he was a big druggie. He called after day two and said he was going to risk it and take the IV needle out.

Andy I remember walking into the orientation the day before school started, dragging this IV pole on wheels behind me. I sat in the back and tried to hide out. Everyone glared at me, except this one punk-rock chick who came up and started talking to me. I guess she thought it was cool. We became friends immediately, and it set the tone for my social life at art school.

While I was studying traditional art at Art Institute of Atlanta, I started really digging into all these late '80s-early '90's erotica and sci-fi comics and graphic novels on my own. Vaughn Bode and his *Cheech Wizard* books, Moebius' amazing girls, Serpieri's Druuna series, *The Watchmen*, Frank Miller, Milo Manara, Ralph Bakshi's *Streetfight*. That's when I started creating the types of characters that would later be New Deal and Element graphics. Using this new style I painted people I saw on the street, bums and bag ladies, cops, security guards, girls I wished I could meet. And at the same time I was getting schooled on the so-called "real" artists—Goya was the most influential on me. I never bought into the difference though, it was all art to me. If anything, Liberatore was much more relevant—he was doing these fantastic stories, set in his futuristic vision of Rome, about an eleven-year-old neo-heroin addict, her pussy-whipped robotic lover and guardian, and preschool kids in gangs. It was like George Orwell's *1984* on steroids, and I loved it.

By the third year of art school I was making a living from art, doing my own board graphics and comics and graffiti. We'd get some assignment at school, like medical illustration, and I'd come in with full graffiti pieces all twisted and disproportionate. The teachers were like, "D." I thought, "Fuck you, I'm already an artist!" I was even rebelling against the conformity of art school. But it did teach me to have self-discipline to get the job done under ridiculous deadlines. There were a lot of all-nighters spent lost in the right side of my brain. Art school also gave me a killer work ethic and the ability to have multiple jobs going on at once. It's something that's probably been my blessing and my curse ever since.

previous and following spreads:
Making and Trading Zines
Virginia Beach circa 1984-1986
Various Artists, Photographers, and Writers

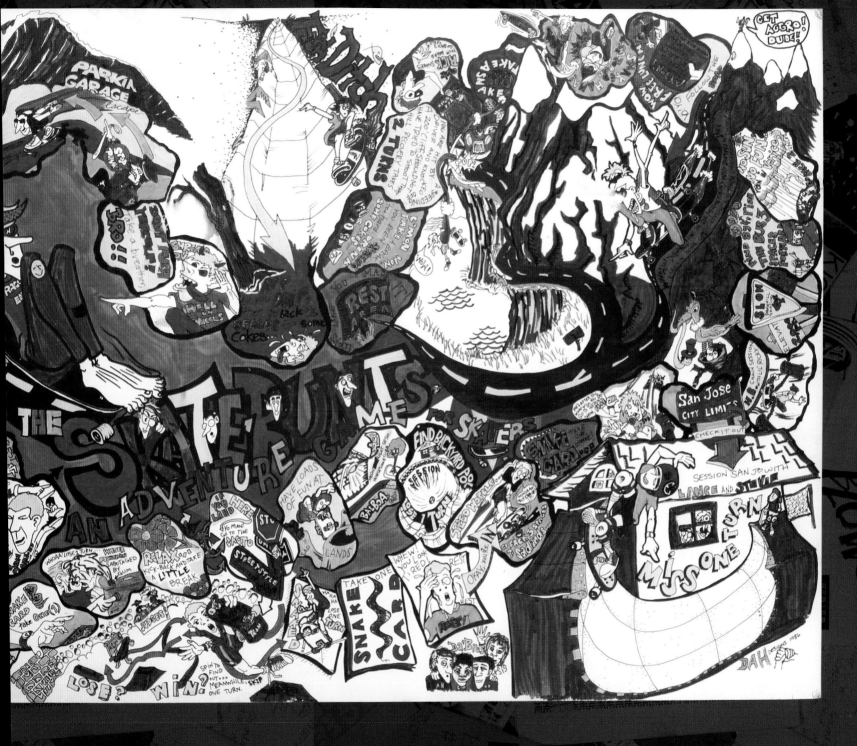

The Skate-Runts, An Adventure Game For Skaters August, 1986
This is a board game I created while I was stuck in the hospital in quarantine for 2 weeks, just before I was supposed to go away to the Art Institute of Atlanta. My mom brought me all kinds of art supplies because I had this grand idea of creating a board game and selling it to Mattel.

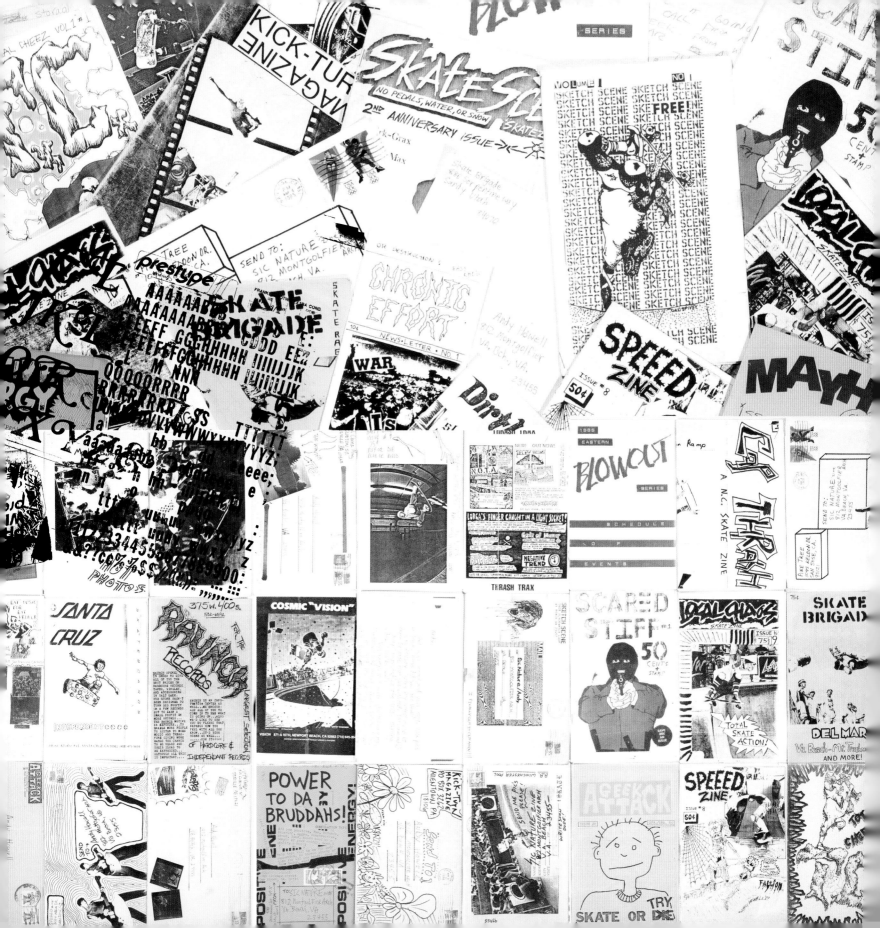

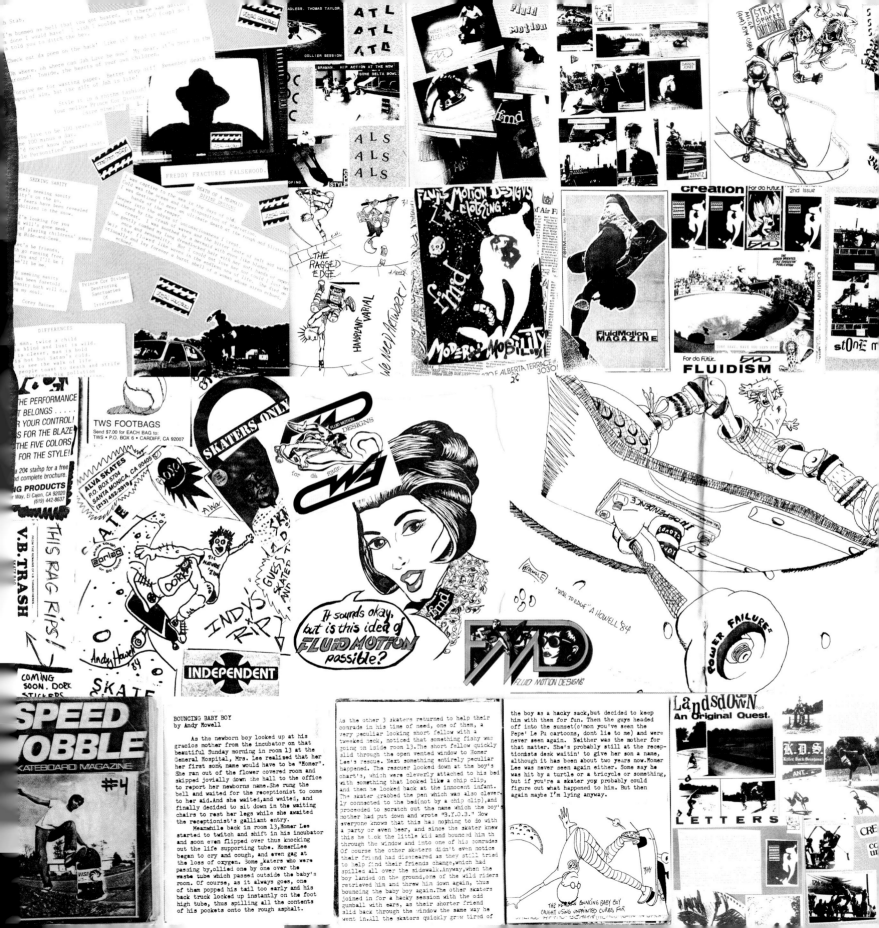

BOUNCING BABY BOY
by Andy Howell

As the newborn boy looked up at his gracios mother from the incubator on that beautiful Sunday morning in room 13 at the General Hospital, Mrs. Lee realised that her her first song name would have to be "Homer". She ran out of the flower covered room and skipped jovially down the hall to the office to report her newborns name. She rung the bell and waited for the receptionist to come to her aid. And she waited, and waited, and finally decided to sit down in the waiting chairs to rest her legs while she awaited the receptionist's galliant entry.

Meanwhile back in room 13, Homer Lee started to twitch and shift in his incubator and soon even flipped over thus knocking out the life supporting tube. HomerLLee began to cry and cough, and even gag at the loss of oxygen. Some skaters who were passing by, ollied one by one over the waste tube which passed outside the baby's room. Of course, as it always goes, one of them popped his tail too early and his back truck looked up instantly on the foot high tube, thus spilling all the contents of his pockets onto the rough asphalt.

As the other 3 skaters returned to help their comrade in his time of need, one of them, a very peculiar looking short fellow with a tweaked neck, noticed that something fishy was going on inside room 13. The short fellow quickly slid through the open vented window to Homer Lee's rescue. Next something entirely peculiar happened. The rescuer looked down at the boy's chart's, which were cleverly attached to his bed with something that looked like a chip clip, and then he looked back at the innocent infant. The skater grabbed the pen which was also cleverly connected to the bed (not by a chip clip), and proceeded to scratch out the name which the boy's mother had put down and wrote "B.Y.O.B." Now everyone knows that this has nothing to do with a party or even beer, and since the skater knew this he took the little kid and bounced him through the window and into one of his comrades Of course the other skaters didn't even notice their friend had disappeared as they still tried to help find their friends change, which had spilled all over the sidewalk. Anyway, when the boy landed on the ground, one of the wild riders retrieved him and threw him down again, thus bouncing the baby boy again. The other skaters joined in for a hacky session with the odd gumball with ears, as their shorter friend slid back through the window the same way he went in. All the skaters quickly grew tired of

the boy as a hacky sack, but decided to keep him with them for fun. Then the guys headed off into the sunset (c'mon you've seen the Pepe' Le Pu cartoons, dont lie to me) and were never seen again. Neither was the mother for that matter. She's probably still at the receptionists desk waitin' to give her son a name, although it has been about two years now. Homer Lee was never seen again either. Some say he was hit by a turtle or a tricycle or something, but if you're a skater you probably could figure out what happened to him. But then again maybe I'm lying anyway.

THE NEWBORN BOUNCING BABY BOY CAUGHT USING UNPAINTED CURBS FOR

SPEED WOBBLE
SKATEBOARD MAGAZINE
#4

Landsdown...
An Original Quest.

K.D.S.
Killer Dork Sessions

LETTERS

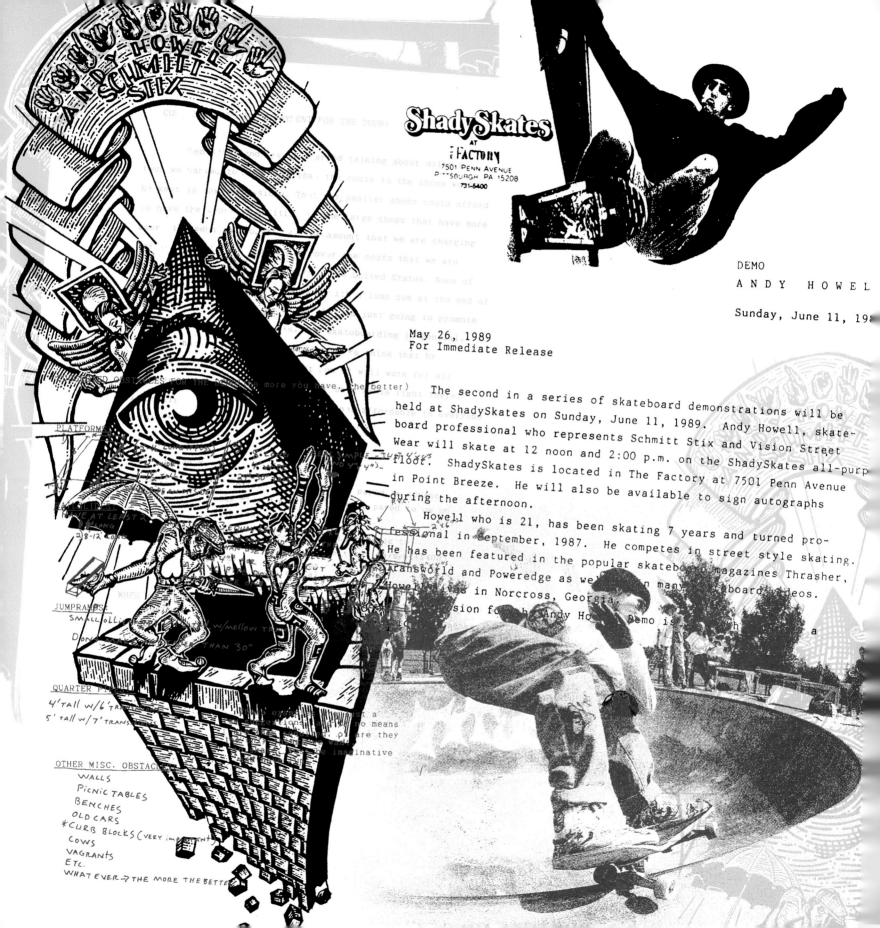

ShadySkates
AT
Ħ FACTORY
7501 PENN AVENUE
PITTSBURGH PA 15208
731-5400

DEMO
A N D Y H O W E L

Sunday, June 11, 19

May 26, 1989
For Immediate Release

The second in a series of skateboard demonstrations will be
held at ShadySkates on Sunday, June 11, 1989. Andy Howell, skate-
board professional who represents Schmitt Stix and Vision Street
Wear will skate at 12 noon and 2:00 p.m. on the ShadySkates all-purp
floor. ShadySkates is located in The Factory at 7501 Penn Avenue
in Point Breeze. He will also be available to sign autographs
during the afternoon.

Howell who is 21, has been skating 7 years and turned pro-
fessional in September, 1987. He competes in street style skating.
He has been featured in the popular skateboard magazines Thrasher,
Transworld and Poweredge as well as in many skateboard videos.
Howell lives in Norcross, Georgia.

PLATFORMS:

RAILSLIDES:
HAVE AT LEAST R...
...LONG
2/8-12 LONG

JUMPRAMPS:
SMALL ROLLI...
DON... THAN 30"

QUARTER P...
4' TALL W/6' TR...
5' TALL W/7' TRANS...

OTHER MISC. OBSTAC...
 WALLS
 PICNIC TABLES
 BENCHES
 OLD CARS
 *CURB BLOCKS (VERY IMPORTANT)
 COWS
 VAGRANTS
 ETC.
WHATEVER → THE MORE THE BETTER

CHAPTER 3
AN UNORTHODOX PROFESSION

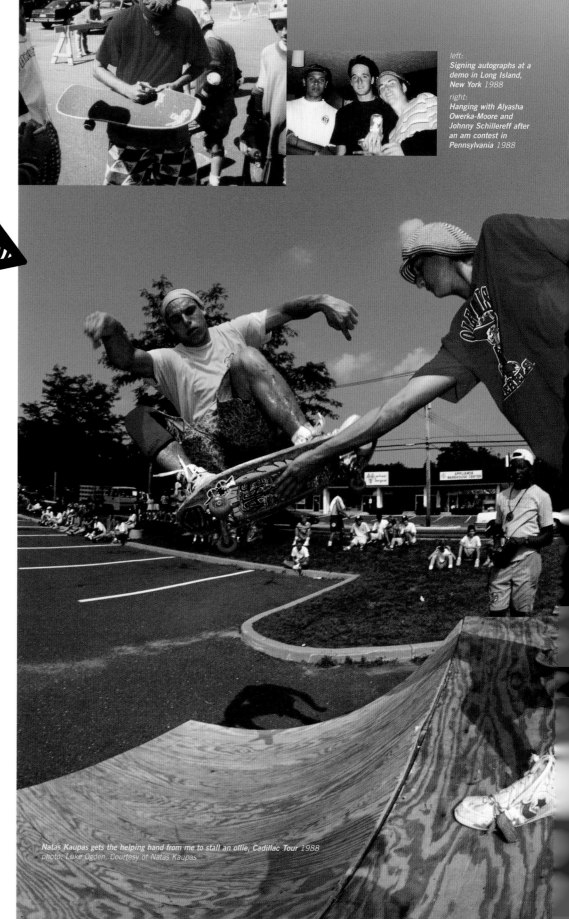

An Unorthodox Profession
Turning Pro Without a Sponsor

Andy As an amateur skateboarder, I traveled around a lot with friends going to contests. By seventeen I was going out to California for CASL and NSA contests. I wasn't getting coverage in mags, but I was starting to get known in this underground web of skaters and 'zines. I had met Tony Hawk, Mark Gonzales and Tommy Guerrero, and still had the dream of one day being a pro skater. But I wasn't getting the support of Santa Cruz anymore. They just stopped sending boards. So I said, "Fuck it, I'm in art school, and I'll just focus on that right now. Maybe this skating thing is just a fantasy." That lasted three or four months. I realized I had to do it, and I knew it was my only opportunity to turn pro. If I didn't do it I might stay unsponsored for a year or two, and I wouldn't be relevant anymore. I'd have to take a completely different course and get a job doing commercial art for some local Kinko's or something.

When I was nineteen, I considered turning pro at the first Savannah Slamma contest where I skated in the practice sessions on an old board my friend Reggie Barnes had flowed me ages before. I'd called Stacy Peralta at Powell and asked to skate for his team, and I was supposed to hook up with Lance Mountain at some point during the weekend and skate in downtown Savannah. I never met up with Lance, but Stacy came up to me during practice. "You gonna skate this one Andy?" he asked me.

"I don't know Stacy, my board's kinda busted up." I was hoping he would miraculously ask me to skate for the Bones Brigade and flow me a brand new board to skate in the contest. But he just paused a minute and then said, "You're skating good, I think you should skate." And that was it.

There was a ramp to wall where I tried my first nollies, so this must have been '88. The jump ramp had a 2x4 deck and then went up against the wall,

Natas Kaupas gets the helping hand from me to stall an ollie, Cadillac Tour 1988
photo: Luke Ogden, Courtesy of Natas Kaupas

and the vert and some street guys were doing frontside wall rides and grabbing the rail to pull off and land on the floor—everybody was doing that. So I'm like, "Screw this, I'm going to skate this like a transition to wall, and go back down into the jump ramp." But there was a lip on the ramp so you could hang. So I went straight up the ramp onto the wall, and started trying to pop my nose on the wall and "nose ollie" back down fakie into the ramp. I was putting my leading hand on the wall and kind of pushing of the wall to try to get a little more pop. Up to this point I had never seen anyone pop off the nose on a trick like

that. I started to make them, then Gonz came over and started skating with me, and called Tony to come over too and skate the wall. I rode up the wall really high and grabbed a backside air and jumped back in and landed a fakey on the jump ramp. Then I did a frontside air and mute air back into the ramp. Tony and Mark started to do the frontside airs back in too. It was really fun, innovating with those two guys, the best in their respective fields. I can remember a really tight quarterpipe close by and Neil Blender was doing pivot fakies on a curb block on top, and Tommy G's massive ollie to mutes to the soundtrack of Eric B. and Rakim's *Paid In Full*. That was the first time I heard hip hop in skate contests. There was a massive budda budda wall that Christian rode all the way to the top of, like twenty feet of vert, and hung on his arm on the railing that held back the crowd, stalling for them in his classic style. That was pretty amazing. The massive oversized street obstacles were so unrealistic, yet the crowds were getting bigger, so people couldn't see the smaller more tech stuff from far away.

I said to myself, "I can't fucking do that!" There were a few guys actually street skating there, among them Julien Stranger, Tommy Guerrero, Natas Kaupas, and Neil Blender. But circus props were in full effect and I couldn't really compete with the vert cats on that kind of terrain. I was too nervous, and didn't want to look ghetto skating a tattered old board, so I didn't turn pro. And Stacy didn't ask me to ride for his team. I went back to Atlanta feeling rejected, but I continued to skate every day with my friends. And I knew time was seriously closing in.

I still had that undying hunger to push through my fears and make it happen. The summer when I was nineteen I set my sights on the Olympic Velodrome

contest in Carson, California as the place I *had* to turn pro. It was now or never. But I didn't have a board sponsor, only 17th Street Surf Shop and Indy trucks, and I was riding a Schmitt Stix Lucero Street Thing that I'd bought myself. I called my friend Blake Ingram and told him I was flying myself out for the contest. Blake and I drove up to the contest in his beat-down old yellow VW Bug, and I remember the fear of not making it to the contest was almost as bad as the fear of what would happen when we got there.

Paul Schmitt Really through the history of skateboarding, if somebody came to a pro contest without a sponsor and turned themselves pro, they were considered a joke and basically never heard from again. It was usually a case of a guy thinking they were something they weren't. But Andy knew that he was what he was.

Andy I remember I stood on top of one of those slanted walls at the Velodrome, which was the customary launch pad for everyone's run. They called my name, and it might have been Kevin Thatcher or Dave Duncan or whoever was the announcer who said, "Next up, from Virginia Beach, Virginia ...? And he doesn't even have a board sponsor ...?" There were these huge pauses that seemed years between the words. For everyone else it'd be, "Skating for Hosoi skateboards ... " and the crowd would cheer, "*Waaaa!*" I get up there and it's like total silence because nobody knows who the fuck I am. I just hear, "He's skating for 17th Street Surf Shop ... ?" I looked down at my hand holding my board and it was shaking so hard I couldn't even put it under my feet.

Once again, there were all these massive circus props to give skaters like Tony and Christian Hosoi, who were amazing vert skaters but not what I considered true street skaters, the ability to do stunts that the crowd would go crazy for. But I came to the Velodrome and thought, "Fuck it, I'm going to skate it the way I skate street." There was one wall with a small jump ramp up to it that vaguely resembled a bank to wall on street. Other skaters in practice were doing handplant wallrides à la Mike Vallely. Aaron Murray and Scott Oster were doing Venice-style wallrides off the ramp and pulling off onto flat ground. Johnny Kopp was throwing his patented boneless off the wall back into the ramp. I started doing wallrides to frontside airs and wallrides to nose ollie to fakie, all going back into the jump ramp, which no one was doing.

Tommy Guerrero Vert was pretty compulsory. There was pretty much the same bag of tricks that everybody drew from, though some could do them longer, faster,

higher, or more stylishly than others and there were always a few standouts with a different approach. Street skating was difficult to judge. There was really nothing to reference. It wasn't like, "Do a standard trick here, then this trick or that trick." It was more about how a skater perceived the obstacle or whatever it was they were going to skate.

Andy Suddenly it hit me. Two weeks previously, I'd gone to an amateur contest in a roller rink in Wilmington, North Carolina where all these rad Carolina skaters like Reed Tysinger, Smith Long, and the Duong brothers—Mark, Billy, and Joey—were doing stuff that never got covered or seen in magazines. We were all skating this obstacle with a one-foot high bank at a 45-degree angle to four-foot-high wall that was eight feet long, and we were doing wallrides to rail slide coming back into the wall and down this tight little bank fakie. Rail slides jumping up to five-O off the end of it, landing fakie on the flat. We did so many tricks off it that when I got out to the Velodrome, I thought, "That's nothing." It was a really easy version of the obstacle my friends and I had been skating in North Carolina.

So I'm standing up there before my first pro contest run with my toe on my board, which looks like it was 100 miles away or like I was seeing it through tunnel vision or something. I see my little tiny front foot reach over to start to stand on my board and I'm like, "Oh my god, I'm dropping into my first pro contest!" I can barely see my board, it looks like this tiny toothpick under my feet, so I drop in, skate the bank, and fly across the middle section with my legs wobbly.

I think I rode a nose wheelie by accident halfway down that huge bank. I couldn't even get my board to stay straight. I was thinking, "Just get me to that wall, if you can get me across this stupid huge bank and get me to that ramp to wall, I know I can do it." And that was all I was thinking. I came across that flatground, and my board was sketching, and I took a push and rode up that wall and slid across it, and I was in the air, thinking, "Oh my god, I'm going to land it." I landed it, and there's Tommy and Natas sitting on their boards at the end of the wall watching my run. They both jump up and knock me off my board giving me five, and they're like, "*Aahhh!*" screaming. I don't even remember the rest of my run or the contest. Nothing else mattered after that: Two of my all-time heroes had given me props on a trick. I made it. There was no other feeling like it in the world.

Natas Kaupas, pro skateboarder, Global Creative Director, Quiksilver That was the best trick of the whole contest.

Blake Ingram Andy was nervous. It was definitely a ballsy move. He stepped up and told himself he was going to give it his best shot. There was a four or five-

CLASS OF 88

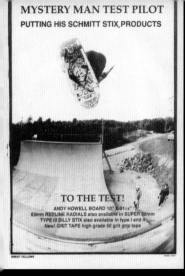

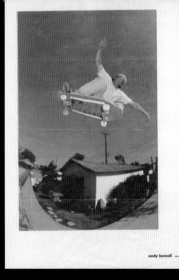

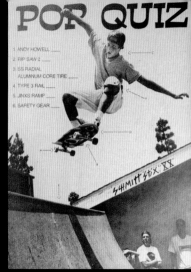

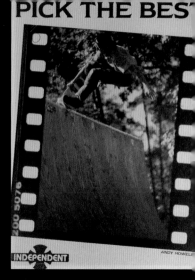

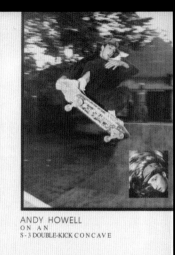

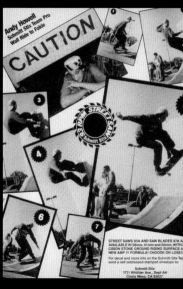

foot wall, and Andy was doing a wallride into a boardslide. I don't think anybody there had actually done that up until this point. So everybody sat up and took notice.

Paul Schmitt There weren't many guys who went pro in '89 who weren't pretty well known as vert skaters. But the NSA Velodrome contest was a street-only contest, which was rare. Andy stood out drastically because his approach was genuine street, not just vert guys riding street ramps. It marked the beginning of something—the start of a generation that gave street its own style.

Tommy Guerrero It always happens that there's some cat who nobody knows who just comes and rips. Everybody's done that. But Andy's approach was different. The trick he was talking about—the wallride up the trannie to a boardslide on a four by eight sheet on its side, off the end of it—it was awesome. And no one was doing it. And Nautas and I were like, "Oh shit, man that was ill!" He was a ripper. Competition is competition, but most of the time you're

competing against yourself. The attitude was never, "I'm going to beat this or that guy," especially amongst me and Nautas and Jim Thiebaud and Eric Dressen, we were just all friends.

Andy I couldn't believe it, I think I placed just outside the top ten, and afterward Paul Schmitt walked up, and he's like, "Hey Andy, I see you're riding a John Lucero Street Thing." I said, "It's the only real street board out right now." I told him it was the only board with a long enough nose to be usable for real street skating, and it had a good tail and was thin. It was almost a hybrid of a street style and freestyle board for that time period. And Lucero was one the first street skaters. I loved it. Schmitt asked, "Do you want to skate for my team?" I was stoked, and could only reply, "Just flow me free stuff, I'd be stoked to ride. You don't even have to give me a model." That was my level of understanding of the whole pro skater game at that time. He assured me to the contrary, that I would get paid *and* get a pro model. Two days later I went back to Atlanta with a fat box of Schmitt Stix stuff, and the

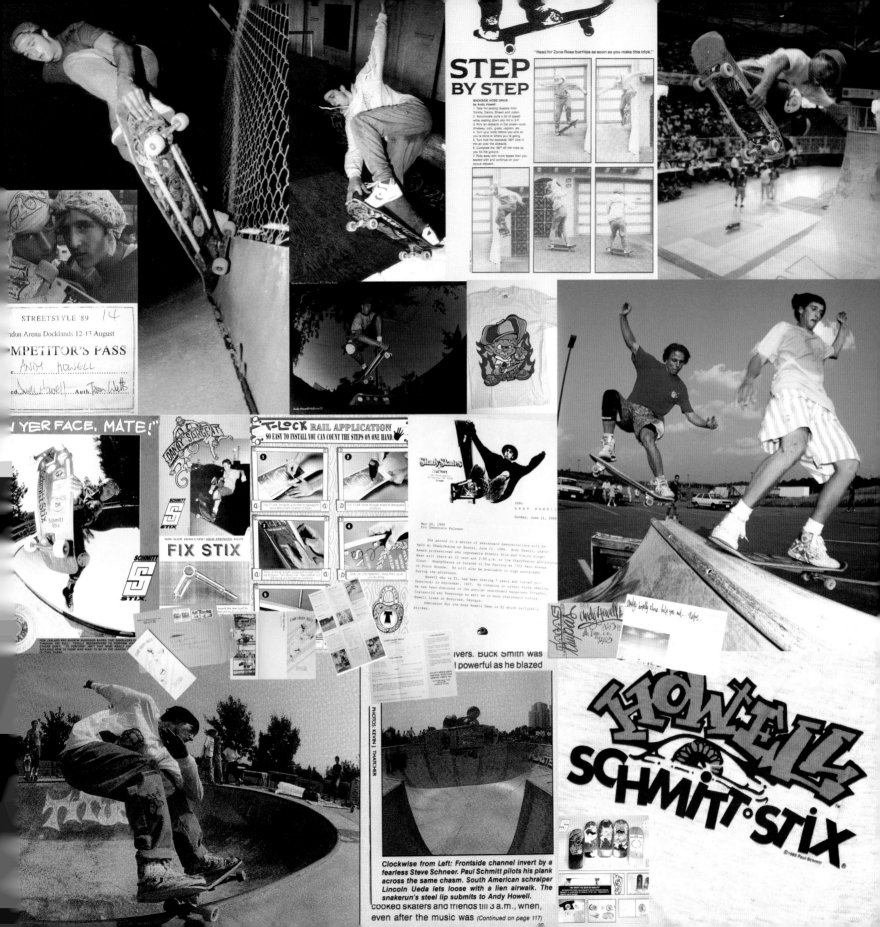

STEP BY STEP

BACKSIDE NOSE DRIVE
by Andy Howell

"Head for Zona Rosa burritos as soon as you make this trick."

STREETSTYLE '89 14
ndon Arena Docklands 12-13 August
MPETITOR'S PASS
c. ANDY HOWELL

N YER FACE, MATE!"

T-LOCK RAIL APPLICATION
SO EASY TO INSTALL YOU CAN COUNT THE STEPS ON ONE HAND.

SCHMITT STIX

NOW MADE FROM A NEW! HIGH STRENGTH! ALLOY
FIX STIX

ShadySkates

May 26, 1989
For Immediate Release

ivers. Buck Smith was
powerful as he blazed

HOWELL SCHMITT STIX

PHOTOS: KEVIN J. THATCHER

Clockwise from Left: Frontside channel invert by a
fearless Steve Schneer. Paul Schmitt pilots his plank
across the same chasm. South American schralper
Lincoln Ueda lets loose with a lien airwalk. The
snakerun's steel lip submits to Andy Howell.

cooked skaters and friends till 3 a.m., when,
even after the music was (Continued on page 117)

cool thing was that though I didn't get top placing in the contest, I think I made a mark. I had a sequence in *TransWorld* of it for the contest story and a full page in the contents page of *Thrasher*—a single full-page shot of me doing that slider on the wall.

Paul Schmitt The wallride that Andy did at Carson was a very big deal, it's what got him noticed. He was very off-the-wall wild. I was like, "Jesus, he's riding my equipment!" The way he skated the course was unlike everyone else, and I knew if I didn't grab him to sponsor someone else would.

Alyasha Owerka-Moore At that time, you never really heard about skaters unless they emigrated to California. But Andy was this Virginia guy who turned himself pro and killed everybody. He started getting in the skate media and all of us on the East Coast totally knew who he was.

Andy I skated for Schmitt Stix from the day I turned pro, mostly because it was owned by Paul Schmitt, a fellow East Coaster, and because the best vert skater in the world, Chris Miller, skated for him too. Paul gave me my first break. I was stoked, I had my own pro model, unlimited money and products, and free travel to anywhere in the world at age nineteen. I was living on permanent vacation from 1988 to 1995. I was able to buy a house in Atlanta, and it became the hang-out spot for visiting skaters and friends.

Paul Schmitt Andy and I were both East Coast guys. A lot of the people who made it in skateboarding were from the West Coast. If you were West Coast, you were already here. You were part of it. If you were East Coast, you had that hunger to make it—to become part of it.

Andy As a rider for Schmitt Stix, I wanted to do my own everything—graphics, T-shirts, advertising. I was in art school, after all. Vision, who owned Schmitt Stix, didn't want me drawing anything. They said, "You can sketch us something and tell us kind of what you want, and we'll have an artist do it." Paul was super cool about it. He was always saying, "Do the work, and I'll take it to them." Finally I got my first board graphic, a pyramid representing money and corruption with these evil hypnotized corpo guys circling around it. It was all about man's obsessions and the evil of money, as well as a subversive commentary on Vision and the monster skate

becoming more open to giving their riders more creative freedom. Graphic design and ad layouts were just kind of the next step. Andy and I both had the agenda of making Schmitt Stix more rider influenced and we pushed that.

Paul Schmitt The point of being a pro at that time was to go to pro contests, skate different places, and have people talk about you. If you were accepted by your peers and they talked about you, then you were the shit. And they talked about Andy.

Andy When my first pro model for Schmitt came in the mail, I almost fainted—my own artwork on my own pro model, to be distributed all over the world? I was blown away.

Paul Schmitt His board was the first that came out with the nose that looked like a kicktail. It was the SK44 Concave. "Give yourself a kick in the nose," was the marketing line he came up with for it. In sales it was number two or three behind Chris Miller and Bryce Kanights. It sold really well. Schmitt Stix was more about hardcore skateboarders, the purest, realest skateboarders that mattered. They're all still in the industry to this day, the Schmitt team guys.

Andy Pro skating opened up a whole new world for me. We'd be on tour, going wild to some extent, partying with local girls, or if we were unlucky hooking up with skate groupies we called betties. But on the other hand I'd also get to hang out with Chris Miller in our hotel room and just make art. We'd connect over our love of art, his love of a girl, and my dreams of one day meeting someone I cared that much about. As pro skateboarders we were all removed from real-world responsibility completely, and everywhere we went we were treated like superstars. All I had to do was show up to the demo or contest and ride my skateboard for a while. I could draw or make music or design T-shirts, or go out and with my friends and do murals and graff pieces anytime.

It was carte blanche for real, total freedom. And that really amped up my artwork. It opened me up to the world outside the U.S., and showed me how this huge community of kids existed who were turned on to skateboarding. It was incredibly empowering to discover that what we were doing might actually be part of a much bigger, shared consciousness. One time at a demo in Austria, this crowd of a hundred kids came up to our van and just started rocking it like they were going to roll us. They were screaming for free boards and stickers, trying to turn over our

companies of the time run by suits who had never even felt a board under their feet. I think I was one of the people that made it legit, like Gonz and Neil Blender, for skaters to do their own graphics. Chris Miller was doing his own graphics for Schmitt Stix at the time, too. It was a challenge because the executives weren't really having it. They thought they knew best.

Chris Miller Skaters doing their own art was becoming a new trend within the industry. This was the era that skate art was sort of born. There were still only a few people who were doing this, so it was a way to distinguish the brand and product from other corporate design stuff. Neil Blender, John Lucero, Mark Gonzales, Natas, and a few others were doing their own graphics. It was working, so companies were

van, holding their boards in the air. It was such a buzz. And it only made me want to do more—to make more, say more, and express more things that people would be into. For me, the whole point became to create a connection with people all over the world through this shared love of skating.

Chris Miller I got on Schmitt Stix after G&S. At first it was hard for me because I had been with G&S since I was twelve or thirteen and I was such good friends with Neil Blender and the whole group. They were bummed that I quit G&S and left them. They sort of took it personally, when it was just business to me. With skateboarding you spend so much time together that there is a lot of personal connection between teammates. It's not like other sports where everyone views it as

business, and you get traded around or whatever. So now I was traveling with a new group of people and gradually being pulled in a different direction and forming new relationships. It was hard for me, and definitely a transition period in my life. Of everyone on Schmitt Stix, I think Andy and I connected right away because of our interests in art and life. When we would travel to contest or events we would room together. I had just met my future wife, Jennifer, and Andy and I talked a lot about love, relationships, art and life in general. I think we kind of made a cerebral connection in our perspective on the art of life.

Sal Barbier, pro skateboarder, co-founder of Elwood Clothing, marketing executive, Zoo York In Louisiana, where I grew up, I found myself skating by myself downtown for what felt like forever—maybe two and a half years. I was skating on the street because all the ramps were torn down. That's all I had access to. And I could never take anything from the magazines or the videos because there was nothing in them for street skaters. There was nothing to learn, so I'd just go out and experiment—on stairs, on gaps, on anything I could find.

One thing that really stuck out for me was seeing pictures of Andy at Savanna Slamma 2 or some contest back in about '88 or '89. He was an East Coast skater riding this wall wearing a pair of shorts—

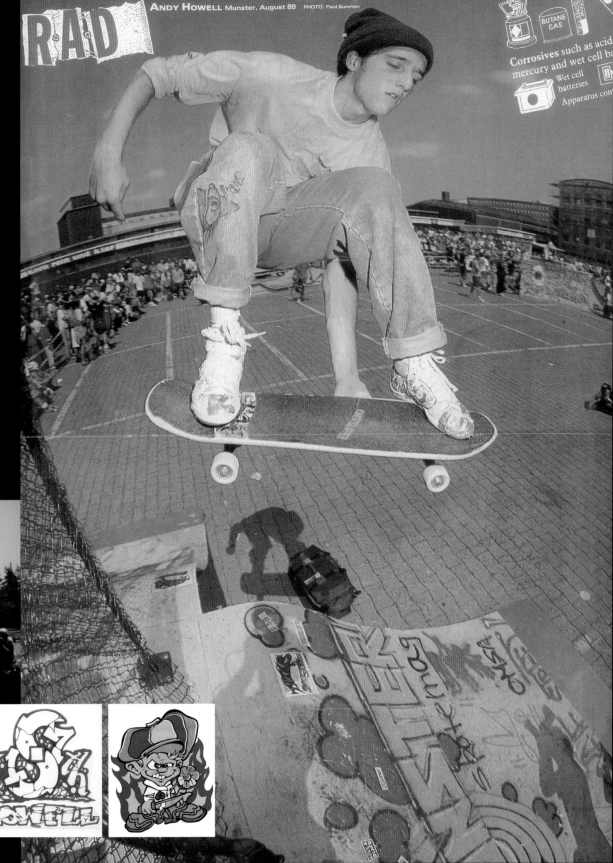

ANDY HOWELL Munster, August 89 PHOTO: Paul Sunman

RAD

ch'ck OUT

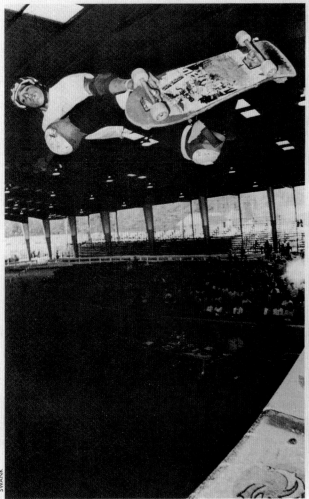

Andy Howell

Born: 2-17-68
Height: Close to 6'
Weight: 150
Sponsors: Walker, Independent
Home: Atlanta, GA

Andy Howell once lived in a city many consider to be one of the hottest skate spots in the country — Virginia Beach. He had the city ramps wired as well as any of the other locals but decided to move elsewhere because he was more into street skating. Andy needed a change of pace.

He is currently attending school in Atlanta and skating better than ever. Ramps are plentiful but he can usually be found skating downtown alone. Andy prefers ripping down hills, sliding, slapping, and constantly moving over any other type of skating.

Andy spends most of his time street skating but can still shred vertical. His recent seventh place finish in the NSA Southeast Amateur contest will take him back to Virginia Beach in October to compete in the Eastern Regional.

Andy's closing comments: "Go back to basics. Before you learn a 360 Rocket air off the junk jump do a haul-ass slappie and some downhill slides. Carve a pool and grind it before you do backside airs and inverts in it. Stay mellow and remember fluid motion. Charlie Dubois and Otha will shred the East coast and Prince Corski will rock the mic."

— Britt Parrott

I remember it clearly. He went off a ramp to wall, into a wallride, then into a rail slide on the top of the wall and dropped off. Me and my friend Charlie Thomas were cocky little kids who'd critique everything in the magazine, but that was one page that made us stop and go, "Hmm, that's actually pretty cool. We can't do that."

Steve Douglas Being on tour could be kind of ridiculous. Before New Deal started, we were going to London for a contest, all the Schmitt Stix team. We'd just arrived back from Holland and were looking for a place to stay. We arrived at Victoria Station and this guy came up and said, "Do you need a place?" Yes we did. He said, "I've got the best place, it's a palace, just like Hollywood, with a fabulous pool …. " So we drive out to the far boroughs of London and finally pull up to this house, and it was ridiculous. In the back of this rundown back garden was this old blue fifteen-foot paddling pool—that was his "pool." In the rooms, there were crates on the floor with old doors balanced on them and mattresses on top, and six of these "beds" to a room. As the one English guy on the team, I was like, "See you later guys, I'm gonna stay with my sister!"

Andy Skate tours and demos were pretty budget when the teams paid for them, but when local distributors in the various countries picked up the tab, it got a little more crazy. One time in the midst of a two-month tour of demos, Rick Ibaseta, Justin Girard, and I ended up in Athens, Greece. We spent one day skating and a week lounging and partying. The Greek distributor also owned a company that imported speedboats, and we ended up taking a hydrofoil to the island of Poros in search of his partner to enjoy a day of watersports. We sped around the island on rented mopeds until we rolled up on this long single dock with jet boats and this tan Greek dude waving us in. He whipped us around in the speedboat on tubes, and then when we got back to the dock he looks Rick up and down and asks, "How much do you weigh?" We thought the dude was gay or something, trying to hit on Rick. But Iba answered him and the guy's face lit up. He looks at all three of us and in his best English says, "How would you like to *parasail*!"

Five minutes later we were lashed together and standing on a floating platform way out in the bay, with a two hundred and fifty foot rope connected to the crazy speedboat on the other end. The engine roared, and we were yanked off the platform and into the bay. As soon as we went under water and before we had time to panic the boat took off and we were launched straight up into the sky over the bay. In seconds we were two hundred feet in the air, and I arched my back and looked upside down at the cruise ships and the boats and the town, and just screamed. It was complete freedom, a once-in-a-lifetime experience, but for a pro skater on tour that kind of thing happened every day.

SWANK

The Chris Miller "Cat" Pro Models at left and on previous spread were among the first graphics done by a pro for his own model. I remember seeing art of Chris' graphic ideas in his sketchbooks when we would roam together at contests. His style on a board and with a pen are still among my all time favorites to this day.

PAUL SCHMITT
179 E. 17th St., Suite A-1
Costa Mesa, CA 92627
Phone (714) 722-0350
Fax (714) 957-8006

January 10, 1990

To the Retailer:

Hopefully you made it through the onslaught of another Christmas season! Schmitt Stix would like to say Happy New Year and welcome to 1990! Not just another year but a new decade! In this coming year I would like to become familiar with your shop and how much or how little of my product line you carry and if things are going okay. Also, does your distributor fulfill your orders and have you had any problems with getting my products?

One item in particular I would like to bring to your attention is my new T-Lock Rail System. I'm not sure if you have seen them. If not, they are a totally new type of rail that basically doesn't have any holes for mounting but instead has a slot on the under side which runs from end to end. Now you still have to drill holes through the board but the mounting hardware itself is the particular item I want to talk to you about. It consists of a bolt and a special fastener nut for which the rail slides onto. Once the rail is slid onto all four fasteners and tightened down firmly, it's on there until you change it next time! The one problem that has with this application is when the bolt part of the fastener was designed, its length didn't match the changing thickness of the different brands of skateboards on the market. If the board is too thick or the grip tape has already been applied, the bolt may or may not be quite long enough, which makes the rail mounting difficult, frustrating and in some cases, impossible.

So in coping with this problem, I believe that it is my duty as a manufacturer to correct this problem and reimburse you, the retailer, for any inconveniences you may have had with the T-Lock System. What I am offering is an 11/64 high speed steel drill bit and 200 8/32" x 5/8" pan head bolts, enough for twelve sets of T-Lock Rails. Use them as you need them. By late February the T-Lock System will have specially made bolts that will overcome all of the current problems. HINT: For those customers who are already using the rails on their boards, I suggest retightening them a couple days after installation. This snugging them up locks them for good!

In closing, if you have had problems with the rails, I would like to apologize for the inconvenience and if you have any questions concerning the T-Lock System or any of my other products, please don't hesitate to call me direct. Also, the Schmitt Stix Spring 1990 Demo program is filling fast, so if you would like to schedule a demo, call me and I will do what I can to make it a positive event! If you are going to attend the A.S.R. show in San Diego, please drop by booth #2800 and say "Hi". I will gladly show you the newest designs and advertisements in the Schmitt Stix product line.

Andy Howell/San Francisco, Ca/Vuckovich

SLTIIFLEL

128

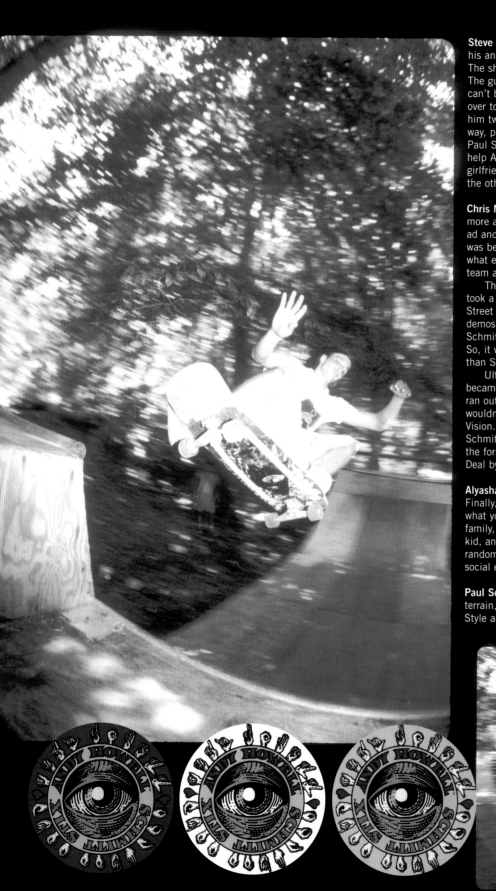

Steve Douglas On another trip to Amsterdam, we got in a fight. Andy had hurt his ankle and he was grazing through this store, eating some raisins as he went. The shop owner caught him and was going to throw him out, so I intervened. The guy said, "He's thieving!" and I said, "C'mon mate, he has a bad ankle, it can't be that big of a deal, leave him alone." So as we walked out the guy ran over to me and whacked me across the head. I ran back to him and whacked him twice. Another guy jumped over the counter, pushed my girlfriend out the way, punched me with his rings on and split my eye open. Next thing I know Paul Schmitt's grabbing me and marching me out the door. I was only trying to help Andy out—Andy didn't want any help, by the way! I had to get stitches, my girlfriend's crying 'cause the guy punched her to get to me, then I was pissed at the other guys because they basically watched my girl get punched out.

Chris Miller For me, one of the best aspects of Schmitt Stix was developing more as an artist and designer. It gave me my first experience of laying out an ad and doing graphics for someone other than myself. Also, with my own art I was becoming more confident in my choices and not worrying so much about what everyone else thought. What was great was that Paul really listened to the team and tried to give us a lot of creative freedom.

 The worst aspect was the fact that as a subsidiary of Vision, Schmitt always took a back seat to Vision. There was a lot of pressure to kind of promote Vision Street Wear, even though I didn't actually ride for them. I would get sent to demos and events that would turn out to be Vision promotions. I was the only Schmitt Stix rider there, and outside of me, the brand would have no presence. So, it would wind up looking like I was another Vision rider and help them more than Schmitt Stix.

 Ultimately I left Schmitt Stix because the corporate politics with Vision became a barrier to achieving what we wanted to accomplish. When my contract ran out with Schmitt, I wanted to renew, and Paul wanted to renew but Vision wouldn't agree and let it lapse. Then they approached me about riding for Vision. I think this demonstrated their true priorities and lack of concern for Schmitt Stix. I was forced to pursue other options. This is ultimately what led to the formation of my company Planet Earth and also to the formation of New Deal by the remaining Schmitt Stix riders and Paul.

Alyasha Owerka-Moore The autonomy of skateboarding was really attractive. Finally, you could find people who appreciated you no matter how you dressed or what you listened to. You could have this kid from a mega-affluent suburban family, a kid from the projects, a Texas white-trash punk-rock kid, some Goth kid, and a British guy all sleeping on somebody's living room floor in some random place in the Midwest. And none of their styles or musical subcultures or social economics ever came into play, just because they were skateboarders.

Paul Schmitt Skateboarding's so individual. Even though you're riding the same terrain, it's not truly competitive—there's nothing scientific about the scoring. Style and flair is so much part of it. That's something Andy always had like

nobody else we knew. We couldn't even quite understand it, because we just didn't know what it was about. How he skated, how he dressed, what music he listened to, what books he was reading, his changing hair and clothes, he's just always oozing style and flair. That's in one way Andy's downfall, the fact that he's not satisfied with what is. He always wants something else.

Blake Ingram Back then I had this bright yellow VW bug, like a bumblebee. Every time Andy would come out to California, Huntington Beach was the focal point. Vision and Schmitt were there, and eventually New Deal. We'd hook up and take road trips to skate camps in Santa Clara County with a big sign on the car that said "Schaeffer Beer, Proud Sponsor of Poor Taste," and "Will Skate For Beer." We'd do our own alternative skate tours. One time it was Jason Lee, Andy, and I, then another time it was us and Ed Templeton, all crammed in the Bug. We'd call ahead to friends in different areas and go crash with them, like Ron Allen in Oakland, who skated for H-Street at the time. There was this big network of people you could just bum around visiting. Couch tours, we called them. At that point, people were making money off of skating—nobody was getting rich, but definitely enough to travel around. That *was* our job. Skating was our life. I'd wake up in the morning, and that'd be the first thing I'd think of. What am I going to skate today, where am I going to skate, who am I going to skate with? Sometimes we'd make a whole day out of skating a curb. We didn't need Playstation back then.

Damon Way, co-founder of Droors Clothing and DC Shoes In that period when street skating was born, skateboarding was definitely an art—there's still an art to it, of course—but with guys like Mark Gonzales and Natas and Tommy Guerrero, it wasn't just skateboarding, it was the way they skateboarded. It was a sort of magic. You'd see a guy like Matt Hensley

skate down the sidewalk and just ollie things, and it was so beautiful. They could do the simplest trick, but the way they'd do it was so amazing. It seems that a lot of that has been forgotten and overlooked, and now it's about, "How many stairs can you throw yourself down? How close to death can you come? And how does that work into a video part that next year becomes obsolete?" I think skateboarding's gotten so disposable. It expires so quickly, whereas before it seemed timeless. That's the heart of the era Andy comes from. Seeing him skate, he was just so graceful and creative.

Matt Hensley, pro skateboarder and musician The late '80s early '90s was a great time in skateboarding, when the skaters started doing it for themselves. Our crew, VSL, was just a bunch of skaters from Vista, we called it the Vista Skate Locals. We all pushed each other to look at things and obstacles in different ways.

Tommy Guerrero At the time I didn't see is as a movement, I didn't see it as anything. I was just skating. It's what I'd done since age nine. Go skate. And it just happened to be that where I lived—San Francisco—meant I was doing it in the streets. I mean, we'd go skate ramps, parks, we'd travel all over, we'd skate anything. It wasn't like, "We're street skaters or we're vert skaters." Now I look back and there was definitely a movement happening. But that had a lot to do with the fact that in California, many of the parks were closing down due to insurance reasons. So a lot of people were like, "Okay, I guess we'll just hit the streets and make our own scene." Completely by necessity. It's a mindset, it's the way you are.

From street skating—from skating in general—you nurture that behavior to be creative, to persevere, to think different, to be tenacious, to have that drive. Just like learning a trick: You tried it 10,000 times before you did it. So you just carried that over to all aspects of life that you tend to take on as you got older. And obviously, being skaters, we never wanted to be part of the mainstream or anything that had to do with the masses. So later in life, we were like, "We're not getting a fucking job flipping burgers." We were going to try to do whatever we wanted.

Steve Douglas When I first met Andy in Virginia Beach, he was mainly a vertical boarder. And he was probably the most diverse out of all the guys there. Everyone else was going really high, big airs, big inverts. Andy didn't go as high, but he had a lot of originality and lip tricks. He was very creative in every sense of the word—there was nothing bland about him. So when he translated all that into a new style as a street skater, it was totally different.

Blake Ingram He had this lanky style, but stylish, kind of free ... like his arms kind of flopped around a little. He was inventive, always trying to come up with his own tricks and stuff, and he never really had a set routine. Very versatile, because he had a background in vert so when he took to street he was very well-rounded. He could just about skate anything.

Andy Gonz was the guy I watched and learned from most. He remains my favorite skater of all time. Wherever I went, I always hoped I'd have the same practice session as him, so I could watch him ride the course making up something completely different—something nobody had ever done before. There was a huge street contest in Ohio, and Gonz was ollieing from a bank to rail slide across a rail and then whipping this crazy nose lipslide thing where he'd go down into a super steep quarterpipe. And he'd come off it going Mach ten, and then he'd cruise up to a handrail and do a huge 180 ollie to backward 50-50 grind down the handrail. Seeing him skate for years later always blew my mind, just like that first time in Huntington Beach.

Alyasha Owerka-Moore Skateboarding wasn't just about technical ability, it was about style, and Andy had both. For me it was really rad personally because he was tall and I'm tall. So like everybody, I was jazzed on him—but I was extra jazzed 'cause he was tall and had mad style. Really fluid but focused. And fast. A lot of people who skated fast just kind of spazzed out all over the place. But everything he did he stuck, which was extra impressive because he was doing things that were pretty complex back then and doing them really big. He was like a gazelle ... or maybe a springbok.

Andy I did the whole pro tour thing, going to the contests, the Ohio contest, Savannah Slamma, the San Francisco municipal pool contest. The year after I turned pro there was Hawai'i street style—I think it might have been a mini ramp and a street contest. Gonz frontside ollied this twelve-foot gap between the two ramps. There was so much sick stuff going on.

Chris Hall, pro skateboarder, director Rick Ibaseta, Tommy Guerrero, Sal Barbier, and Jim Thiebaud held this camp in Amherst, Massachusetts in 1991, called Interskate '91, where they put on demos and taught kids how to skate. Ali Mills and I drove up there from D.C. and just stayed the whole time and skated. We would do these little sessions where we taught kids, and we filmed our first video parts there. We made up some tricks, too. Andy was there. I might have been the first person to do a kickflip nose wheelie, which no one had seen before on tape. Ali did the first nollie kickflip on tape, which no one had seen before either. It was about innovation, showing people some new stuff. It was really fun. Rick, Andy, and I were filming stuff one night, we had squirt guns. We'd pull up at the lights and find people walking and filmed ourselves hitting them with water. It was crazy funny, until one guy threatened to shoot us with a real gun. It was about ten years before *Jackass* did it.

Andy Interskate '91 was a very innovative environment. There were actually some really good obstacles, but that wasn't what made it innovative. It was the people who showed up to the camp, Tommy, Chris Hall, Thiebaud, Ali Mills, Sal, all these guys who were really pushing the envelope during that time. Ali Mills was

unbelievable, he was one skater who got slept on big time, a real innovator. We were there for only about two weeks, but so many tricks for our video parts came out of it.

Tommy Guerrero Interskate was out in the sticks. Jim Thiebaud, my friend and now my partner at Deluxe, and I would go out there and meet a bunch of the other cats out there like Alyasha and Barker and so many friends from the East Side. We'd all get together and skate and create mayhem. One night in particular I remember with Andy— we had our personal disdain and frustration with the U.S. at the time—and we got really drunk and were talking shit going, "We're out of here. Let's divest and sell everything and just split." We really liked London because it was still really urban and had this big city vibe. So we were like, "Let's move there and get the fuck out, man." And it was pretty funny the next day we were like, "What were we talking about?" Now it's our ongoing joke. "When are we selling out and moving?" It's more relevant than ever now I guess.

Andy Even through all of this, I always wanted to impress my mom and dad. Everything was fun and games, we were making new videos and skating and traveling, and I was doing a lot of art on the street and for graphics and ads. But I never felt that my parents really cared about what was going on with me. I continued to feel as I had from my early teen years, a bit isolated and cut off. And definitely craving their validation. But it never seemed to come. I can remember skating, creating completely new stuff, yet thinking, "This isn't good enough." I was constantly beating myself down but at the same time forcing myself to go farther than I could have ever imagined. I'd think, "This sucks, my skating sucks, my art sucks." I had a lot of self-doubt that came from hearing earlier, "You should go to business school, no one ever makes a living from art or from skating, you picked the two worst things you could do, so... prove us wrong." Shit, I was constantly wondering, did I make the right decision? Should I do this? So much self-doubt. But I was never afraid to go for it. I just kept busting.

When I see an idea in my head it looks so real, already colored and moving. I just started to believe if I could imagine it, then it was already real, the rest was just the mechanics of bringing it to the physical world. It wasn't until much later that I heard the infamous quote from Picasso, "Everything you can imagine is real." I combined that with my other primary code of conduct: "We're doing it; it doesn't matter how long we have to stay up, we're getting it done today." And so I just kept bustin'.

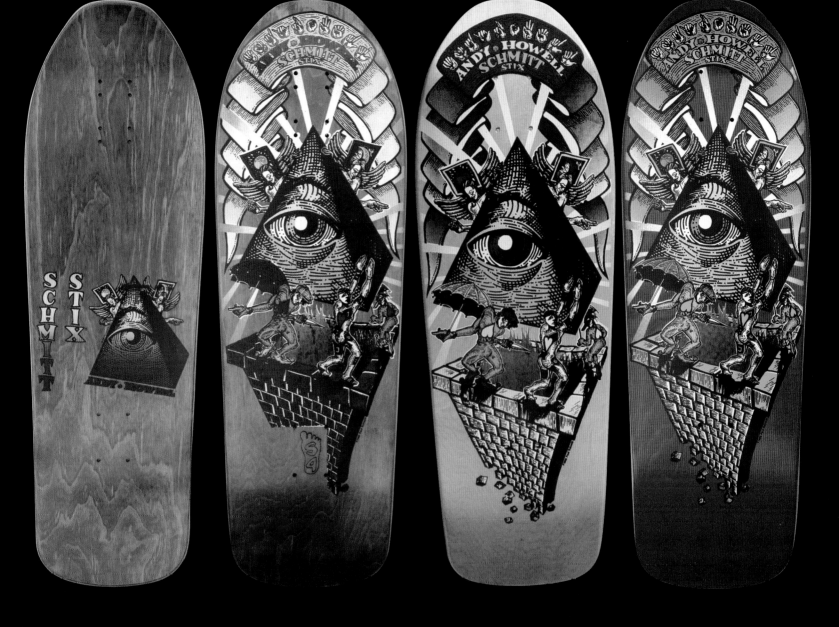

My first pro model for Schmitt Stix came out in 1989. When I created the artwork for it I was really into Stanley Kubrick, and I was reading alot of conspiracy theory and free masonry stuff. I pictured society like this very unstable wall built up around the mirage of security and happiness created by money (represented by the all seeing eye). These evil Clockwork Orange characters with upside down hearts had cornered a pure hearted man on the edge of the wall and were ready to force him off. Nobody could communicate, so the angels of light and dark above were making hand signals to the people below. Everything seemed so temporary and superficial to me at the time, symbolized by the wall, which trailed off into the abyss and eventually crumbled into nothingness. When my board came out I started to get a lot of fan letters, and many people thought beacuse I had used hand signing to spell my name that I must have been deaf. Actually the original graphic I submitted to Paul Schmitt didn't even have my name written on it, and I had spelled my name with hand signing. I told Paul I wanted it to be a mystery, something the kids buying the board would have to figure out themselves. Of course that didn't fly with the commodification of my name as a pro skater, so I had to add my name into the graphic.

CHAPTER 4
A NEW DEAL

The New Deal *By Skaters, For Skaters*

Andy All of us on Schmitt Stix wanted to do our own company—we were always talking about it. Chris Miller kept going to Paul and saying, "Let's split up from Vision and start our own thing." But Paul wouldn't buy it and Chris couldn't wait around. He bailed and started Planet Earth and subsequently launched Rhythm, Adio, and Hawk Shoes. Steve Douglas, Ed Templeton, and I, along with some of the other guys on the team, knew that was the last straw. He was our best skater. It was at the Del Mar Street Contest when everything went down, the one where Tony Hawk won and gave his trophy to Hensley because Matt by far blew everybody's doors in that contest.

Steve Douglas We were in a Denny's at this Del Mar hotel. Chris Miller had just left, and Paul was about to go to Europe the next morning. So I said to Andy, "It's time to do something, and I've got a plan." The relationship between Paul and Brad Dorfman was horrendous. We were the second-class citizen company. But I'd worked all the trade shows and already met a guy from NHS who said, "When you're ready, we'll back you." Turns out, Paul had actually known this all along! So we basically all stormed him and said, "We're starting a new company, and if you don't agree, we're leaving." I'd just come back from the U.K. and my friends over there had a store called The New Deal, so I was wearing their T-shirt and had the sticker on my board. That name just seemed to fit. We wanted a new deal!

We went back to the hotel, all happy, then John Lucero, who was in the next room down, came out and looked at me and said, "You Schmitt guys look way too happy. Why are you all smiling? Chris Miller just left. Hmm." He looked at me in my T-shirt and said, "I think you're going to leave Vision and start a new company ... called New Deal." It was thirty minutes after we'd decided to do just that—I was totally shocked! So I said, "No no no, Paul's got no balls. He won't do that." My heart was beating—we had to keep it quiet!

By the time we got back to our room, Andy was already sketching our New Deal logo on a napkin. Paul came in and said, "As long as we're not a rock and roll band and we don't make coffee, we're okay." He'd given in, and already researched the name to see if we could use it. So we said, "That's our first ad; here's our first logo!" And Paul's words became the tag line at the bottom of the ad.

Andy Ed Templeton, his girlfriend Deanna and I went to this grocery store across the street, and I bought a set of crayons and a cheap drawing pad. We went back to the hotel room, and I drew the New Deal logo that same night—totally in crayon. Everybody was stoked, and I thought, "It's messy, it looks like kids did it, and it's perfect for a skateboard company made by skaters." At the time every board graphic out there was hyper-realistic skulls and wack '80s graphic design done by professional artists. It was nothing we gave a shit about.

Paul Schmitt My success was always in research and development, not marketing, so if I hadn't let go of Schmitt Stix I probably wouldn't have had the success I had.

I let go, took Andy's lead, image- and marketing-wise, and Steve's lead in terms of the drive to build a team.

Andy Paul got put between a rock and hard place and finally had to give in, but luckily, he'd secretly built his own woodshop. He'd had it hidden away for about two or three years and it was his R&D lab where he was developing new concaves and molds and basically innovating boards through the '80s. When he got pushed over the edge by all of us, he broke his contracts and together we started New Deal, and since we now already had our own custom woodshop, we could make all our own boards. That's how he'd earned the nickname "Professor Schmitt" in the '80s. He'd started off as an apprentice boat maker and then turned his attention to boards, not boats. He was the mad scientist of skateboarding, constantly innovating.

Johnny Schillereff, President, Element Skateboards Launching this new, punk-rock start-up company was a super ballsy move, especially for Paul Schmitt. If there was anybody who took a massive risk, it was the guy who had a company called "Schmitt Stix," decided to not call it that any more and leave his name behind for a corporation to use if they wanted, and start New Deal instead.

Steve Douglas It was a great time, really creative, we used to camp out at Paul's house in Costa Mesa, secretly doing this company. We had to keep it quiet because we were still getting our checks from Vision.

Andy I was living in his garage, sleeping on an old mattress, freezing at night. I stayed there for five months as we created the company. We did it all just sitting at his kitchen table creating the graphics and the look: I gave New Deal a very do-it-yourself vibe with hand drawn logos and black and white ads with simple text blocks. I used a spot color of yellow, and that became the company color. The cartoon-style graphics were basically all the stuff that my friends and I were graffiting on walls in Atlanta. It was a total blast. Whenever we got sick of working, we'd go out with a camera and film footage for a promo video to launch the whole thing.

Shepard Fairey New Deal helped push skateboarding forward from the skulls and slick graphics phase and brought in an urban aesthetic that better fit street skating. Everything went from vert skating and backyard suburban culture—all leather jackets and mohawks—to a new culture of railings and steps and hip-hop and graffiti.

Andy There weren't many companies solely created by people who lived and breathed skateboarding. We had a perfect unit, me on all creative fronts—board graphics, ads, promo videos, clothing design, overall creative direction—Steve Douglas managing the team and acting as the general company visionary, and

New Deal Box, *1990*
When we started New Deal and I was creating all the graphics and the look and feel for the company, I was obsessed with customizing everything. My friends and I in Atlanta were drawing alot of graffiti styled charcters and I decided to create a box design for New Deal that told the story of a kid bombing the New Deal Logo on a wall. One side would catch him in the act, and the other side would show the wall after he had finished the logo and split the scene. I had drawn a series of spraycans with the New Deal sun on them, and I incorporatied them into the design. And of course I added in my trademark sarcasm on the box top as a warning to anyone who dared open it. By the time the box was released, New Deal owned the bright yellow color we were using in our ads, so the box became this glowing beacon, and shop owners could see us coming when the UPS man came to make the delivery.

Professor Schmitt with the mad-scientist approach to making products in his woodshop. All the pieces were there, so it was a natural progression. It was a complete blast to do exactly what we wanted and what we felt would work.

I took these inspirations that I was feeling from my life in Atlanta and being around hip-hop and graffiti and stuff, and I mashed it with all the cartoons I grew up on as a kid. It became the style of New Deal. I was never the best artist in the world. I was the guy who knew how to put things that I was seeing or feeling together, and it translated into a Middle America skate phenomenon. What I was doing was so different from anything out there—but still it was really accessible. Because when I mixed up *Ranxerox* and Moebius and Victor Moscoso and all these cats into my art, it was like kind of a tweaked version of the Disney comics that kids were growing up on. They already knew all that stuff, it was like cornerstones of their lives already, so they understood where it was coming from.

Sal Barbier When you're coming from Louisiana like I was, you're not looking at the people from California for the trends. You're looking at whoever is standing out in the magazines and video—and that was Andy. That influenced me. He didn't look like he was from San Jose, where they're wearing leopard-skin kneepads and playing bass guitar when they're not skating. He had this whole other vibe of graffiti-slash-hip-hop-slash-skate, all thrown into one. And you could see that in the New Deal graphics.

Andy When New Deal popped out, it was the antithesis of all the big corporate skateboard companies run by fiftysomething execs who had no idea what a skateboard even felt like. It felt touchable, it didn't feel like it was about superstars. Up to that point, skating was Gator and Christian Hosoi—Hosoi was one of the biggest inspirations to me ever in the vert days, but the period of big vert skating and the superstars was now becoming totally irrelevant, and we had chucked the whole corpo approach. What was coming across to skaters around the world through us doing New Deal was, "Screw that, we're skaters making a company for skaters, and you can go out and do it yourself too."

Paul Schmitt I was startled in a sense by what Andy and the others were doing. I was up for it, though some of it was debated. It didn't feel like a risk, though, because we were confident in what we knew how to do. Due to my connections to the magazines, I could sneak our ads in and no one knew who we were. That mystery helped us create interest in the brand, and the company grew extremely fast. We shipped our first product on June first, 1990, and by the September trade show, we were ranked number-three in the market. We had a promo video in the shops featuring great progressive skating and products, but no one knew where it came from—we marketed this great mystery, partly for legal necessity, and it really worked. Nothing since has had that start-up success

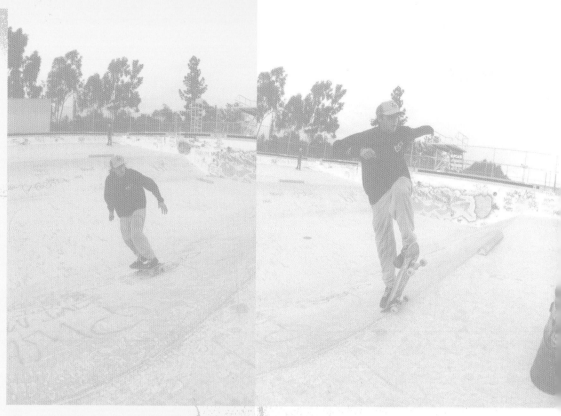

for us. Andy was the slightly established street person, Ed Templeton was the new generation street person, Danny Sargeant was right behind Andy, and then it went off the Richter—Ed won three contests in a row and the brand really launched in a gnarly way.

Andy I saw early on the potential of what we were doing. This kid named Gorm Boberg from Gothamberg, Sweden, had somehow gotten on the team as an am. He'd come out to California and he was staying with a Swedish friend of his called Hans Lindgren, a freestyler we were putting on New Deal who'd previously ridden for Schmitt Stix. Freestyle was almost completely dead, but we wanted an all-around team with vert and freestyle so we kept him on the team. So when we started the company, Gorm was hanging around and was like, "Dude, I'm into all this stuff, too. I love graffiti, I like to draw, this is exactly what I am all about." And somehow I knew that if this kid from Sweden was into it, then what we were doing was going to be worldwide. I'd been certain that New Deal would work in New York, Atlanta, San Francisco, D.C.—but now it was like, "Holy shit, this is going to be global." Gorm and I ended up designing a bunch of the original New Deal graphics together.

We started selling a lot of boards and we were stoked, everything we did caught on like wildfire. I got hundreds of letters from kids across the country sending me drawings mocking my style and board and sticker graphics. It didn't matter if the kid was from Indiana or New York City. New Deal was relevant because it was a new movement in skateboarding, a new way to build a company, and a new image that

wasn't controlled by a marketing plan set up in some boardroom. It just came from some kid sitting at Paul Schmitt's kitchen table, coming up with the idea, and doing it. That's all it was—it was one step above us doing a skate 'zine, with the added bonus that we actually had the means to produce skateboards.

We inspired maybe fifteen or twenty new companies to start like that. It wasn't just us—Steve Rocco was doing his own thing; there were skater-owned companies in San Francisco, and Chris Miller had started his own company, Planet Earth, as well. We were part of a whole generation of skaters that was like, "Fuck this, we're going to do it our way." Although Rocco had left the Vision fold and created World Industries, he was creating something similar. We volleyed off each other a little, and that inspired the H-Streets and Plan Bs and the Rhythm Skateboards that emerged too. It changed the direction of skating. We tried to keep vert skating in our videos—Andrew Morrison ripped—but then Rocco and his companies came out with the whole "Vert is Cut" campaign, and because they were becoming so influential in skating, vert riding virtually disappeared overnight. The old-school vert skaters fought it but eventually vert became extinct or dormant, the damage had already been done and vert was pushed underground. All the people that came to our team from then on, like Justin Girard and Mike Vallely, were street skaters. It was sad, street skating had cannibalized vert, and skateboarding would never be the same again.

When we started New Deal we were such a small operation, there were only three partners and a few

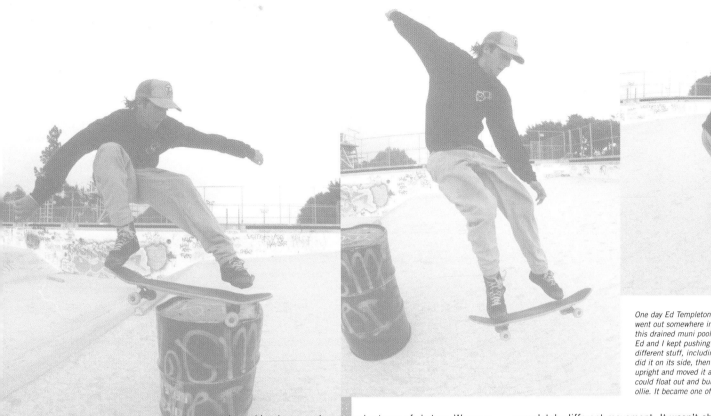

One day Ed Templeton, Christian Kline, and I went out somewhere in Orange County to skate this drained muni pool that Christian knew about. Ed and I kept pushing each other to nosebump different stuff, including this big drum. First we did it on its side, then we figured if we turned it upright and moved it away from the bank we could float out and bump it at the peak of our ollie. It became one of my ads for New Deal.

the NEW DEAL skateboard products

scoot this over

New Deal Logo 1990
New this with crayons the night we decided to create New il, while we were in a hotel at the Del Mar Pro Contest. I bought the crayons and drawing pad from a grocery re with Ed and Deanna a couple of hours earlier.

people working in a warehouse and a team of skaters. We were the opposite of a company like Vision, which was a massive company riding on the back of Gator Rogowski being made into a superstar. Vision did cheesy fashion shoots—that was the kind of marketing kids were consuming. And it wasn't their fault—they didn't have anything else! I mean, I was a kid wearing Vision Street Wear shorts. I rode Vision Street Wear shoes for a while because that was all you could buy. But I was thinking, "Shit, this isn't me. I'm not Gator, I'm Andy. I have a different feeling for what my thing is all about."

By 1991, Vision was toast. Brad Dorfman was this money-hungry, corporate executive, he was the antithesis of what New Deal was. He was the guy we were running from. And he fell off because his superstar Gator had got to major saturation, vert was dying a quick death and nobody liked him anymore. I remember being at a contest in Munster, Germany, the Munster Monster Jam. I woke up totally hung-over after partying the night after the contest and looked down from my room to the street below where I saw Lee Ralph, this big guy with this dirty red beard from Australia or New Zealand. He was one of the real skaters ushering in a new movement of guys who could skate everything—he skated street as good as he skated vert. He'd been up skating all night long and he was sitting on the curb, totally sweating with his skateboard flipped over on the street, and up walks Gator with a girl under each arm. Two totally hot, German supermodel girls. And Lee Ralph's like, "Aw Gator, fuck you mate, you don't know what the fuck's going on, you look like a fucking rock star." And Gator goes, "I've won more trophies than you'll ever see in your life, I *am* a fucking rock star."

I remember thinking, "Oh my god, I can't *believe* I just saw that!" It was one of those "aha" moments validating that skateboarding was changing and that we were creating a completely different movement. It wasn't about being a superstar, it was about DIY and doing exactly what you wanted, which for me was riding skateboards, drawing shit, painting graffiti, hanging out in the city, partying and meeting girls. To clarify: I was certainly still a dork. I wasn't pimping chicks, it never felt like that. Sure, we'd hook up with girls everywhere we went, and had crazy times partying and traveling, but the partying wasn't the thing. Skateboarding was the thing. After all was said and done, we wanted to know, "Who did a rail slide on that kinked rail? Who's making what trick? Let's get in the car and drive and go find out." The mentality was, "I don't know where we're staying, but if we show up at the spot and it's not dark, we might see some kids that live near there and we'll find a place to crash." That's what we were about.

We didn't have someone going out and filming us with professional cameras, we had these huge, barely hand-holdable VHS cameras, horrible quality by today's standards. And in using them to document our scene we helped usher in this new aesthetic. It was like, "Okay, you don't have to just see it as a sequence in a magazine anymore, here it is on video, and here's how we sound when we're talking, and here's our life as skateboarders. Here's Andy describing his graphic to you in the video so you understand what he was thinking when he made it." It was as if our teenage 'zines became the videos—previously the 'zines were the only form of communication, but now we could use the videos we made to connect with all these kids around the country.

I wanted the videos to not only be about showing us skateboarding, but also all the other stuff we were into. We were giving kids around the world new things to think about, new music, new art, new tricks. Today it's called "youth culture" by the statisticians, but to us back in the day it was just our scene.

Our only cost was our video cameras and the $1.25 to have the tape copied, the cover printed, and the pack shrink-wrapped. It just wasn't the high gloss production that skateboarding had been up 'til then. There was no lights-cameras-action thing, no, "Okay we're rolling, Gator, you can tic-tac across the boardwalk and girls on roller skates are going to look at you and smile." We wanted to go out, get stuff on tape, and basically just see if we could do these tricks.

Damon Way It was a time when skateboarding was really challenged in terms of its own viability relative to business and everything else. And it created a pretty big void in the market. The space created by the big corporate skateboarding companies in the late '80s was filled by DIY-ers from the sport or the culture. So the early '90s set up a whole new generation of business within skateboarding. It was fueled by a lot of guys who were pros in the '80s for whom the next level was to create a new board company or a clothing company or whatever and create a future for themselves.

Steve Douglas The skateboarding industry had gone from all these old guys who didn't skateboard, the Big Five running the industry, to young people suddenly deciding to start their own. The big companies were used to doing 30- to 40-million a year, then we came in and thought four million a year was great. That was our strength.

Damon Way I think for all of us starting up then, operating in ignorance worked to our advantage. I don't even think we thought we couldn't do it, 'cause we didn't have the kind of training that would set ourselves up to doubt ourselves. So it was more like, "Let's let our passions drive us, let's do this, let's not have expectations and see what happens." With my business Droors, and later DC Shoes, my partner Ken and I never really had any expectation for quite some time, it just grew organically, and before we knew it we had this big viable business.

I think what was different is that we were letting our creativity and passion drive us rather than these big financial expectations that will inevitably cloud the vision and the motivation. The difference from doing that today is that we were able to have this learning curve because we were the first to make soft goods. We weren't challenged by big companies that had the structures in place and knew how to do all this stuff. Our quality was crap, we couldn't deliver, and so on, but somehow because we were the only players it gave us this bracket of time to learn how to do it. It doesn't seem like that opportunity's there any more. You've got to come out of the gate on top—you can't fuck around.

Chris Miller I think that by embracing individuality, creativity, self-expression and a do-it-yourself mentality, we did help influence the direction of skateboard culture. That spirit and desire to do our own graphics and then ads and company logos, eventually led to the desire to start our own companies. Doing my own brand was very rewarding. At the same time it also presented a new set of financial realities and challenges. Creative control and financial responsibility are two different things. The jump from designer to owner wasn't easy, but it's one I can now say I'm glad I took.

Andy At the time, skaters were still wearing these tight Vision shorts. But in Atlanta we had these ratty cutoff jeans that we'd buy extra baggy because it was so fucking hot in the summer. Tight jeans would stick to my body and become so wet I couldn't skate, but the hip-hop kids were all wearing these big baggy jeans that were coming in and showing up on *Yo! MTV Raps*. So my friends and I got these baggy jeans that we lashed up with huge belts and cut the bottoms off of. We'd have to buy size 42 and put safety pins on the side to make 'em smaller—they'd puff out from little tiny waists and usually the cuffs would turn into this raspy tail dragging on the ground, and they'd get so dirty you'd have to throw them away at the end of the day. Those are what showed up in the New Deal videos, and they're the reason I came up with the idea for Big Deals, the first baggy skate jeans ever. My business partners were like, "Those are clown pants, you can't wear those!" And I told them, "This is it, this is what people are going to wear." I fought my way tooth and nail through Paul Schmitt and Steve Douglas to make them.

Paul Schmitt If I'd had my choice, it never would've happened, because design-wise I just thought it was stupid, but Andy knew what the market wanted and he paid attention to it. Big Deals were phenomenally successful—we couldn't make enough of them. In terms of the production of a huge garment line, however, Andy and Steve didn't have a grasp of the reality. Andy was a dreamer, a true creative. He could care less about what it took to make things happen on the more boring, back-end part.

STREETSTYLE IS FREESTYLE?

SKATEboarding TRANSWORLD JANUARY 1992

SKATEboarding

What's the **deal** with **Andy Howell**? Special interview inside

AMERICA STORMS EUROPE } PRO STREET/VERT CONTEST COVERAGE

skate/snow connection— is there common ground?

Andy But once we made Big Deals, they just took off. We gave them out to the team to wear in videos. Once the videos came out, there was no way a kid would walk out of his house with regular-fitting jeans on. If you did, you were ridiculed. We created a new style movement, and with that we were helping to create the look of the whole culture. I'd look down at what I was wearing on any given day and go, "Hmm, why don't we make this into a product?" I remember throwing so many pairs of socks out after skating because my feet used to stink like crazy—Atlanta's like 100 degrees with 200 percent humidity—so I said, "We've got to make socks, I have to have socks I can wear and throw away! I'm not going to keep going to Kmart!" So we did. And that was the impetus behind so many of the products we made during that time.

It was a utilitarian fashion movement, in a way. Big Deals were a fashion phenomenon within skateboarding, and were soon knocked off by the other companies, then later entire clothing lines and a whole culture of baggy pants-wearing ravers was created based off those same baggy jeans that my friends and I had been skating in.

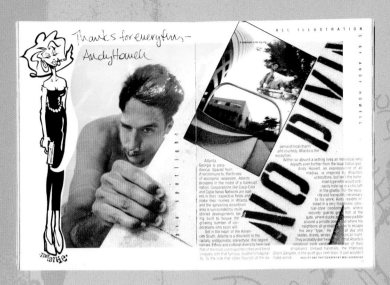

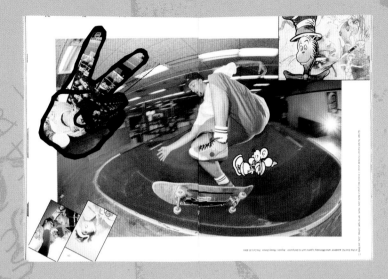

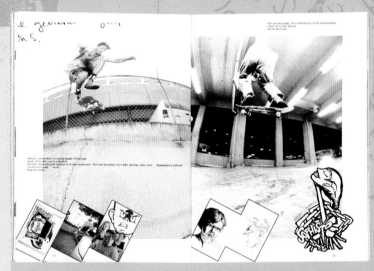

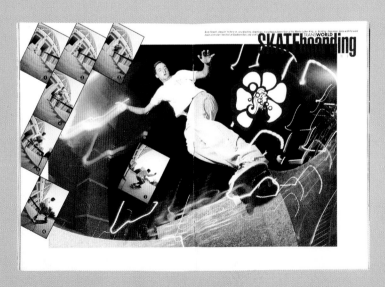

Steve Douglas Videos weren't yet a genre. They were a complete innovation. If it weren't for Andy, we wouldn't have done *411 Video Magazine*. I wanted to make a recurring skate video magazine, but the other partners weren't into it. They just didn't see the potential. Andy instantly, straight away got it. He could see it in his mind with absolute clarity. If he hadn't been into it, it'd never have happened. But because he was, we were damn right going to do it. He brainstormed the music, saying, "It should start like you're watching *Cheers* or *Hill St. Blues*." And he came up with the whole concept of icons that were a visual system to guide you through the video, and that remained the look of *411*.

That said, he was an absolute nightmare to make the New Deal videos with. He had all these sketchy bits of paper with how he wanted his video part to be and I'd have to try to decipher what he wanted. His notes were things like, "Man at Bank." And I'd be wondering, "Is that a man at a skateboard bank? Or at a financial institution?" I'd be searching through the footage forever until I saw a shot of a man walking out of a bank—he wanted that clip thrown into the tricks, then a clip of a George Michael video ... oh it used to drive me crazy. It was always completely last-minute.

twelveightyone

another insidious home movie presentation about winos, store owners, businessmen, and street vendors, brought to you by the same derelicts who produced *useless wooden toys.

Tommy Guerrero The conceptual idea of a video magazine was really cool, especially for young people then. Even before *411* there were the Powell videos and the H-Street videos and they changed everything. When the medium of video came around to expose skating, that really opened the doors for people to see what was going on, either in the States or elsewhere, and they just mimicked it, which led to the emergence of skaters around the world who are just beyond incredible.

Andy I didn't always know exactly what I wanted to do, but I could feel it was time to do something new, and I just wanted to keep doing everything I could. And I had the opportunity at twenty years old, because I'd made bank from skating and I had connections to do or make almost anything I wanted. So I decided, "I'll do this, this *and* this." Where other people were just blowing cash on random shit, I was starting these projects with it. That was my approach, always push the envelope and create a bigger picture.

*Useless Wooden Toys

HOWELL 43 MAGNUM

NEW
COMPLETELY LIFELIKE WEAPON!!
Make Your Friends Believe
You've Really Shot Th...

*useless wooden toys

"a graphic moving picture documentary about a part of life that the common man deems absurd and foolhardy..."

"Four thumbs down!!" - Biskel and Egbert

*december 1st

*Useless Wooden Toys

Approx. 2648 seconds of a graphic moving picture documentary which examines a part of our culture that the general public really doesn't want to face.

A MAJOR MOTION PICTURE

*useless wooden toys ™

*useless wooden toys ™

"The director dares to shed light on a subject which our good society knows is completely ridiculous. A complete flop!"
-B.M.Dubbillyu, Suit-n-Tie Quarterly

"It ain't gory enough fer me, needs plenty work..."
-Redneck Billy, Country Corner Magazine

"A masterpiece of modern cinematic creation, I'd see it again if I had the money!"
-Mike, the New Deal

"It's great man, like watchin' the Super Bowl in 3-D with no commercials!!"
-Biff Jones, Jockstrap Monthly

"A nightmarish look at a rampant disease that plagues our great nation, not a good thing."
-Jane Doe, Happily Ignorant Magazine

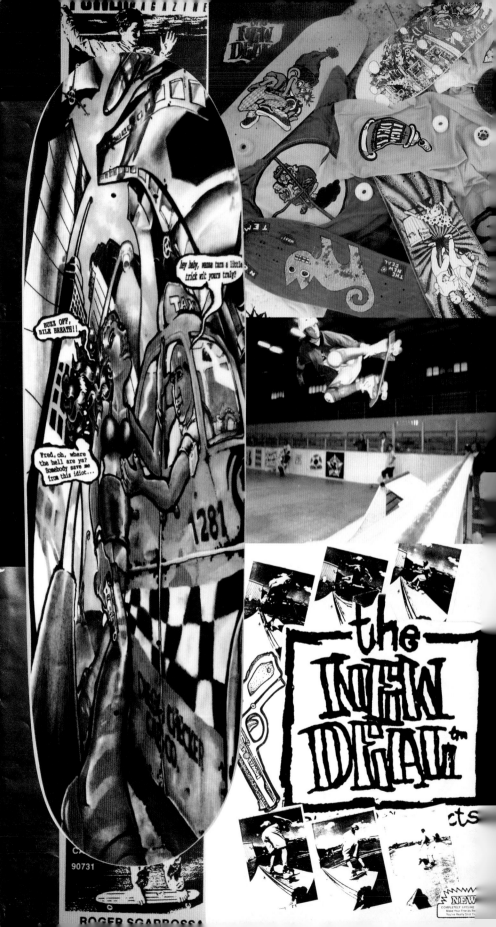

New Deal Howell Molotov Cocktail Model, *1991*
This was the last in a series of three pro models featuring the same character. He first showed up on my second Scmitt Stix model standing on top of an 8 Ball holding a knife. Then again on my first New Deal model he was burning through the city on his tricycle, causing general mayhem and stressing out the local shop owners. Then finally in the third model he had blown up the same area of the city and was standing on a pile of rubble about to light a molotov cocktail. What a hoodlum!
Top Graphic at far right of spread shows the character chilling at home with his newspaper clippings on the wall.

right:
New Deal Howell Fred Olande Perverted Cabbie Model, *1992*
I have always been into fisheye lenses and mirrors that distort perspective and reality. I was doing alot of full color renderings using only primary colored markers and blenders at the time. The hooker in the picture is bored and frustrated with the cabbie, who is just off duty and perving out on her big time. Of course as he reaches out to cop a feel he has no idea that she is strapped, carrying a revolver in her shiny purple panty hose. Surprise... Note the cab is #1281.

top

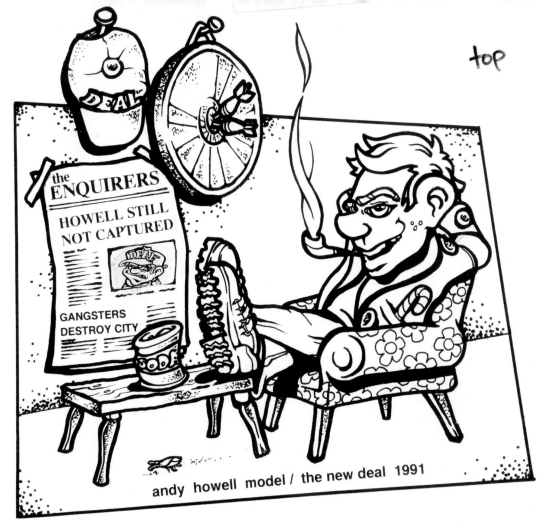

the ENQUIRERS

HOWELL STILL NOT CAPTURED

GANGSTERS DESTROY CITY

andy howell model / the new deal 1991

HACK!

the andrew "morri" model is now out. if you have any questions, consult a physician immediately. This has been a public service announcement.

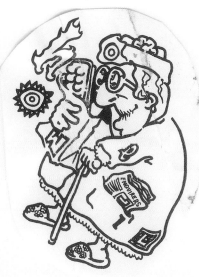

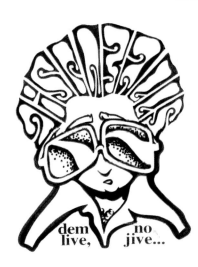

dem live, no jive...

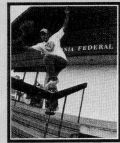
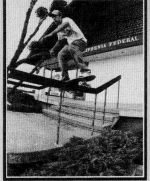
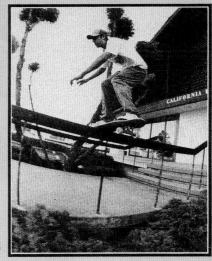

FIRST NATIONAL BANK OF REALITY,

proud sponsor of the ongoing quest for social stagnation, announces its newest cause: the fight against skateboarding. Yes, that's right, we here at First National realize the **urgency** of this situation, and will be holding a fund raiser,**"Rock Against Social Heresy"** (R.A.S.H.). These heretics are scarring the city's synthetic skin that we, as **respectable businessmen** and positive contributors to the community, have worked so hard to create. A ridiculous idea to begin with, it has become obvious that our advanced culture must put an end to the **farsical and conciously primitive pastime of skateboarding,** before it gives people the utterly **preposterous idea** that the ability to think for yourself without the benevolent guiding hand of authority is feasible. **National Celebrities** will be on hand to accept donations, or you may mail them directly to us. We here at First National aim to make your reality as safe and uneventful as possible.

714 546 DEAL

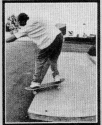

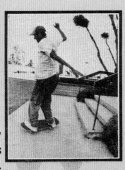

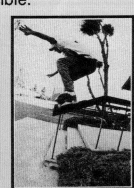

andy howell, obviously
in need of authority's
guiding hand, h.b.

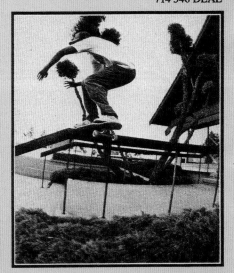

Left: One day I told Christian Kline and Ed Templeton I wanted to slide the railing behind California Federal in Costa Mesa, but they told me it couldn't be done. I don't know if people had done any kinked rails up to that date. Well Christian reluctantly agreed to go with me the next afternoon, though he said he didn't want to waste too much film. The first try I ollied out and slid the whole rail, jumping off at the end. Christian quickly loaded his camera and shot me trying it about six or seven times before I made it. When I told Ed I did it he didn't believe me.

below: When Miki Vuckovich came out to shoot my Pro Spotlight for Transworld, we went over to Johnny Schillereff's (far right) house and shot this photo. Dave Merten of Graphic Havoc fame is on the far left. I am in the middle with my girlfriend Kim and buddy Michael Higgins (to my right).

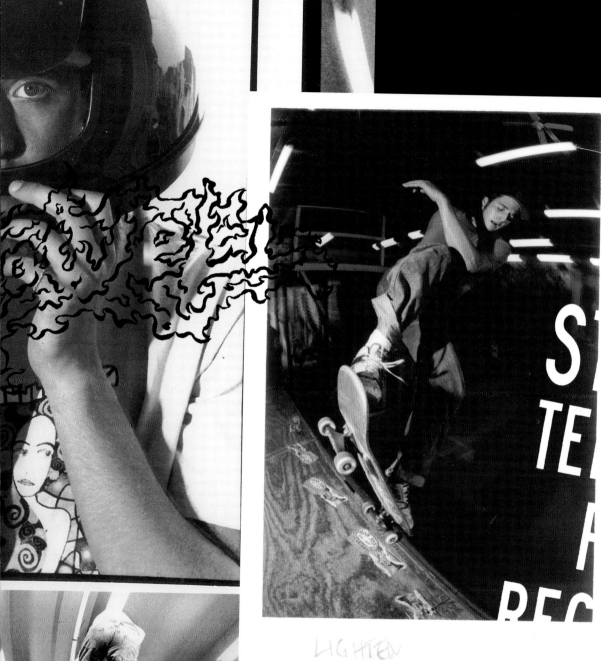

NO
S OPPING
TE PORARY
OLICE
REG LATION

CITY OF PHILADELPHIA

LIGHTEN

101.5%

New Deal Graphics, *circa 1990-1992*
*I did most of the graphics when we started New Deal, and with the help of
Gorm Boberg pumped out a lot of work in the first few months of the
company. Gorm and I created the Siamese model together, which was the
first ever street board with the same size nose and tail. Jose Gomez was 15
years old when Felix Arguelles introduced us at a demo in Florida. I saw
Jose's sketchbook and hired him right there at the demo to do a Steve
Douglas graphic. By the time he was 16 he was doing a lot of boards for New
Deal. On the opposite page he did the glowing alien at the far right top, as
well as the Montesi Gargamel and Smurphette Slick second from bottom left.
The rest of them are mine. The graphic below became a slick for Armando
Barajas, and the girl ended up standing in a wooden crate holding the
Tamale. The board with the trucks on it at
right is an Andrew Morrison model, one of my
favorites. He actually described the idea to
me of the two vines turning into people
kissing, and I loved it. Also the Pimpball
Wizard Model for Justin Girard was
hliarious. Justin and I came up with some
funny characters for that one.*

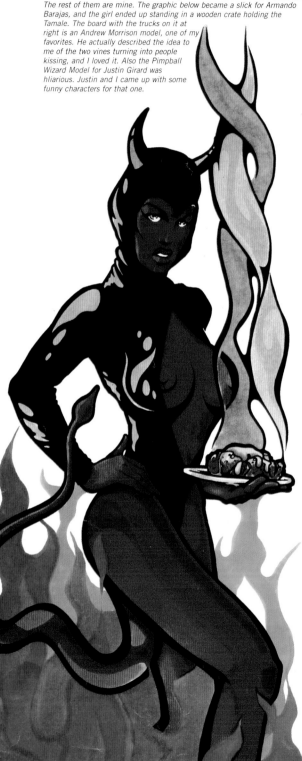

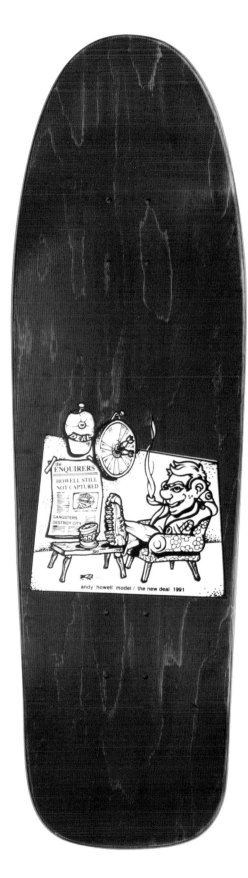

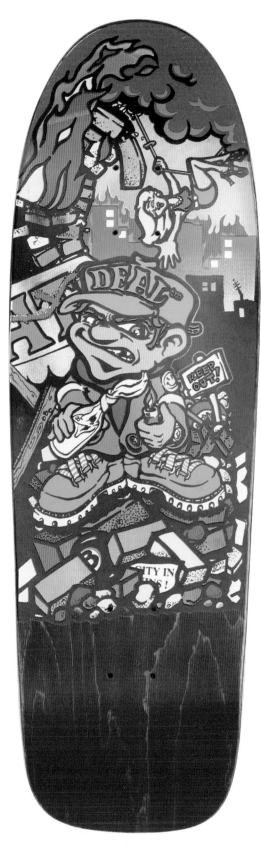

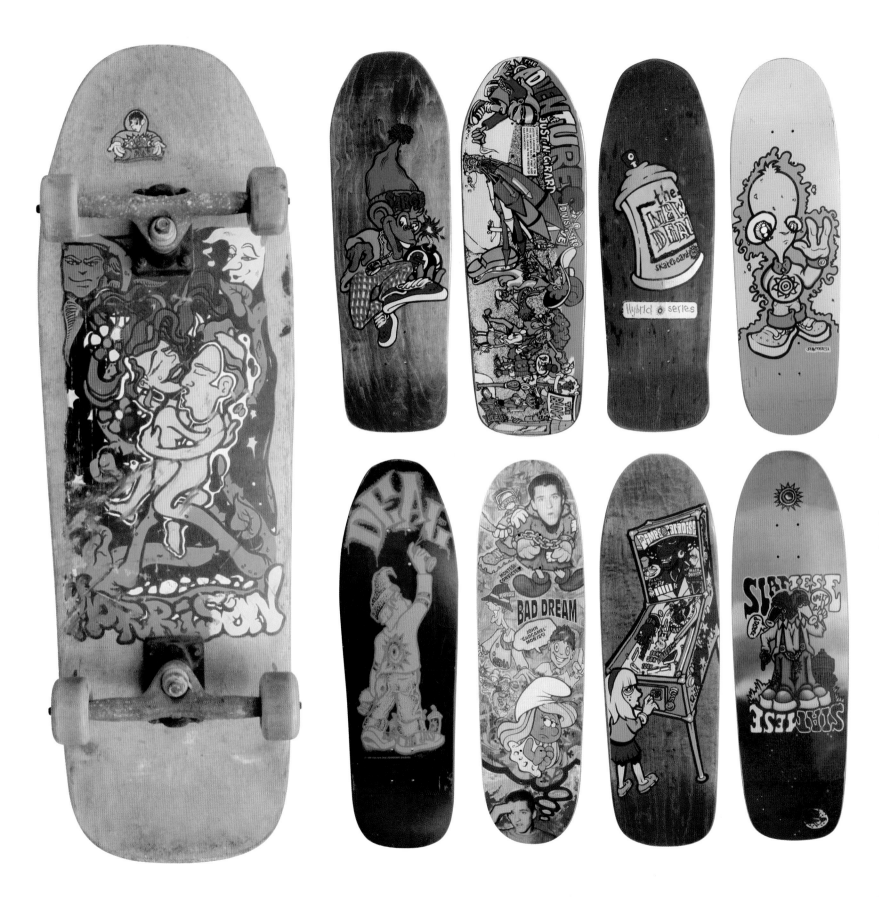

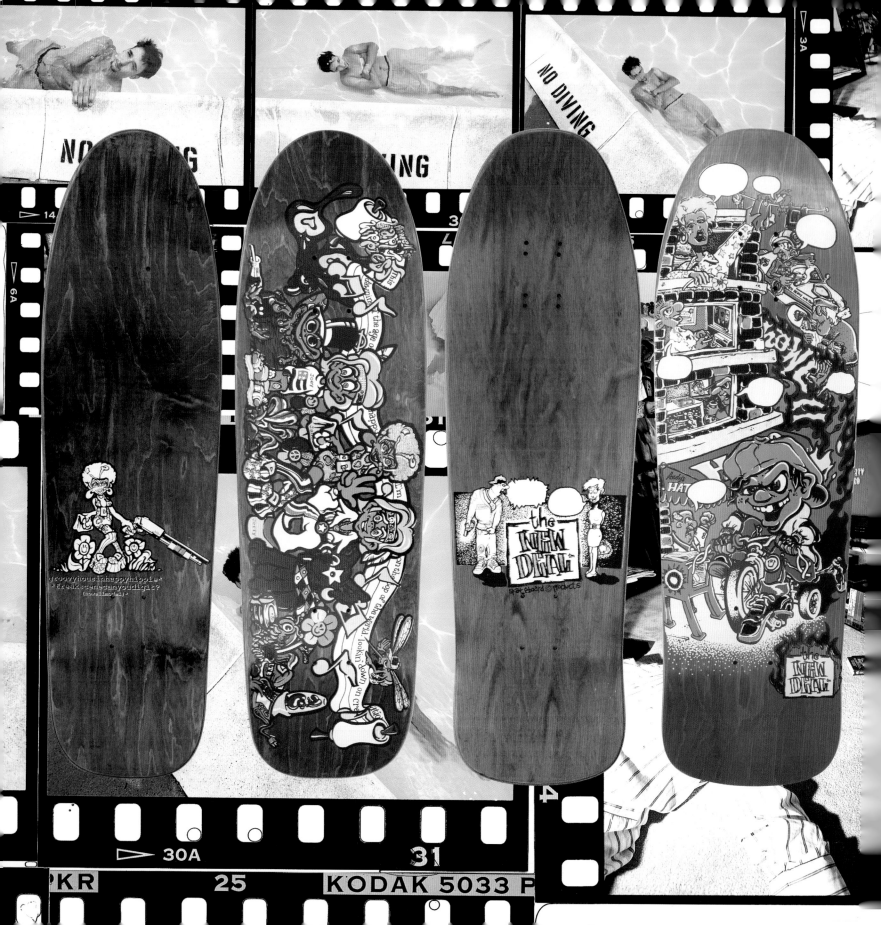

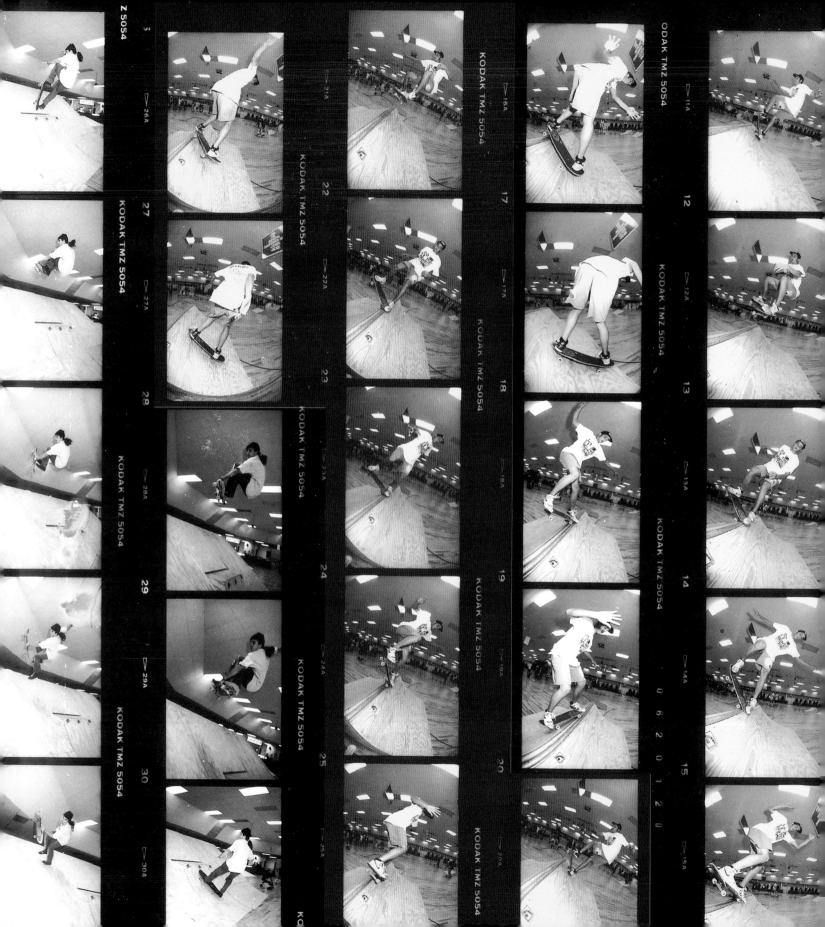

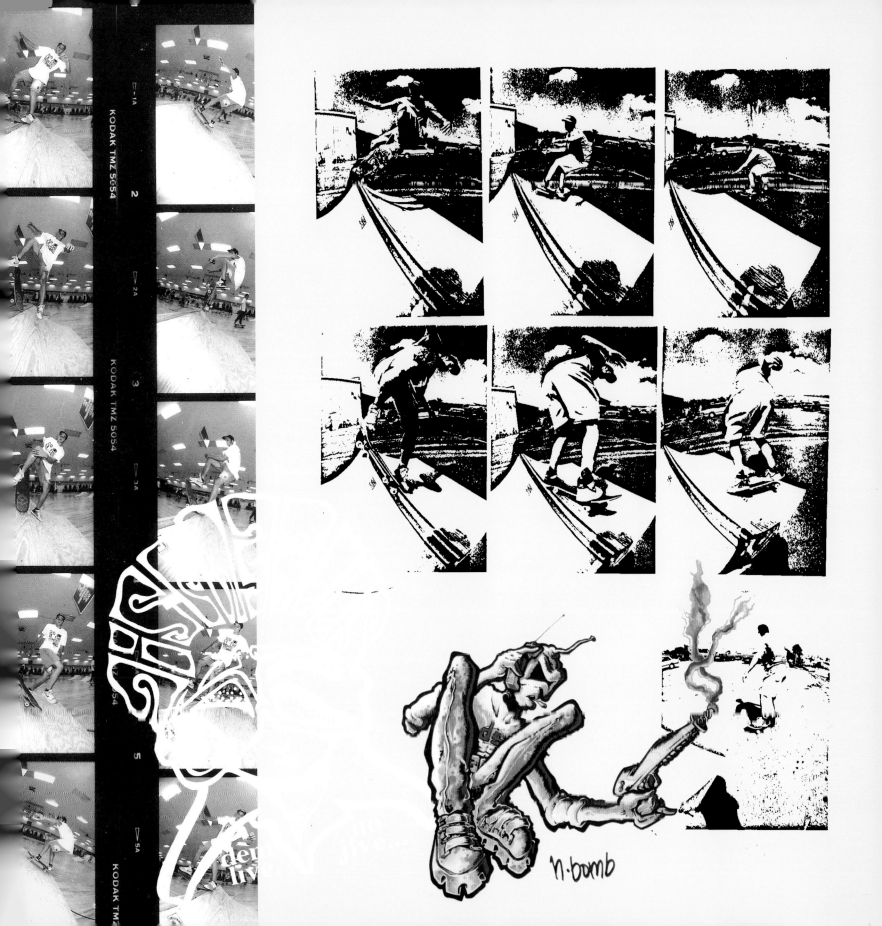

n-bomb

above and two spreads back:
New Deal Howell's Happy Hippies / Howell's Disco Gangstas Models *circa 1991-1992*
This series of boards, tees and stickers was inspired by Ice T's Power album cover, where Darlene is standing on the front in a sexy pose, but when you flip it over you realize she is holding a huge gun behind her back. I was really into hippies and disco at the time, so I made the first board graphic called Howell's Happy Hippies, with this group of characters based on my friends. There were butterflies and flowers and happy song lyrics all over it. Then when the next model came out, Howell's Disco Gangstas, I showed the view from the back of the Happy Hippies and you could see they were actually carrying guns and bombs and ready to throw down at a moment's notice. My friends and I loved the irony of it.

next page:
Fan Mail *circa 1989-1992*
One day I got my first box of fan letters. Paul Schmitt would collect them from the p.o. box and send them out to me. I realized that the experience of when I had sent Tony Hawk his very first fan letter had come full circle, and now the next generation was sending the same kind of letters to me. It was a strange experience to read thoughts and praise and ideas from people I had never even met before, and until I started to get fan letters from all over the world I really didn't realize how many people the art I was creating in my home studio in Atlanta was reaching. It was inspiring and satisfying to me as an artist. I still get many letters to this day from people who grew up during that era and had an experience through my art or skateboarding that influenced them to take the risk to pursue their creative dreams. It still inspires me just the same way the first letters did.

andy howell

Andy Howell

ANDY HOWELL
23111 PLANTATION Dr
ATLANTA, GA 30324

Andy Howell
23111 Plantation Dr.
Atlanta, Georgia 30324

Andy Howell
23111 Plantation Dr.
Atlanta, Georgia 30324

Nick Falcone
2140 Ralph Rd
Lakeland, FL 33801

JOSE GOMEZ
18603 SW 53 LANE
MIAMI, FLA 33175

deaL?

ANDY HOWELL

PAINTINGS

clockwise from top left:

Deluxe Hair Flip 1995 / Acrylic on Canvas / 30"x30"

Sabrina For Lunch 1995 / Acrylic on Canvas / 30"x30"

Excuse Me, Miss Lu 1995 / Acrylic on Canvas / 30"x30"

Hey Nineteen 2003 / Acrylic, Spraypaint on Canvas / 24"x36"

That First Night 1997 / Acrylic on Canvas / 9"x12"

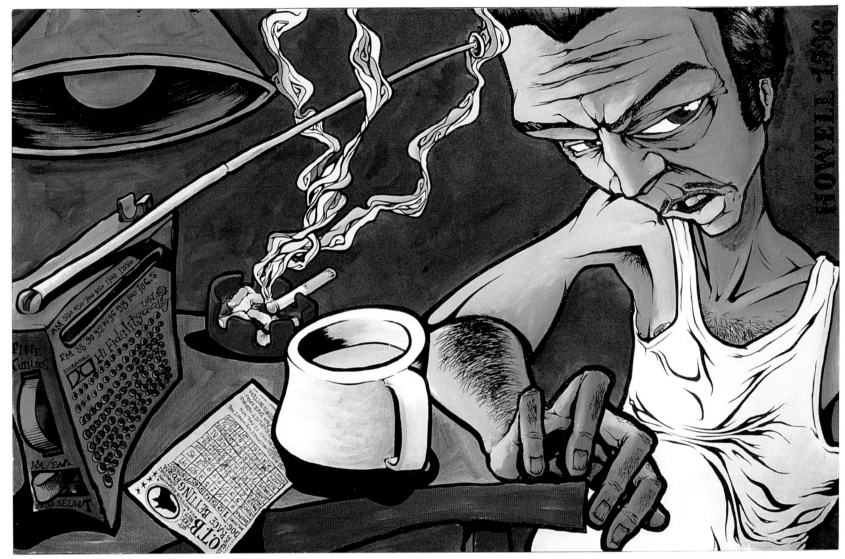

Tough Luck, Eddie... 1996 / Acrylic, Paint Marker on Canvas / 48"x24"

from left:

100 Sonetos De Amor 1997
Silver Acrylic on Black Board
28"x18"

The Good Wife 1996
Acrylic on Canvas
24"x36"

The Common Mosquito Fly 1998
Paint Marker, Fat Marker, Graphite,
Watercolor on Paper
24"x36"

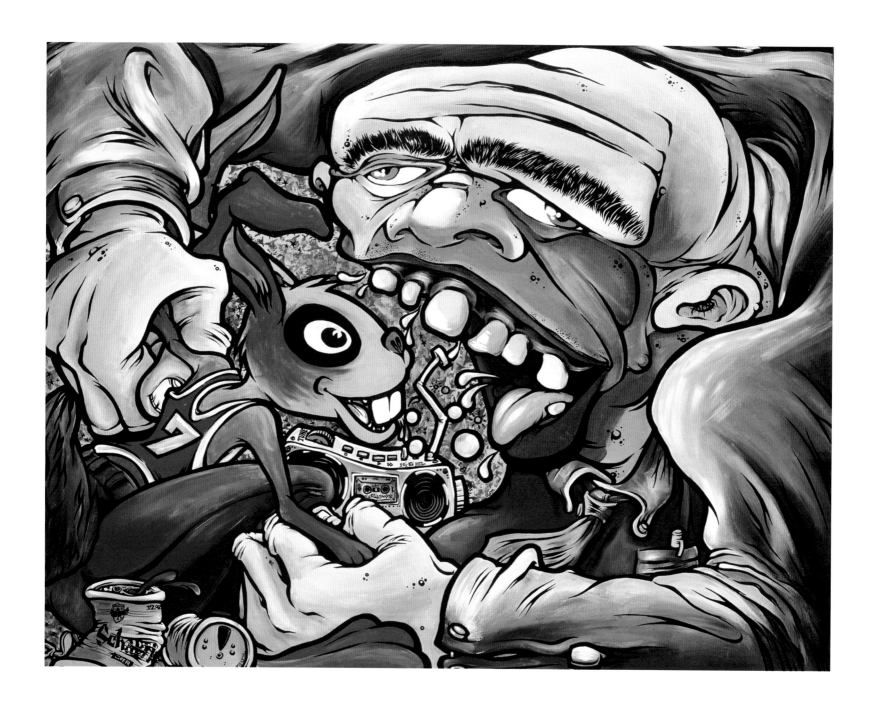

Harvey Credwinkle and Ole' Lucky Seven Sampson 1999
Acrylic on Canvas
60"x48"

Coffee Fiend 1998
Acrylic on Broken Skateboard Deck
9"x17"

The Last Lunch 1998
Acrylic, Ink, Photocopy Transfer on Paper
9"x12"

The Age Of Reason 1998
Acrylic, Paper, Newspaper on Canvas
30"x40"

Bubble Bath 1998
Acrylic, Ink on Paper
9"x12"

Keeps Following Me... 1998
Acrylic on Skateboard Deck
9"x32"

Illegal Tender 1996
Acrylic, Paint Marker on Canvas
30"x40"

Feed The Family 1998
Acrylic, Paper, Newspaper on Canvas
30"x40"

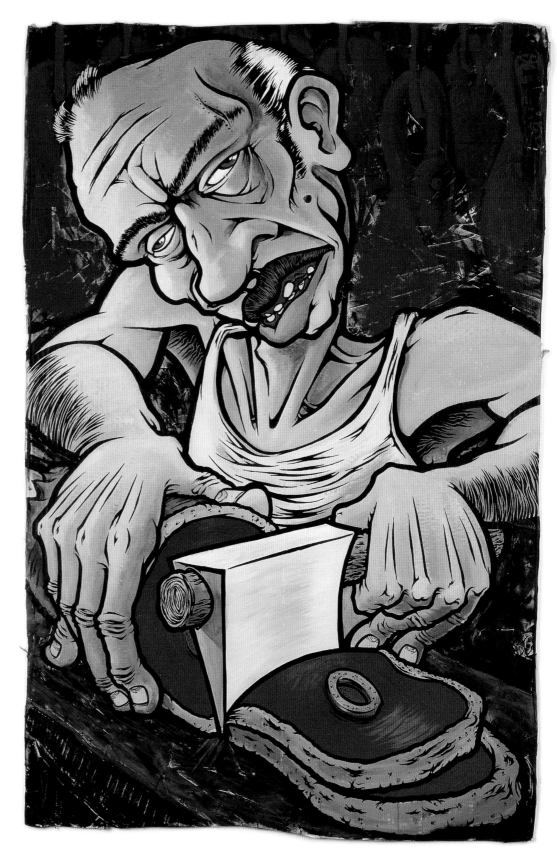

Choice Cuts 1998
Acrylic, Paper, Newspaper, Athletic Tape on Cardboard
33"x49"

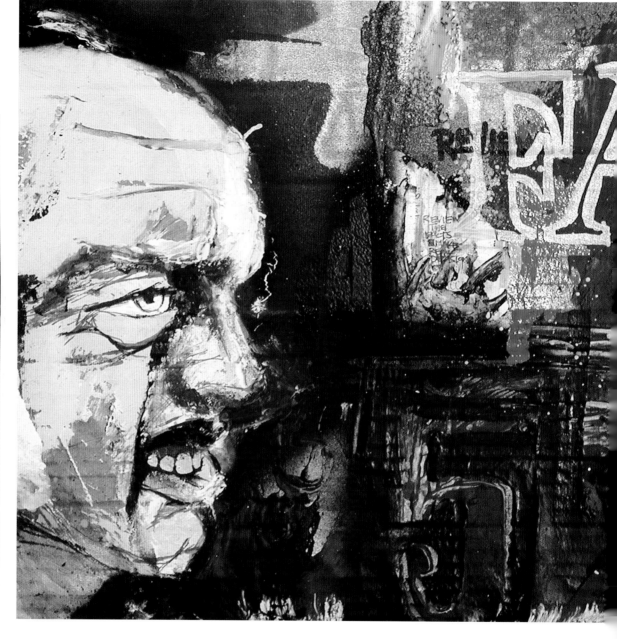

The Deed Of All 2001
Acrylic, Steel Fork, Canvas Tape on Masonite Board
18"x36"

Fact 2001
Acrylic, Spraypaint on Cardboard
24"x24"

Employee #037 2001
Acrylic, Plastic Bottle Caps, Spraypaint on Pegboard
36"x20"

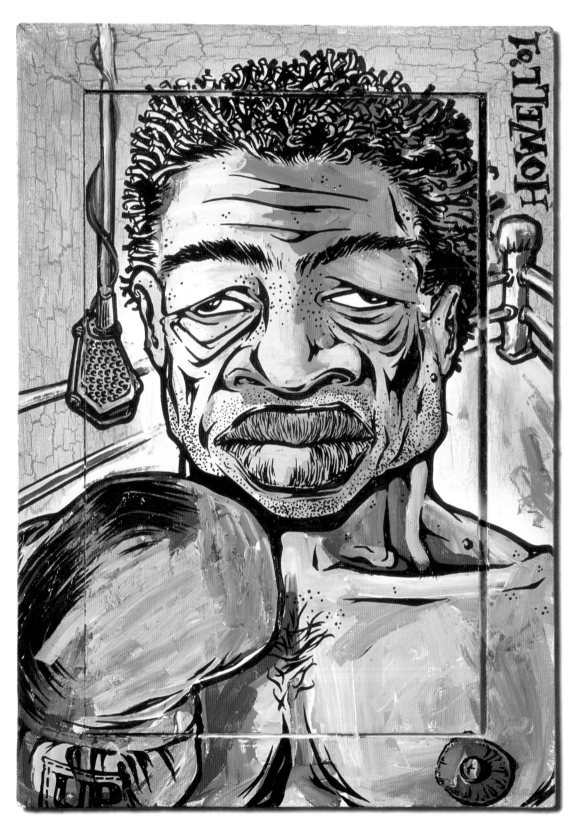

The Ghost Of The Bronx Bomber 2001
Acrylic on Wood Door
14"x20"

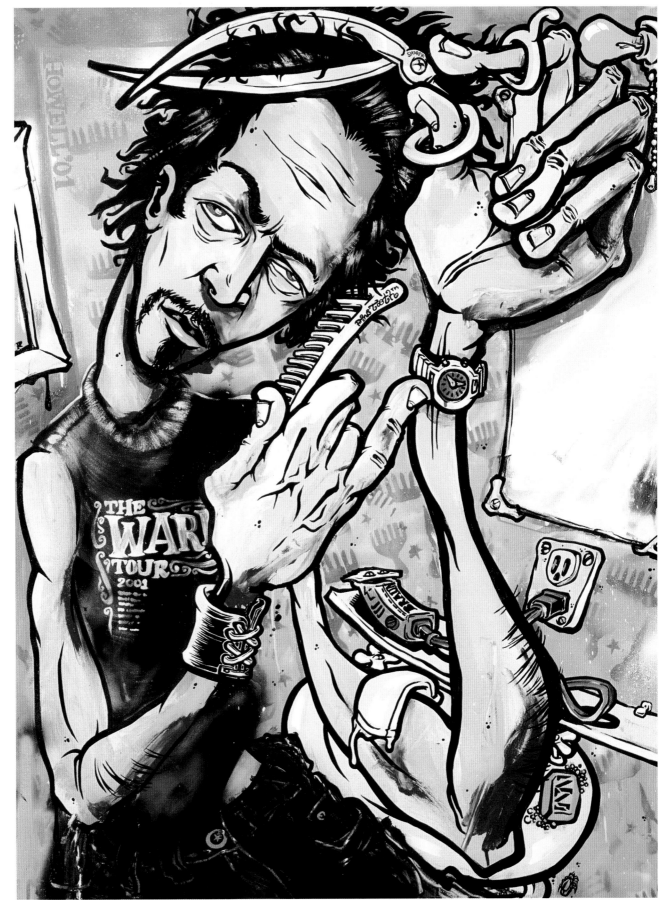

Travis Haircut 2001
Acrylic, Spraypaint Stencil on Canvas
36"x48"

Hessian 2002
Acrylic, Spraypaint on Canvas
60"x72"

Pay To Cum 2002
Acrylic, Spraypaint on Wood
24"x48"

What I Meant To Say 2002
Acrylic, Spraypaint, Lettering Enamel on Wood Door
32"x78"

Miss You 2001
Acrylic on Canvas
24"x48"

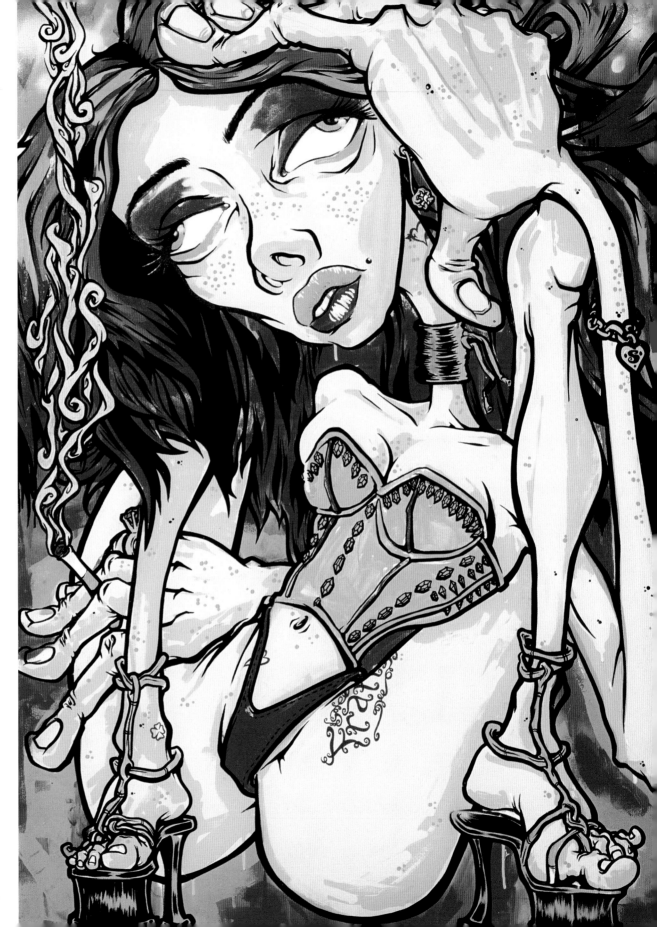

Princess Nº19 2002
Acrylic, Spraypaint on Canvas
60"x72"

Lillypod Follies 2001
Acrylic on Canvas
10"x12"

Krudco 2002
Acrylic, Spraypaint on Wood Box
10"x14"x4"

opposite page, clockwise from top left:

We Are Champions 2002
Acrylic, Metal Key, Spraypaint on Canvas
48"x24"

Business Monkey Remix 2002
Acrylic, Spraypaint on Metal Platter
12" Diameter, .75" Deep

Business Monkey Throw Up 2002
Acrylic, Spraypaint on Metal Platter
12" Diameter, 1" Deep

Too Much Pressure 2003
Acrylic, Spraypaint on Wood Door
22"x10"

Hand Of God 2002
Acrylic, Spraypaint on Canvas
30"x60"

Hand Of Man 2002
Acrylic, Spraypaint on Canvas
30"x60"

Love Tales 2002
Acrylic, Paper, Conte Pencil, Spraypaint on Wood
54"x48"

clockwise from top left:

A Spicy Adventure 2002
Acrylic, Chalk, Spraypaint on Wood
12"x18"

The Common Flying Mandarin Frog 2002
Acrylic, Spraypaint on Wood
36"x20"

Veronica And Claire 2002
Acrylic, Spraypaint on Wood
36"x36"

Honeymoon 2002
Acrylic, Spraypaint on Canvas
72"x60"

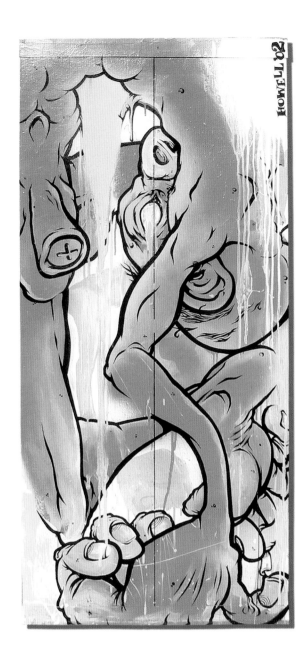

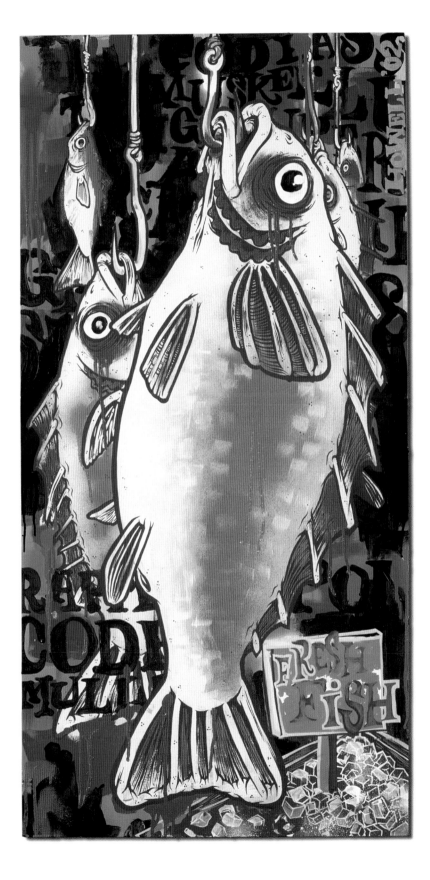

Unbearable Lightness 2002
Acrylic, Spraypaint on Wood Door
20"x48"

Gifts From The Fish Monger 2002
Acrylic, Spraypaint on Wood
24"x48"

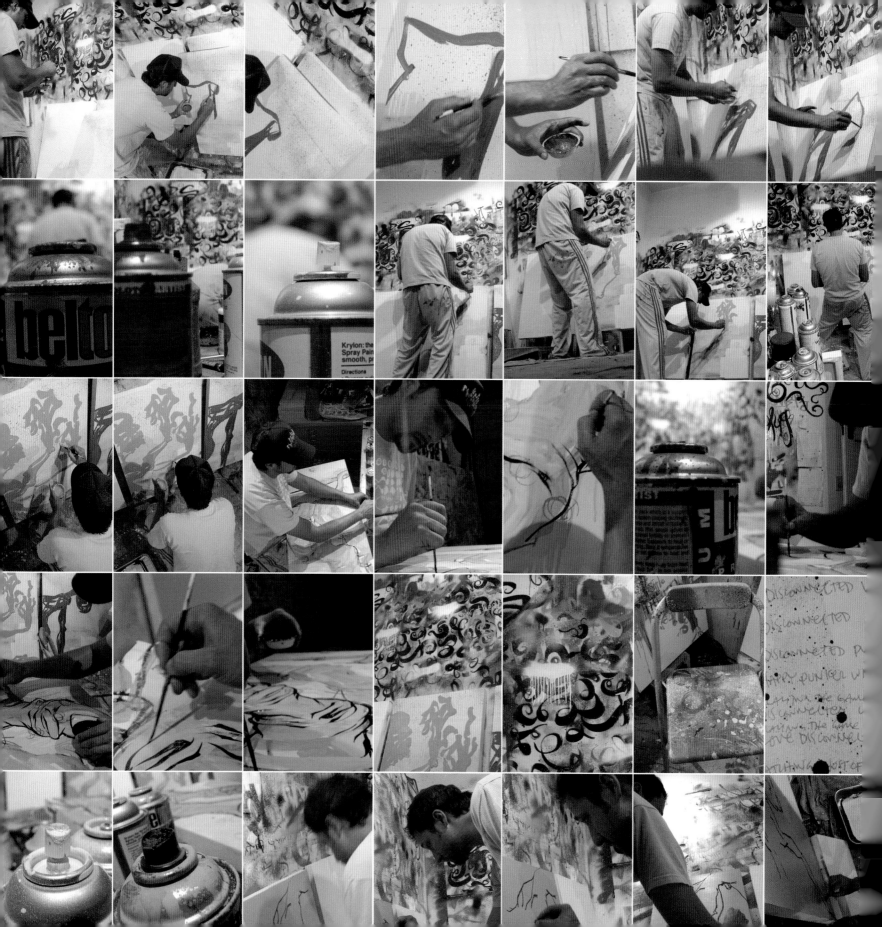

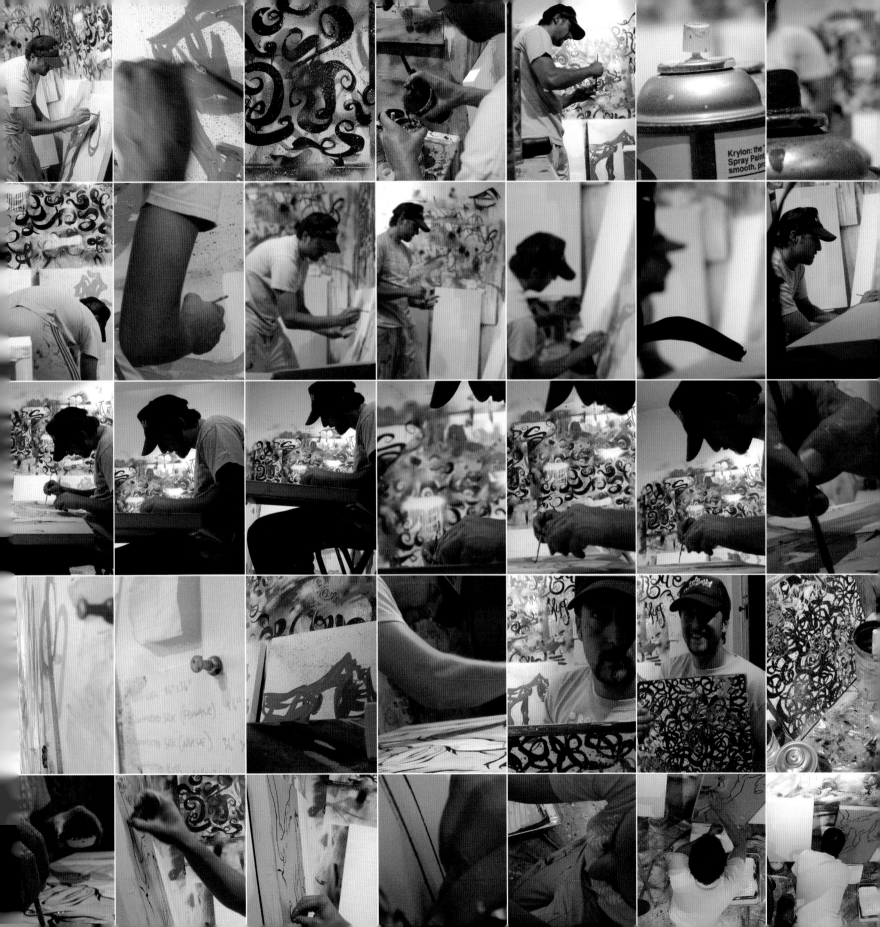

Studio Birds Eye View 2002
photo: Mike Blabac

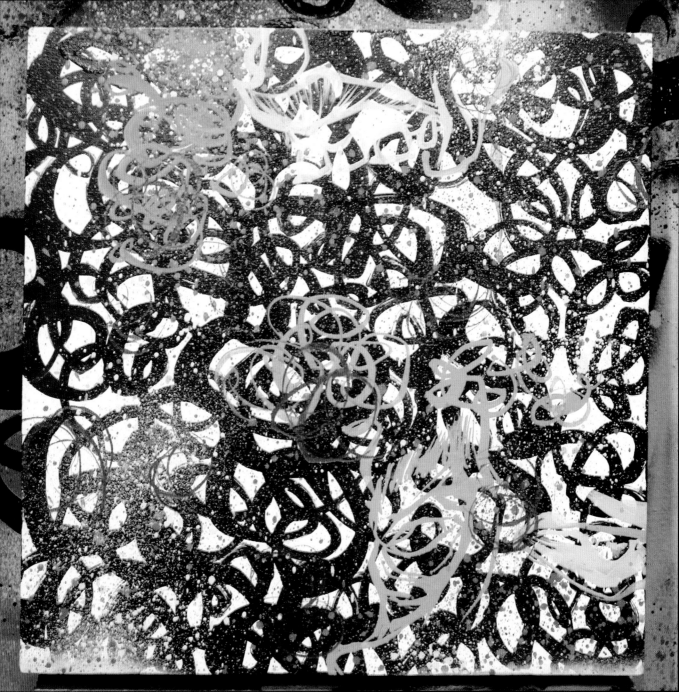

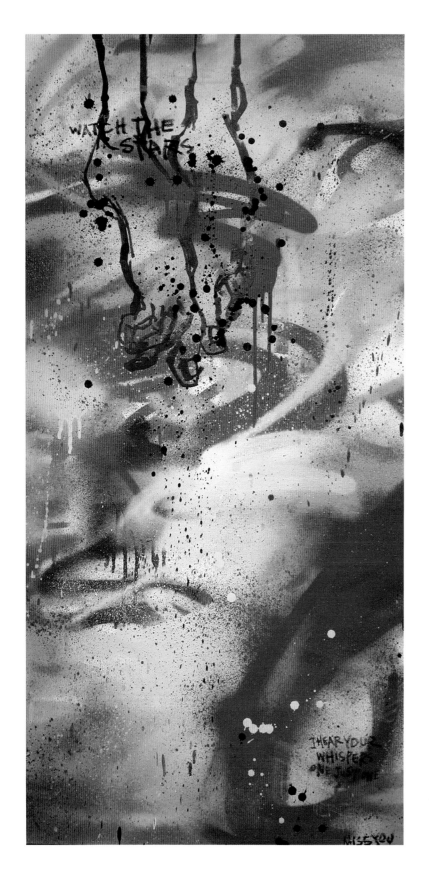

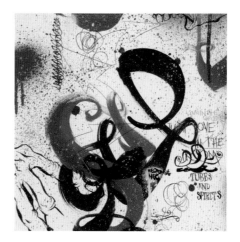

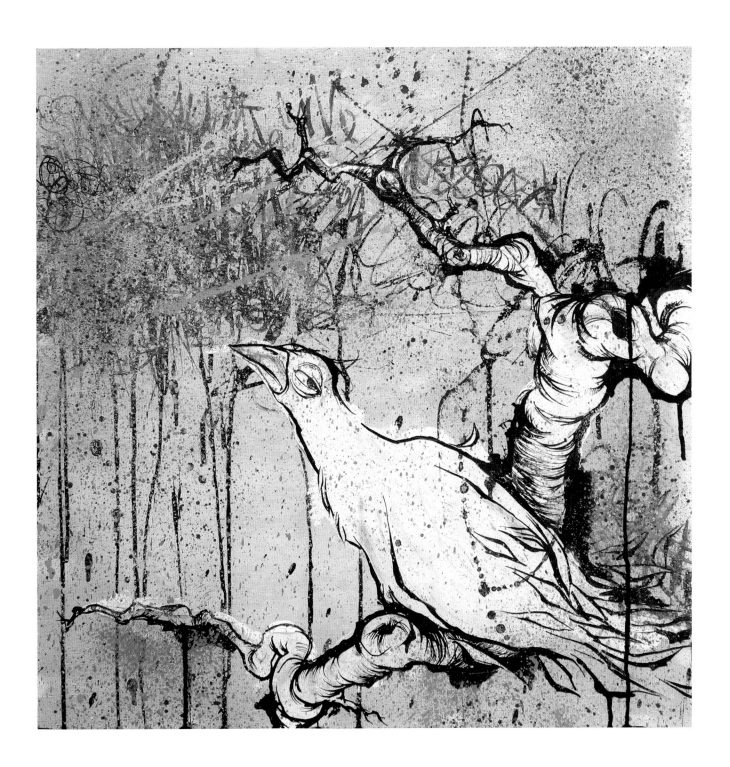

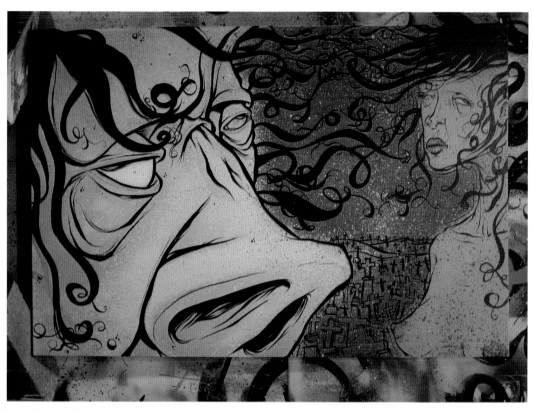

clockwise from top left:

Then She Turned Into A Bird 2003
Acrylic, Spraypaint on Canvas
24"x48"

When We Finally Met Again 2003
Acrylic, Ink, Spraypaint on Canvas
36"x24"

Then She Turned Into A Bird (Detail) 2003
Acrylic, Spraypaint on Canvas
24"x48"

Making Love In The Orange Grove (Detail) 2004
Acrylic, Ink, Spraypaint on Wood
96"x36"

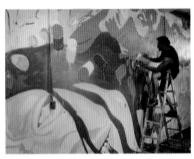
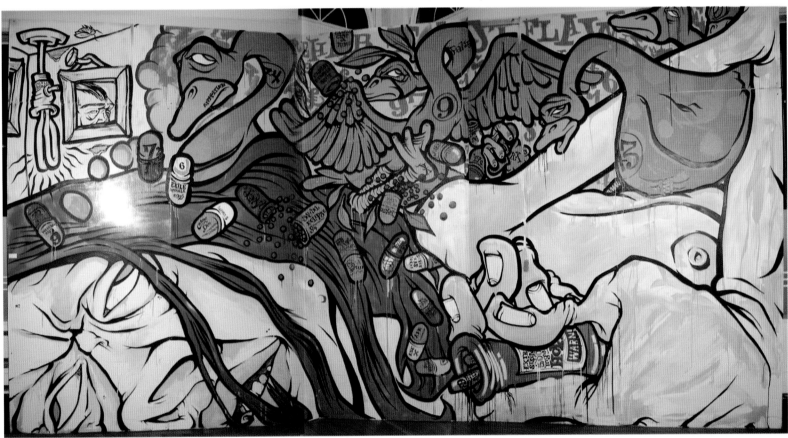

Veronica's Prescription Dream 2002
Acrylic, Enamel, Spraypaint on Wood Panels
240"x120"

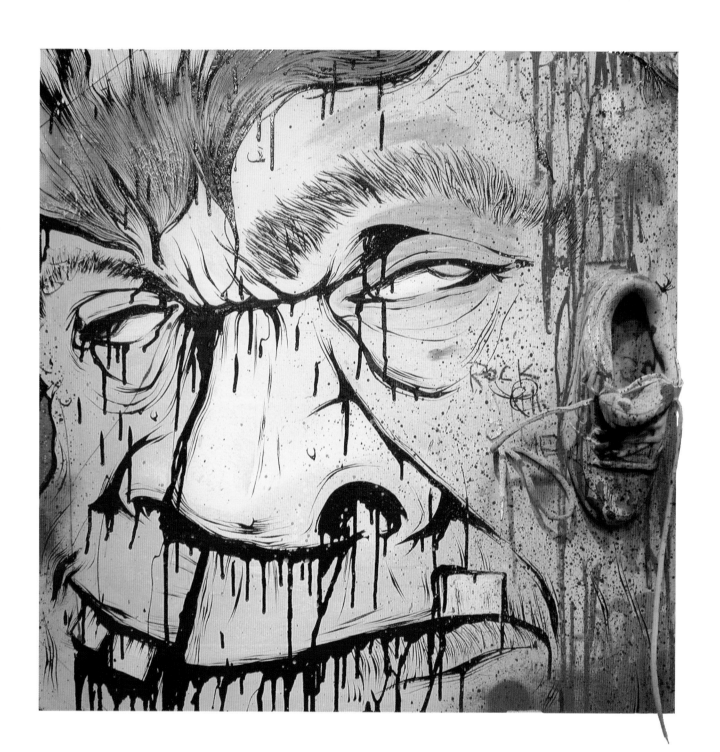

Eyes That Lie 2003
Acrylic, Spraypaint, Ink on Wood Door
20"x14"

Dislocated Kisses 2003
Acrylic, Spraypaint, Ink on Canvas
30"x40"

opposite page:

Titan Of The Industry 2003
Acrylic, Spraypaint, Shoe, Enamel on Wood
36"x36"x7"

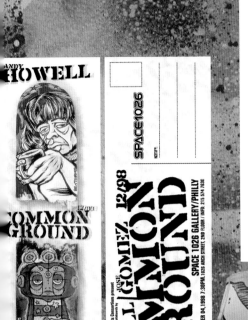
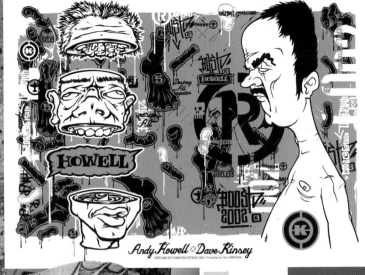
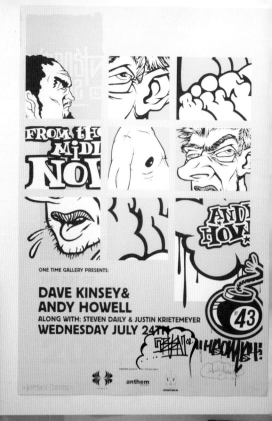

CHAPTER 5
THE DiRTY SOUTH

The Dirty South
Graffiti, Hip Hop, and Skating in ATL

Andy Down in art school in Atlanta, I was still sort of an outcast. There were a lot of kids who listened to punk, new wave and The Cure, but really nobody who skated. And there was definitely no street skating scene, only a few random skaters here and there who were starting to street skate. So this guy Thomas Taylor, who has a skate shop down there, and I started one up. Soon enough I met Jose Gomez and Dave Kinsey, who skated and who also came down for art school, and we all started skating and doing art together in a little graffiti crew.

There were two guys who basically held down the fort in Atlanta at the time, Kenny Dread and Jaz, who went by SenOne and JazOne. Jaz was an amazing illustrator, and I think he inspired Dave and I to start painting on walls.

Dave Kinsey I'd known Andy a few months when one day I said, "Why don't we go try some graff. It'd be dope, you know?" We came up with some tags—I was X Factor and he was HOne—and when we did it we got this huge rush out of it. At the time I didn't have any money, so Andy reluctantly picked up the bill for the spray cans. Most people would've stolen them, but he was pretty well off with his skate career, so I guess he was invested in keeping himself out of jail. The first time, we went to Kmart and filled up a whole shopping cart with paint and then went down to this yard and found an abandoned building and just started throwing stuff up on it.

The next thing we knew, we heard people talking about it in the clubs. They didn't know we did it, but they were just like, "That stuff looked different, it was pretty interesting." When Andy did something new, it was noticeable. Of course Jaz and Sen and their crew got really pissed. They were like, "Fuck you guys, you guys are

toys," because they'd been writing since the '80s. I became good friends with them a couple of years later and they ended up telling me they'd wanted to kill me. After the first couple of months they started bombing poems on the walls telling us how it was and we respected that. I didn't want to cause any problems, I just wanted self-expression.

Andy We'd go out and bomb a whole area with characters, guys on turntables and girls with their hair blowing everywhere. Jaz and Sen totally dissed us, I remember a message from Jaz with one of his sickest characters holding a burnt match saying, "Suckas burn to learn." But we kept on painting until one day they both rolled up. We'd never seen them before; Sen was this white dude, a dread-inner-city cat, and Jaz was a black guy with a beard and a beanie. They started talking to us, and Sen actually admitted we had some cool characters.

For me the characters I painted didn't really feel like anything else that was happening in graffiti at that time, because they were only loosely based on graffiti styles, using thick outlines and bubbly characters from graphic novels. I was into these fantastic representations, and when I painted on walls I was really just sketching out the most distorted versions I could do, trying to stretch my own boundaries. And painting with spraypaint on giant walls is incredibly liberating for an artist like me who until then had been stuck using rapidograph pens on fourteen by twenty-inch cold-pressed illustration board.

Johnny Schillereff Andy's style back then was so mimicked. He picked up influences from all these other graffiti artists, then with his fine-art background managed to mesh all these genres and create the Andy Howell thing. Most of the artists we worked with back then ended up knocking it off. We'd always joke around and spot the big clown feet. He pretty much created that one, the big clown feet on everything. Mickey Mouse feet on characters. And big hands.

Andy This loose group of artists I was friends with became the CAP Crew, which stood for City Aerosol Posse. It was me, Kinsey (X Factor), Jose (Zero), Gary Woodward—known as BaseOneRock—and Scott King, whose tag was Verse. I signed pieces Sir Fresh or HOne, then HBomb, then HBomb43. We were all toying around with names, tags that we liked or that were easy to letter. I'd paint these huge characters that I was thinking of putting on boards for New Deal. Then I'd just redraw them with black pens on paper, and they'd become board graphics. So the New Deal graphics felt like something that kids had done on the street. At that time, graff-influenced art was completely taboo in any mainstream or commercial application. There just weren't enough people who were even aware of graff or these distorted cartoon-style graphics to drive a brand on it. So I dumbed down the wildstyle characters I was doing on walls, and that style, mixed with a DIY aesthetic that was burying the corpo-style stage of skateboarding, became the image for New Deal. We decided, "Everybody's gonna wear beanies, everybody's gonna

this spread, clockwise from top left:

Andy Howell, spun out in Atlanta 1991 photo: Charles Harmon

Kenny Dread holdin' it down in ATL circa 2002 photo courtesy of Dave Kinsey

Andy Howell, Bart's Ramp, Atlanta 1991 photos: Charles Harmon

HBOMB43 and Dallas Austin rollin' Phantom, ATL 2004 photos: Howell / Austin

Andy and Dallas at Freeworld NYC Launch 1998 photo courtesy Dallas Austin

New Deal Street Kids Deck Graphic 1992 Artist: JazOne, ATL

have baggy pants, and the graphics are gonna be these crazy bubbly graffiti-ish characters."

They weren't so raw that they didn't look good. I just made up all these characters and did graphics I thought were cool. When kids saw it, they were into it because they thought, "These guys did it themselves, and they're skaters just like us." It was touchable, instead of being all about the superheroes of the skate industry. That's what epitomized every aspect of New Deal: everyone who was involved was stoked to be doing something that had never been done before. Plus, my friends in Atlanta and I were stoked to have all these stickers of kids bombing walls with spray cans.

Dave Kinsey Our stuff was a little more modernized. Some of the old-school graffiti had more blocky letters and simple colors, while we were doing more character-based stuff and lettering that was a little different from the lettering out there. Then the guys from Graphic Havoc, Randall and Lern, moved to Atlanta. Next thing you know, there's all this new-school stuff coming up, the young kids in art school starting to express themselves on walls. In the next three or four years there were like 50 artists constantly doing stuff on rotation. We'd just paint over each other's stuff at the Civic Yard, a.k.a. the L Wall. No one really dissed each other too hard—if you did a piece that was at least equal or topped somebody else it was cool, it wasn't something you'd cause heat about. Though occasionally someone would bomb bubble letters over something you'd worked two days over. Andy's stuff has always been very free and very wild. He has a crazy imagination. I don't know exactly where it comes from … but it must come from somewhere.

Andy Kinz kept hounding me to let him do a graphic for New Deal. We were skating together a lot and painting walls, and his art was starting to get really sick. So I asked him to do one of my graphics for a slick bottom board, a picture of me as a little kid getting chewed out by a teacher who was failing me in school. He busted the illustration and it came off, we actually collaborated on it. I believe it was Kinsey's first graphic he ever did for hire, and the only one of my own board graphics done by someone else.

Jose Gomez was sixteen when I met him. I was down in Florida at a skate demo, and since I was traveling I wasn't able to do a lot of graphics. Steve Douglas was calling and pushing me to get his new board graphic done, and as it happened my buddy Felix Arguelles, who later started Rhythm Skateboards with Jose, was like, "Dude, you have to meet my buddy Jose, he's in this graffiti crew called Free Agents in Miami and he draws crazy characters." So I met him, and he's this little peanut-head kid with all these crazy drawings in his sketchbook. I said, "Do you want to do a board graphic?" And he was like, "Board graphic? Okay. How do I do that?" That just says it all about that era. Nobody knew how to do any of it. We were all making it up as we went along.

Jose went home and was just crazy serious. He drew nonstop. We didn't have fax machines so we were sending stuff by FedEx or by US Mail or anything we got our hands on to transport ideas back and forth. Jose was still in high school back in Miami. Soon he was getting paid like 500 bucks a month to do New Deal art, while living at home and going to school. He bought this killer car which he built out with a crazy

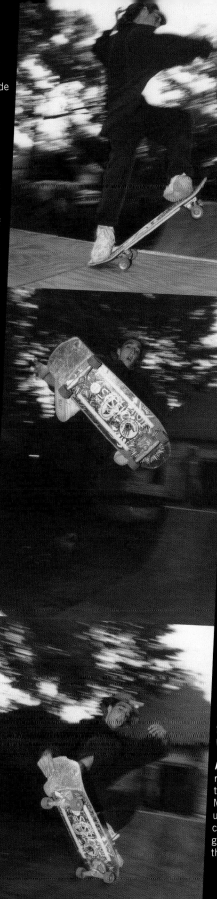

stereo system. He was still only sixteen years old! I told him he should move to Atlanta to work with us after graduating, and when he came and Kinsey moved down to attend Art Institute, all of us together had this extreme energy. We wanted to draw, to paint, to do anything we could get our hands on.

Everyone in my life at the time was either from art school, graff, skateboarding, or hip-hop. And all the art I did was directly inspired by the music. So what happened was what I believed was the second boom of skating—the first one was Dogtown—and this time skaters kind of meshed and crossed over with hip-hop kids. There was a time when you'd have a skateboard and the hip-hop kids would be like, "I don't know what that is. Keep it away from me." But at New Deal we were using hip-hop music in our videos, and meanwhile hip-hop dudes started wearing skater clothing in places like New York. The two things started totally crossing over. With my graphics, and Steve and Paul creating the business formula to make it work, New Deal became a phenomenon. Pretty soon we had everybody's attention.

Chris Hall I'd been doing graffiti way before I started skating, in D.C. there was a whole crew doing it. I used to go out when I came down to Atlanta and tag with Andy and people like Sen, who taught me a lot about street culture. MATA was my tag way back then. It didn't stand for anything really. Just some letters I threw together and that I thought represented me.

Dave Kinsey Doing graffiti affected everything we did later. It gave us a good understanding of what you can do with the right tools, how to apply art to the streets, and how art integrates with the public.

Andy A while after we set up New Deal, and after I had some money coming in from that, I created Urbanistiks. It was a collective workspace that was the crossover between skating and urban culture. I've always had this utopian idea of bringing artists together, inspired I guess by my vision of what Warhol's Factory must have been like. For me, Atlanta was a whole mixed bag of creative people coming together and meshing. So I was like, "Let's create a Factory, but let's do it our own way, with our own screenprint shop and a Mac lab"— nobody had a Mac lab then, not even the Art Institute where I was a student. I got this 2000 square foot warehouse and built two lofts in it and it became the headquarters for me, Jose, Johnny, my friend Ron Siegel, and Kinz.

Dallas Austin, musician, Grammy Award winning music producer Urbanistiks was in a real urban part of town they hadn't developed back then. Pretty much crackhouses and shit all around. Very inexpensive. It was this little operation centered in a warehouse and all the guys who worked on projects with them there were guys like Menelik, who was one of the trendy nightclub door guys and is now a big deejay in Atlanta.

Andy Downstairs we built a music studio which was pretty remedial, but it had turntables, boards, and a computer, and then we had five Macs downstairs for design. They were these Mac II CI's, which had no memory or anything, we could barely use Streamline and Illustrator but we were drawing all these crazy characters, streamlining them in and turning them into graphics for skateboards or record labels. We did graffiti all over the walls and Kinsey did his first really big mural in there with

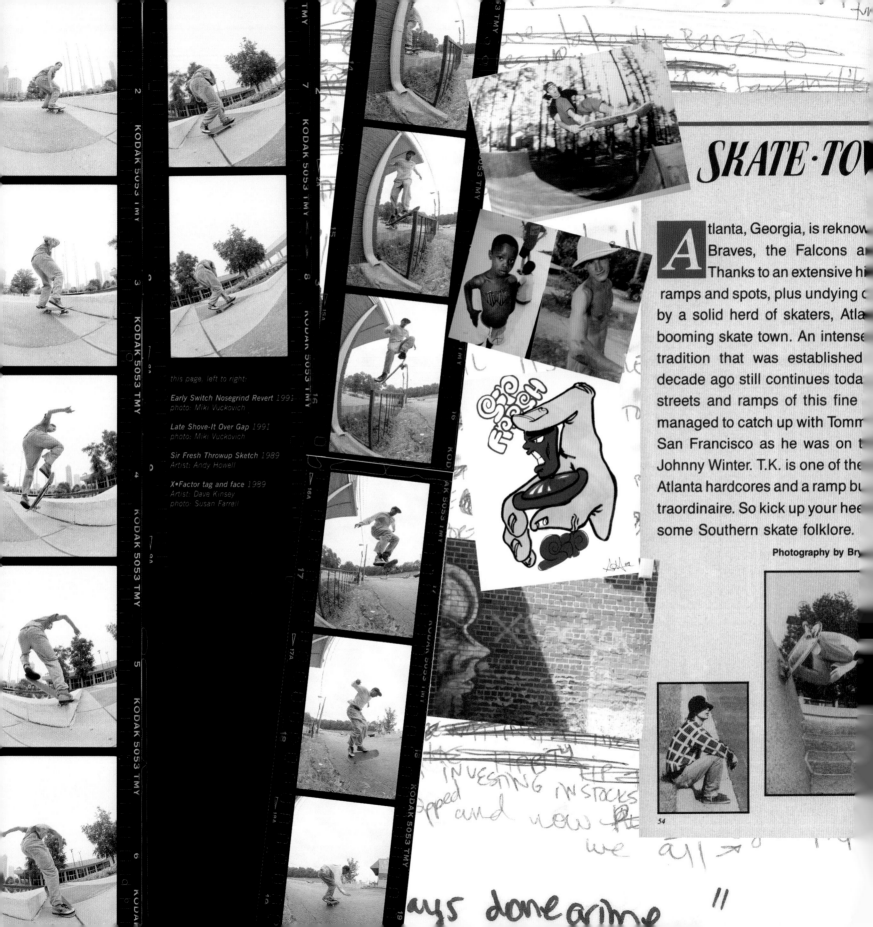

this page, left to right:

Early Switch Nosegrind Revert 1991
photo: Miki Vuckovich

Late Shove-It Over Gap 1991
photo: Miki Vuckovich

Sir Fresh Throwup Sketch 1989
Artist: Andy Howell

X•Factor tag and face 1989
Artist: Dave Kinsey
photo: Susan Farrell

SKATE·TO

tlanta, Georgia, is reknow
Braves, the Falcons a
Thanks to an extensive hi
ramps and spots, plus undying c
by a solid herd of skaters, Atla
booming skate town. An intense
tradition that was established
decade ago still continues toda
streets and ramps of this fine
managed to catch up with Tomm
San Francisco as he was on t
Johnny Winter. T.K. is one of the
Atlanta hardcores and a ramp bu
traordinaire. So kick up your hee
some Southern skate folklore.

Photography by Bry

54

A T L A N T A

more than just the
uthern hospitality.
pools, skateparks,

ANDY HOWELL,

I just wanted you...

END RACISM
BOTH
BLACK & WHITE

From Left: Ron Seigel ponders the Atlanta skate scene. An Atlanta local banks on a steep slope at the Southern Bell Concourse. Long-time Ranchero Lenny Byrd bones it frontside at the Steel Ramp. The tight transitioned Honeywell banks take some abusive slashing from Andy Howell.

55

Dallas Austin When I saw Andy's set up, I thought he was a pretty smart kid to be doing this stuff, and I asked him, "How are you doing all this stuff?" He was snobby as hell, which was cool with me. He was a pro skater and an incredible artist and back at that time, just like now, whenever you have that alternative thing going for you, a skateboard thing or graffiti graphics, you were the shit with it. It's just a whole part of the play of that era, of not being accepted.

I saw he had the same thing going on that I had in music. I had this kind of music camp where I brought young people up under me, to help their dreams. Andy kind of had the same thing set up with the clothing, skating, and painting and stuff, doing ads and marketing and everything. I was really impressed and said, "Hey man, let's make some T-shirts." I'd signed a rap crew called Y'all So Stupid who hung out with the skate kids, and I also wanted to make the same kind of clothes Andy was making for a store I was opening, called Rowdy. I wanted an urban version of skate stuff. He had been making these T-shirts with Michael Jackson in an afro, and a logo at the bottom saying "Souled Out," or "Inside Job," with Martin Luther King and Kennedy on it. And he used these really cool characters—I actually still have all of them. We were all so young to be that progressive, barely twenty one, so we had a big respect for each other.

Andy None of us at Urbanistiks had real money at first. I mean, I was making a living from skating, but was driving a Honda Accord, and Dallas was this ultra-successful, Grammy-winning producer the same age as me. He'd drive his Porsche down the dirty old gravel road to our warehouse and trip out because Kinsey had a huge burner on the wall of the studio. We were soul mates from the beginning and we knew it, we were like, "This is what you're about? That's what I'm all about!"

Dallas Austin In our generation, all of us have learned to do so many things. I'm a producer, but I like to produce lots of things—not just music. I like to produce houses or buildings or businesses or places or styles. It kind of goes across the board. With Andy, he kind of does the same thing. Whether it's doing graffiti or doing some kind of music, you really want to be able to stay going both ways and be able to do everything that comes off of your work. The same way that Shepard developed his Obey and Andre stuff; it was always about creativity not just, "Shit here's something I can sell." The grounding for all of us was in creativity; that's what tied us all together. Creativity will always override everything.

Andy At Urbanistiks, we made music, worked on the New Deal videos and promos—*Useless Wooden Toys, 1281*—designed clothing and T-shirts, did all the board graphics, and all the ads from concept to completion. It was everything creative all rolled up in one and it was nothing like what I had learned in art school. But it fit me perfectly. Everything we did was totally DIY. It went, "I think this is a cool idea, so let's do it." We'd just make everything ourselves. It was the same in the projects we did for people like Dallas, just an extension of ourselves. The lines between fine art and commercial were pretty blurred—it was everything that expressed who we were, but it was also about selling products. It was like some third zone of the in-betweens we hadn't known existed until we invented it.

Jose Gomez, artist, founder of Shilo Studios, co-founder of Rhythm Skateboards and Adio Shoes Andy always inspired me to do things I thought I couldn't do, things I thought I'd never do. He used to always say stuff like, "Hey, Jose, don't you feel like directing some music videos? We could make the dopest shit—c'mon, let's call up MTV." And somehow he would have the craziest shit set up for us the following week. Who knows how he hooked it up but he would always come through with the opportunities of a lifetime. That's the kind of stuff that Andy gets a rush out of—doing something that has never been done before, and doing it better than anyone else before him, not just to be better than anyone else but just to see if he could do it. It's the kind of attitude that spawns the most powerful creative feeling in other people.

Andy Life at Urbanistiks soon got completely out of hand. There'd be one person on the phone doing a deal with somebody in London to distribute clothes, there'd be someone else doing PR with magazines, and people visiting from out of state to check out what we

Mass Prophets and Crew PR Shot, 1992
left to right: Lil' Jon (Jonathon Smith), HBOMB (Andy Howell), D Money Tha Skratchaholic (aka Sleepy Shawn), Joh Quest (Johnny Schillereff), Matt B The Child Prodigy (Matt Bolding), J-Sun (Jason Buckner). The blurred guy with the brown jacket in the background to the right of J-Sun is Dave Kinsey

below:
CAP Crew 1992
City Aerosol Posse: Dave "X•Facto Kinsey, Jose "Zero" Gomez, Andy "HBOMB" Howell.
RAD Mag, London

- Andy Howell, Atlanta, June '92

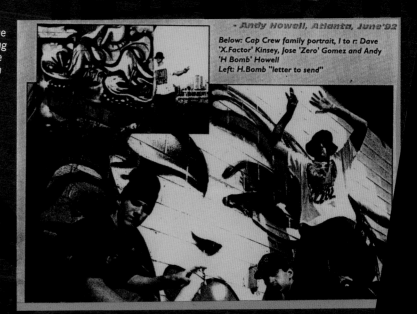

Below: Cap Crew family portrait, l to r: Dave 'X.Factor' Kinsey, Jose 'Zero' Gomez and Andy 'H Bomb' Howell
Left: H.Bomb "letter to send"

were doing. Meanwhile Jose and I would be downstairs doing new graphics, and Speech from Arrested Development would drive up in his Suzuki Samurai and be like, "I want to meet you guys and see what you're all about." He wanted to hire me and Jose and Kinz to bomb his music studio, and I suspect he was thinking we weren't going to fly with his whole image because we were white kids who were graff artists. I guess we passed his "authenticity" test because we bombed his studio a week later, totally freestyled it. We blew his spot up with a forty by ten foot piece, me, Zero, and X Factor. Johnny kept in touch with him and acted as the go between. Eventually we ran the Element creative offices from Urbanistiks too. It was pure excitement. To me there was nothing better than spending every day coming up with new ideas, putting them into play in the studio, bombing walls at night, skating at three in the morning. Ironically the focused energy came from the sheer freedom of knowing that we could do anything we wanted, at any time.

Shepard Fairey I visited Andy in Atlanta in '92 and I was blown away by his whole set up. It was definitely the place to be: there were a million skateboarders coming over—and girls. I was like, "Wow, This is the life!" I was really amped by his whole ambition to create a company that was its own interesting culture with art, music, a new type of street skating, and then fashion incorporating social commentary. The fact that Andy was doing it and succeeding at it was very motivational for me. A lot of times you don't try things 'cause you don't know if they're possible or not, but if someone else is doing it, it's proof.

Andy There was a picture of me and Johnny Schillereff in some magazine, a tiny black and white shot of us each sitting in front of our computers at Urbanistiks, wearing beanies, and a graphic on the screen of a kid with a beanie that I had drawn. It was us creating this image of what our life was. And I got so many letters—and still to this day get emails—from people saying, "That picture inspired me to see that we can get together and just do this, make work be the way we want it to be." So many of those people own their own companies now, or have made a movie, or they're animators in Japan. I think my instincts about wanting a Factory were pretty universal—it turns out there were a lot of other creative people out there wanting to be part of a group like Urbanistiks, or to go out and create their own. I think it empowered people in that way.

Blake Ingram Andy's responsible for getting me into graphic design. He was one of the first people I know that worked on a computer. He was doing basic cut and paste stuff for New Deal and I was like, "Wow, this is amazing!" Right after that, I got a Mac for thousands of dollars. My telephone today has more power than that thing had.

Dave Kinsey We had a pretty huge group of people that had become this big collective, everyone from the Graphic Havoc guys to the rappers and deejays we worked with, all joined together in this sort of creative conglomerate of ideas and shared thoughts. It was

inspiring, everyone was feeling it, and it was fun. We went out every night and would go skate and bomb and go to clubs. I was poor but made the best of it. We'd go skate the Brookhaven MARTA station across from my house at night when it was closed or go skate the civic center downtown cause it had three stairs and all these ledges. The pros like Jefferson Pang and Rick Ibaseta would come into town and skate with us and it was fucking dope. Skating for us then was about cruising the urban environment and having fun. The whole art thing bound a lot of us even tighter. But at the same time it was limiting because we were in Atlanta, and Atlanta's surrounded by Georgia.

Johnny Schillereff Andy was kind of iconic back then. He was a pro skater and people wanted to hang out with him, they sweated the hell out of him. So he started being able to draw this incredibly talented group of people together. They'd just come and go—there's a lot of that in Andy's story. We had this crazy thing going out of Atlanta, and a lot of it was bleeding out into the rest of the world. People were seeing it in California and because we were doing stuff for Giant Distribution, it was ultimately global.

Andy For a while I was painting all the time, with Kinsey, Base, Verse, Jose, the Graphic Havoc guys, and Goofy, who later became Estro. I had an extra bedroom which was literally floor-to-ceiling with drawings, board graphics, photos, and inspiration. That room is where a lot of New Deal and Element came about. The only time I was alone and thinking was when I'd do art.

Meanwhile, the teachers at the Art Institute were failing me on projects because I would draw the stuff that I was already making a crazy living from. To me it was as artistically valuable as anything I was learning in school. My artwork was all over the world on thousands of skateboards, T-shirts, stickers, boxes, everything—it was already real. They didn't understand it. If you look around now, everybody in the mainstream knows what graffiti is because it's been on mainstream applications like McDonald's Happy Meals and because MTV has appropriated it for their gimmicks. But in the late '80s our teachers were like, "This will never work, this isn't even *art*, it's just vandalism." It was a culture that wasn't even recognized by the mainstream and definitely not seen as legitimate art.

Dave Kinsey When my teachers at Art Institute told me I was going to fail, it did fuel the fire because I was very strong about what I wanted to do. Especially being around the art scene we'd built, I was inspired. I felt like my art had a place in the world somewhere. At my portfolio review all the teachers but one slammed my shit. But subsequently they asked me to come back and speak to the next year's graduating class. Haha!

Andy We were speaking our own language with art and music that wasn't even recognizable by anyone who wasn't part of our scene. There was a certain belief that we were unsophisticated, from the teachers in art school and from the people on the street. And I was

angry, because no one could understand me, not my art teachers, not the mainstream, only a handful of graff artists and skaters. During the growth of our whole visual movement, I was writing a lot and listening to a lot of hip-hop. My stories and poetry started to turn into rhymes. Johnny and I would freestyle when we went out skating ever since he'd lived in New York, and now I was starting to actually write rhymes and formulate songs and hooks in my head. When the new Tribe, 3rd Bass, and KMD's *Mr. Hood* albums came out, it was mind-blowing. Johnny and I had casually talked about making music, but I was seriously writing stuff I wanted to record. So I bought a cassette recorder with eight separate tracks and some remedial mixing controls on it, and a sampling keyboard and a mic. I recorded a song and played it for Johnny and he was stoked so we started to write some stuff together.

Were we actually going to start making hip-hop too? Somehow to us it just seemed like the obvious thing to do. Our visual art movement was in full swing, all around town people were talking about it, and RAD magazine in London asked me to do a centerfold featuring the graff and political commentary we were starting to put out. It was ill.

Johnny Schillereff Andy had graduated art school but I was still going there and I had all these music major friends. We'd get invited to hip-hop clubs and be the only white guys in the joint.

Andy On one of the New Deal tours, Rick, Justin Girard, and I had traveled the entire globe listening to Gang Starr's new album *Step In The Arena* obsessively. Over two months of traveling and doing demos, we were listening to just that one album—we went to Portugal, Spain, Switzerland, Austria, Greece, Germany, Hong Kong, Tokyo. At our very last demo in Tokyo, Rick was taking a break while Justin and I were skating. He looked up and there was Guru standing there watching our demo. He'd heard his own music bumping at our demo, while they were signing records next door at Tower Records. So he came over and said, "You guys comin' to our show tonight, right?" It felt like total fate, or at least serendipity. I brought in some Sophisto gear and styled them out with it while they were on stage, as Rick, Justin, and I stood up in the front screaming every word to every song. Of course we went backstage with them after the show, and for me it was like meeting one of my heroes in skateboarding. I told Premier I was interested in making hip-hop music, and so he gave me their number in Brooklyn and told me to call anytime.

When I was back home I started calling Premier and talking to him about how to make beats, and he taught me some stuff over the phone. He told me about sampling single jazz and big band drum hits and snares to make his own authentic sounding drum sets, with all the old crackly sounds from the records left in. I went out the next day and bought all the Gene Krupa records I could find. Just the way I had learned to skate street from Gonz, now I was getting tips on making beats from Premier. It was a magic time. I felt like, "Oh shit, I want to get into rap music now, and I want to be a producer."

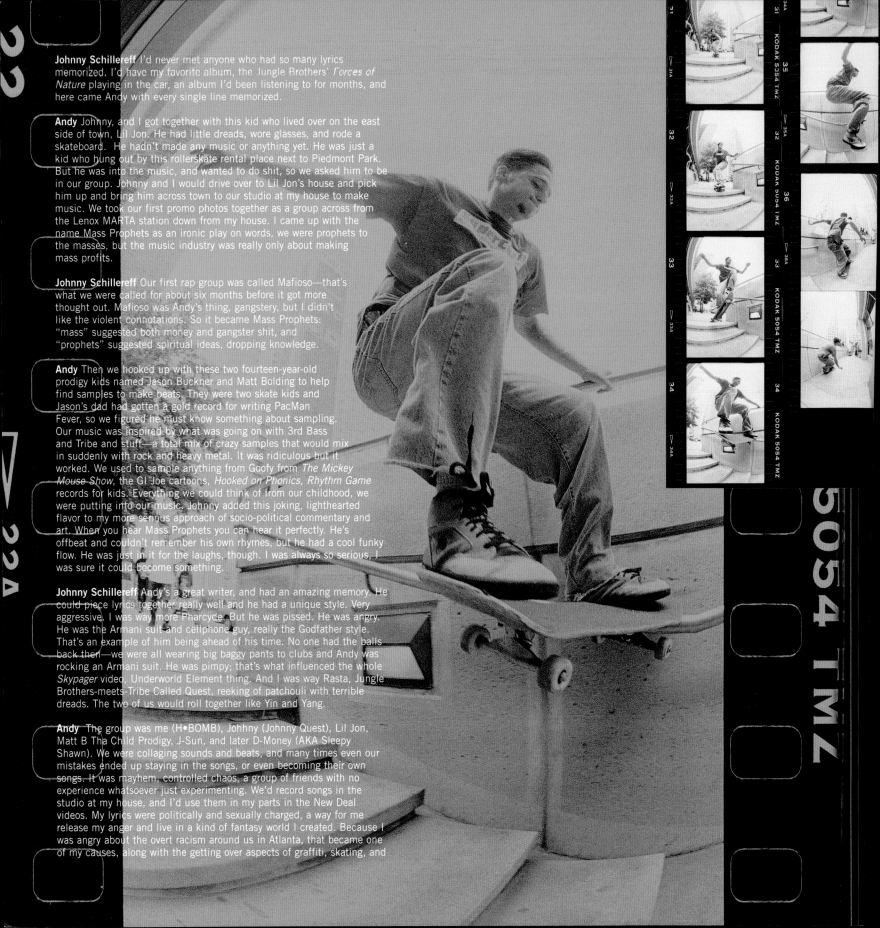

Johnny Schillereff I'd never met anyone who had so many lyrics memorized. I'd have my favorite album, the Jungle Brothers' *Forces of Nature* playing in the car, an album I'd been listening to for months, and here came Andy with every single line memorized.

Andy Johnny, and I got together with this kid who lived over on the east side of town, Lil Jon. He had little dreads, wore glasses, and rode a skateboard. He hadn't made any music or anything yet. He was just a kid who hung out by this rollerskate rental place next to Piedmont Park. But he was into the music, and wanted to do shit, so we asked him to be in our group. Johnny and I would drive over to Lil Jon's house and pick him up and bring him across town to our studio at my house to make music. We took our first promo photos together as a group across from the Lenox MARTA station down from my house. I came up with the name Mass Prophets as an ironic play on words, we were prophets to the masses, but the music industry was really only about making mass profits.

Johnny Schillereff Our first rap group was called Mafioso—that's what we were called for about six months before it got more thought out. Mafioso was Andy's thing, gangstery, but I didn't like the violent connotations. So it became Mass Prophets: "mass" suggested both money and gangster shit, and "prophets" suggested spiritual ideas, dropping knowledge.

Andy Then we hooked up with these two fourteen-year-old prodigy kids named Jason Buckner and Matt Bolding to help find samples to make beats. They were two skate kids and Jason's dad had gotten a gold record for writing PacMan Fever, so we figured he must know something about sampling. Our music was inspired by what was going on with 3rd Bass and Tribe and stuff—a total mix of crazy samples that would mix in suddenly with rock and heavy metal. It was ridiculous but it worked. We used to sample anything from Goofy from *The Mickey Mouse Show*, the GI Joe cartoons, *Hooked on Phonics*, *Rhythm Game* records for kids. Everything we could think of from our childhood, we were putting into our music. Johnny added this joking, lighthearted flavor to my more serious approach of socio-political commentary and art. When you hear Mass Prophets you can hear it perfectly. He's offbeat and couldn't remember his own rhymes, but he had a cool funky flow. He was just in it for the laughs, though. I was always so serious, I was sure it could become something.

Johnny Schillereff Andy's a great writer, and had an amazing memory. He could piece lyrics together really well and he had a unique style. Very aggressive. I was way more Pharcyde. But he was pissed. He was angry. He was the Armani suit and cellphone guy, really the Godfather style. That's an example of him being ahead of his time. No one had the balls back then—we were all wearing big baggy pants to clubs and Andy was rocking an Armani suit. He was pimpy; that's what influenced the whole *Skypager* video, Underworld Element thing. And I was way Rasta, Jungle Brothers-meets-Tribe Called Quest, reeking of patchouli with terrible dreads. The two of us would roll together like Yin and Yang.

Andy The group was me (H•BOMB), Johnny (Johhny Quest), Lil Jon, Matt B Tha Child Prodigy, J-Sun, and later D-Money (AKA Sleepy Shawn). We were collaging sounds and beats, and many times even our mistakes ended up staying in the songs, or even becoming their own songs. It was mayhem, controlled chaos, a group of friends with no experience whatsoever just experimenting. We'd record songs in the studio at my house, and I'd use them in my parts in the New Deal videos. My lyrics were politically and sexually charged, a way for me release my anger and live in a kind of fantasy world I created. Because I was angry about the overt racism around us in Atlanta, that became one of my causes, along with the getting over aspects of graffiti, skating, and

hooking up with hot girls.
"Tables turn now it's DJ Lil J-O-N,
spinnin' fat so shut you trap and catch a second wind.
I got more chicks than Minnesota's got pool sticks,
Base's Trooper stylin' (...Nobody's Smilin') in tha tape decks.
Idiots check respect to get greased like Ron Ray-Gun,
Everyone gets some, we play dumb like Exxon.
I heard watcha did, but yer ears are sorta wet kid,
You can detect my dialectic but it's hectic cuz I wreck shit.
Sweat the profile, girls, and you gets done,
Greek-style, meanwhile I'm getting' lit like Thomas Edison.
Can't go back when you're runnin' on M.P.
H-Bombs got high test like computers got SYMPTE.
I say PEACE to Shawn, Lil Jon, all my brothers,
Matt B., J-Sun, cuz what's one without the others.
Quest smothers with rhymes, turnin' nickels to dimes, it's simple
J-Sun and Matt B macin' tricks from the Tempo.
'Yo that kid got the curb, that's word to Bruce's herbs,'
Ample samples inserted, H•BOMB's got the words.
It's absurd I could get this mad juice from the suburbs.
Take a little listen for investin' in a lesson,
I Shake-nBake the rhythm while I'm livin' in progression.
Park the fessin' Fester, cuz you besta justa chill,
Prophets in cahoots getting' loots we Shoot To Thrill.
And to distill the mellow illin' Matt B and J are top billin'
Skeletonic beats, H•BOMB provides the fillin'."

At that time we had turned Piedmont Park into this hang-out where we would all go on Sunday afternoons. We'd take coolers of beer, food, and skateboards. The graff writers and all the girls started coming down and everyone in the scene knew that was the place to be on Sunday afternoons. All the dreads would be up on the facing hill in a massive fifty-man drum circle, playing crazy beats and passing the lead around. That's how we all started to connect it musically. Johnny would come down and bust breakin' moves. Everyone was just hanging out and having a good time. It was like a super crew.

Dallas Austin Back then, everyone had crews, like Hieroglyphics; you'd have music as a part of it, painters as a part of it, skateboarders, all these different kinds of people would join together and make this one movement. So Mass Prophets was one of those, a bunch of different artists and stuff, joined together. It was kind of snobby actually because once you had a crew like that, you know that you were the shit. People wanted to be a part of it, they wanted to be accepted into it. It's like being in a fraternity or a gang - but different because it was different types of creative people.

BaseOneRock, artist My memories are rolling to Velvet with the Mass Prophets crew. Bumpin' in the Trooper, bombing trains and shit down town. A trip to the Georgia mountains with Bust, a.k.a Kinsey, and everyone. Painting the Civic Yard when there was still exposed brick and we had to roll it first. Beef with Jaz

and Sen for a while. The night me, Andy, Johnny, Jose, Bust we all got on the VIP list to that full on black hip-hop club and we were on the fucking stage all surrounded by security and shit watching a booty shake contest with Dallas! And we overheard some dude say, "Who are these kids, the Beastie Boys?" That shit was mad ill! The only fucking white boys rolling deep in that club!

Johnny Schillereff We were kind of like the Beastie Boys with rhythm and proper hip-hop skills. There was a punk side to us and we were definitely skaters, but I think we were true musicians and rappers. The real deal.

Andy Dallas Austin had just created Another Bad Creation and TLC, so he was already a really a big deal in Atlanta. He was producing all these mainstream groups: Boys II Men, then later Monica, all high-end R&B shit. And we would hang out around his studio. He was like, "You know what, I make good money doing this music, but dude I want to make hardcore punk music and just other crazy shit too." He and his technician Rick were already farming other talent and thinking of ways to do it differently. And I was like, "Let's do it with Mass Prophets." I remember when we had first met Dallas and had to bust freestyles for him and right hand man, David Gates. There were so many walls up to get into Dallas' posse, I thought he was kind of stuck-up at first. Dallas had this crazy studio, DARP, with five to six complete studios with soundproofed rooms and chill-out areas with pool tables where whoever was recording at the time would hang out between sessions.

Dallas Austin Mass Prophets were real underground hip-hop. A little wacky but with a little more East New York hip-hop attitude. Nothing that people commercially would've bought, but people that were into hip-hop would've liked it. Everybody was into underground at that time, all you had to do was not be a part of the norm to have a chance that an audience would like you.

Andy Mass Prophets started out as friend of mine in the U.K., Fraser, was helping me get Zero Sophisto, the clothing line I simultaneously launched, into all the Kings Road shops, which were the shit in London at the time. He said his roommate was starting a record label and wanted to hear our demo tape. So I sent him one, and the guy was super hyped. Simultaneously, Dallas and his camp were into our demo and were negotiating a contract with us, taking us to all the clubs every night, partying with people like Shadz Of Lingo, Joi and Gip, or Busta Rhymes, Too Short, and all these people in his industry. We would go to booty-shakin' clubs, and if you've ever been to a booty butt-ass club in Atlanta, you'll know what I'm saying. It was nuts. There was a club called Phoenix, which we would roll up to with Dallas, Beaz, Dave Gates, all these heads from Dallas' camp, and we'd get the red carpet VIP treatment from everyone. Free everything, our own private section with hot chicks trying to climb under the rope at any moment. There was this dancehall night there, and the club had mezzanines with girls dancing and hanging on the

rails. I'd never seen girls get down like that, I mean they could wine down like nothing I had ever seen before. Dallas had us on the inside track, and we were just like, "We're gonna put out an album? This is ridiculous!"

The guy from London offered us an EP of a few songs, but since Dallas was talking about an album, we declined. The deal with Dallas didn't end up working, he told me later we were all too impatient. I realized we had wanted it all to be immediate like the other DIY stuff we had done, but the record industry just didn't work that way. We became disillusioned, and since we had told him we were going with Dallas, we felt embarrassed to call Fraser again. As it turned out, the guy from London was James Lavelle and the record label he was starting was called MoWax.

Johnny Schillereff I think we would've had an album out, no doubt. But we weren't prepared to put everything into it. The two of us were sidetracked by so much shit. I had college, and I started a hip-hop club, and then there was New Deal, Sophisto, Velocity the screenprint shop, Giant Distribution•... we just didn't have the focus.

Dallas Austin The people I've grown up with in Atlanta have become this force in pop culture. Whether it was Andy, whether it was Chris Tucker, whether it was Ludacris, or Big Boi from Outkast or TLC or Lil Jon or Denzel, I've watched us all grow into our dreams. Once we did ABC out of Atlanta, and Boyz II Men and TLC, we kind of opened it up. Jermaine did Kriss Kross and Speech did Arrested Development, that's what made Atlanta this place where you got to see all your friends take off in their own areas. Pretty much everybody around us at that time has made it in a major way with whatever they were doing. It's still a creative mecca. It's just different for us now because before, you didn't necessarily have the money to see things through the way you wanted to.

Andy Dallas and I have stayed close friends, and he became one of those big inspirations for me, alongside Tony Hawk, Mark Gonzales, and Bad Brains. Besides that week with Gonz in HB when I was fifteen, the times I spend with Dallas inspire me more as a creative visionary than anyone I have ever known. We speak the same language, in a right brain spatial-thinking sense, and I value his opinions and his ideas.

When I started New Deal I was inspired by my life in Atlanta, doing graffiti and listening to hip-hop. And I was also starting to spend a lot of time in the summers in New York, skating with those cats there. And the more time I spent there, the more I started to see myself as a city kid.

Johnny Schillereff Andy at that point was getting on the tail end of his skating career and was getting more interested in art and fashion. One thing about Andy back then is that he'd jump all over the place. He was an eccentric and eclectic visionary. Which meant that the second he wasn't interested in something, he was just out. He'd drop everything and move to the next thing. He did it, conquered it, and was over it.

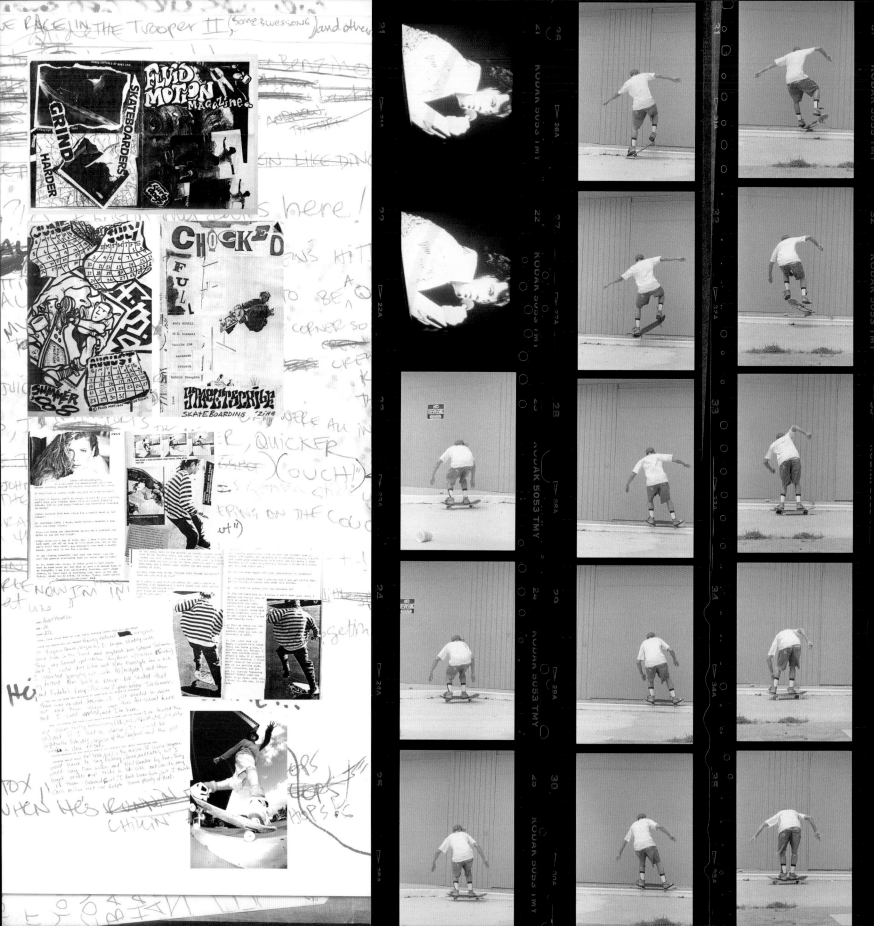

THE CITY BUSTLING, THE JUNKIES HUSTLING,
FALL IS PRETTY WHEN THE COLORS ARE RUSTLING.
BUT HERE I AM AGAIN AWAY FROM HOME,
AND SOMETIMES THAT MAKES ME LONESOME
 FOR MY OWN HOUSE, MY OWN BED, MY OWN
ROOM, YOU'VE THOUGHT TWICE ABOUT ME I'D ASSUME.
 IT'S JUST THAT SOMETIMES, I DON'T KNOW,
 I JUST CAN'T HELP BUT MISS THE
 WARM FEELING OF MY OWN PLACE,
 NOT HAVING TO ASK ANYONE FOR ANYTHING,
NOT HAVING TO SELL MYSELF
 SHORT, NOT HAVING TO
 WAKE UP IN SOMEONE
 ELSE'S BED, OR HAVE
 SOMEONE ELSE'S IDEAS
 OR EVEN SOMEONE
 ELSE'S FACE,
 SOMETIMES I JUST WANT
 TO BE FREE AND ALONE, NOT
 NECESSARILY LONELY, BUT ON MY
 OWN, IN CONTROL, ALIVE, IN SYNC
 WITH MYSELF

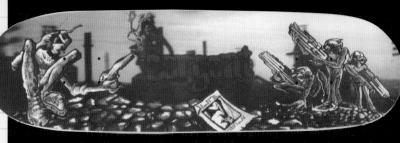

SEND TO MOM...

Monday, early A.

Dear Andy,
 thank you so much for
having me visit with you in
Atlanta - I really enjoyed my
visit with you (and Michael, too.
You were such a good host.
 My plane arrived 30
minutes ahead of schedule
in Norfolk - but, of course, Dad
was there anyway. I barely
made my flight in Atlanta -
my bags didn't. We had to
go back to meet the 6:00 flight
to pick up my suitcase.
 I really enjoyed having
breakfast with Michael's mom
and sister - that's a great place
for breakfast. I really enjoyed my

(center handwritten, partly legible)
...Santa for a visit, you'll
...his... there ...
...glad we got as much
...lished as we did ...
...and I look forward to
...again when all the ...
...place.
...friend from N.Y.
...and sound. I
...'ll enjoy having you
...her Atlanta -
 When I was cleaning out
my pockets yesterday, I
discovered that I had a receipt
from one of your purchases
and I'm enclosing it. Put it
with the rest of your receipts
for safe-keeping. Don't imagine
you'll need it for anything,
but you never know.
Well, hurst go for now ...

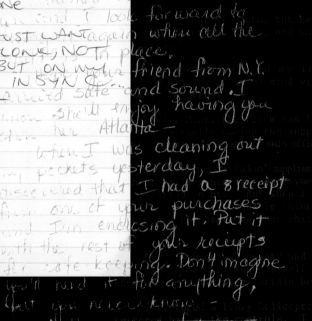

=!WHAT A TRIPPIN' FOOL!=

ANDY HOWELL
ADLANTA
Mr FINSTER

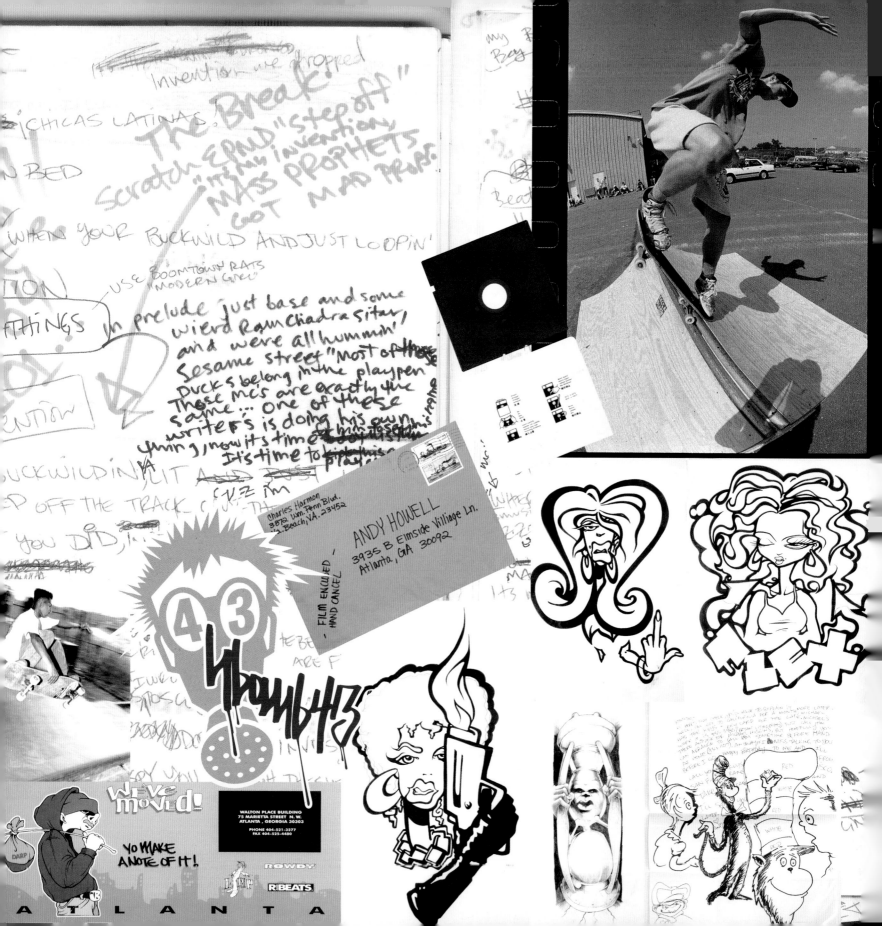

Invention we propped

¡CHICAS LATINAS!

The Break!
scratch Erud "step off"
"It's my invention"
MASS PROPHETS
GOT MAD PROBS.

IN BED

WHEN YOUR BUCKWILD AND JUST LOOPIN'

USE BOOMTOWN RATS "MODERN GIRL"

In prelude just base and some
wierd Ramchadra sitar,
and we're all hummin'
Sesame street "Most of these
Ducks belong in the playpen"
These mc's are exactly the
same ... one of these
writers is doing his own
rhyming, now it's time... his name
It's time to...

BUCKWILDIN' IT

STEP OFF THE TRACK CUZ I'M

YOU DID,

Charles Harmon
3872 Wm. Penn Blvd.
VA. Beach, VA. 23452

ANDY HOWELL
3935 B Elmside Village Ln.
Atlanta, GA 30092

- FILM ENCLOSED -
- HAND CANCEL -

43

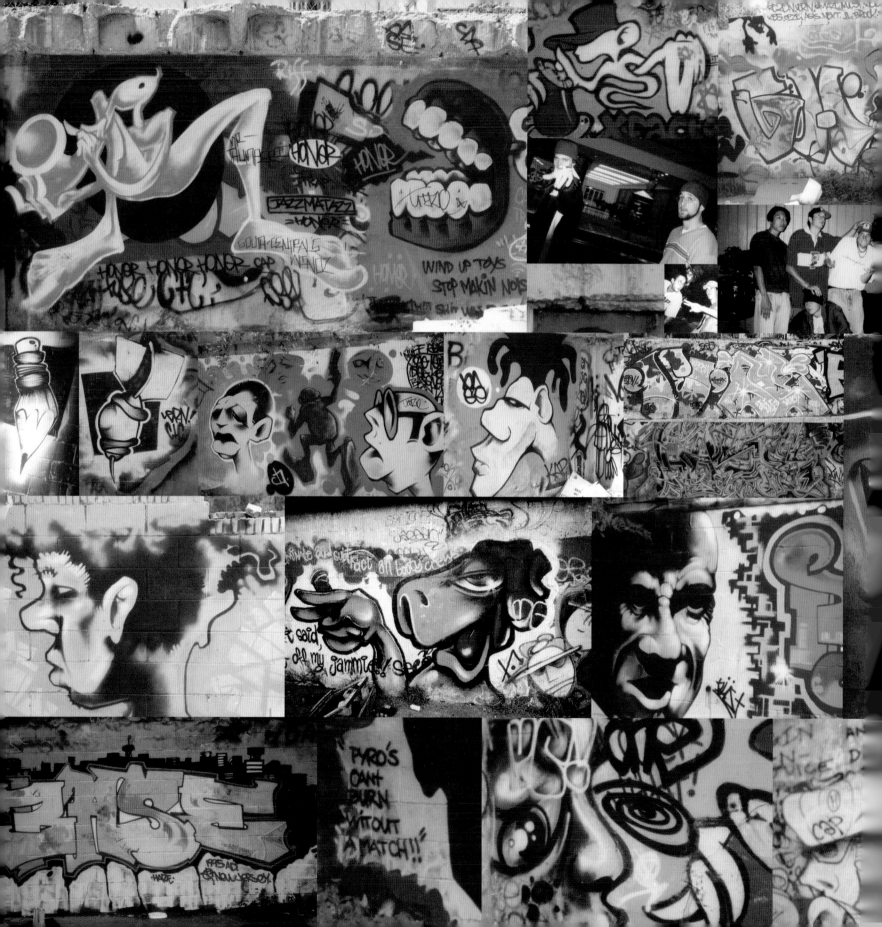

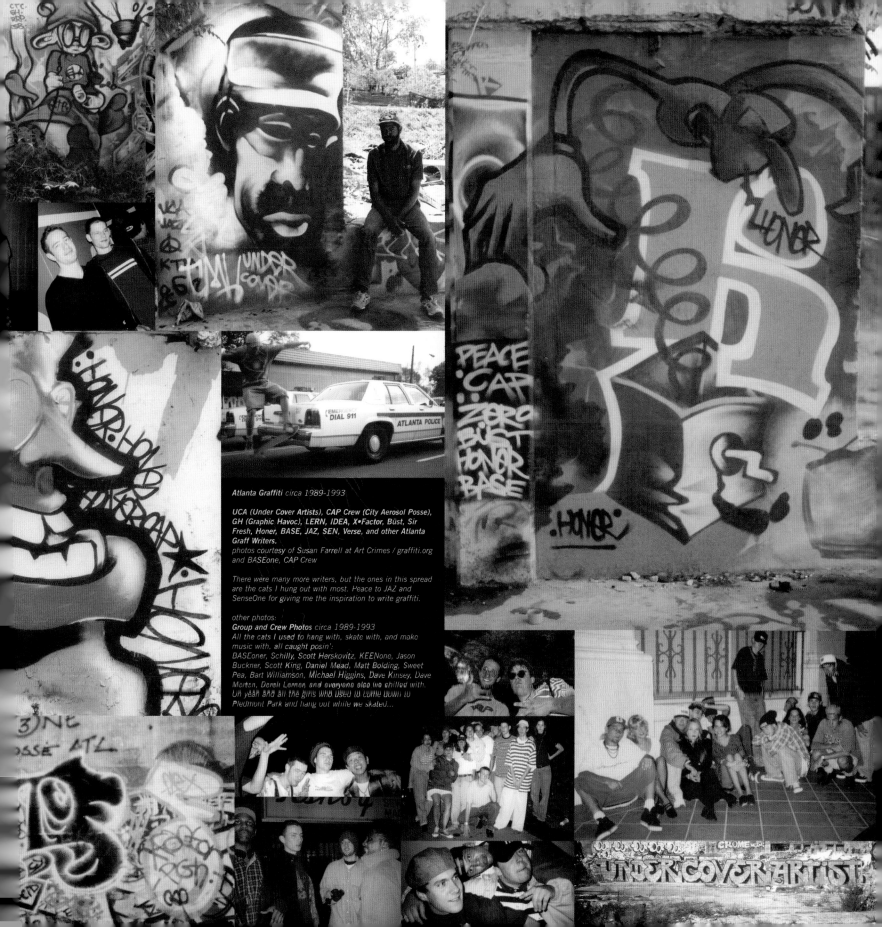

Atlanta Graffiti circa 1989-1993

UCA (Under Cover Artists), CAP Crew (City Aerosol Posse),
GH (Graphic Havoc), LERN, IDEA, X•Factor, Büst, Sir
Fresh, Honer, BASE, JAZ, SEN, Verse, and other Atlanta
Graff Writers.
photos courtesy of Susan Farrell at Art Crimes / graffiti.org
and BASEone, CAP Crew

There were many more writers, but the ones in this spread
are the cats I hung out with most. Peace to JAZ and
SenseOne for giving me the inspiration to write graffiti.

other photos:
Group and Crew Photos circa 1989-1993
All the cats I used to hang with, skate with, and make
music with, all caught posin':
BASEoner, Schilly, Scott Herskovitz, KEENone, Jason
Buckner, Scott King, Daniel Mead, Matt Bolding, Sweet
Pea, Bart Williamson, Michael Higgins, Dave Kinsey, Dave
Merten, Derek Lerman, and everyone else we chilled with.
Uh yeah and all the girls who used to come down to
Piedmont Park and hang out while we skated...

WARNING: The Surgeon General has determined that skateboarding in any form is hazardous to the health of our society, because it promotes creativity and individuality at a young age. Prolonged use of this unacceptable activity can result in devastating amounts of enjoyment.

warning:

CHAPTER 6
UNDERWORLD
ELEMENT

Andy By late 1991, The New Deal wasn't new anymore. It had become an established brand with a huge following. We had helped to usher in a new standard in street skating and videos, propelling the second wave of New Deal riders like Ron Knigge and Armando Barajas into the spotlight. I was traveling for demos and contests, filming, doing ads, designing clothing, whatever needed to be done creatively to push things forward. But my work ethos was unlike the other guys in the company. I had to be inspired, and when I was I would work straight day and night for a week and a half making a new line for whatever brand. I literally didn't sleep because I was over in the right side of my brain so much of the time. Then I would crash for two days, and spend the next three hanging out with my friends up at the waterfall at Tullulah Gorge or partying in Atlanta with a girlfriend. It's the way it works for me—the nine-to-five gig was never my bag—and I know that confused and irritated Douglas, who was like a machine with an unwavering schedule.

Paul Schmitt Ultimately with New Deal, I think Andy just got bored. Steve worked 98 hours a day and couldn't respect anyone who didn't work at that same pace. Whereas Andy was like, "The longer I can hang out in a Jacuzzi, the better." He wanted to rap out and do music. I respected Andy's creativity, I saw the value in it. But as soon as he got bored, the results started to be affected.

Andy Yet again, my mind was going, "What's next, what's next?" I was already thinking ahead. I think it's what drives all creative people, an undying urge to keep changing and to keep pushing past my own boundaries. It's always been my gift and my demon. I can't stand to keep doing things the same way for long, I always feel the need to innovate in some way. And another new idea had started brewing.

At the time I had become completely obsessed with the lifestyle of being a skater in the city. I felt it in Atlanta, but the urban landscape of Atlanta was still very limited at the time. My friends and I were skating a lot of mini ramps, and progressing there more than anywhere. I was traveling like crazy and spending a lot of time at Tommy Guerrero's house in San Francisco and Jeremy Henderson's pad in New York.

Ever since I'd turned pro for Schmitt Stix, I'd spent the summers in New York with Jeremy Henderson and all the Shut crew. Jeff Pang, Shawn Sheffey, Barker Barrett, Rodney Smith, Bruno Musso, Peter Hunyh. Everyone would meet and skate the banks under the Brooklyn Bridge, skate through the city all day, and then go party on a rooftop with some deejay spinning hip-hop. I remember the first time I met those guys at a contest in O.C., Maryland, it might have been at the beginning of SHUT Skates in '87 or '88. Alyasha Moore was with them, a tall kid flying down the street outside the contest with loose trucks and a Chet Baker *Let's Get Lost* T-shirt. Aly would become a dear friend and a great inspiration to me, everything about his world was inspiring. I'd go to his house on Bergen Street and he'd be working on beats for Jungle Brothers. All these heads lived near him in Brooklyn, like Mos Def, and Aly's mom Carolyn was restoring art in the house, so her assistants would be working on projects to the soundtrack of Aly's sampled jazz and funk beats. It was a very creative environment.

Whether it was delusional or not, I have no idea, but I was becoming a true city kid and getting immersed in the culture of New York. It was all mixed together, the hip-hop, the lyrics, the skaters, the streets, the artists, the people. I know where the bumper sticker comes from man, because I Loved New York. The city was infectious, everywhere we went something completely new was going on, and it was the ultimate impetus for creativity.

Alyasha Owerka-Moore When we met Andy, Shut was just a bunch of kids from New York City who used to skate together and make skateboards on the roof of my mom's house. It was totally DIY—we'd be up there on the roof, tracing shapes onto uncut boards, cutting them out with a jigsaw on a milk crate, and beveling the edges with a disk sander attached to a drill. Eli Gessner and I folded a piece of paper into nine parts, then each skater drew into a box and we photocopied them onto sticker paper—and those were our first stickers. It went on to Rodney, Bruno, and a couple of guys founding a formal version of Shut skates. That's what put East Coast street skaters on the map. They'd travel to contests around the country and just blow doors. Everybody in the industry was freaking out because there were these city kids killing it—not just doing well, but totally killing it—and none of them were pros

except for Jeremy. It was a completely different thing from what people were used to seeing, a much more aggressive style because we actually had to skate in the streets, holding on to the backs of buses. We were always the underdogs and that made us hungrier.

Andy The New York scene was the perfect fusion of metropolitan skating. I remember skating to the old Shut factory on Mott Street in Little Italy, this totally old, Italian gangster part of town. Since Bruno, one of the Shut founders, was Italian everybody kind of imagined that he had some connection to the mafia. What was so great was that it was an Italian kid and a black kid—Rodney Smith—who started the company. That melting pot style was my experience of New York in a nutshell.

Rodney Smith, co-founder of Shut Skates and Zoo York It was really fun for us to skate with Andy, because we got to see how his style was dictated by his territory. He had access to skateparks and stuff, and we had none of that in New York. The parks had been closed since the '80s and we were really searching for things to skate. I was from New Jersey, 35 minutes from the city, and my first encounter with Jeremy, Harry Jumonji, Bruno Musso, and numerous other skateboarders really gave me a new outlook on skating. So for Andy, being from where he was, the first time he had the whole New York skate experience was a big thing. In New York, you carry your skateboard everywhere, like you wear your wallet or your watch. It's also your weapon, it's also your form of stress relief, it's so many things. And Andy probably had never met anyone with that kind of passion about their skateboard, about having the city streets wide open to do whatever you want.

Andy The whole skate lifestyle was immersed in the reality of living in a massive city. Your skateboard was everything. It wasn't a toy, it was a vehicle of urban manipulation that was attached to your body. I'd skate with people like Harold Hunter, who couldn't have been more than fourteen or fifteen at the time, and was stealing pager numbers to get free long-distance calls from some phone card thing he had going on—that was how we'd keep in touch. Skating with Harold was a trip: he knew everybody in the city. You'd be hanging out and over there were the guys that started Supreme, and then somebody else from Shut would come around or we'd hear that Jeff Pang was skating at the Astor curbs, and we'd go and skate there for a while and drink forties and talk to friends or heckle people walking by. On some side street between spots, Harold would stop, flip his board up on the sidewalk, and just take a piss on the side of the street. We were so crazy dirty and sweaty you'd see sweatlines on people's faces and clothes by end of the day. You could be out at a party that night across town still dirty and salty as hell, but no one ever thought twice. It was just that raw.

Washington Square Park was a convening place at that time. People would go there to buy weed, or just hang out and skate. I remember meeting Harmony Korine down there, way before he wrote *Kids*, with a big oversized beanie and baggy pants on. He was a kid whose family had come up to the city from down south and he was going to film school I think. He gave me a copy of his first student short film, a little black and white piece called *Bundle of Minute*, starring him and a bunch of his family. That was the kind of people who convened there, it was like the Beat Generation of the '90s, skaters and hip-hop kids and writers and artists. Instead of bongo drums, the soundtrack was beats coming from a boombox someone had brought.

My response to all this was, "Holy shit, this is hardcore, I've never seen this before!" In Atlanta, we'd drive around in my Honda, pull over and decide, "Okay, let's skate this curb." And we'd get out, skate a little bit, wipe the sweat off, put the board back in the trunk, and drive away. Atlanta was a country version of a city, albeit one that was just giving birth to its own crazy hip-hop scene. As for the rest of the skate culture, they weren't getting it. In the Southern California *TransWorld* universe, the kids were basically beach kids who came home after school every day, ate their peanut-butter-and-jelly sandwiches, and drove to some high school to skate. They became so technically advanced and so good at skating handrails and ledges, that ultimately they pushed a lot of innovation of big skating, because they were focused on that one spot the whole time.

But in New York it was the complete opposite. Kids there were immersed in the whole metro landscape because there were no cars—moving was about either skating or subway. They lived every second of it.

Jeremy Henderson had been the most inspirational character to me in New York when I had just turned pro for Schmitt Stix. All the cats in New York were like, "Cool, Andy Howell is an East Coaster who's made it." They adopted me into their fold and were like brothers from another mother. I'd go stay at Jeremy's killer loft on the Lower East Side, right on Stanton and Ludlow. Max Fish was just a quiet bar with a pinball machine, nobody would be in there except some of the skate kids and Jeremy. Aaron Rose had a teeny-tiny homemade art gallery right next door, Alleged. We'd just hang out in this neighborhood and skate. The routine was simple: wake up in the morning, grab your skateboard, and spend the day and night on it.

Rodney Smith Jeremy had this loft that was the starting point and ending point to any skate session. Jeremy was a pro for Dogtown, he'd turned pro back in the late '70s or early '80s. He was from England originally but had lived in the city for years, and he was a seasoned city skateboarder—the guy to go to when you needed to know anything. Andy was wowed by him, he was this wild guy into all this funky music and painting and living and skateboarding. Andy probably first thought, "God, these guys follow him like he's the Pied Piper." But you had to, because Jeremy was always pulling something out of his bag. Soon, he was the King of New York as far as Andy was concerned. Andy got the ultimate treatment as a skateboarder partly because of that relationship.

Alyasha Owerka-Moore I don't think enough people give Jeremy the kudos he deserves. He was our outlet to the rest of the skateboarding world. Jeremy was this older guy who kind of chaperoned us, and we were these ducklings following him around. One, because he was an amazing skateboarder; two, he had the sickest record collection; and three, he'd traveled the world, and all the pros would stay with him when they came to New York. He was also an amazing artist and it just so happened that a lot of the people he'd connect with in skating were artists as well. His big old rad loft was filled with shitloads of art from skateboarders, as well as original Basquiat pieces. He

knew that whole crew of people, the old-school graff writers, the original Zoo York graffiti guys. You want to talk about the roots of contemporary pop art, well Jeremy had stuff from Andy, Chris Miller, Mark Gonzalez, this guy named Ducky, I mean like early stuff. That was what bound a lot of us even tighter, the whole art thing.

Andy There was never a time in New York when we didn't skate twenty spots in one day. It'd start at these super tight transition banks next to a big hotel, then all of a sudden we were downtown, skating these long ledges that went over a stairway, and then, "Oh yeah, there's this gold rail around the corner that we've got to check out," and then we put a cement bench down three stairs. All these tricks that I had only done on flat surfaces, people like Pang and Felix Arguelles would do down stairways. That's where I got the idea for creative urban manipulation, which became the tag line of Underworld Element. It wasn't creative-ramp-in-your-backyard-in-the-middle-of-Podunk-Mississippi manipulation. It was creative urban manipulation and was happening everywhere: San Francisco and New York and Chicago and Detroit and Los Angeles and Atlanta and D.C. and London and Paris and Tokyo. There was this universal feeling that we were all doing the same sort of thing in different places at once.

Salman Agah, pro skater, founder of SkaterAid and Academy of Skateboarding The whole urban environment made skating what it was. In San Francisco, the Embarcadero's Justin Herman Plaza was the spot. That was a place I skated daily and where much of the modern-day street skating was developed. Mike Carroll was there, Jovantae Turner, James Kelch, Henry Sanchez—that's where innovation was happening, in '90, '91, and '92.

Chris Hall In D.C., the years from '90 to '94 or '95 produced a lot of powerful skaters. Pulaski Park was known worldwide as a skate mecca. It's a big marble plaza covered in ledges, stairs, handrails, and banks. It was very rugged. Everybody who was anybody in D.C., Maryland, or Virginia came there and skated all day long. I'd hang out with Pepe Martinez, Andy Stone, Eben Jenke, Carlos Kenner, and Jim Gordie. We became really good at skating ledges and flat ground. It was a showboating thing, you'd hang out all day and basically show off your tricks. We were more aggressive skaters than West Coasters. It was a weird time too—

violent for no reason. People I was with were robbing other people for their boards and fighting for no reason. Maybe because it was such a mix: ghetto kids mixing with suburban kids, all vibing off each other.

Andy Meanwhile in Paris, it was going on with Stefane Larance, and all these cats who were just devastating. In London there was a whole new generation coming up, the Deathbox guys, Anarchic Adjustment, and street skaters like Curtis McCann. You'd hear about them, and you might not even see them until you went on tour that summer, and of course you'd end up skating with these guys. It was this whole network of inspirational people living in metropolitan areas who almost always, were not just skaters. They were designers and graffiti artists and musicians as well.

There was always a clique of skaters rotating between different cities. I'd go to San Francisco for two or three weeks and stay at Tommy Guerrero's house. He lived on Turk right above Divisidero. We'd skate all day long with people like Theibaud, Coco Santiago, Micke Reyes, and Danny Sargeant. I remember thinking, "I'm not going to show these people that I'm so fucking tired." They were like machines, they never stopped. Everyone would bomb these crazy steep hills at backside 9th doing 35 to 40 miles-an-hour. It was death-defying—the energy was so amazing.

A whole new generation of street skaters were coming out of there: Mike Carroll and Henry Sanchez and Mike Cao and James Kelch, Rick Ibaseta, and Justin Girard, skating flat ground and ledges. Tommy and his friends were out bombing the hills and skating the reservoir hips. For me it was a constantly terrifying experience, having never really skated hills like these cats. I remember chasing TG and his crew down backside 9th, and they would just disappear into the distance, down the hill below me. Yet I was so stoked on that style of skating it always pushed me to go faster in any circumstance. Tommy was one of the most inspiring guys to me ever as a skateboarder and as an artist—he was living in SF doing music, which eventually came out on MoWax, and other record labels. As a kid he and his brother Tony had been in Free Beer, one of the famous punk bands from San Francisco, and he was also one of the best skateboarders in the world. We spent a lot of time just hanging out at his pad, talking about music and ideas, while he jammed on the bass or guitar and spun records.

"Switch Nosebump" Underworld Element Dirty South Tour, circa 1992, photo: Chris Ortiz

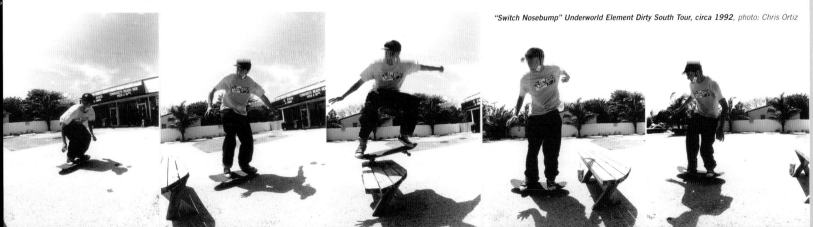

Tommy Guerrero There's definitely different approaches—your environment creates who you are to some extent. We all have to deal with our surroundings, and in San Francisco we had to deal with hills, lots of cars, and constant traffic. One of the things that was cool was that when the ollie came around, you'd be flying down a hill, and since you were now learning to ollie straight or 180, you could ollie up a curb, and keep going down the hill. That was a huge contribution to everyday travel through the city. Because for us, the skateboard was a mode of transportation. It was functional.

You'd meet a lot of cats from certain parts of the East Coast who were a little more technical because they tended to dwell on the flat surfaces, while we were just taking a different approach. When Andy came to stay with me in San Francisco, what he brought to the table was that he had more technical ability and a really creative sensibility as far as skating and art and everything. I don't think he was used to skating hills, but he charged it with the best of them. That just became part of the way he skated: faster and more aggressive. We'd go skate at Jim Thiebaud's ramps, too. Jim had different spots where he had built the most amazing ramps, mostly mini ramps. One was in a backyard, another was in a warehouse. And Andy being super skilled at skating trannie as well, he'd bring the tech stuff to the mini ramp stuff and blow people away. Super stylish and smooth.

Andy One of the most crucial, and most creative, developments of this era for me was nollies (from "nose ollies") and then skating switch. Nollies hinted that things could be done the opposite way, and subsequently switchstance opened a new door in skateboarding. The whole era was defined by innovation in the equipment—and in the way we skated on it. If we could think of it, we made it. Doing New Deal, I started imagining what it'd be like if boards had two tails. I learned to ride up a wallramp and pop my nose of the wall. I was doing a nollie off the wall, over the lip of a jump ramp, which was a two by four, and it only took me eating shit a couple of

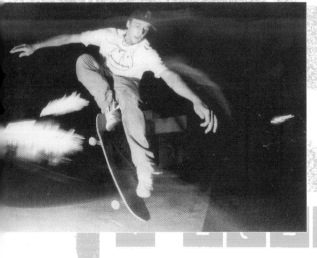

"Nose Ollie" circa 1990. photo: Christian Kline

times to realize I had to do something or I'd hang up. I had to pop my nose off the wall and got air off it and then land back to fakie in the ramp to wall. That was the first nollie I ever did and I realized, "Shit, you can do that! It's possible." This was at Savanna Slamma 2.

After that I started popping ollies off my nose on the street. I could barely catch air, but I could tell it was possible, so I started using speed bumps to help me launch them. I asked the photographer Christian Kline to go out and shoot me nollieing off a speed bump in Huntington Beach on one of my trips. He lay down on the ground by the speed bump, a little confused, while I started popping a couple of them. He shot a few, and then said, "What the hell are you doing man, that's stupid, it's not even a trick!" And I said, "Yeah it is, it's a 'Nose Ollie'."

Needless to say it didn't deter me from continuing to try to learn nollies. So Paul, Gorm, and I created the Siamese Twins deck, and I began to do nollies and switch ollies. I was starting to skate down the street backward and thinking what would it be like to do all my tricks opposite-footed. I was watching Rodney Mullen and the way he did nollies. For a nollie gazelle, he'd pop into the air, do a 360, and land it riding perfectly. But he was doing it on a freestyle board, a tiny little board with super tight trucks that had no place being on a city street. It was made to ride on small areas of flat ground with no obstacles. Rodney has always been the king of the whole freestyle movement. He was the innovator of all the tricks that later were appropriated for the street by Jason Lee, Ed Templeton, and a slew of other guys that took Rodney's skateboarding moves onto a street board and integrated ledges, rails, and grinds. Well, Rodney turned around and said, "I can do it too," and he made a street board for himself. He learned how to do every single freestyle trick on the street, and created a new array of street-Freestyle hybrid tricks like half-flip caspers to tailslides across picnic tables. And his innovation ended up being the full-circle inspiration for that element of street skating and switchstance.

All that was starting to churn up ideas in my head about skating completely switchstance. I learned switchstance frontside ollies and tailslides, switchstance ollies to grind, switchstance impossibles, switchstance impossibles to blunts—which ended up being switchstance impossibles to noseblunts, and then I learned all the different noseblunt tricks and variations. I had seen Gonz trying to noseblunt in Hawai'i at a skate contest earlier. By that time, everybody was doing the same 180 ollie to grind down rail that he had pioneered the year before, and were using it in their contest runs. So Gonz came out of nowhere and tried to do a frontside ollie and land on his nose, in a noseblunt on slider bar on top of a quarterpipe. I thought, "Oh my god, that's impossible! But I have to see if it *is* possible," so I went home and skated every single second of every single day on a quarterpipe until I could do it.

It was like learning to skate again—so refreshing and so inspiring. I learned how to think the opposite way. I did a frontside ollie to noseblunt to 180 to pivot

on my nose truck, like a 180 pivot on a grind, which actually ended up being a switch backside pivot into the ramp. Anything I knew how to do regular, I was like, "Fuck it, I can do it switchstance," so I came backwards and fakied up the ramp and did a switchstance backside 180 ollie to noseblunt to backside 90 degrees out to nose pivot to end fakie, which was basically me doing a switchstance backside 180 ollie to a regular blunt pivot to go in forward. The names all started to become confusing, because it was already getting so technical and then we threw switch into the mix. But it was completely switchstance, skating opposite-footed—and had happened for me because I just imagined it *had* to be possible.

In one of my first video parts in the New Deal videos, I started to do nollies from flat ground and nollies up onto islands, nollies to nose manuals across blocks. We'd combine regular street skating with this and then nollies to 180 to ride a backward nose manual across a block. That was actually a switchstance half-Cab to manual across block. A lot of that video part showed skating switchstance, and people didn't realize it, they just thought I wasn't going big. They'd go, "What's up with Andy? He's wack, he sucks!" Then the end the video cut to me skating regular on some bigger tricks and they'd say, "Oh *snap!* He was skating backwards the whole time."

Salman Agah Nollieing is where switchstance started for me. The shapes of the boards started changing. Mark Gonzales, Andy, and a couple of others started putting a longer nose on the board. It made it possible to ollie off the nose. As a street skater, my whole mindset was always about progression and learning new tricks and manipulating the board to do things I hadn't done before. The natural progression of it was to roll backward. It felt good, it came easy, and I went with it. In the early '90s, it was a big deal to be an innovator, to be doing things first. I'd always take whatever I was doing to the farthest extreme I possibly could.

Andy It was the universal mind theory in action: creative people in far-flung places are simultaneously dreaming up the same things. It had to happen in order for the sport to keep progressing. These days you see young kids doing switch backside Smiths down a handrail. It's as if they start skating and learn a nollie the exact same time they learn an ollie. They're ambidextrous with their feet. Soon they'll be equally strong going both ways and the word "switch" will become redundant. But we didn't have that. We had to create it.

Steve Douglas After a year or so of New Deal, Andy was getting bored I could tell, we were working so hard and not getting paid. But we were doing so well that we had a lot of ams waiting to turn pro, so he said, "Let's start another team." That's how Andy is—he's into something for a while, then after a while he just gets bored. He's a creative spark, absolutely, and a great visionary in that aspect. But he's not so interested in the back-end stuff.

Andy I pulled a bunch of the sickest skaters from major cities around the world to come down to Atlanta and form a new company called Underworld Element. It wasn't just a team, it was a gang, a crew. Skating *felt* gangster then. We felt like complete outlaws to convention, especially in cities like Atlanta. Our attitude was, "Society doesn't understand that we *have* to skate on benches downtown at 2:00 am. It's what we do to live."

Johnny Schillereff The original Underworld Element team was a bunch of hard, knucklehead dudes. It was gnarly. And of course it was cool—that's what skating was at the time. Skating was the black sheep.

Andy We were a small group of people pushing the edge. Julien Stranger was just the fastest skater around, and he lived alternately between San Fran and L.A. at that time. He came from Dogtown and then the SMA fold. Jefferson Pang was pure New York City. He had a totally fast style and the ability to take on any obstacle. Rick Ibaseta was a New Deal skater from San Francisco. Chris Hall was the master of the flat ground, flip, and ledge. And then me in Atlanta. Our only am was Curtis McCann from London. Later on, I added Pepe Martinez from D.C., Harold Hunter from New York, Daniel Powell from Atlanta, and Lil' Stevie Williams from Philly.

Jefferson Pang, pro skateboarder, Zoo York My first major sponsor was Shut skates. It went out of business in about '90 when I had just finished high school, and I was making money doing electrical work. I'd quit skating, and was just trying to make a living. One day I got a call from Andy saying he was going to do Underworld. Last time I'd seen him was on the curb in Astor Place—sitting in the spot where Bruno got in *Thrasher* doing a frontside slappie—and he'd told me about his idea for Underworld. So when a few months later he invited me to be a part of it, I said, "Andy, I don't skate any more." He said, "Let me send you a board, and you just see what's up." At that time Shut was still doing spoon noses even after everyone in the industry was doing double kicks, so he sent me this brown, stained, double kick board with a drawing he'd done of this beautiful girl's face in black marker. I was really psyched.

Included with the board was a plane ticket to Atlanta. I had no idea what was going on. When I got to the airport it turned out that Rick Ibaseta was coming too—it was the first time I met him—as well as Julien Stranger and Chris Ortiz. I knew Chris Hall was already down there. When we got down to Atlanta, it was so cold that everyone else couldn't even skate. It was maybe 35 degrees, but it didn't affect me at all, it was just normal for me. During the trip we made all these bombs from *The Anarchist's Cookbook*, using buckshot and a piece of Styrofoam with a nail in it. We'd launch them like spears and they'd explode everywhere. I guess we were quote-unquote anarchistic—our first ad was this criminal mug shot. So that was the birth of Underworld Element. I guess I owe my career in skateboarding and in the industry to Andy. Otherwise I'd be an electrician with kids and a beer belly.

Andy I took pieces of video of Pepe, Chris Hall, Andy Stone, and Ali Mills to Douglas and Paul and told them, "Flatground skating is the next shit, for sure. And these guys are inventing it!" I remember having to seriously defend that style of skating and also defend the skaters because they hadn't reached their full potential yet. They were still doing things slowly and put-putting around. Paul and Steve couldn't understand my obsession with it, and I think just didn't get it at first. But of course the rest of the world started to come around six months later and I was vindicated when Chris Hall's next part came out, because it was one of the most innovative and stylish parts for a video ever. The same with Pep. Ali Mills lost interest, I think he went away to college. He was so ultra-creative and intelligent and talented, he did what he wanted to in skating and then he moved on. He was a kid who created something new every day, and once even filmed himself doing ollie to tailslide and noseslide simultaneously on the parallel rails inside parking lot shopping cart holders. I called him one time at home up in Virginia to see what he was filming and he was like, "I got this new thing where I bump my front wheels against stuff when I ollie over it." That "thing" became the nosebump, a trick that everybody and his mom did in every park in the following years. He was the first one I ever saw do it. I remember he was laughing because he didn't think it was a trick—the first one I ever saw him do was over a bike rack—he ollied over it clean

the first time, then the next time clipped it, you could hear this "Dink!" and I think he realized, "Shit, I think you could ollie over and bump your wheels off of stuff on purpose." Later Ed Templeton made it famous.

Ali was so super technical and advanced in the ways he could aim his board, that he ollied up and bonked his wheels off the bike rack which was like thirty inches high. This was a guy doing ollie front foot impossibles, the first kid who ever did a hard flip. In his video part he did a kickflip but the board went between his legs and flipped, and he landed riding backwards on the board. It was amazing, but he was barely moving, so when I showed Douglas this, who was super committed to everything being really fast, he was like, "You can't put this right after Andrew Morrison's part!" Andrew was hauling ass through these crazy snakeruns in Australia and doing amazing skating, but it was a different *kind* of skating. This was a new school, all about innovation. It wasn't about how fast you could go, it was about doing something that had never been done before. That's what had always turned me on about skating, so I gravitated toward sponsoring that kind of skater.

Sal Barbier A few skaters at that point were into hip-hop—mainly underground rap. Back then, a lot of skating was affiliated with punk rock and looking like a dirt bag. It wasn't our thing. We thought hip-hop was the new voice of the underground. We'd heard the Metallica album one too many times. We were nicely dressed kids wearing name brand stuff. Backpack rappers. We wore Polo rugbies, basically we looked like frat boys with baggy clothes. In the beginning, a lot of people didn't like it. But if you looked at the new talent emerging in skateboarding—whether at the Embarcadero in San Fran or in a schoolyard, this is what you saw.

Tommy Guerrero I got into hip-hop right about the moment when it came around to the West Coast, and I skated to some stuff in contests that people had never heard. A lot of skaters were playing a lot of punk, so having the other side of things—hip-hop and music from the funk genre—people were like, "Whoa, that's not punk!" They were surprised, especially with my background being in a punk band. In Japan, I was the first one to skate to Public Enemy, and no one knew what was going on. The appeal of skating to hip-hop was that it was super rhythmic. Tempo wise, it's almost on par with skating a lot of the times. The repetition is another aspect of it, getting sort of in a state where ... it's not exactly Zen, but it makes you less conscious and less self-aware, because there aren't a lot of changes in the music. It helps you really sink into the rhythm and the groove. It's kind of funny that people say I ushered hip-hop in to skating. I never thought much about it, it's just what I was listening to. A couple of my good friends were deejays who'd bring their turntables to my house.

Andy I took inspiration from '40s-era gangsters and hip-hop for Underworld Element. The first ad was a bite of the Geto Boys first album cover, a mugshot line-up. We held prison placards with our names, cities, closest subway line, and aliases from graffiti or nicknames we made up. I bought the *Poor Man's James Bond* book, brought the team and photographer Chris Ortiz out to my house, and we started making this crazy promo video with us blowing stuff up and skating all over and having snowball fights in freezing cold Atlanta. In the last clip of the video, Julien Stranger throws a homemade shotgun shell bomb off a parking structure, and there's a huge explosion. You can hear Ortiz say "Oh shit, dude!" when it hits. I used that scene as the last clip in our promo video for Underworld Element, but I don't think Paul and Douglas were ready for it yet. But what I was saying was letting people know, "Watch out, 'cuz we're gonna blow this shit up!" Stuff that probably would be considered terrorism today. At the end of the day though, it was about real street skating: fast and creative and technical.

Sal Barbier The division that was happening was more between the ramp skaters, who were wearing pads and had a punk-rock vibe, and the street and mini ramp thing. The music in the existing videos was punk rock, but Andy had rap in his videos and so did I. It wasn't about driving a 1984 rusted Impala. It was, "Hey, maybe I'll get a new car, put it in my ad, and I may even have rims on it." Street skating and hip-hop culture became one. The graphics of that time—Andy doing Sugar Howell from Sugar Hill Gang and Pang Starr from Gang Starr, and my team taking KMD graphics—wasn't knocking off so much as paying homage. Santa Cruz

Salvador Lucas Barbier, Gangster Slick, Plan B circa 1993
I didn't do this graphic, but I like this one because I think
Sal just may be the O.G.

Skateboarding in Atlanta 1992
photos: Miki Vuckovich

next page, boards circa 1992-1994 from left to right:
Andy Howell, My Baby's Boomin' System *Underworld*
Element, Artist: Andy Howell
Andy Howell, Skooled By Da Hat *Underworld Element*
Artist: Andy Howell
Andy Howell, Miseducation *Underworld Element*
Artist: Dave Kinsey
Rick Ibaseta, Ultraviolence *Underworld Element*
Artist: Andy Howell
Andy Stone, Excuse Me I Thought You Were... *Element*
Artist: Andy Howell

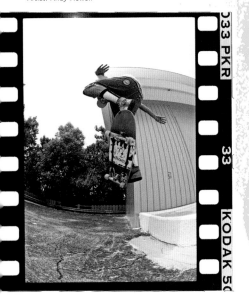

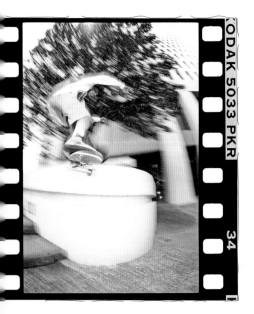

and Powell Peralta didn't understand it. They were skull and bones and the music in their videos was punk rock. But what we were doing was creating the voice of modern street skating. It wasn't tight jeans and Vans. It was a whole new aesthetic we were bringing to the table.

Andy Partly it was this subversive thing, a way to freak out the industry. These were the bad seeds of skating all coming together. I definitely wasn't the first person to ever think of this urban crew thing, I was just one of the first to make it into a skate company.

Chris Hall Underworld Element was really street. It had a lot of urban characters on the clothes. It was graffitish, innovative, and pushed the limits. At the time it was a very fun experience. Everyone on the team was really incredible. We all came together and meshed.

Andy The whole concept flew right over a lot of people's heads in Middle America. I remember Ted Newsome saying, "I was the hugest New Deal fan, but you lost me with Underworld Element because I lived in Alabama and just didn't get it." I knew it was pushing it. But it was a highly niche company that was made for what we were experiencing: Skating in a living, working, metropolitan landscape, getting hassled by cops and security guards at two in the morning downtown, having to rip your boards out of their hands and run. It wasn't marketed to the kids who skated on a dead-end street with a couple of friends in the country. That had become New Deal's market in my mind, so I set out to take over the cities, where it became hugely popular. Even in places like Tokyo and London, people still talk about Underworld Element before anything else I've ever done.

Rodney Smith The way I see it, Andy's contribution to skateboarding was about an East Coast attitude. His whole vision and persona is an East Coaster.

Andy Pep said to me at one point, "You got to get this kid. He'll be dope." It was Lil' Stevie, he was unsponsored, and he may have been thirteen or so. I saw footage and knew he was going to be sick, even though he was putt-putting around. I sent him some boards and I remember his mom called me and said, "What the hell are you doing sending these to my son!" I was like, "Ma'am, we're a skateboard company that is sponsoring your son, we send him those boards to skate!" And she was like, "I'm packing these up and sending them back, I'm not paying for them!" I guess she didn't really know what it was all about. I'm sure he was an anomaly to everyone in his neighborhood. "He's that weird kid who rides a skateboard." And he was one of the guys who became really famous at Love Park. Skating for me on Underworld Element was his first sponsorship.

After about a year, Urbanistiks was rocking, albeit playing a passionate, very rough, and unpolished song. I was able to get us all press in mainstream and endemic magazines because of my reputation in skating, and because I was doing so much art within skating, and because my brand Zero Sophisto was making such a splash around the world. So in interviews or stories I would discuss the idea behind Urbanistiks, and talk about the projects with Speech or Dallas or something outside of skating, so people could understand the bigger picture of what we were trying to do.

In the underground art community, I was starting to do shows, or set up shows with a few friends coming together to do dance, music, or art, or a combination. I had done a group show at Alleged in New York, and some shows in Atlanta and California, all related in some way to the crossover of art and skateboarding. The graff and hip-hop scenes were so underground, that even at the art shows people were often confused if what they were looking at was really art. It was simultaneously empowering and frustrating. On the home front of Urbanistiks was this group of talented people with fresh ideas, kind of being led by me, who were having a hard time waiting out the growing pains and stabilization of their first start-up. The others wanted to see cash instantly, though I knew it would take time to build, and tensions started to mount. I could weather the storm financially, but these guys were scratching to get by.

I started to have differences of opinion with my partners. Johnny and I were at each others' throats a lot of the time. I had hired him as my team manager for Underworld Element right out of art school, because he desperately needed money and didn't want to get a "real" job. I didn't really respect the creative input he was making from a team manager position, mostly appropriations of existing graphics or logos he would find. He had ideas, though at the time I thought they were more copies of other people's than his own. But he had style, and he was creative in other areas, though he was probably still finding his creative voice. I was much looser in my creative work, driven by the inspiration of whatever was going on in my life or what I was seeing on the street. Granted, I did come up with the Underworld On Wax series with Pang Starr and Cypress Hall, which was more of a conceptual tip of the hat to the cats that were inspiring me musically.

By age 21, I'd founded three companies, including my new clothing company, Zero Sophisto, as well as having my pro career. No one in the groups I'd initiated, either Urbanistiks or Mass Prophets, was making any real money except me and Jose Gomez, who was making money on the job I got him at New Deal. Jose was super rad, he just pumped out drawings, but he hated the strife at Urbanistiks because of everyone's money issues. He just chilled with his girlfriend after work so we rarely saw him. Kinz was broke, Johnny was broke, everyone was complaining, everyone was arguing. It was ridiculous.

We all had agreed in the beginning to split the rent of the studio according to the real estate we were using. So it was more of a collective than a single company. Johnny lived there, so he paid rent for his loft plus working space. I had used Sophisto money to help pay the landlord for improvements already. Sophisto and Velocity paid a huge part of the rent, and the others were relatively minor contributors. Every time the challenge of money would rear its head they would revert to me and say, "Andy, we need this, we need that, when are you gonna get it for us?" I ended up being really bitter. I'd always had my own money from my skating and art, so in their eyes I was rich and it was my responsibility to cover everything. I had the money, and did end up covering a lot of it, but I hated being used. And everyone wanted a piece. To them the bottom line of responsibility was negotiable, and to me it just couldn't be. We *were* partners after all.

The thing was, all the people I met in my own financial situation, except for Dallas, were completely stale and boring, especially the girls. Girls were often initially attracted to me

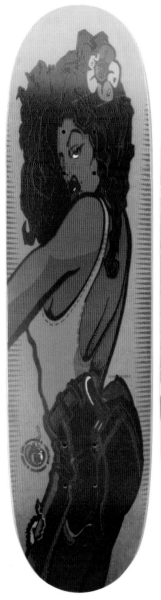

a fly by night goldigger tryin' ta get paid on what he made finds the grift and a facelift ain't gettin' her the free gift!

ELEMENTAL FILM GROUP PRESENTS

TO CATCH A THIEF...

a film by Andy Howell

urbanistiks

OK. FREEZE !!

IBASETA UNDERWORLD

because of all the crazy shit I was into and had going on. They would see my passion and get drawn into it. But it was never too long before the reverse started to happen. My girlfriends would inevitably become jealous, and resent the attention I was giving my projects or art or skating, and really there just weren't enough hours in the day for everything. So the relationship would suffer. Sometimes I would ease up on working on things for a while, and start hanging out with the girl more, but I would always begin to get depressed, and have to start working on things again at my normal pace. I'd start to resent her for putting me in the situation that in reality I had actually created. Then came the fights, because there was basically this ménage a trois between me, the girl and this third party which was a culmination of all the things I was working on.

It was confusing, because I was just doing the things I felt passionate about, and I couldn't understand why that would become a problem. Didn't she have something to do, damn, something to occupy her time? But it just isn't normal to work the way my friends and I liked to work, so consequently many great girls got kicked to the curb. It was the same in relationships with friends, unless they were part of the projects and brands that I was working on. People would come in and out of my life, because there just never seemed to be enough time. I always reverted back to hanging out with my skate buddies even though I was simultaneously separating from them, too, by the fact that I was kind of chillin' money-wise and they were all struggling. It sucked, because I was again trapped in the zone of the in-betweens.

In retrospect, having run and owned different companies since then, the downfall was that I had this utopian vision of everybody being equal partners with no one leader. But if there isn't one person in charge, it becomes a hodge-podge of egos, all scrambling for a chance to steer the ship. And none of us really knew the final destination, we were once again making it up as we went along. With Urbanistiks, I wanted everyone to be equal partners and to share in equal responsibility, though no one really had the experience to handle it. I shouldn't have stepped back as the leader, though I really wasn't in the place to do it, for sure, and those guys weren't even close to it, having just gotten out of school. But we still made some pretty rad shit happen, so for me it was a great experience overall.

Andy We had all this opportunity—four of the most creative people in the whole skate-art culture, who all ended up having major impact on the industry to this day. Jose started ill companies in skating and shoes and motion graphics, Kinz having such a huge influence with his illustration style and Blk Mrkt, and Johnny later taking over Element and growing it to the largest skateboard company in the world. But we were too young and cock strong and naïve to really make it work together. And maybe I wasn't secure enough in my own skateboarding fame, or my art, or where I was in my life, to be that person to just be unwavering about being the leader. I was looking for validation from my peers at the same time as trying to rally the troops.

Dave Kinsey I think Andy rebelled against his own success in the skateboard industry at a certain point. I went to his house one day, and he was throwing away all his graphics. I was like, "What the hell are you doing? You're throwing away original pieces of artwork!" And he goes, "This is bullshit, I don't want this crap! It's just skateboard graphics and I don't want it anymore." He was stuffing it all in the trashcan. When he went out of the room for a minute, I grabbed a bunch of it and stole it. He was rebelling against it cause he'd done so much of it. He wasn't attracted to it personally anymore and wanted to light the whole thing on fire and move on.

Andy When the record deal with Dallas was slow to come through, I bailed on my lease on the Urbanistiks warehouse and packed everything up and moved to San Diego spontaneously—I decided to do it on Thanksgiving of '93, and landed in Oceanside at Ted Newsome and Chris Markovich's house on New Year's Eve, with a 28 foot U-Haul, and my Jeep and hot tub in tow. That's how we always did it. Nothing ever held us down.

I set us up in a house in Oceanside on the strand. It was me, a production manager I had hired named Matt and his girlfriend, and Johnny and his girlfriend Heather. I paid the down payment and we all shared the rent. I had been out scouting for locations before we moved, and I found a warehouse/office in the Palomar Airport road area in Carlsbad. It was on 2131 Las Palmas Drive, between Planet Earth and eventually Rhythm Skateboards—home to Chris Miller, Jose Gomez, and Felix Arguelles—and Droors, which was home to Damon Way, Ken Block, and graff artist Persue. There were a few other brands around, I think XYZ was there, first with Tommy Caudill and later his partner Danny Way owning it. The Palomar Airport Road area was becoming the SoCal hotbed for action sports companies, and TransWorld was right around the corner in Oceanside. I was like, "Okay, it's on. These guys are thinkin' like me out here. This is the shit."

But pretty soon Paul and Steve started telling me I was spending too much time on other projects like Zero Sophisto. I felt that the brands could all compliment each other, but they gave me a formal warning to decide what I wanted to do and they demanded I "clean up" Underworld Element. In

comparison to New Deal, it had a much smaller audience. To me that was always the point—it was a very niche company. But they felt it was too underground, too far from Middle America, and that sales should be higher. To them it had niched itself into a corner. It was sort of like a Zoo York or something back then, way ahead of it's time, before the urban skate crossover became a mainstream trend.

So I decided to change the name to Element, an idea I'd had since the beginning in Atlanta anyway. I knew it was a hardcore move to start such a gangster style company, so I had always imagined it would eventually split into two companies: Underworld would remain underground, and Element would become a cleaner, more mainstream version. But they wanted to get rid of Underworld altogether. I did a single-page ad with Pepe Martinez and new additions Andy Stone and Billy Pepper, and had them each do their tricks on one spot on a curb. Pepe was doing this super stylish kick flip over the curb with his hands in his little signature Pep move, Andy did a 360 flip or an impossible, and Billy did a high kickflip. Pepe's friend Dave Schubert from Washington D.C. took the picture of them from below, so they were looking down. I wanted it to feel completely lighthearted. Everyone was joking around, their arms around each other. The tagline was a quote. "Skateboarding is about hangin' with your friends and having fun." Although I had done two other ads and put out stickers already using only the name Element, that ad marked the monumental turn from Underworld Element to Element. Instead of the hardcore urban videos, I then came out with a cleaner and more upbeat style for the Fine Artists Vol. 1 video, and got new am and pro riders for the team.

Even though I was kind of halfhearted about the company after having to make the changes, I still wanted it to have that vibe of skating that's always driven me: to be super creative, stand out from what everyone else is doing, and always be doing something new. The Fine Artists Vol. 1 video connected the idea of skating with creativity again, and I decided to focus on that as the alternative to the hard-ass marketing I was doing previously. That video really stood out for the amazing part from Pepe Martinez, rest his soul, to this day one of my all-time favorite skateboarders ever. Pepe devastated Pulaski Park in it, he had a switch kickflip backside 180 down this set of eight stairs, caught it way up in the air, and landed it going forward. And finally, as I knew would be the case, he was skating faster than anyone around doing super tech and big stuff.

We did a whole series of ads after I dropped the "Underworld" from the brand's moniker, and they were received with mixed reviews. Maybe the hardcore people I had attracted before thought it was selling out, or just too soft, even though the skating was always respected. It's true that the Underworld vibe had kind of backed me into my own corner, it was an idea ahead of its time as usual, and the energy I was projecting had been bringing some rough types of people into the mix. It didn't please Paul and Steve to have Julien Stranger onboard. He was one of the raddest all-around skaters, but to their minds he and

the others were too hardcore to have anything to do with the New Deal brand and Giant Distribution—which was the umbrella company we set up to contain the different companies. The partners were *always* hassling me that the level of skating in the footage I was getting from my team riders wasn't up to par, but I kept telling them for me it was as much about covering the lifestyle as it was about the number of stairs they were throwing themselves down. Soon both Pang and Julien left the team, and I was a bit frustrated. I was already feeling jaded when it got worse: I had to fire a few of the remaining skaters on my team at Paul and Steve's request.

I decided to bail out for a few weeks to Costa Rica to surf and clear my head. Johnny and a few others came out to meet me along the way, and it was during that trip that my frustrations came to a head. Being in a world where there were no trends and no skateboards and no art studios, only surfing and fishing, took me back to being a kid. It made me want to express my true self and take risks and not compromise. And being there crystallized the tensions I was having with Johnny. He'd never been as adventurous or dangerous as me; I considered him a little too soft. Surfing together somehow highlighted our differences—I wanted to paddle out at these random gnarly breaks, and he wouldn't even get in the water. His experience level wasn't at a place where he felt comfortable. But I was having these moments of clarity that I had to keep moving forward and pushing myself to the next challenge, and there were these lead weights attached to my ankles. The weights weren't just him, they were anything and anyone who ever tried to fit me into a box I didn't want to be in. I was seeing the situation more clearly there than I could've back home, and I knew I didn't want to work with Johnny or even be around him anymore. And it was surfing, the thing that I had been doing since I was about eight years old, the thing that had attracted me to skateboarding in the first place, that gave me that feeling that things were coming full circle and maybe it was time to get out of the skateboarding industry altogether.

Douglas and Paul had already said to me, "Look, you've created all these things. What's up, what do you want to do?" But they'd added a qualifier to that, saying, "We'll want to buy you out of the company if things don't change." The timing was appropriate in a way because I thought I was ready to get completely out of skating. I still loved to skate but I was starting to be more interested in design, using the computer, doing photo shoots, and art directing. I started to have the feeling that maybe it was time to move on and do something different.

When we got back from Costa Rica, I went up to New Deal to meet with Douglas and Paul. I offered to sell them my shares of the company, as per our contract. I was done with it. This isn't why I had gotten into this game. I just wanted to concentrate on design and push Zero Sophisto forward. Meanwhile, Johnny came into the office at Sophisto and said, "I can't take it anymore, I'm outta here, I'm quitting Sophisto, and by the way I'm moving to Costa Mesa to work at New Deal."

I knew that all along he must have been talking to Paul and Douglas behind my back, this guy who I had sponsored and hired at New Deal, and been in this movement of Urbanistiks. I felt like I got done really bad, because I'd worked so hard to build a way of working at Urbanistiks that was based on creativity, excitement, and shared inspiration. Suddenly, I felt backstabbed, and it all seemed to come down to money and personal ambition. It was one of the worst points in my career.

Johnny Schillereff I had been Andy's apprentice, more or less. When he left, I had to pretty quickly pick up the pieces of the core part of the brand, which was Element. I didn't like the whole mafia tone of the "Underworld" part. Because I was—and still am—Mr. Positive, Mr. Let's Spread a Good Message. In actuality, what Andy was doing then was totally what *Jackass, CKY, Viva La Bam* does now. It was pretty gnarly.

Andy I was in a different place back then than Johnny. He considered himself Zen, but I thought it was fake, he'd roll his hair into dreads and be trying to twist this white-boy hair into plaits, chewing on a root while listening to Bob Marley. We used to call him Schilly Vanilly back then, and I am sure he had much worse names for me. Ultimately Johnny did a great job with Element. He had a vision and it was palatable enough for a skateboarding culture that was ready to become mainstream. I am glad that Kinz, Shep, Jose, and all

the cats I collaborated with got to shine on their own, and I'm glad Johnny got the chance, too. Everyone deserves that, and man, what an experience that must have been. I told him recently I'm glad he did it because I could have never worked on the same company, with the same people, for over ten straight years like he has.

In retrospect I am accountable for creating my own reality, of course. I was stressed, I am to this day very controlling, and often times it doesn't vibe well with people, even other creatives. It's funny to look back at how we get all twisted over the smallest things, when in reality we are all these powerful loving beings with so much to share emotionally and creatively with each other. It's the plight of the romantic artist, I guess, that these intense personal relationships become so volatile. The rift with Johnny ran pretty deep. But still I think we were "connected" on a different plane. Or else he never would have entered my whole sphere.

From a financial standpoint, me bailing out of Giant Distribution like that was a completely stupid move. It was an established company that was growing and I owned a third of all of the combined brands of 411, New Deal, and Element. But money has never been the driving force behind my life. Yeah, everyone likes to make a living and not have to worry about getting by, but I hadn't worried about it up until that point, and I couldn't see having to worry about it in the future. So boom—I sunk all my money, energy, and every waking minute—into Sophisto.

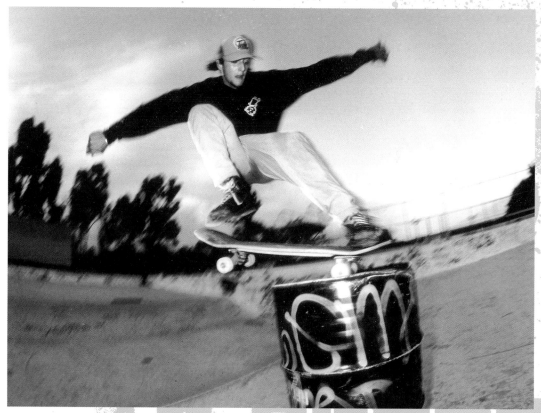

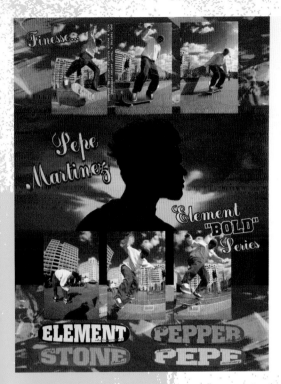

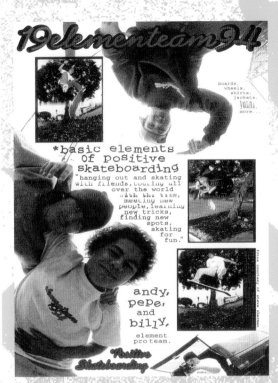

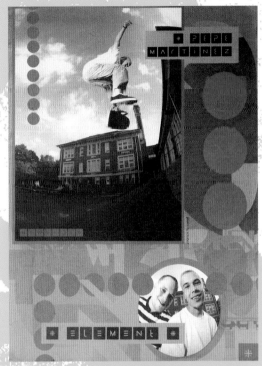

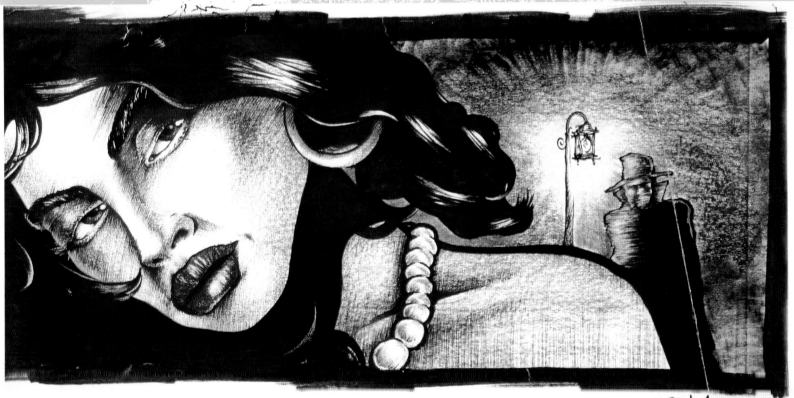

previous spread: *Underworld Element Models for Chris Hall, Andy Howell, and Rick Ibaseta, Various Artists circa 1992-1994*

this page from top:
Element Ads for Pepe Martinez, Andy Stone, and Billy Pepper circa 1992-1994
I'm Being Followed 1994, Ink and Colored Pencil on Paper, 20"x10"

UNDERWORLD ON WAX

BOARD

UNDERWORLD ON WAX SERIES

CURTIS BLOW
L O N D O N

CURTIS MCCAN "CURTIS BLOW" MODEL WITH SOME U.K. TWISTS TO IT. BE ON THE LOOKOUT FOR HIS "COMING TO AMERICA" MODEL IN THE FUTURE...

PANG STARR

THE HITS JUST KEEP COMING... PANG

©UNDERWORLD 1993

Q: WHAT THE F@©K IS U.E. ON WAX?

A: IT'S A BIG JOKE ON ALL THE RIP OFFS OF RIPOFF RIPOFFS. IT'S LIKE THE COOL THING TO DO, THE EASY WAY TO REALLY MAKE IT BIG. PEOPLE WERE SWEATIN OVER "HOUSE OF PANG" AND WE WERE LIKE, "THEY RIPPED THAT OFF FROM MICKEYS MALT LIQUOR, SO WHAT'S THE BIG DEAL?" SO WE JUST SAID F@©K IT, JUST DO IT, AND WE BUSTED THE COMIC LINE ON ALL OUR FAVORITES. BUT IT'S NO OFFENSE INTENDED, JUST HAVIN' SOME FUN WITH IT. AND THE (WOOD)SHAPES ARE PERFECT, SO F@©K IT...

CYPRESS HALL

CHRIS HALL IS WAY UNDERGROUND. HIS NEW BOARD FROM U.E. ON WAX SERIES IS "CYPRESS HALL."

SLICK RICK

THE NEW IBA BOARD FOR THE

Underworld Element Photocopied Catalog/Zine circa 1992

We had just started to used Typestyler and Illustrator to do graphics at Urbanistiks, and I really wanted our catalog for UE to feel like a skate zine from the 80's. So I photocopied some photos of team riders Daniel Powell and Curtis McCann, and I combined them with the graphics for the new boards and wheels.

We had just created the Underworld on Wax series, featuring Cypress Hall (Chris Hall), Curtis Blow (Curtis McCann's first model), Pangstarr (Jeff Pang), Sugar Howell Gang (Andy Howell), and Slick Rick (Rick Ibaseta).

DELIGHT." FROM THE WAY WAY BACK

ALSO LOOK FOR "LOVE CHILD" SLICK IN THE DISTANTLY NEAR FUTURE...

CONFRONTED HIS ANSWER WAS EXPECTED: "YOU SHOULDN'T HAVE DONE IT."

UNDERWORLD ELEMENT

COCK D
HARD ASS WHEELS

nibbles are made from some hard goving shit for face nite.

nf modules warn you to escape mod>>nistic mind comp by using your own.

MCCANN-ROLL MODULES-UNDERWORLD-CURTIS

daniel energizer wheels. keep going, and going, and going. 39mm.

spanish flies

WHEELS

AND THEN WE GOT LOTTA CLOTHES AND HATS AND MORE SHIT AND THE MAIN THING IS IT'S JUST WHATEVER WE FEEL LIKE AT THE MOMENT.

DANIEL POWELL—PRETTY MUCH LIKES TO STAY OUTTA THE PUBLIC EYE. BUT DURING A TRIP TO L.A. ORTIZ TOOK HIM TO THIS LONG LEDGE. HE SORTA. HAS AN OBSESSION WITH THAT KINDA SHIT, SO WE WERE LIKE MAN HE'S LIKE ENERGIZERS HE JUST KEEPS GOING.

AND GOING. AND GOING. AND GOING. AND GOING. AND

UNDERWORLD

CURTIS MCCANN (A.K.A. CURTIS BLOW), ENJOYING ANOTHER HOBBIE...

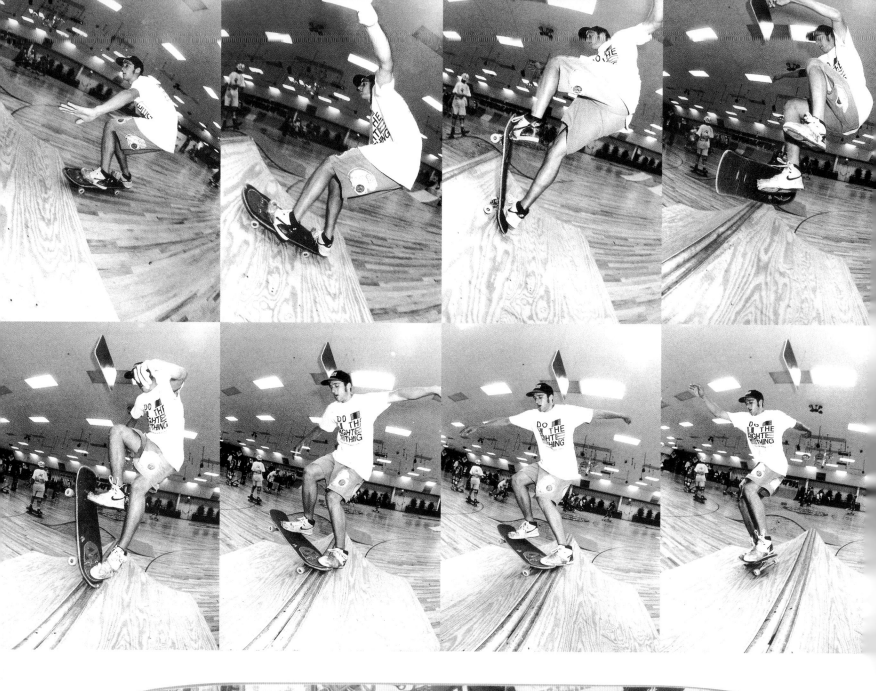

warning:

The skateboarders in this video
mutant byproducts of the system
creativi the req
limit in sly pa
excuses ve ma
to find t on o
n our ould
omple we
nders ou
egarded as garbage be c
ondoning their behavior wil
prosecuted to the full extent of the

PAL

SkyTel™
SkyPager®

warning:

The skateboarders in this video are
mutant byproducts of the system whose
creativity has gone beyond the required
limit in our society. Obviously pathetic
excuses for people, they have managed
to find complete enjoyment on objects
in our cities that we would deem
completely useless. Since we do not
understand them, they should be
regarded as garbage. Anyone caught
condoning their behavior will be
prosecuted to the full extent of the law.

CHAPTER 7
THE ANGRY ENTREPRENEUR

The Angry Entrepreneur

Sophisto, Girly Things,
Freedom Video, REN, and FBI

Andy All the while that I'd been building New Deal and Underworld Element, I'd been dealing with a lot of internal struggles. I was turning 22 years old, and the desire to impress my parents hadn't subsided at all. I felt an undertone of disapproval and lack of interest every time I would share news of new projects I was working on. It carried over into a need for validation from my peers as well. I was getting kudos within the industry, but since Mom and Dad didn't seem to care, no one else's words of validation stuck.

There were deeper and darker thoughts below the surface shine of skating, producing music, and having fun. After a few years of

living in Atlanta, I was angry. I was angry about getting fucked with by security guards and cops and businessmen while I was skating in the city. Angry about the deep-seeded racism around me in Atlanta, about the wall of prejudice and resentment between blacks and whites there. I could identify with the anger coming out of rap and the urban black population. I empathized because I could feel a hint of a similar unwarranted prejudice as a skateboarder. I was mad that the world looked at skaters and street artists—and basically anyone not working in an accepted institution of creativity—as totally unsophisticated. I thought, "Fuck man, all these people think of me as a full-on zero. What crap! We have our own language, our own terminology, our own way of talking and communicating that we've developed and you just don't understand it so you deem it irrelevant." People would jump out of the way if they heard my wheels rolling over the cracks on the sidewalk—I'd seen people literally jump into the

bushes. Society, as well as Mom and Dad I thought, only knew skateboarding as this horrible thing kids did.

I was disgusted by the racism I saw around me in the South. Skating is inclusive, it doesn't really have racism issues, but everywhere else I looked in my city, racism's what I saw. One time in particular, Kinsey and Base and Verse and all these cats and I went hiking. I had this huge yellow jeep with 34-inch tires and we were driving out in the mountains to find this gorge with a 100-foot waterfall so we could dive the cliffs. We went way far out and passed by this one corner with a homemade sign that read "Aryan Youth Camp" It was shaped like an arrow which pointed down an old dirt road, and I said, "What the *fuck* is going on down that road!" It was a KKK training camp, that's the kind of thing I was living in the middle of. I was like, "That can't be real. I've got to *do* something." So the art I started making reflected my experience of moving to a Southern city that was completely encased by racism, and the feelings I had from realizing how powerful that racism was made my blood boil. We were in Atlanta, which was a fairly modernized city in the midst of a complete redneck environment. That's one of the reasons we connected with people like Speech and Dallas, because they didn't fit in either.

Alyasha Owerka-Moore A lot of the things Andy did had really important social political commentary. It's a problem with pop art today, too many people doing stupid doodles that don't say anything. Whereas he was saying a lot from the jump.

Andy One day I sat down and drew this pissed-off character with a swollen head and an exclamation point on his brow. It manifested in a half-dream state as I had fallen asleep the night before. He had those Calvin & Hobbes-style evil eyes, the way Calvin has when he's doing something devious. I started to fine-tune it and think about who he was and why he was so pissed off. And basically, *he* was *me*. He was the guy who the world at large considered a big nobody. A kid who lived in this secret zone of the in-betweens. So I named him Zero Sophisto. I think the first time I heard the word "sophisto" was in *A Clockwork Orange*, when Alex and his droogs use it to describe some aristocrats during a scene at the Moloko Milk bar. I thought it was perfect, because the "sophistos" are these people in society's *accepted* institutions who just don't get it. They *think* they do, but they don't.

I realized Zero Sophisto was my alter-ego. I started making up a story about him: His mom is almost a homeless drug addict, who loves him but wasn't there for him, so he grew up on his own in the midst of the city. He took chalk and wrote and drew all the things he was seeing and feeling onto the streets, and in doing that he made all these commentaries on society. Zero scrawled his statements about racism and prejudice, and corruption cause by man's greed and

the worship of money. I'd seen the corruption of Vision up close and the bastardizing of all these cool things my friends and I were into. Brad Dorfman was the Antichrist to me at that time, so he became the symbol of the Corrupt Man and inspiration for all these bad characters I created for Sophisto.

Of course I was partly responding to the fact that, in my mind, everything I was doing was becoming really commercial. In a way I was being sucked into the same machine, because I had learned to use this channel of communication to get my message out there. New Deal was a super commercial company and even Underworld Element was basically all about selling product. As political as I was making my message, there was an irony in the fact that in order to get it out to all these kids it had to be marketed, sold, and distributed through these channels we had within skateboarding.

I needed some way to express the things that I was thinking about, and to work through some of these contradictions. It amused and inspired me to make polemical statements on clothes that skaters would wear, kind of commenting on and dissing the very industry we were part of. Because skateboarding had always existed in this mixed-up realm of rebellion and commodification—there was no way to escape it. I'd wanted to make skate teams full of anti-heroes in the past, kids who were not only the opposite of Johnny Touchdown and Biff the Baseball King, they were the opposite of superstar images created by corporations using the Gators and Hosois. Yet the anti-heroes soon enough became the heroes and sold more boards because of it and their lives would invariably change. The original spirit they'd had of skating with friends would inevitably always be affected. It left me wondering, "What is authentic? What is success?"

The first Sophisto design was this young kid shooting up with money. He was shooting up with a syringe filled with green fluid, and all these bubbles of green were crawling through his entire arm. His eyes were rolled back in his head. I wrote this subtext in his forehead, what Zero Sophisto must have been thinking, about money being the fork-tongued, omnipotent demon that everyone in society inevitably becomes addicted to. I thought it was hardcore to put it on a shirt, because these kind of statements weren't the most palatable for the general public, but clothing was another way to express my vision. I'd known T-shirts were a powerful medium since I made my very first New Deal shirts. Months later I'd been at a demo in the Austrian mountains where twenty of the 150 people present were wearing my New Deal shirt. It was astounding.

I started to see them as billboards to express all that little Zero was feeling. And the psychology of someone wearing a T-shirt that makes a statement is that person must believe in what the shirt says to walk down the street wearing it. So it was kind of like this little rebellion of people wearing Zero Sophisto shirts, and you could actually see sophistos on the street having visible and sometimes audible reactions to the shirts. One shirt showed a picture of Martin Luther King Jr on the front making one of his famous

speeches. In gold below MLK was a lower-case gold-lettered word, "prophet". On the back was a picture of him in jail, obviously paying the price of speaking out against Southern racial prejudice, and the word "martyr." Some people were enraged when they would see some white skate-kid in Atlanta wearing the shirt, but some people would cheer and be glad to see those racial barriers being ignored, even eroded, even if only by one kid in the midst of a giant city. And it caused people to ask questions, or make comments. At any rate people who never would have exchanged words at all were communicating about a subject that mattered.

When we bombed the Civic Yard in Atlanta, at the most, a few hundred people a day would drive by and see our work, and only for a split second. Many would not even understand it. But with the huge messages on Zero Sophisto T-shirts, that exposure was magnified, because I figured those four or five thousand shirts a month could each make a few hundred people stop and think for a second. And it wasn't just in Atlanta, it was all over the world, everywhere that the skate brands were being sold. It became global. There weren't really any other clothing brands for skaters, especially ones that were rocking any kind of conscious messages.

The computers we had back at Urbanistiks were Mac II Ci's with like two megabytes of memory. And before that at my house I was using a Mac SE, which had even less memory and RAM. You couldn't do anything with it, so all the designs were basically done by hand. At home in my bedroom I created this little Xeroxed 'zine that told the story of the Zero Sophisto character, then made a bunch of copies of it and took them out to Cali. I had done ten or fifteen designs in a three-day period the week before I went out to Costa Mesa. I just couldn't sleep. I did a shirt with just a big barcode and gold lettering that said "PRODUCT" on the front. I started seeing people with the Product shirt and other Sophisto designs in magazines, while all these skaters were wearing it around the cities. It was getting into people's faces and saying something so loud about life in a tight-lipped and prejudiced Southern society. That's why I kept Zero Sophisto there for so long and later ended up printing and shipping it all from there, because it was so intertwined with my life in Atlanta. I was supposed to be working on the next Underworld Element products but instead I showed up with this 'zine and said to Paul and Douglas, "Here's my new clothing brand." They were like, "What!" I'm sure they thought I was crazy. I was so excited about it. I explained everything, and I was so passionate about it and so complete in the vision that they were like, "Uh, okay …"

When I finally did move to Oceanside due to pressure from Paul and Douglas over the Giant brands, I got a house right by the beach and started surfing three times a day. I had a warehouse in Carlsbad for Zero Sophisto. Damon and Ken had just started Droors and moved into an office right down the same street. It got off to an amazing start. *The Face* magazine did a story on me and Sophisto, and then it was on Y'all So Stupid's album cover. I thought, "This is it! I can make a clothing company!"

Ted Newsome, Director, founder of REN, former art director of Transworld Skateboarding Magazine When Andy moved to California, he called me the day he arrived. I didn't know him that well, but we'd looked at houses before he moved and tried to figure out where he should live. So once he settled, we used to skate on our work breaks. We totally connected because it was the first time either of us had to make a conscious effort to get exercise, because we were both working so much and were getting older. We'd meet up in a bank parking lot in Oceanside at lunchtime, skate these curbs, and work up a sweat. It was super funny.

Andy On the one hand, Underworld Element had been an idea before its time. But that also meant that many of the people who followed what I was doing later turned out be the most cutting-edge and forward-thinking people around. That's the kind of people it attracted. So when I put all my energy into Sophisto and started making it into a kind of rebellious, politically conscious skate clothing line, the political T-shirts became a full-fledged clothing brand.

At first in Atlanta it had been just Ts, but after lot of pro skaters and sponsored ams started asking for the Ts and wearing them in the magazines, and since the Big Deals I had designed had become so popular, I knew it had to expand into more than just shirts. Some of my friends and I had always been into fashion, and I was always soaking up any new knowledge I could about how that industry worked. Through my friendship with Victor Chu, who was one of the head designers at Pepe

Jeans, which had been acquired by Tommy Hilfiger, I'd watched how the hip-hop market had adopted these kinds of labels. I was intrigued with the possibilities of making a clothing brand for skateboarders that could cross over into the hip-hop market.

All of it seemed so synergistic to me, because of my experiences in Atlanta, so I flew out to New York to visit Vic at the Hilfiger offices in central Manhattan. While I was there I really started to see the bigger picture of the fashion industry. It was massive in comparison to the skate industry! Vic introduced me to Andy Hilfiger, who had been the conduit for the Hilfiger sponsorship of a lot of the big hip-hop celebs of that time, including LL and a bunch of the Def Jam heads. There were pictures of Andy with all these cats all over his office walls. I thought to myself, these guys are seriously just latching on to the culture of hip hop, they don't even know what's up. I've been living that shit for most of the last decade, there has got to be a way to take Sophisto, a brand that already speaks the language, and cross it over into skateboarding *and* hip-hop!

Yet I was also facing a challenge within skateboarding culture. I was no longer an owner of a hard goods company, and at that time you were not considered an authentic skate brand unless you made decks and supported a pro team. I wanted to be different, I wanted to make a statement, both with the designs and the fact that I purposely never made Sophisto decks. I was challenging myself to see if this clothing brand idea could stand on it's own merit. The first pro shot in editorial that Sophisto ever got was John Montesi doing a backside five-O on a rail, and I was so stoked because it gave me a much-needed stamp of validation within the industry. I made some DJ Transporter bags and added them to the line, and they started to get into magazines like *Vibe* and *The Source*. Sophisto was starting to cross over to a true hip-hop audience, a move no skate-oriented company had done up to that point, except maybe a brand new hard goods company from New York called Zoo York, which had been started by Rodney and Eli from Shut Skates.

I ended up making a really cool video, *Freedom*, along with Ted Newsome who was art directing *TransWorld Skateboarding* and had a T-shirt line called Racial Equality Now (REN). It featured a team of skaters that was even better than the Element team. The riders weren't necessarily better, but now that I wasn't attached to a hard goods company I could sponsor anyone from any board company without any conflicts of interest. A skate clothing company was a new concept then, and even confused some of the people I asked to skate for me, who asked if they would have to leave their board sponsors in order to skate for Sophisto. My team riders, John Montesi, Jamie Thomas, Josh Kalis, Stevie Williams, Aki Nishimura, Pepe Martinez, Julien Stranger, Chris Hall, Ryan Bobier, Kenny Hughes, and Karma Tsocheff were some of the most innovative skaters out there. They were all amazing in their own way.

John Montesi was my first rider, he'd supported both Sophisto and New Deal from the beginning. He was an awesome kid, really talented—and an East Coaster so he was unassuming and very down to earth. These days he has a skate shop in Florida.

Then of course there was Pepe Martinez, who really blew my mind. A real smooth operator on a board, for certain. I would watch Pepe in any situation, skating or not, and he was just smooth, a kid from Virginia just outside D.C. I'd first seen footage of Pep skating way back in the day—Chris Hall had told me about him and Ali Mills—and they both only needed about ten by ten feet of ground because all they did was appropriate freestyle tricks and turn them into flat ground street tricks. The first thing I saw of Pepe, barely putt-putting along, doing a 360 kickflip, 360 body varial, made me go, "Come on, dude, that's not even possible!" I wanted to sponsor him for New Deal, and Douglas immediately was like, "No way dude, don't put him on, he's not even moving!" I was like, "Douglas, he's gonna be the illest, he just doesn't have any power yet." Creatively I was thinking, this kid is insane, but he was barely moving when he did tricks. Well Douglas finally gave in and let me put him on Underworld Element. Chris Hall had been skating kind of slow too when I had first sponsored him for New Deal, but man, he got a fire going the next time around and he had one of the most forward-thinking video parts for that time period. I knew Pepe was gonna be the same way, and it was no surprise when later for the Element *Fine Artists Vol. I* video he was hauling ass, busting Switchflips to tailslides, switch backside 180 ollies over benches, moving really really fast.

Learn About Each Other

SOPHISTO

JOHN MONTESI
CRAZY SKATEBOARDER

SOPHISTO
CLOTHING CO

FINE HAND TAILORED GARMENTS

Charlie TRADING CO.,LTD. 03-3402-9622

FREEDOM

JAMIE THOMAS
JOHN MONTESI
AKI NISHIMURA
JOSH KALIS
PEPE MARTINEZ
LABAN PHEIDIAS
JT PULFORD
MELVIN REYNOLDS
TABIAS WALKER
CHRIS LAMBERT
DANNY CROOM
MATT MUMFORD
IAN ROSS
FRANK HIRATA
KRIS MARKOVICH
JASON MAXWELL

USC

ROCK'N'FILM PROJECT
Freedom

25 September 1995

Dear Freedom:

Would you please send us a review copy of Freedom for our Rock'n'film collection. This will be used for research and study purposes only, and will have no circulation outside the classroom. Thank you for your consideration.

Sincerely,

David S. James, Professor and Chair of the Division

But it was the little creative elements that I liked about Pep. One time he was visiting me in San Diego, and we went out skating at this high school. We hit the benches and ledges, but there was this one time where Pep started looking at the wall at a weird angle with his head a little cocked. He skated up to the wall, kind of beside it, and did a huge nollie up toward the wall, turning a little backside so his back was to the wall. He had put his front foot off to one side of the nose before he nollied, and it made his board quarterflip 90 degrees in the air while still on his feet. All of sudden he was in a wallride about two or three feet up the wall. He had done a backside nollie into a wallride way up this wall, and he just rode out of it perfect. I go, "Pep, what was that all about?" He just kind of smirked a little bit and said something like, "I don't know dude, just saw it like that." It was the way everything he did looked, like he was in a constant state of innovation, even in the middle of a trick.

Billy Pepper had started skating for me for Element when I made the change over from Underworld, and he had a very clean image, I thought. He was really short, but man could he snap an ollie or a kickflip, it was really pretty, especially in a bank or park environment. His part in the *Fine Artists* video had been really good, and I had used the Steve Miller Band's "Fly Like an Eagle" for his video part. And boy did he fly. I liked Billy, despite what

I perceived to be his ass-kissing tendencies back then, he really wanted to fit in to the Element team, but I don't think we ever really connected in any way other than our love for skating.

Aki Nishimura was my Tokyo connection—a local pro in Japan, and a really cool kid. He has a part in the *Freedom* video where he's just flowing through downtown Tokyo, tagging walls, in a hip-hop club, skating through all these rad spots. When I was editing his part I really had a good time, he was very alive and vibrant for a Tokyo kid. And he had really good style. I knew he was destined to remain in Tokyo forever, but I liked the idea of having a rider there who was holding it down, because there were a lot of up and coming kids, and Japan was starting to develop its own identity in skating. I think the seeds of creative inspiration for Japan had also been planted by the U.S. and Europe by then, and Tokyo-based kids were starting to come out with some really creative stuff. This led to the design revolution there: deejays like Honda and clothing dudes like Nigo of Bathing Ape were starting a pop renaissance thing and Aki was right in the middle of all that. I was inspired by his whole scene.

Aki also spoke English really well and one time I had him sit in my office while my Japanese distributor came in to preview a line. I wasn't fond of the distributor's wife, and I was sure the feeling was mutual, so I asked Aki to say "hello" in his best American accent and listen to the conversation in Japanese. Every time I spoke she would say something to him, smiling at me but in a very sarcastic tone. Of course I had no idea what she was saying to her husband. So I just smiled and did my song and dance with presenting the line. Later Aki told me everything, and my

suspicions were confirmed. She was calling me an arrogant bastard little kid, that I knew nothing and why didn't they just leave. It was funny. Aki and I laughed about it for a long time after.

The Sophisto team was kind of headlined by Jamie Thomas, who was getting coverage in So Cal like nobody's business at the time. I'm sure I was one of the first sponsors he ever had. Jamie had gone up to San Francisco and camped out early on and just skated super hard. He was really competitive, with himself mostly, I think. He may have rubbed some people the wrong way up there because he had gotten a rep, people weren't too stoked on him. Some of my friends up there were like, "That guy's wack, he's this, he's that." But when I saw him skate I was amazed. He had an ethic to his skating that was religious and relentless, which is why he ultimately became successful. His raw talent was incredible, and he was able to learn anything, master it, and film it from every angle within a single day.

At this time skaters were taking basic tricks and adding stairs and rails to them. There was no technical advancement happening, but there was definitely a burliness to it all that was impressive. Jamie was a lot of both, totally fearless. He could do any tech trick and any big trick. He had great 360 flips. And he was concerned about his style and appearance in pictures and videos above all. He was jumping around with his personal style, finding himself, I think. He would shave his head and eyebrows and show up bald, then grow his hair out shaggy. He looked different all the time, although the shaved head thing lasted a while.

I invested my support in him and his skating from the beginning. He skated for Sophisto, posed for my product shots, and was incredibly helpful. I always liked him. At the same time he was always restless, and was going through board sponsors like crazy, it seemed. He probably kept thinking the grass was greener. He never ceased to amaze me with his photos in mags, interviews, and parts for the *Freedom* video, or even his ads for me—the roofgap ollie was beautiful. He was competitive with himself mostly, which made him super rad to watch and harmless to skate with. Like skating with Markovich back then, who totally ruled and was a nice guy. And Jamie filmed nonstop. He was determined to make an indelible mark on skating, and he did. One day he called me up and said, "Andy, I am gonna start a board company, and I was wondering if you would mind if I used the name Zero?" I guess he was inspired by Zero Sophisto, or maybe he was just feeling the same way I had back in the day and it fueled him to create the name. It didn't matter, he seemed inspired, and I totally appreciated his respect, I said "Fuck yeah, dude, go for it!"

Julien Stranger had skated for me with Underworld, and so he agreed to skate for Sophisto. Of course I was honored, he had been one of my favorite skaters since the first time I saw him skating the old quarterpipe in Venice years before. He was into the edge of Zero Sophisto, but when it started to reach a level he deemed too commercial, I think he just lost interest in it. Julien is the definition of underground. It's not even his choice, it's his inherent nature. He was the guy who would come up to a spot and seriously blow away anything done before with a lightfooted style that made it seem his feet were only loosely tied to his board, yet as if he never doubted they'd find their way back into position before he landed. He was graceful, but in the most street sense. Julien was way ahead of his time, a near equivalent to Gonz in many ways, I thought. I remember him doing a 180 pop shove-it at the Savannah Slamma and it was when everyone else was barely doing flat shove-its. He popped it right over an old tire and just kept going. He always skated so fast.

One time we were in Florida on an Underworld Element tour and Chris Ortiz was driving the van. We went to the famous Burdine's spot, which was a complete bust. You ollie up a curb and then there is a ten-foot perfect transition of bricks up to a wall. Julien got out of the van like he was starving to get to the bank. He dragged his board running toward the bank, jumped on, ollied up the curb, and ollied a gap across a door the first try with ease. It was

starting to get dark outside, dusk was falling. Within a few minutes he had Ortiz pulling him at like 35 miles per hour toward the curb and the transition. I think Pang was announcing the speed as it increased on the approach. When they hit 35, Julien let go of the open door of the van and effortlessly ollied up the curb, almost immediately hitting the transition. I think he bailed the first ollie but he got up and did it again, and he just floated it for days. Landing with his patented lookback style, he cruised off into the darkness. Ultimately Julien is the quintessential "anti-hero" so when he ended up finding his home at Deluxe and AntiHero instead of skating for my team, I wasn't offended in any way. I think it was just natural.

Sophisto was on fire at this point, it was around '94 or '95, I couldn't make enough stuff at all, and my team was better than most board companies at the time. I did an ad with some of my riders when they were in town for a trade show in San Diego. We went out and casually filmed some 8mm-looking stuff for the video, and then I took them over to Balboa Park to this huge tree I used to walk by every day. There were branches for every rider and I had them all climb up in the tree and look down at the camera for the shot. Some were not into it, but as per normal, I couldn't be persuaded otherwise. We got the shot, and that ad is one of the best reproductions of my vision of what a skateboard team should be: a tree, a family, people who inspire each other and are attracted to skate with each other for similar or complementary qualities. Of course it probably wasn't the case at all, but for a split second in my mind it was perfect, and I still think of that today.

Ted Newsome We decided to make the *Freedom* video as a promo piece for our companies, Sophisto and REN. We had no idea at all how to make videos. Andy bought the equipment, and I'd go over every night after designing *TransWorld* all day, and we'd cram, just figuring out stuff and experimenting totally DIY style. We would just geek out and do it all night long.

Andy We were cutting and pasting a skating 'zine together but with moving pictures, color and animation, and creating new animations by exporting film strips on photos and adding textures in Photoshop and importing into Premiere and making these animations, it was another creative element we wanted to master. That's the blessing and the curse of being driven creatively. You can't come up with new stuff if it's got to look the same for a decade, so that you compete with Tommy Hilfiger. I

never could have done a blue square and a red square next to each other for ten years.

Andy The image behind Sophisto was changing from being this super political vibe to, "Shoot, now I'm living in a beach town again. So much of my stress in Atlanta was caused by my reactions to the environment there. There's no socio-economic pressures here, it's a white bread paradise. Guess I could just relax a minute now." There was no longer an immediacy to the weight of all the political causes I was carrying on my shoulders. I started to let go of my anger, and channeled it into my surfing, where I was communing with nature. This natural expression and release was making me feel much better about life and myself. And after being inspired by friends like Vic Chu in the fashion vein, Sophisto started to become a more style-oriented brand, not just political T-shirts. The brands that were crossing into urban a little bit—Hilfiger, Polo and that kind of thing—also influenced me a bit. I said to myself, "Sophisto is going to be one of the first clothing lines made for skaters." It'll have everything functional for skaters, stuff for the super stylish skaters and the punk skaters and the hip-hop heads too. I'm going to make it universal so everybody can be into it. I learned how to design clothes and do ad shoots with models—it was just the next level of creativity for me.

I had always been into fashion. Back in Atlanta, I used to wear suits to nightclubs because I listened to 3rd Bass, a sick Def Jam group that was basically two white kids, Serch and Pete Nice. Pete Nice was the old-school guy who smoked a cigar like the '40s and '50s gangsters I was into at the time. He had a cane and wore a pimping suit. When I had made some money from skating, I went out and bought a two-thousand-dollar Armani suit and started rocking it to every club when I'd go out. Graffiti writers would come up and go, "What is up with you?" and I'd be like, "It's the stilo dude. Don't sleep."

That was the feeling behind everything, if I was feeling it you couldn't convince me otherwise. I got into clothing and fashion design thinking, "Could I do the same thing with designing clothing that I did designing skateboards? Could I take clothing and make it the way I wanted to feel and the materials I wanted?" I started learning about stitching, yokes, fabrics, and how to cut my own patterns. I was learning to be a clothing designer. I met and started to form a real friendship with Damon Way, who had similar views on life and fashion, and he and his partner had just sold 8-Ball clothing and started Droors.

Businesswise, I was on my own again, and a wave of relief and excitement started to come over me. Sophisto was going off, and though our shipping left a lot to be desired, it was all coming together. It grew to being a full men's line with 40 pieces in it. My distributor, Charlie Trading in Japan, was growing the company and our sales crossed 1.5 million just after the first quarter of the second year. I only had a few employees and I was making money, and Charlie was really supporting the brand in Japan. He'd ask me

about Damon and Ken down the street, because he knew they were my friends, and he would later become their distributor too when they started DC. He was always pushing me to make more product, do more lines, expand the lines, so I was stoked to have that support. And sales were booming.

Shepard Fairey At the trade shows, I'd be there in my tiny corner with a few of my Andre the Giant T-shirts, and Andy would be there with his cute rep and get stacks and stacks of orders for Sophisto. He'd be like, "Hey Shep, let's go out to dinner, how 'bout this place?" And I'd be like, "No, I can't afford it." He'd offer to pay but I'd have to say, "I'd love to go there, but I'm not going to have enough gas to get home if I do."

Andy Droors was around the same size then, and since we were friends and peers, we would hang out and share ideas, which of course is heaven for me. Persue was rocking all the graphics, and Ken was directing him, and Damon was designing cut-and-sew stuff. They had two little offices and a warehouse. I remember walking over one day, and Niko Achtipes was standing outside in the parking lot of the Droors office with Ken and Rob Dyrdek, up against a white van. Rob was smoking a cigarette. Niko said, "Okay, do it," and I think it was Ken who poured blue paint all over Rob's head while Niko was shooting away with a motor drive camera. Rob was bummed, he couldn't stop complaining, with fucking housepaint in his hair and probably never coming out of his skin. I thought the color was great while they were shooting, but didn't really think the idea was so strong. But man that ad really made a mark for Droors, and for Rob, I think. It became a benchmark for anyone advertising in the space.

One day I came over on a lunch break, and Damon pulled out a new product I hadn't seen them make before. It was a navy-blue corduroy Droors lowtop shoe, basically a knockoff of a converse Chuck, and he said, "What do you think about this?" I was like, "This is rad, dude, how did you make it? *Where* did you make it?" He was very secretive about it, and had that Damon smile, the one that says, "I know something you don't." I think about six months later they announced the launch of DC Shoes.

Soon I started a girls' line called Girly Things. I could see that there really wasn't anything out there for girls who hung around with skaters or surfers. I saw a growing void in the marketplace that I knew was a great opportunity for me. Girls who hung around would wear the guys' clothes, guys' big T-shirts. I felt, "Man, they need their own stuff, their own brand. Stop wearing your boyfriend's cast-offs please! The day of the skate betty has to come to an end here!"

Shepard Fairey At that time I was suffering back east in Providence, R.I. I was totally poor and so frustrated I almost bagged it all and got a job. But the thought of accepting defeat and admitting I couldn't make it as an artist irritated me so much I wrote a list of things to accomplish. One of them was: "See if you can find a

INDUSTRIAL JEAN MFG./U.S. DENIM LABOR UNION N° 12351

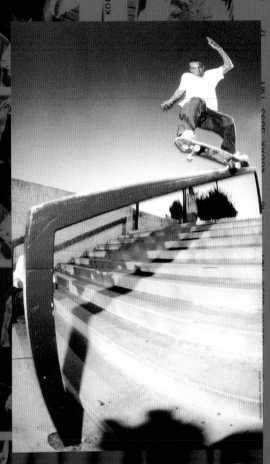

SOPHISTO

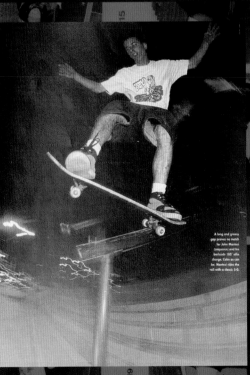

this page and following spread:

Ads and Editorials featuring Sophisto Team Riders circa 1993-1995
Since many sponsorships were tied to board companies at the time when I started Sophisto, many of the riders were confused because the only clothing companies in skateboarding that weren't owned by a board manufacturer were Sophisto and Droors. I was able to sponsor many of the top skaters, because there was no conflict of interest. My team included John Montesi, Pepe Martinez, Jamie Thomas, Karma Tsocheff, Billy Pepper, Julien Stranger, Aki Nishimura, Josh Kalis, Stephane Larance, Jimmy Chadwick, Vinnie Ponte, Jeff Pang, Kenny Hughes, and Chris Mountjoy.

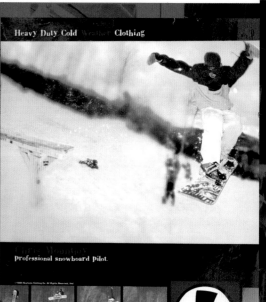

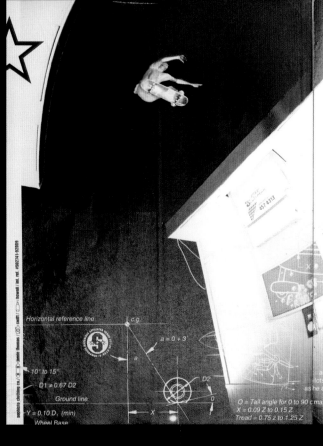

Horizontal reference line c.g.

$a = 0 + 3$

10° to 15°

$D1 = 0.67\ D2$

Ground line

$-Y = 0.10\ D,$ (min)

Wheel Base

$O = $ Tail angle for 0 to 90 c max.
$X = 0.09\ Z$ to $0.15\ Z$
Tread $= 0.75\ z$ to $1.25\ Z$

FREEDOM

 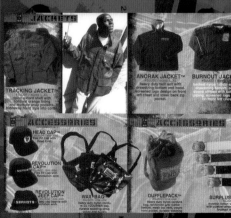

ZERO SOPHISTO
4043773900
P.O. BOX 5303 ATLANTA, GEORGIA 30307

FULL JOHN WINTER COLLECTION

SOPHISTO

ONE EARTH

quest takes a retro trip to the love age in a denim 'floppy style' cap.

menelik and thomas conducting currents

in 'chinos' pants, 'communi-cator' jeans,

and the 'vicious circle' shirt.

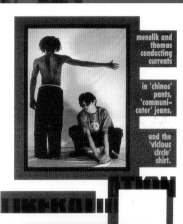

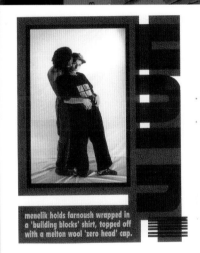

menelik holds farnoush wrapped in a 'building blocks' shirt, topped off with a melton wool 'zero head' cap.

lynn backs up thomas with a 'bombhead' shirt, while he hangs in a 'broken chains' design.

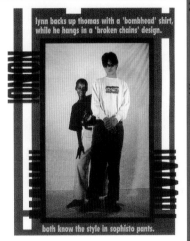

both know the style in sophisto pants.

TO CHANGE

johnny quest crouched in a 'jean shirt' while scotty keeps watch

in a 'free your mind' shirt and a 'zero head' cap. 'chinos' pants also to buck the system.

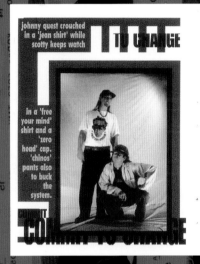

COMMIT TO CHANGE

farnoush contemplates on it all in a woolen 'bar logo' cap...

TRANSCEND

thomas mellows out in a 'zero head' soft embroidered sweat,

KEEP

while menelik packs his bag for the high road...

FIGHT

scotty-boy kickin habits in a 'zero head' melton wool cap and a 'free your mind' shirt. johnny quest stayin low in nothin but an 'american dream' skinny beanie...

menelik packs his dreads into three skinnie beanies: building blocks, american dream, and exclamation.

ABSTRACT

AD: **Andy Howell**
Video: **David Kinsey**
Agency: **house**, Carlsbad, CA
Client: **Sophisto Clothing**

Sophisticated Grab

Don't bother squinting to read the type. It's just the skateboarder/fashion plate's name, a "fine...garments" tag, and a phone number. But the composition, and the photo effect, are striking. "Video grabs," Andy Howell reveals. "It's, like, the cheapest way to get photography. I did this with Premiere and a Photoshop plug-in called Video Vision Grabber—which is like a scanner, but from off a video. I took four frames from within one second. They were in color, but I duotoned them with a greenish gray [in Photoshop], to make that red in the logo stand out. I blurred them a few times, then sharpened the two at the bottom again. And I blew out and darkened them, to make it a super high contrast. I think that's the best kind of b/w photography. It was a takeoff on that.

"It's hard," Howell adds, "because it's moving, to grab exact frames. In the bottom left his mouth disappeared. I think it's classy, and that was the challenge. To make something classy out of video grabs." Isn't "classy skateboard clothing" an oxymoron? "The trends are towards clean styles now, it's not raggedy, orange hair anymore—it's Polo and Nautica."

way to work with Andy." I was too shy to ask for a job, but when I called him up, he said I should come out to Cali to visit and that I would be better out there, closer to the industry. So in '96 I sold my screenprinting company and moved west.

Andy With Girly Things, I wanted to do something very feminine and cute but with a bad-girl image. So I designed the Smoking Girl logo, which was a takeoff on the Hello Kitty logo thing that's so big in Asia. I knew it would sell in Japan. I took the '50s classic girl, the square meal-square deal kind of thing, and depicted her smoking a cigarette with a huge smile on her face. It resonated with people because it had this girl-power kind of thing, pre-Spice Girls, post riot grrls. A lot of the graphics were girls with their fists raised up. Then the label started to get noticed in the U.S. I saw it on the cover of *Spin* magazine—Kim Deal from Breeders was wearing my T-shirt. It was the coolest thing in the world to me to have my design so validated outside of the skateboard world completely. Then immediately following the Kim Deal thing, I saw a photo of Naomi Campbell rocking one of my shirts in a story in TimeOut NYC Magazine, where she and Spike Lee were doing press junkets for his new film Girl 6. Girly Things immediately hit, because there was nothing else like it out there at the time.

But maybe my eyes got too big for my stomach, so to speak. Because of the boom in snowboard clothing, my distributor in Japan wanted us to make snowboarding clothes, too. We tried, but since we were new to the clothing manufacturers, we were put at the back of the production line and a delivery came in a little late. The Japanese distributor refused three-quarters of the delivery, an illegal move on his part. So we had a huge surplus of clothes and almost 300,000 dollars that had to be paid to the manufacturers. It put a quick halt to everything that was going on capital-wise. I was disheartened by the whole thing. I couldn't do business to make money to pay banks off because of all the calls from creditors.

Shepard Fairey When I got there, I didn't realize Andy wasn't in the greatest shape financially. All I'd ever seen was great press, but since he'd retired from pro skating, he

didn't have money from that. Sophisto was struggling because he wanted to do all these crazy products but he wouldn't meet the minimum on the runs and couldn't deliver. So his buyers lost faith.

Andy I hired a guy who had been referred to me by my accountant to come in and help deal with the creditors. It was so depressing and embarrassing. The guy was an accounting consultant who specialized in getting creditors to settle accounts for less money. I was thinking seriously about filing bankruptcy, because there didn't seem to be any light at the end of the tunnel. I had sunk all my time and energy into Sophisto, which was totally booming, and then almost instantly I had no money and was wondering how I was going to make it through the year. I had asked Shepard to come out before this sudden crash when everything was going great, and then it hit, and he moved out around the same time so I was scrambling to work it out with him.

Things were getting pretty bad but I tried to start a new distribution company with Shepard and the guys from Treefort, where my ex-roommate Kinsey was working. It started to launch and we put out a whole line of T-shirts for Sophisto and the first skateboards for Shepard's Andre The Giant line to accompany his widest offering of T's to date. Then the guys from Hobie Oceanside, who had been funding the production of Treefort, pulled the plug when the guy running it got arrested unexpectedly. We had made a bunch of initial sales but the Hobie guys froze all the accounts, thus cutting our new startup short. I went to them and pleaded to let us get our money out so we could move forward, but they wouldn't pay. It was like my legs had been cut out from under me again. I was forced to abandon Sophisto and Girly Things, and subsequently let Shep down completely.

A few months later a company from Tokyo got in touch and asked me if they could license the Girly Things brand, which was still very hot in Japan. They said, "We think it will bring in twelve million the first year, sixteen million the second year, and 25-million the third year—and you'll get a seven percent royalty on all sales". I couldn't believe it, I couldn't even do the math on numbers like that! I immediately signed the deal and got very excited about it. Then three weeks later they called and told me someone else owned the trademark in Japan. My distributor in Japan who'd sold Sophisto had registered my trademark under his name and wouldn't give it back. I was crushed, then immediately infuriated. Despite working with lawyers on it for three years to get the trademark back, the deal went stone cold. Back then, I had about a year to play with. A trend like that lasts for about ten minutes now.

I felt defeated and disillusioned, because this company I had given everything to had virtually evaporated before my eyes. I was skating the curb outside my office one day to let off steam when the consultant Brian I had hired came out and asked me, "Hey Andy, you want some feedback?" I had no idea what he meant, and in my mind dismissed him, though I replied, "Sure dude, whatever, sure…"

He proceeded to break it down for me on a personal level, how I was showing up, what he assumed I was facing, what my actions were telling everyone around me. It was like he was reading my mind, really eerily on point, but without being condescending or patronizing at all. It struck a chord within me, and I asked him how he could possibly know all of this. He just asked me to go to a guest presentation for a seminar he had been attending, and I half-heartedly replied, "Sure, dude, whatever." I had never been very good at sharing my deepest feelings, and was skeptical of anything like this that felt to me like some sort of a cult.

But I went to the guest presentation. In the presentation the facilitator had everyone get into "Diads" with a partner who had already been through the program to "share". I looked around confused, and realized that he meant us to sit facing each other with our knees almost touching, which apparently was the best position for two people to communicate. I picked a cute girl to pair up with and I thought to myself, "This is complete bullshit, what am I doing here?" Then the facilitator asked each person to share with the other an experience that had hurt them or made them sad. I went first, staying on the surface, not really opening up at all, and without ever making eye contact with the girl sitting across from me. Then she shared with me, I mean a

real story about her relationship with her family, and she was completely vulnerable to me, ending in tears with a smile on her face, never once taking her eyes off of mine. It was so powerful, I felt amazed, then scared, then threatened. How could someone be so strong as to share her real feelings with a total stranger? I knew I had to experience the program, and signed up within fifteen minutes. The program was called *Impact*.

Within the program, a microcosm of society was formed among twenty people and we experienced a controlled version of modern society together. I learned more about myself personally in the first four days than I had learned in the 26 years I had been alive. It was an amazing experience to face myself, my fears, and my ego in a way that challenged me a thousand times more than any business venture ever could. I learned that we are actually connected, despite our fixed beliefs and the prejudices that we all carry around with us. It was something I had always sensed but never put into words. Life felt lighter than to me than ever before. My negative views of the world around me started to evaporate, and I began to feel happier and empowered. Even my disastrous and formerly insurmountable financial situation was survivable. *Impact* had a profound effect on me that lasts to this day. I started looking at things differently again, but this time it was the way I was living my life that I wanted to switch up.

My roommate Kinsey and my friend Scott Herskovitz thought I had gone crazy during Impact. All of sudden I had gone from being totally depressed to totally weightless, and my cynicism and anger had seemed to instantly disappear. I wasn't the "H" they had known before, and they both just told me they didn't want to be friends anymore. Kinsey moved out and got an apartment with Hersk in La Jolla, and I decided to move out of our apartment in Encinitas and live at my new friend Brian's house to save money. My old friends just disappeared, except for Damon, who was the only one of my friends who wasn't deterred by my newfound energy. He just looked at me smiling and said, "Ooh, what's going on with you? I want some of that." We'd become good friends over the previous years and subsequently Damon went through Impact, as did his wife Suzy, and my dad, my girlfriend at the time Erin, my friend Mike Nelson, his wife Melissa, and friends Ed and Kiersten Cleary. So many people eventually ended up experiencing it, and all inspired each other to take it on. I started to meet so many spiritually connected people, because I was putting out a positive and open energy instead of shutting out or judging everyone who came into contact with me. Damon and I became much closer through the experience, another soul mate for sure, and through *Impact* and a number of other experiences together he joined Tony, Gonz, Dallas, and Bad Brains in a very tight circle of inspiration in my life.

Shepard Fairey At a certain point we realized that the effort versus the return on that size clothing company was very unfavorable. Andy was going to let Sophisto die. He phased it out. Meanwhile we'd been working on an idea called FBI, First Bureau of Imagery, with Dave Kinsey. It was the first stab at turning our talents towards doing marketing for other people's companies. It had been kind of a part-time hobby for a few months, but when Dave lost his job at Treefort Skateboards we put all our energy into it. That was a big move. Our whole thing was that we liked being entrepreneurs, but if it wasn't going to pay off, we should figure out an alternative way to be creative and make money.

What's so funny about it was that we'd all already done a bunch of commercial graphics, just as projects on our own. I had band posters I'd done for free, simply because I liked the bands, bands like Slayer and The Unsane. Then Andy had stuff he'd done for Sophisto, New Deal, and Element and *Freedom*, the video he put out. Dave had some comps for Levi's and Treefort stuff. So when we threw it all together, it actually looked like a fairly big body of work for diverse clients, even though it was all our own shit. The reason it was effective was that we also came up with a concept for a photo shoot. We played out the whole FBI shtick. We wore gray suits and rented a Taurus sedan like FBI guys. We had keyboards under our arms like guns. We had bios too written in that style, Casefile: Andy Howell.

When we sent it out, people were like, "How have we not heard of this agency? They really have their shit together." It was right as the X Games were starting, and companies realized the action-sports demographic was viable. They were all like, "Holy Shit! We've been totally sleeping on the whole BMX, skateboard, in-line thing." We immediately got stuff from Netscape, Mountain Dew, and all the skateboard companies. One year, about 25 percent of the logos in the ASR guidebook were ours.

Andy I really wanted FBI to work. Once more it was part of my whole utopian dream—the idea that creative people could get together and make something happen equally, all pushing each other and making something collectively. But there was friction between us. Inevitably, some power play happened. Egos got in the way.

Shepard Fairey The dynamic between Dave and Andy ended up pulling the company apart. Andy was really good at what he did, but less into the structure of things. Dave was super super hungry. Andy had made money; Dave had never had money. If the waves were good, Andy wanted to surf. Or when *Jurassic Park* came out, Andy wanted to blow off work and go see it. Dave was like, "No, no." I also found it weird to take these liberties, but as long as we had money I thought it cool to have some flexibility. But Dave started to resent Andy; he was working really long hours— although he took it on himself to do that. And ultimately Dave wanted out.

Dave Kinsey FBI was sort of Andy's concept. It worked for a little while, but I wasn't happy in it, the working dynamic and the timing wasn't quite right. So I made my way out and ended up starting Blk Mkt. Andy was in a different place in his life, had a lot of stuff he was doing with his own clothing companies, dealing with distribution problems. He went on to bigger successes, though.

Andy In many cases people might be equally driven, but there's a huge range of where they are in their lives and all have a different need to fill. Each one has an agenda, and none of them match. Even though FBI was my concept and my idea, I did the same thing as at Urbanistiks. I said, "Let's all put our ideas together." At the same time, I do want to lead. I can see things very clearly and I want to implement my vision. I was the one who saw the name, FBI, and the imagery we should use. It was all crystal clear. And even then I was setting myself up for failure because I was only half way into controlling it. I think those guys just looked at it and realized, "Fuck, that's an amazing idea, but I'm not going to own that idea 100 percent." Shepard was always primarily focused on Giant, and for him I think FBI was just a paycheck to free him up to work on his prints and street art. I also had felt very burnt and disillusioned in the financial experience brought on by my Japanese distributor, and that was coupled with a new approach to life which took focus off of work and put it on happiness. So Kinsey had to step up take the reigns, and he became resentful about that, and wanted out.

I was crushed, for about a day. With FBI Shepard, Kinz, and I had begun to cultivate a part of ourselves creatively that would help shape each of our professional lives for at least the next ten years. A few days after the great FBI scandal I picked up the phone and called Dallas in Atlanta, and it just so happened he was starting a new record label and wanted me to be the creative director. We started talking about doing another clothing company, and the creative juices started flowing again. And through the experiences of losing it all financially and finding my spirit I had created a new outlook on life, which would inevitably guide me in the right direction. I went on to creative direct Freeworld Entertainment and Rowdy Industries, and then to consult with one of the pioneer action sports agencies McElroy Communications. Later I would roll all of that experience into a new company with snowboard industry maverick Gregg DiLeo. It would be called Imagewerks.

Looking at FBI from the outside, people often thought, "How cool that all the artists are coming together," but it's still a big struggle. The ego—or the ability to put away the ego—becomes a huge issue. Ultimately if an artist puts away his ego, he's putting away his art at the same time. Because I think fundamentally his ego or sense of self in regards to the world inspiring him is what's driving his art.

ZERO SOPHISTO CLOTHING CO.

SOPHISTO
CLOTHING CO.

SOPHISTO
available now:
OVER 20 SCREENED
TEE • SHIRTS, SWEATSHIRTS,
FLANNELS, CHINO JEANS,
FREEDOM JEANS, SHORTS,
FLEECE PANTS, CORDURA
JEANS AND JACKETS,
BASEBALL JERSEYS,

SKULL • CAPS,
SOLID TEE • SHIRTS,
SPORTSTER TEES,

BASEBALL CAPS,
FLANNELS,
L/S AND S/S BUTTON UPS, BELTS,
WINDBREAKERS, NYLON, COTTON and
FLEECE JACKETS, BACKPACKS,
DJ and BOOKBAGS, WALLETS,
AND then MORE...

r.e.n.
(racial equality now)
available now:
TEE • SHIRTS,
POCKET TEES,
JEANS, BELTS,
BASEBALL HATS,
BEANIES,
SWEATSHIRTS,
BACKPACKS,
MORE...

*FREEDOM JEAN
AND CHINO DETAIL

new!
girly things
available now:
BABY TEES,
TEENY TANK TOPS,
SPORTSTER TEES,
LOW CROWN CAPS,
DRESSES,
MORE...

Ask
For
Tiffany!

FEATURED TEAM RIDER: JAMIE THOMAS

DEALER ENQUIRIES INVITED.

Visit us at ASR show...
TEL [619]431-8996 / FAX [619]431-9922 [800] 574-4331

SOPHISTO
CLOTHING
1994

sophisto
+
ren
RACIAL EQUALITY NOW
CHANGE THE WORLD
=

call 1-800-574-4331
to change the world

SOPHISTO
1995

SPRING/SUMMER
PORTFOLIO

ANDY HOWELL
TEL 404.377.3900
FAX 404.377.3938
P.O. BOX...
ATLANTA, GA 30309

ZERO SOPHISTO

URBANISTIKS

ENJOY.

SOPHISTO
TRADE SHOWS
1 • 9 • 9 • 4

invitation for
SOPHISTO Clothing,
r.e.n. (Racial
Equality Now),
and NEW
GIRLY THINGS
Clothing

Girly Things

ZERO • SOPHISTO
CLOTHING CO.
uNcle sCam thinks,
"is pretty facking
uNameRican."

shops call
800
574
4331

SPHISTO

sophisto
clothing co.
jeans•khakis•shorts•dj and bookbags•backpacks• softon down pulse
flannels• fleece and nylon jackets•snowboard jeans•long john shirts
painted boxer shorts• and over 25 full color t-shirt designs...
conscious clothing. dealers call 1-800-574-4331 for free color catalog.

pepe martinez

the fashion wire
Sophisto Targets South America. The young men's line of urban-inspired streetwear is targeting South America...

Gold's Gym Muscle

GEAR
Messenger bags are durable enough to withstand rain, sleet, and
snow. Ask any courier. And in today's urban-active-carryall culture,
bigger bags and cool colors are the thing. Globe Canvas, Tommy
Hilfiger, Sophisto, Manhattan Portage, and John Peters all offer mes-
senger bags ($40–$75) that do the job with flavor.

ゼロソフィスト＆サービス
ニューアイテム

ストリートで大人気のブランド

RDP·159

free thinking professional wheelieboarder billy pepper enjoying a life of idle pleasures.
curious skateboarding carriers call SOPHISTO CLOTHING CO. at 1•800•574•4331 and ask for tiffany.
•SOPHISTO Clothing•r.E.N. Racial Equality Now• and introducing GIRLY THINGS Clothing

Summer Action Lifts Boutique Show Budgets

SATURDAY & SUNDAY & MONDAY

seventeen

Sun and games

Time Out New York

Fashion flash!

Waiting for Naomi

Naomi on...

Fine
人気ストリートブランド
CLOSE UP
SURF SUMMER

Fine
1995スタイルBOOK

Fine
ストリートファッション

the jean

Girly Things
クローズアップ

GIRLYTHINGS

MTV SPRING BREAK '95: DUMB AND DU

SPIN

Deal
Breeders Leader Gets Pissed
by Charles Aaron

ELASTICA
Absolutely Fabulous

TO HELL AND BACK
Confessions of a Junkie

rawdeal

GIRLY THINGS

U·H·F

ACHIEVEMENT In FASHION and DESIGN

BEST WOMENSWEAR
[honorable mention]

presented to

GIRLY THINGS

Certificate of Merit

UHF 1995 Awards

Girly Things

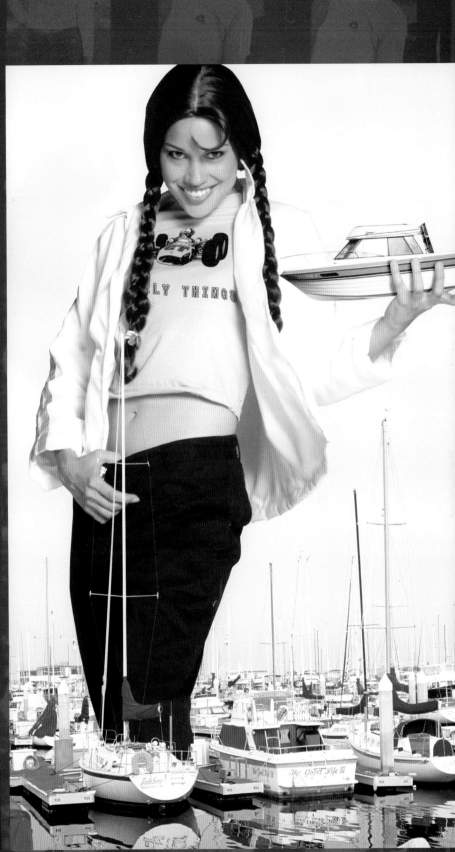

GIRLY THINGS

some girls
just got it
like that…

Girly Things

CLOTHING / JEWELRY / ACCESSORIES
call 800.574.4331 / tel 619.431.8996 / fax 619.431.8922

Girly deliciously yummy silliness tickling dreamy little powerful delicate Things.

SUMMER CLOTHING JEWELRY ACCESSORIES 800 574 4331

GIRLYTHINGS®

619/431/8996
CLOTHING
ACCESSORIES
SHOES

GIRLY THINGS

C£1.75 / ¥2500 / $3.75
U.S.PRINT#435-5197

FORMULA—SUPERGROW

LARGER THAN **LIFE**

GIRLY THINGS
FALL 1995

SUPER GROW FORMULA

"HIPSTER"
#GPA01 / XS.S.M.L

"CAB DRIVER"
#GPA04 / XS.S.M.L

YES, IT'S THE DENIM SENSATION THAT'S ROCKING THE NATION!
HIPSTER...
AND SHE'S THE KINDA GIRL WHO CAN CATCH YOU OFF GUARD WITH AN OFF HAND REMARK JUST WHEN YOU THINK SHE'S CURLED UP WITH HER HEADPHONES FOR A LITTLE EASY LISTENING. INDIGO DENIM CONSTRUCTION WITH CUSTOM LABELS AND HANGTAGS.

HEY MISTA CAB DRIVER, GIMME A RIDE DOWN TO THE PARK OVER OFF BLEEKER. YEAH, OVER THERE. OK IT'S COOL. THESE, THEY COME IN ASSORTED COLORS. SMOOTH TWILL, WITH LIKE CUSTOM TACKS AND LABELS. YEAH, RIGHT OVER THERE'S COOL. THANKS, KEEP THE CHANGE.

"POOL PARTY"
#GDR07 / XS.S.M.L

"PIT STOP"
#GDR08 / XS.S.M.L

FULL ON POOL
SESSIONS. WITH OR WITHOUT BOARDS. RIGHT ON, COOL WATER, COOL FRIENDS. COOL RAYS. FOR LIKE THESE HAVE A FAUX ZIP ON ONE SIDE. THE REAL THING ON THE OTHER. ASSORTED INDIGO DENIM WASHES AND SOME COOL LABELS, CUSTOM TACKS AND EMBROIDERY.

JOHNNY FAVORITE IS REALLY RIPPING IT UP AT THE CARLSBAD 500 TODAY. HE'S LAPPED SIX COMPETITORS AND NOW HE'S PULLED IN FOR A PIT STOP. BUT WAIT, NOW HE'S GETTING OUT OF THE CAR, AND NOW HE'S WALKING OFF WITH A GIRL FROM THE CROWD. SHE'S WEARING A POPLIN SKIRT WITH OPALESCENT BUTTONS UP THE SIDE, AND CUSTOM LABELS. WOW, SHE MUST BE SOME GIRL TO PULL JOHNNY OUTTA THIS RACE!

"CHOPPER"
GJA03 / S.M

"WONDERLAND"
GJA04 / S.M

VROOOOOMM, VVR-RRROOOMM, ON YOUR ROOMATE'S GOTTA BIKE, RIGHT? YEAH I HEARD IT'S T00000 FAST, FLAMES ON THE SIDE. YEAH? WELL, I GOT THIS FRESH JACKET WITH STRIPES DOWN THE SLEEVE. IT'S CONSTRUCTED OF FINE POPLIN AND IT'S GOT ZIPUPS FRONT AND POCKETS WITH A PENDANT ON THE ZIP. COMES IN ASSORTED COLORS.

THIS AIN'T NO REAL WORLD ANYMORE. CHECK OUT THOSE LIGHTS. ALL CRAZY AND SPARKLE UP, WILD AND WATERY OUT THERE, LIKE A WONDERLAND OR SOMETHING. IT'S A NEW JACKET WITH NYLON AND CONTRAST SPEED STRIPES, LINED WITH CUSHY MICROFLEECE. COOL ZIP UP WITH A PENDANT PULL AND WOVEN LABEL I.D. TRIP OUT.

this spread:

Girly Things 'SuperGrow Fomula' Catalog 1995
I created this catalog at a time when photoshop did not have multiple layers or undo's. I actually had to write down my game plan on a piece of paper and save individual files along the way (progress 1, progress 2, etc) in case I had to go back a few steps. And saving the files took forever.

Ron Seigel and I did the catalog together, he shot the raw photos of classic LA scenes, and I shot the models in a studio using brooms and ladders to pose them standing within the buildings. If you know LA, you'll realize I removed and added floors to alot of the buildings. It was a real crash course in photo manipulation.

HAPPY GIRL TEENY T
GTS03T / S.M

SUPERHERO TEENY T
GTS02T / S.M

TEDDY BEAR TEENY T
GTS25T / S.M

RACE CAR TEENY T
GTS24T / S.M

QUEEN OF HEARTS TEENY T
GTS23T / S.M

ZIPPO CHICK TEENY T
GTS06T / S.M

TAYA LIKES JUST HANGIN' AROUND
AT SAKS SOMETIMES TO PLAY WITH ALL
THE EXPENSIVE TOYS.

BULK RATE
US POSTAGE
PAID
CARLSBAD, CA
PERMIT NO 1452

FOR CREATIVE SOCIAL INTERACTION

GIRLY THINGS
2131 LAS PALMAS DRIVE SUITE E. CARLSBAD, CALIFORNIA 92009
TEL. 619.431.1000 FAX. 619.431.9922

FBI

FIRST BUREAU OF IMAGERY
PORTFOLIO

CLASSIFIED DOCUMENT #1805-92119>ADM
MARKETING / IMAGERY

FBI BOSTON, MA.

CLASSIFIED DOCUMENT

FIRST BUREAU OF IMAGERY

1286 UNIVERSITY AVE. SUITE - 506 SAN DIEGO, CA. 92103-3392
VOICE 619.544.9585 • FAX 619.544.9316

ATTENTION:
FIRST BUREAU of IMAGERY IS ROUTINELY RESPONSIBLE FOR REVOLUTIONARY INNOVATIONS IN GRAPHIC DESIGN AND DIGITAL IMAGING. AND ALONG WITH AN ACCURATE SENSITIVITY TO CLIENT NEEDS THIS ENABLES OUR DESIGN AND FIELD AGENTS TO CREATE EFFICIENT AND COMPREHENSIVE MARKETING CAMPAIGNS WITH THE VISUAL COMMUNICATION NECESSARY TO MAXIMIZE CLIENT PROFITABILITY. THIS CONFIDENTIAL DOCUMENTATION WILL PROVIDE YOU WITH THE CONTACT INFORMATION NECESSARY FOR YOU TO OBTAIN OUR SERVICES.
- END TRANSMISSION.

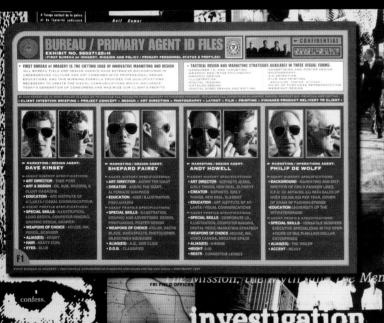

BUREAU / PRIMARY AGENT ID FILES
EXHIBIT NO. S6037129>H
(FIRST BUREAU of IMAGERY: MISSION AND POLICY / PRIMARY PERSONNEL STATUS & PROFILES)

CONFIDENTIAL

FIRST BUREAU of IMAGERY IS THE CUTTING EDGE OF INNOVATIVE MARKETING AND DESIGN.

TACTICAL DESIGN AND MARKETING STRATEGIES AVAILABLE IN THESE VISUAL FORMS.

CLIENT INTENTION BRIEFING • PROJECT CONCEPT • DESIGN • ART DIRECTION • PHOTOGRAPHY • LAYOUT • FILM • PRINTING • FINISHED PRODUCT DELIVERY TO CLIENT

DAVE KINSEY — MARKETING / DESIGN AGENT
SHEPARD FAIREY — MARKETING / DESIGN AGENT
ANDY HOWELL — MARKETING / DESIGN AGENT
PHILIP DE WOLFF — MARKETING / OPERATIONS AGENT

FBI FIELD OFFICES

ADVERTISING DESIGN FILES
EXHIBIT NO. S7037139>FBI
(FIRST BUREAU of IMAGERY: INNOVATIVE ADVERTISING EXECUTION)

CONFIDENTIAL

GIRLY THINGS — CLIENT> GIRLY THINGS
CLIENT> TREE FORT SKATEBOARDS
SOPHISTO — CLIENT> SOPHISTO JEANS
DANNY SUPA — CLIENT> TREE FORT SKATEBOARDS
CLIENT> SOPHISTO JEANS
DUB — CLIENT> DUB WEATHERGEAR

IMPRINTED GRAPHIC FILE 2

BOARD SPORTS EVIDENCE FILE

POSTER DESIGN FILES

CORPORATE I.D.

IMPRINTED GRAPHIC FILES

HOWELL

DRAWINGS

ANTI

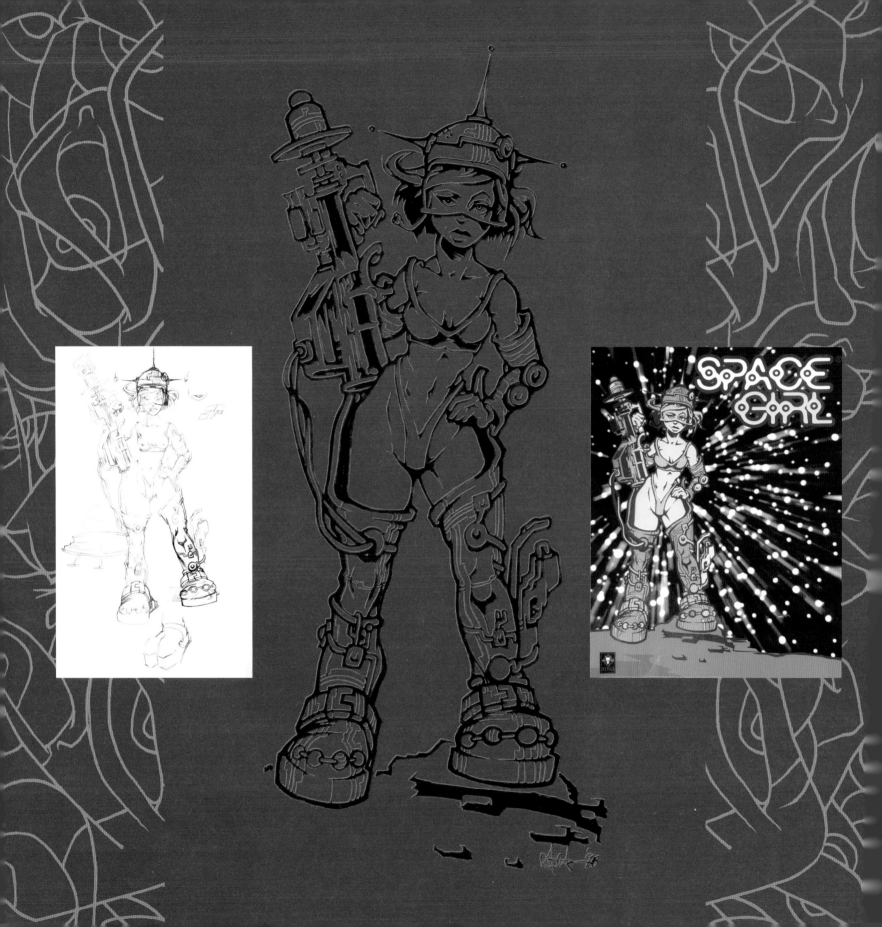

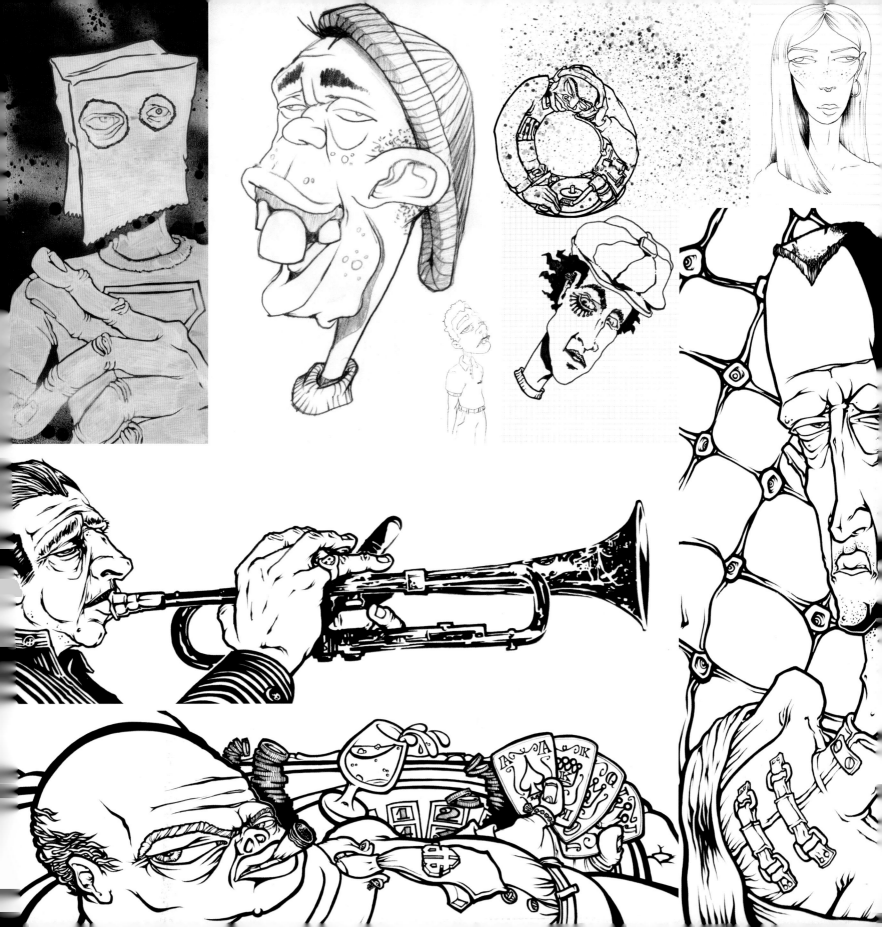

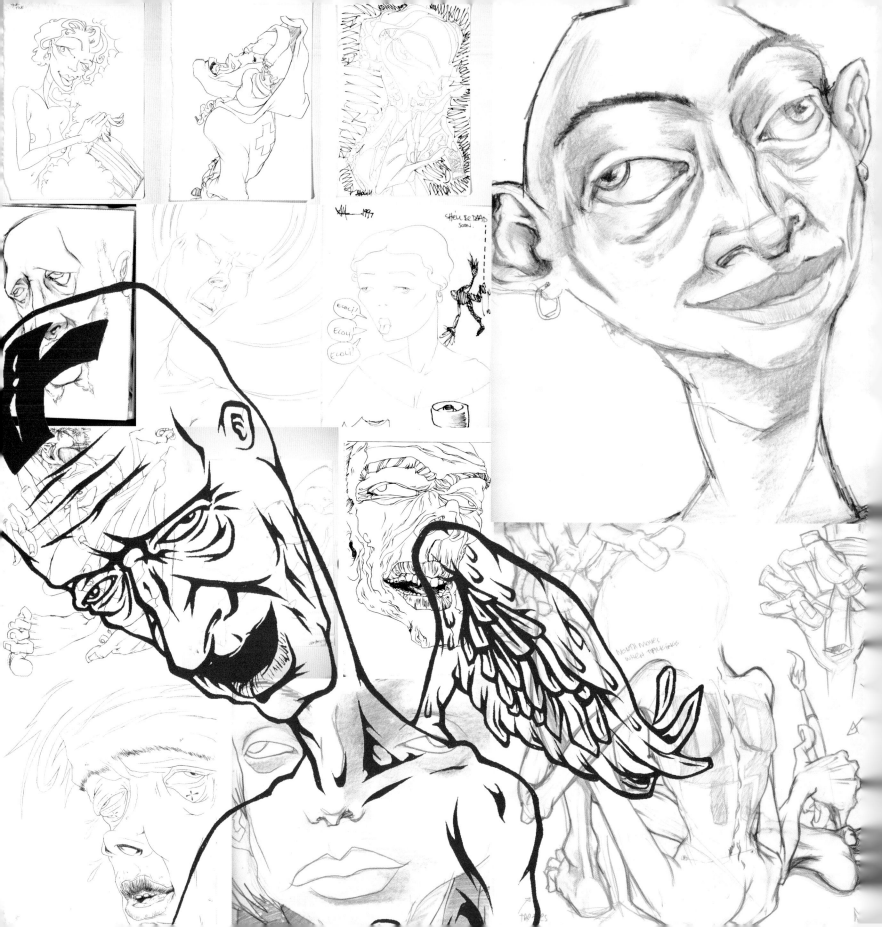

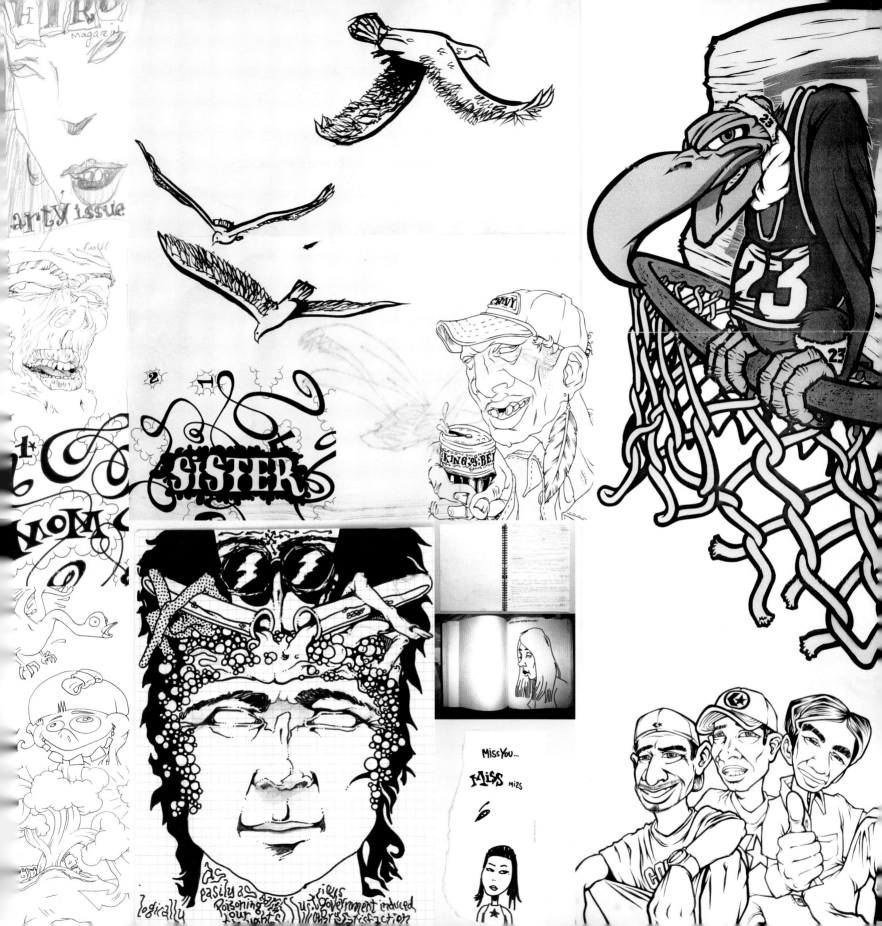

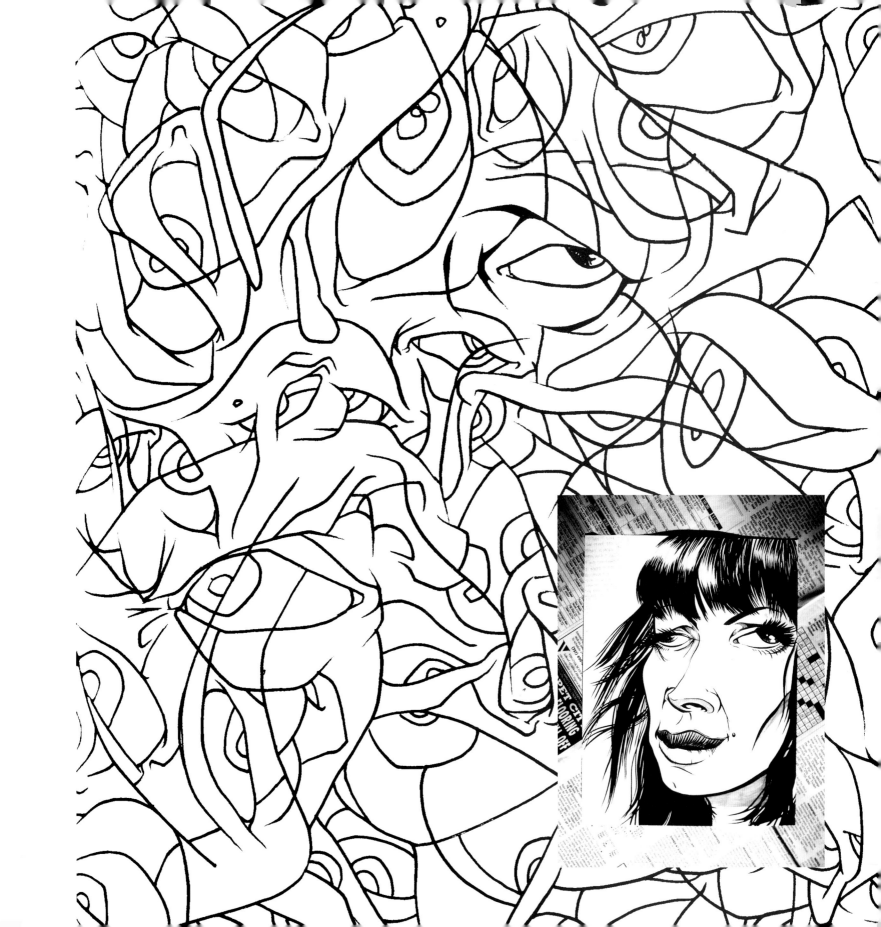

(DISCONNECTED)

HOWELL'02

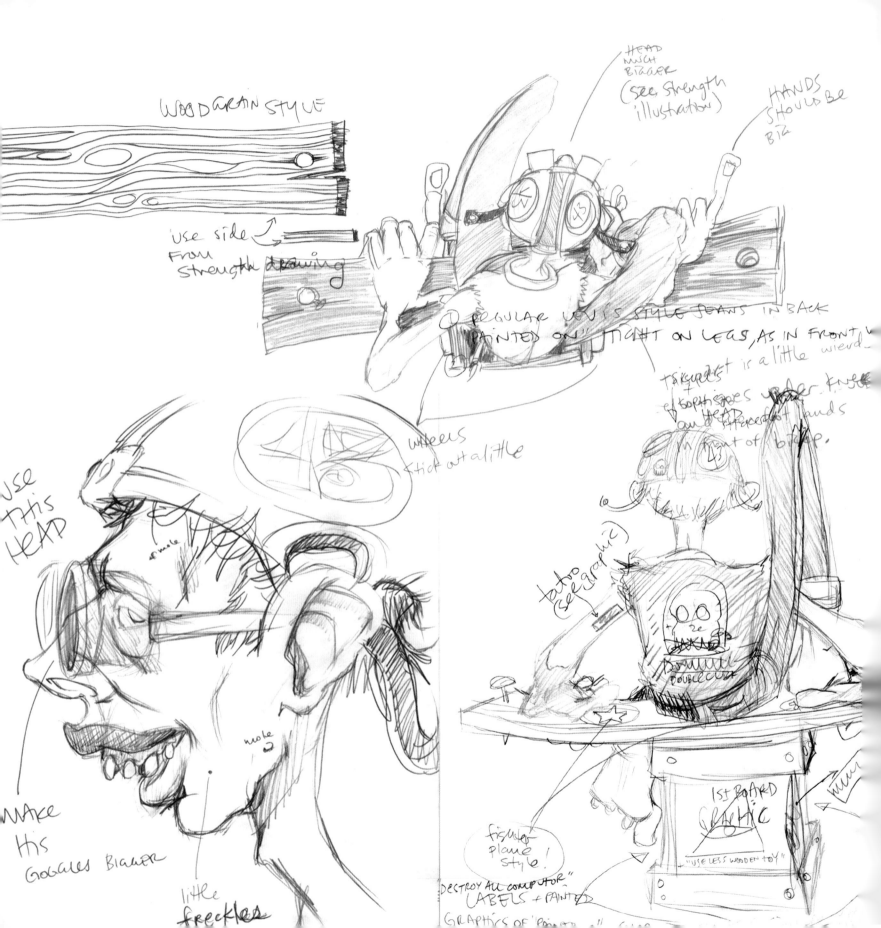

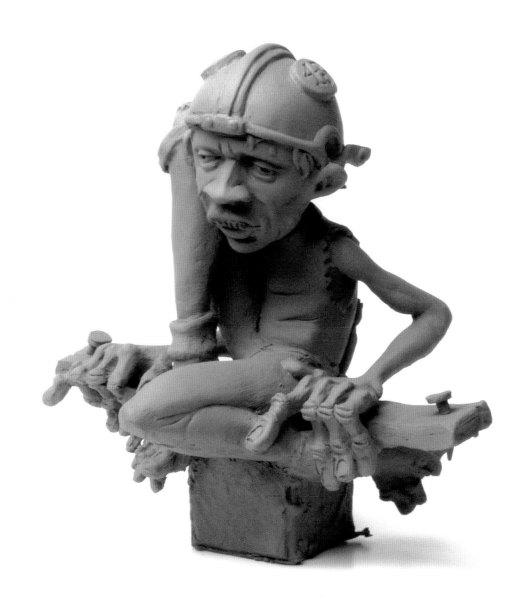

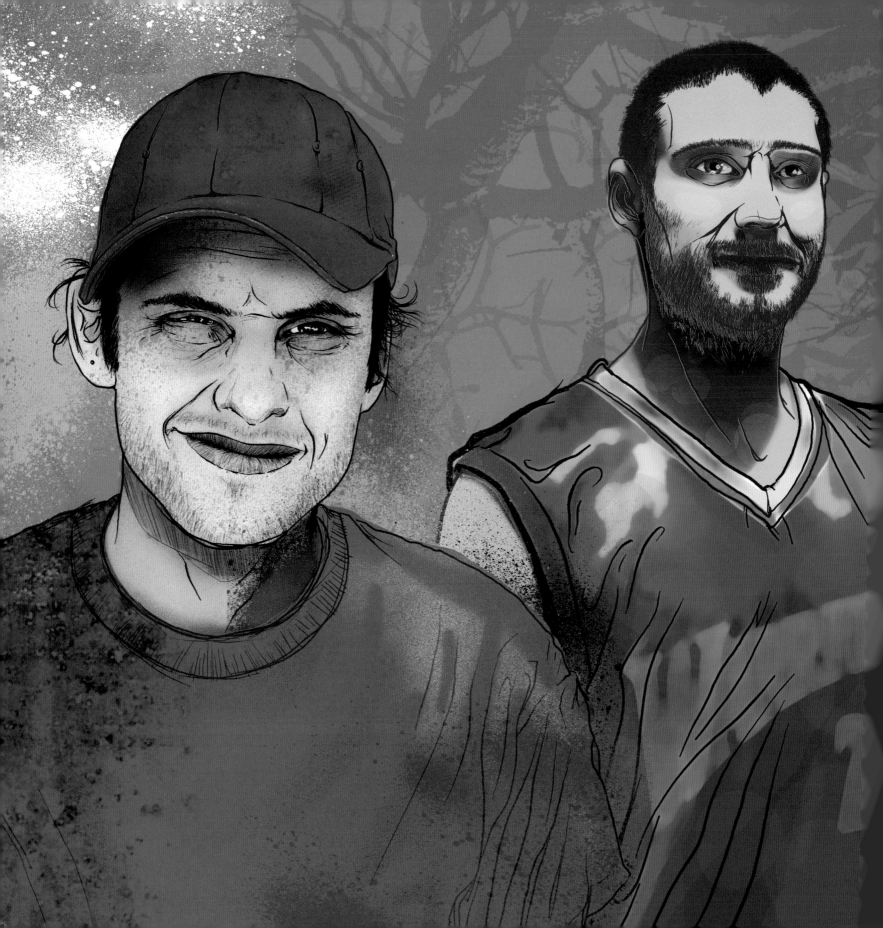

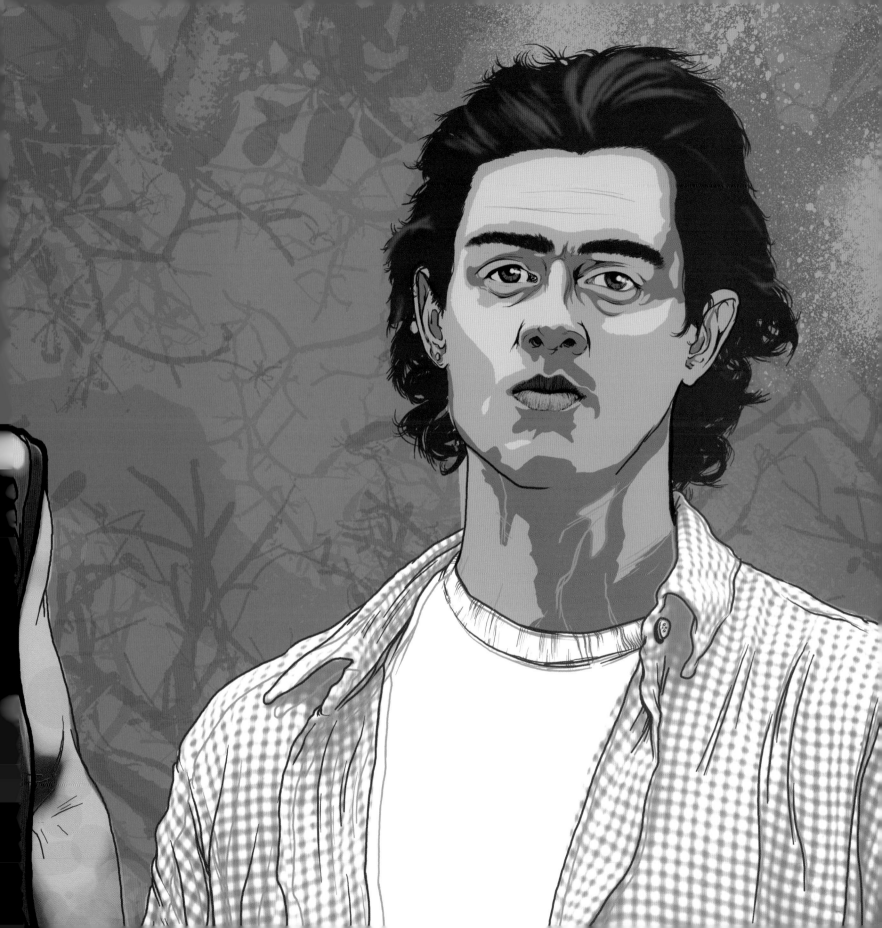

CHAPTER 8
FROM BOARD TO BOARDROOM

From Board to Boardroom *Imagewerks: Creative Megaconglomerate*

Andy When we started Imagewerks, it felt perfect—a platform for me to do multiple projects for different brands across a number of genres within the action sports industry. It was the best thing since sliced bread! I didn't have to own the companies I was creating for, I could just own the idea, build a campaign from it to help the brand succeed, and of course get paid for it. After FBI finished I'd gotten in touch with Dallas to creative direct for his new label, Freeworld Entertainment, which is now part of Capitol. I was flying to New York all the time and partying with Dallas and his friends. He had a three-floor apartment right in the middle of Manhattan, and a driver with an all-black Suburban with tinted windows. Around midnight every night Dallas would say, "Hey, y'all call the driver; it's time to go to the club." Those guys were crazy.

The merger that formed Freeworld Entertainment was between Kevin Czinger, who owned Volcano records, and Dallas' label Rowdy Records. Until it was purchased by Capitol Records a year later, I was the West Coast creative director for all the visual aspects of Freeworld, including the corporate identity, logos for groups, and record sleeve designs. I remember the launch we did for Freeworld in Manhattan, I think it was at the BMG building, where they made this huge banner of my futuristic-military Freeworld logo. I did one cover for a girl named Lysette who had a song called *Young Sad and Blue*—man she had a beautiful voice—and I remember being in the studio while Monica, another Dallas protégé, was recording songs for *The Boy Is Mine*. It was always amazing, and it made me want to dive back into the music world again for a while. Dallas and I started mulling over bigger-picture ideas: movies, cartoons, interactive books for children. He asked me if I was ready to start a clothing line together, but my instinct was that I didn't want to move everything back to Atlanta or New York just yet—I wasn't sure why. I stayed put in San Diego, moving from Downtown SD to Cardiff By The Sea in North County. That's where I met Gregg DiLeo.

Gregg DiLeo We met when Andy moved in across the street. One day he stuck his head into my garage and saw my racks of snowboards, gear, and Ducati bikes, and said, "You must be in the industry."

Andy Gregg DiLeo and I had both founded action-sports companies—he founded Division 23 and later Forum snowboards. He had sponsored Peter Line as an am and groomed his image as the best snowboarder in the world for better part of a decade. So his experiences in the snowboarding industry mirrored mine in the skateboard industry. We started talking about where things were going, hypothesizing on a new pro tour called the X Games and its impending effect, and we said, "You know what? This whole culture's

going mainstream. The whole music, skating, snowboarding, So Cal culture, blink-182 thing—it's all mainstream."

When we both first started in action sports in the early eighties it was an underground culture, but to say that anything can remain an underground culture is, I believe, naive. If it does remain relatively untouched by the mainstream, it means it never really had the primary things that drive people to follow something religiously anyway. Or else it's something overtly obscene and offensive, a subculture so disturbing that it alienates a wider audience. Only a few of the graphics in skateboarding could possibly be considered obscene, and it was only really offensive in that it destroyed public property and the kids dressed in clothes that the mainstream didn't understand yet.

Gregg DiLeo Back in the '80s, anybody who loved skating or snowboarding was creative in their own right. It attracted people who were self-sufficient, driven, and creative. If you were involved, you were basically keeping the sport alive, because skateboarding was in its dormant stage from like '85 on. It was asleep in terms of cultural influence, and it was underground.

Andy What Gregg and I knew from our history was that skating was going to get commodified again. We'd both skated in the mid '80s. When I was an am skater I'd get calls from people doing commercials. They'd say, "Come do this commercial for a bank." I'd be like, "Cool, we're gonna be on TV." We'd go skate and the guy shooting the commercial who knew jack all about skateboarding would say, "I want you to jump off this ramp and hold out your skateboard and go, 'Yeah!' and land on your feet holding your board while smiling at the camera." So corny and lame. We weren't completely naïve. We'd go, "We know this is total bullshit but they're paying us 50 dollars." That was a mint to us at that point.

But what happened is they made skateboarding look so stupid that it became like hula hoops. A novelty. That's why skateboarding died in the '80s. Suddenly these mainstream companies latched onto it and had no idea how to make it look cool at all. Ten years later it got on TV though, in the mid '90s, and it started to become a jock sport. Every kid who saw EXPN said, "I want to jump high like that on a ramp." And like the Circus Props in the late '80s, the contest courses for TV started getting tailored to the superstars again. So the fate of skating was once again hanging in the balance. Would big business come in and whore it out for a quick buck? Or would the new generation of self-taught action-sports entrepreneurs preserve its unique culture enough to allow it to grow to the next level?

Once, Dad wanted Son to be a pro football player. But now those boys are guys of my generation, saying to their kids, "Yeah, here's a *good* skateboard for you, go surfing, ride motocross!" And the result is you've got seven-year-old kids going down handrails on skateboards.

Everyone in the industry knew this growth was inevitable. When I was skating at age sixteen it had gotten massive really fast. I'd go into Kmart and they'd be selling shit skateboards produced by the millions in China. Kids would have a horrible experience on a crap board with no grip. They'd break their arm and think, "I'm over this shit," and move on to soccer. The performance of the entry-level product that was

available to the masses was so drastically inferior to what the pros in the magazines were skating, that it was actually detrimental and dangerous. So kids' first experience with skateboarding was often that they were riding a board that really didn't even function properly. No one wanted that to be the case again.

Gregg DiLeo Andy and I started talking about the huge opportunity. We recognized the gap between the big companies that wanted to talk to youth culture in a cool way and couldn't do it, and all the action-sports companies that wanted to expand their horizons but didn't know how to get into the mainstream and maintain their image.

Andy We thought at the time, "Nobody really has the collective experience that we have in growing these brands, branding for this culture. We've been involved in many parts of the industry and culture, from me being a pro skateboarder, designer, and skate company owner to Gregg working in shops, running snowboard teams, and founding snowboard companies.

Gregg DiLeo We saw the opportunity to fit in the gap, to be the conduit and translate messages both ways.

Andy My first motivation was, "Skating is either going to go mainstream and completely be wack, or we can go out there and do some of the work for these companies and skateboarding, and all these things will keep living." Then of course there was the opportunity to work with big budgets and possibly create commercials, huge promotions, and ad campaigns. That was my school training and my dreams of one day directing a feature film talking. Once again I faced a dichotomy: How can I help skateboarding *and* make a living *and* work on bigger projects without losing myself and the authenticity of skating in the process? Gregg and I discussed that too, and our reasoning from a business sense became, "Someone is going to do it anyway, and most likely they are going to have much less experience than we do, so it may as well be us." We didn't know how the industry or the mainstream was going to respond, but our idea was already becoming real in our minds, so as per normal, we decided to go for it.
 We started to develop the idea of "cultural translation" which was the only way we knew to describe the process—a natural one for us—of translating culturally driven communication, either for core companies who wanted to expand their audience, or non-endemic brands that wanted to focus on a more savvy one. We'd never built a real agency before, but we knew how to do advertising, promotions, team building, graphic design, production, and illustration, so we figured that we would actually have a leg up. We knew we had one thing that the more mainstream agency competition could never have: we lived and breathed the culture we were marketing to and we had already founded, owned, and built a number of very successful brands within the action sports industry.

Gregg DiLeo The next day we started the company in the extra room in Andy's condo. Within a week, we had our first client.

Andy Yet again, it was another enterprise launched from a bedroom. We though of the name Imagewerks as an homage to a mutually favorite music group, *Kraftwerk*—a group that had crossed over and influenced a brand-new genre of music. I designed the logo the first day and Gregg made calls on my home phone to people like Fran Richards at TransWorld Media. Within a week we were starting to design collateral materials and ads to help Transworld group its publications together in a neat bundle called *Teen Active Network* and pitch high-dollar, non-endemic advertisers. For our very first real client pitch, with K2, we stayed up all night with layouts spread all over the floor, and we'd do all our creative meetings totally on the fly. Our new business had the same exciting DIY vibe that had flavored everything I'd done before, only this time we were riding it straight into mega corporations. The intention since we started Imagewerks was always to see if we could create a good size boutique, partner with a large agency, and get "bigger" work: commercials and branding. Our friends were all doing commercials for companies like Jeep, making successful indie films, doing music videos, all the crazy stuff we wanted to do. But we were in the action sports world, and those opportunities didn't exist yet. We decided to *make* those opportunities manifest, "Anything you can imagine is real."

Street & Smith's SPORTSBUSINESS JOURNAL

Major league building boom near end?

Investment banker predicts action will wane away from U.S. pro arenas to colleges and foreign venues

EXTREME SPORTS — SPECIAL REPORT

Ad firm skates to lifestyle marketing

BY DAN CRAWFORD

Shepard Fairey I do firmly believe that when you're talking about skate people becoming influencers, it's because they are never trying to figure out what the lowest common denominator is and how to work in that paradigm. So they end up being the people who are looked up to as rebels, and people emulate them. That goes on until the whole tipping point of commercial success happens.

Skateboarding was one of the first white subcultures to embrace hip-hop and as far as the art goes, the graphics on boards and shirts have influenced culture so heavily, so when you're a skate company owner, you're a combination artist/entrepreneur/graphic designer and you're immersed in stuff that's at the forefront of emerging trends. It's logical that you're seen as kind of epitomizing the vanguard.

Andy Imagewerks immediately generated income and got some pretty substantial business branding K2 snowboards. The company started to grow and get press in magazines. There wasn't another agency doing what we were doing, no skate or snowboard-related branding or ad agency existed, because the action-sports companies weren't big enough to support one. But since we were so small and specialized, just Gregg and I, we were able to get clients like K2, Hawk Shoes, and Rhythm Skateboards.

Anthony Yamamoto You always see Andy putting his spice into his work. I think that's what makes you successful in that field, though: taking your unique vision and being able to mold it to what clients need.

Andy We got an office and before too long there were six employees and Imagewerks started to really grow. We broke into what I would say is the next tier of action-sports related stuff: non-endemic companies like Activision that are one tier outside the sport, meaning that they didn't actually make products you needed to ride skateboards. But they *were* making a huge impact on the public image of skateboarding. We did the creative direction for video games like *Tony Hawk's Pro Skater 3* and *4*, *Tony Hawk's Underground*, all the advertising for games like *Kelly Slater's Pro Surfer, Shaun Palmer's Pro Snowboarder, Shaun Murray's Pro Wakeboarder,* and *Travis Pastrana's Pro Motocross.* We were producing global launch events for these games and doing cross promotions between the brands and the country's biggest retailers, like Wal-Mart and Best Buy. What came with that were bigger budgets and opportunities to do bigger projects.

Mark Dowley, who started the alternative-oriented sports and entertainment *Momentum* division of *McCann Erickson Worldwide* had courted us since there were just two guys and an assistant. "I see something here," he said, "You guys have something we don't have anywhere within McCann Erickson." Then he dangled the most ironic carrot, "How would

you like to be on a much bigger playing field with some major players?" A football metaphor, I thought, how classic! We told him thanks, but no thanks, for now—we were only a small operation. He kept in touch with us for a year and a half. Finally we called him and told him we'd be interested in taking on a partner, so Dowley invited us to New York to become part of his group and present what we were about in a worldwide meeting, with every international head of his global agencies. We pull up to the offices—all jeans, backpacks, and skateshoes. We walk into this meeting room, totally nervous, to see a 40-person conference table and huge flat screens on the walls, and a massive window overlooking midtown Manhattan. All these people stream in wearing Armani suits and setting up their video presentations, and Gregg and I are looking at this big screen behind us going, "Shit, man, all we have are these little things we printed out on paper, and our backpacks filled with T-shirts. We don't even have a PowerPoint or *anything*."

Mark Dowley was tearing new assholes in his new South American divisions who were fucking up, and then he's like, "I want every single office to have a uniform image across the entire planet—except for these guys," and points to me and Gregg. "Imagewerks will always keep its name and have the same image." So we did our presentation and walked around giving T-shirts to the suits and it turned out great. We were totally winging it. Some of the offices had these professionally edited videos showing all the work they'd been doing, full of 3-D graphics, so we were totally intimidated, but afterwards people came up to us going, "That was great! You guys really know what's going on!" That's just the way we've always done it. Since then obviously we learned how to use PowerPoint.

Dowley had offered us the opportunity to come into McCann and help develop a new "Youth Culture" arm of the agency, to put together a road show and go around to all the top Fortune 100 clients and start

pitching ideas. He had us make a list of all the clients we would want to do within the McCann Family, and a list of the ones we'd like to help bring in from the outside.

But a month after we were acquired, Dowley left McCann to form Interpublic Sports and Marketing, pulling together some of the other larger agencies within the McCann and Interpublic Group folds, including Octagon and others, and started with over a hundred million in revenue in the first year. When Dowley left so did his vision of how Imagewerks could

work within this massive corporate megaconglomerate web of agencies.

A few months later a new CEO took over, the second of four during our involvement with *Momentum*, named Mark Shapiro, who had run a Saint Louis based agency called Louis London before being brought in by Dowley a few years before. We were all invited to a big corporate meeting in Las Vegas at the Bellagio, the usual McCann all-expenses paid corporate meeting, including plush gold inlaid rooms and front row seats to the Cirque Du Soleil's *O*

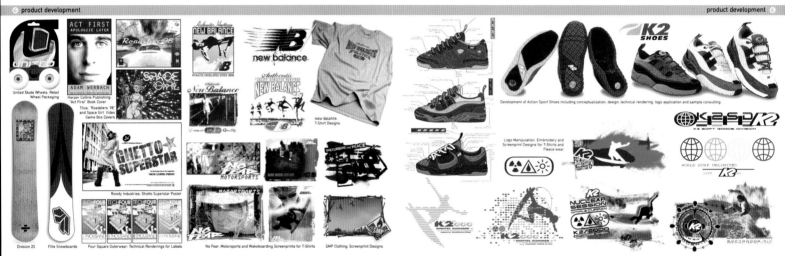

Product Development

Conceptualization, Design and Styling for products including Skateboards, Snowboards, Wheels, Video Games, Posters, Point of Purchase Collateral, Book Covers, Clothing, T-Shirts, Trims/Labels/Hangtags for Soft goods. Clients include New Balance Shoes, Titus Software for Nintendo 64, Harper Collins Publishing, Rowdy Industries, United Inline Wheels, Flite Snowboards, Division 23 Snowboards, FourSquare Outerwear, SMP Clothing, No Fear.

K2 Sports, International

Product Development, Styling and Image Consulting including Action Sports Shoe Designs and T-Shirt Designs.

Gregg and I went up with our list of clients and big hopes for our new venture, but when we got out of the presentation meeting and finished shaking hands with some guys from the London and Lima offices, Shapiro dropped the bomb.

"The Youth Culture Action Sports segment is not a big enough market to drive real business revenue. And *by the way*, we can do all the things you guys can do right from our offices in Saint Louis."

Gregg and I looked at each other and literally laughed in Shapiro's face. "You're *kidding* right?" But Shapiro was convinced that his whole Middle America approach to the youth market was more valid than two guys who had grown up with and even helped to create it. After that slap in the face, Gregg and I walked away like two guys who had just been shammed royally, and said, "That guy is a fucking clown. Fuck him. We'll do it ourselves." And it set the tone for the rest of our relationship with him. So we went back to SD, put our noses to the grindstone, and started pitching new clients.

We created an open door to do whatever we wanted with massive budgets in comparison to anything we had done before. Instead of a little promotional company working for a shoe company, we were doing a huge launch of *Tony Hawk's Pro Skater* at 55 skateparks across the U.S. We sent 110,000 flyers to kids thanking them for supporting Tony, and inviting them to come skate for free. We showed up to one of the parks in LA that day with Tony and a bunch of skaters from the game and kids were literally blown away. That was the highlight of Imagewerks for me. It was a fusion of two passions, skateboarding and design. It helped me realize why I went to school for all that time. Even Mom would be proud now. We worked for McDonald's, and Coke and all their brands, like KMX, Fanta, Fanta International. We did a line of cans for them, and made three commercials for Converse's big skate program, and worked with Toyota to launch their Scion sub-brand.

Shepard Fairey It's totally amazing doing creative work for big corporate clients. They're so out of touch with youth culture that when we throw our spin on a graphic they're just like, "Wow. You've turned this into something else," like it's alchemy. And it's hard for me to get perspective on it, because I've been living so long in the culture they're trying to market.

Gregg DiLeo We'd walk into meetings and talk about what comes naturally to us, and these people are hanging on to our every syllable because they're like, "Oh my god, this is what we

were looking for because we couldn't crack the code. These guys will crack the code for us!" It's kind of hysterical, because we could do it with our eyes closed. Not just Andy and me, but anybody who was coming from the lifestyle and working in it at that level could've done it. Partly because action sports attract people with certain personality traits. Driven people who want to make a statement and show people what they're all about, express something about the alternative lifestyle they're living, show the world why it's creative and why it's cool.

Andy and I worked really well together because Andy, even as the incredible artist and designer he is, can be so accommodating when it comes to saying, "Okay, I understand your vision; here's my way of doing it, now here's your way." A lot of our best stuff came when we met in the middle. That's such a highly valuable trait to have.

Andy In two years we sold the company to McCann, which is owned by IPG, the biggest ad conglomerate in the world. In our contracts we agreed to work for them for three to five years. That was the ultimate antithesis, I think, to the approach I had been taking for my whole career. But ironically it was the perfect thing for me. I didn't have to own the company, I could just do cool things that I loved to do, and get paid for it. Doing a skate-themed Happy Meal promotion for McDonald's—as a creative person that was a huge rush. I was stoked that I snuck in the "CAP crew" tag and my own tag, "HOner" into the art for it. It's funny because McDonald's has this massive book of rules for creatives when they do work for them, and I don't think they ever realized I basically graffitied the product I was making for them. It had kind of come full circle from tagging the bathroom of a McDonald's in Atlanta to now tagging their actual packaging and creating a whole promotion for them. I reached over 73-million kids in three or four weeks with my artwork and tags and my graff-based cartoon characters, and the promotion landed in the top ten Happy Meals of all time for North America, and the number one of all time in Australia. The irony was hilarious!

Shepard Fairey One time, someone from a youth-culture research company interviewed me for a trend-report video and asked me whether big

TINADIXON

TRAVISPARKER

corporations should do street marketing. And I said, "No because they'll do it wrong. They'll never do it authentically and they'll end up causing more damage to their brand than good because kids will start to hate the brand. They need to find the people who are creating the culture to create the marketing to the culture too." Next thing you know, Mountain Dew calls to hire me. Even after I'd dissed their whole approach to marketing. It's like when you rebuff the girl and she wants you more.

Andy Companies had absolutely no clue! I remember going to Nestlé one time, and the company people were almost panting. For one of our presentations for Minute Maid, we flew out to Texas. The only thing we had with us were these big backpacks. We walked in, looked at everyone, took the backpacks off and dumped the backpacks on the conference table. All this shit—flyers, skate stuff, magazines—fell out. The people were like, "Oh my god! *This* is youth culture!" And we were thinking, "This is the stuff that was under our desk that we wanted to throw out, fuck it, let's take it to the meeting," That was the level of it.

Gregg DiLeo It was a trip, to see how we'd gone from promoting our own punk shows and building our own ramps and circulating 'zines all so ground level and under the radar—and then actually doing that stuff on a global level, organizing promotions for huge brands. It was the same stuff I'd done as a kid, just on a much bigger scale.

When we pitched for big clients like Coke or McDonald's we were basically pitching our lives. People got really into it because we had this passion for it and they enrolled in our vision. But in the end it always came down to, "How would this affect our sales and our bottom line. How many units will it sell?" And all the air just comes out of you when you hear that. But at the end of the day, it's a business, and you have to deal.

Damon Way The skateboarding business is a tricky balance. It's so tricky that if you make the wrong move it'll turn on you in a second. Oh my god, there's not a whole lot of room for error. Look at Airwalk, it got chucked in literally just over a year and it was done. Vans have struggled to capture the core market. As soon as you take your eyes off it, the kids know it immediately. It's bizarre.

But as to whether I mourn skateboarding becoming so mainstream and no longer being underground, I think it's all relative. Me personally, I'd kind of left that culture years ago. I'd grown out of it, maybe that's why I find the mid-late '80s so much more interesting. I don't relate to the super "underground" aspect of the culture any more, and therefore I'm able to be part of a company that is bigger than the culture, or at least whose span of business is broader than the culture. As a business we're extremely sensitive to that dichotomy, though. As much as we put outside, we put twice as much back to the core, supporting skateboarding on a grass roots level in many different forms. It is important.

Shepard Fairey I don't really have a problem with doing marketing work for big companies. The only things I won't do marketing for are Hummers and cigarettes. My whole outlook about doing my Giant/Obey work while doing big advertising stuff too … well, some people have called it hypocrisy. I call it irony and think it very amusing. I'm not a paternalist at all. If you don't know a sugary beverage is bad for you, you probably deserve to die anyway. People have a free will and can make their own decisions. I didn't have any issues with doing ads for Mountain Dew.

Andy Because my mom always wanted me to be a businessman, there was a part of me that wanted to validate myself in that way. It was amazing to realize through Imagewerks that, "Shoot, I can do that too." It was a huge education to learn how creative actually works for somebody like McDonald's and be involved in the whole process, doing packaging, marketing, advertising, and promotions on that scale. I think knowledge is power: get it, and then decide if you want to use it to reinforce the status quo or subvert it—or do both depending on your mood. Without knowing how things really work, you'll always kind of be weakened and forced to operate on the margins. Above all I always let whatever I am really feeling guide me.

After selling our company and making some money and moving on, I felt like, "Okay, now I'm schooled in that."

Anthony Yamamoto The crazy part about where we all are now is that everything we did to grow skate culture, our whole lives, was done out of love. It wasn't something that was forced. Now that I have this big job at Quiksilver, my parents come to see my house, and they're like, "Oh my god, we grounded you for doing this, you didn't listen to us, and look at you now." They used to hate me for breaking my wrist and not being able to play the violin because of skating, and now they're so proud of me, you know? They have respect for me.

It's amazing to look back at all the people who were kids skating and surfing in my area, in North County, in L.A. Now a lot of us own companies, host TV shows, and do work for major brands. And we all just did it out of love.

Andy Imagewerks was a thrill ride from a commercial art standpoint. But Gregg and I would look at each other during those three or four years and go, "Wouldn't it be rad to do another brand? To start our own company, a clothing brand?" In the back of our minds we knew we'd still have to do something like that.

During Imagewerks I had sort of resigned myself to the obvious fact that I had a "day job." I was painting like crazy still and traveling to shows on weekends, all the while hustling the long days at Imagewerks. I really enjoyed the creative we were doing at the agency, but because of the way the brand managers for the companies were forced to dilute our concepts down to virtually nothing, it wasn't fulfilling. I was exhausted while preparing for art shows, because I was burning the candle at both ends.

Gregg DiLeo The bottom line for anyone who has an agency, especially people like us who did a lot of "radical" alternative stuff, is that the client always picks the most conservative of your pitches. The full-on, left-wing, really creative idea you and your partners would want to see realized doesn't make it. They end up whittling away at the most conservative one until they get to the basics.

Andy It's kind of weird, I went from one end of the spectrum doing all this crazy underground, grassroots stuff and then to the other end as mainstream as could be, and I really began to feel that I wanted to be outside the spectrum completely. So my painting and illustration was starting to come much more into focus.

XMAS CHEER®

(YEAH, IT'S THAT TIME AGAIN...)

HOWELL 01

Gregg DiLeo I think Andy's happiest anywhere he's inspired, but also where he can truly bring his own vision to fruition. It doesn't matter what genre it is, be it film, fine art, advertising, graphics, designing a shoe ... he just wants to create.

Shepard Fairey I'm still doing my thing and doing my street art as vehemently as ever, because I like to set an example by doing things that are maybe bending the rules a bit, but that will get you somewhere in a creative way. I want to share the empowerment of it. Me as one guy with a shoestring budget was able to build this image industry competing with massive corporations with huge budgets behind them.

A lot of people don't do stuff because they're paralyzed by fears of failure and the first step is actually trying. I like to keep that spirit with everything I do. To incubate the creative culture. And I guess my success has come from not pandering to people and doing things my way. What's so great

about skateboarding is that within the stylistic conventions of the genre there's so much room for creativity and independence.

Tommy Guerrero What will happen to skating in the future? Well sure, there's other stuff that people call trends coming in and out. Kids are kids and they'll want to try everything. But the ones who stick with skating will be different for the rest of their lives. It will change their lives no mater what. I know people from all walks of life who still carry it with them—be they a banker or artist or whatever. Skateboarding's definitely never going to die. People talk about the "commodification of skating," but regardless the one thing you can never take away the rawness of skating. You can never denounce some kid who's throwing himself down twenty stairs and bleeding from every pore. That's just so raw. You can never take it away. Beat yourself into the ground several thousand times and you'll be dedicated for life.

this spread, clockwise from top left:

Time Warner's Teen Active Network, Speak The Language Ad Campaign 2000
This campaign was the first big ad campaign we did which ran in MediaWeek and AdWeek. It was to package all of the Transworld magazines for mainstream ad buyers. Grant Brittain shot it at the studios at Transworld.

Team Converse World Tour Poster and Sticker Campaign 1999
I illustrated this collection of caricatures from photos provided by Converse, and the sticker collection became so popular at the demos that it actually spawned a worldwide promotional contest for kids to collect all of the team rider stickers.

Tornado Wheels Logo, Products, and Catalog 1998

Rhythm Skateboards Danny Montoya Ad 2000

TEAM CONVERSE

CONVERSE ALL STAR

WORLD TOUR 99

CONVERSE ALL STAR

KENNY

CONVERSE ALL STAR

FELIX

CONVERSE ALL STAR

STEPHANE

Felix Arguelles · Chany Jeanguenin · Kenny Anderson
Stephane Larance · Jerry Fowler · Danny Supa

TEAM CONVERSE

CONVERSE ALL STAR

WORLD TOUR 99

Venezuela · Costa Rica · Italy · France · Belgium · Holland · Germany · UK
USA · Asia · Australia · Japan · Spain · Hungary · Israel

this spread, clockwise from top left:

McDonalds Board Buddies Fingerboard Happy Meal *circa 2000-2001*
Ed Cleary called us one day and asked if I would illustrate some characters for a Happy Meal. As I was drawing them I started to create a story around them, a logo and a whole range of character ideas. When the Happy Meal promotion launched almost a year later it sold over 73 million units in 5 weeks, landing it in the top ten Happy Meals of all time for North America. It went on to run in other parts of the world, and became the most successful Happy Meal of all time in Australia and New Zealand. We didn't get paid much for it, but I believe it is one of the campaigns that positioned us for aquisition by IPG's McCann Erickson Worldgroup the following year.

GYRO

SKECH

SKURKLE

above:

***Time Warner's Teen Active Network, You Thinkin' What I'm Thinkin'? Giant Postcard Campaign** 2000*

Gregg and I came up with the tagline "We know what's up and who's down" because we knew that the mainstream ad buyers we were targeting were totally clueless, and basically didn't speak the language of the youth culture we were coming from. So we sent out these huge 2'x1' postcards with the images at the top of the page where the person asks" You think' what I'm thinkin'?" to all the big media buyers, then followed them a week later with the postcard images featuring the headline "Didn't think so..." It was such a success because no one saw it coming, and it caused a lot of the majors to question if they did know what they were doing, and to eventually connect with Transworld for advertising.

below:

***IZ/TV Title Sequence and Show Intro** 2002*

This was my first adventure in motion graphics, which I created using After Effects, Infini-D, and by making hundreds of bitmap images and importing them into the Henry editing machine at one of the studios in Hollywood. I took footage from friends and the show's producers, and mixed it all down with music in a 30 second opener . It aired on about 15 cable stations, and opened a new door for me to television and film production.

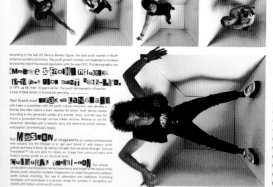
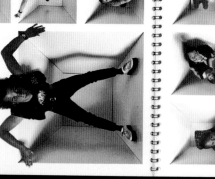
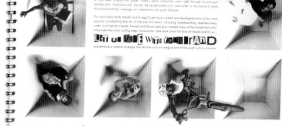

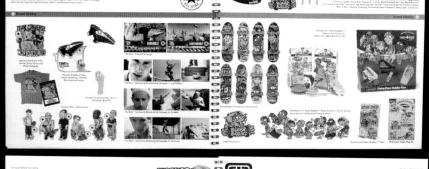

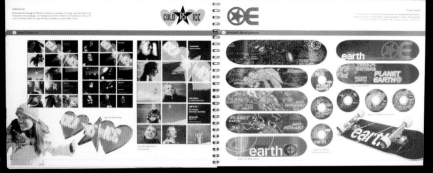

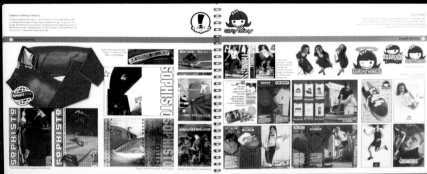

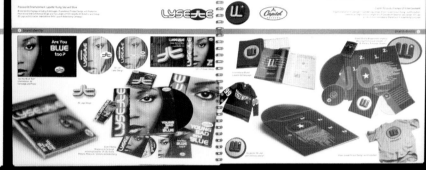

imageworks.

Our Story

In an age when trends move at fiber optic speed, Imagewerks, Inc., a trendsetting boutique agency in Southern California has solutions to the challenges of communicating with the youth audience. Imagewerks connects companies and products with the "coolest" customers utilizing it's unique method of "Cultural Translation" to create, recondition, and adapt brand identity for the cutting edge youth market.

Historically, the youth market has always been tough to reach and this is even more evident today. "Kids are smart, they can see through the smoke and mirrors" explain Imagewerks co-founders Andy Howell and Gregg DiLeo. "The youth market today is much more sophisticated than say 15 years ago. Kids have access to way more technology and the internet has had a big impact on how quickly trends move. In order to capture a large market share with a true following a brands image must be cutting edge and impressive to the most trendsetting individuals." To cope with this crucial issue Imagewerks has created "Cultural Translation" a process which utilizes their intuitive foresight of what's cool with sophisticated visual communication disciplines and marketing strategies to create, recondition, or adapt a brands identity for the trend savvy youth market. "We grew up as trendsetters, so there has never been a question of who or what's next", says Howell. "It's not just a matter of picking a certain color which is coming in or a hip word or phrase or maybe even a cool looking kid. It's the process of combining all of these elements and adding the 'secret sauce' which will peak the interest of the trendsetters in a given market."

Howell and DiLeo are true authorities on youth culture trends, they are the quintessential subjects for every trend forecaster's research. Both grew up immersed in the trendsetting, individual sports lifestyles of skateboarding and snowboarding. "We are products of our environment, the board sports subculture that sets many of the core trends which become mainstream staples." explains DiLeo. "We aren't on the outside looking in, Imagewerks is on the inside looking out. We understand how to adapt brands for the youth market. There is so much more to communicating a brand's image than just traditional advertising. Our creative approach to alternative marketing techniques enables us to maximize a brand's success."

Andy Howell's roots in the alternative sports industry developed during the seven years he spent circumnavigating the globe as a professional skateboarder beginning in 1988. He formed friendships with countless emerging artists, magazine groups and action sports distribution companies around the world. Howell enjoyed the opportunity to meet, skateboard, and connect with kids from many diverse cultures in his travels which has given him a keen insight into the understanding of youth trends.

During his career as a top professional skateboarder Howell received his Visual Communications degree and founded New Deal Skateboards, Element Skateboards, and Giant Distribution. As Creative Director at New Deal, Howell was the prime force in ushering in the still prevalent trend of graffiti and cartoon influenced graphics for skateboards and t-shirts. His "Big Deals" were the first baggy jeans designed specifically for the boardsports industries. Howell then moved on to create and direct Sophisto Clothing, MTN, Girly Things Clothing, Freedom Video and Rowdy Industries.

Howell has art directed for an eclectic array of companies including Freeworld Entertainment, Casio, G-Shock, Vans, Inc. Tornado, Skateboard, Wheels, Rhythm Skateboards and Times Mirror's Teen Active Network. He has created extensive clothing and textile designs as well. His work has been featured in magazine reviews including: The FACE (UK), R.A.D. (UK), Sky (UK), Women's Wear Daily (NYC), UHF, SPIN, Transworld Skateboarding, Transworld Snowboarding, WARP, Time Out (NYC), Art Direction MINT (Microsoft Online), SPTV (Turner Online), Big Brother, Skateboarder, Lodown (Berlin), Seventeen, Sassy, VIBE, Rolling Stone, The Source, EYE, Photo, and Slap, among others. His Video and design work has been used for classroom study at the School of Cinema and Television at USC San Diego. Howell creates illustrations and paintings that are displayed on skateboards, snowboards, t-shirts, posters, print ads, flyers, catalogs, storefronts, at art shows and on the street. He has shown his illustration and fine art work in London, New York, Atlanta, San Diego, Los Angeles, Philadelphia and Tokyo, in notable galleries such as The Alleged Gallery, The Candide, The Art Institute of Atlanta, The Art Institute Gallery of San Diego, ModArt, Dysfunctional, London, Move 2, and Space 1026.

Gregg DiLeo accents his 10 years of extensive experience in the snowboard industry with a lifelong dedication to the sports of snowboarding and skateboarding. He draws from an eclectic background of corporate identity development, marketing and creative direction within an industry that's roots are on the trendsetting edge of the youth culture. He was creator of Division 23 Snowboards and founded Forum Snowboards, two of the fastest growing snowboard companies in the industry's history. Both companies have had some of the most substantial impact on the sport of snowboarding and have taken use of brand identity to a new level in the sport. He has used these companies to display his talent for seeking out market niches in a tremendously image conscious industry and maximizing their potential growth.

Division 23 advertising campaigns have been some of the most memorable campaigns in the sport of snowboarding and have been used as a proving ground for snowboard advertising since. They redefined the use of imagery in snowboard advertising to exemplify the personality of the athletes as well as brand identity. The Division 23 ad campaigns have been awarded with accolades 'most popular ad campaign' and 'favorite individual ad' in the Transworld Snowboarding Magazine readers polls for 1995 and 1996. Snowboard graphics that DiLeo has conceptualized and art directed have been featured in publications such as Playboy Magazine, Transworld Snowboarding Magazine, Snowboarder Magazine, the New York Times, Details, the Wall Street Journal, and many others.

DiLeo also has extensive experience in image development and management of some of the most notable professional snowboarders in the sport. He has used his acute understanding of the importance of image development to optimize their talents and bring these athletes to the forefront of celebrity status in the snowboard industry. One of his more famous protege's is professional snowboarder Peter Line, whose image he developed from his beginnings as an amateur rider and who can only be described in layman's terms as a Michael Jordan of the individual sports world.

To get connected e-mail us at
contact@imagewerks.org
or visit us at
www.imagewerks.org

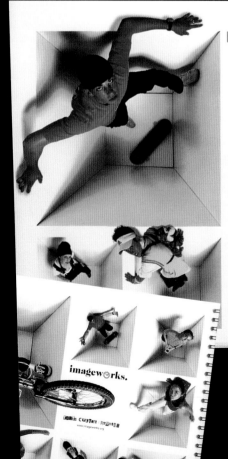

imageworks.
www.imagewerks.org

Activision's Tony Hawk's Pro Skater Series *2001-2003*
In 2001 Gregg and I landed Activision as a client,
just after the launch of Tony Hawk Pro Skater 2. We
took over alll graphic and logo applications, as well
as the print advertising for the franchise. By 2002
we were also helping them brand a new division of
Activision which we named 02 to signify "big air".

A slew of new games were launched, including Kelly
Slater's Pro Surfer, Travis Pastrana's Pro Motocross,
Shaun Palmer's Pro Snowboarder, Shaun Murray's
Pro Wakeboarder, and Mat Hoffman's Pro BMX.

Gregg and I also took over the launch promotions of
the games, and for Tony Hawk's Pro Skater 3 and
Tony Hawk's Underground we did nationwide events.
The Tony Hawk's Pro Skater 3 launch was my
favorite, because we actually bought out 55
skateparks around the US and mailed out 110,000
invitations from Tony to enjoy a nationwide "Skate
Free Day." Transworld Skateboarding did an article
about it, and we made surprise visits to a couple of
skateparks in the LA area with Tony, Bucky Lasek,
Bam Margera, and a few of the other skaters in the
game. It was the most successful launch of the
franchise.

left:
Tony Hawk and Andy Howell *2003*
photos: Grant Brittain

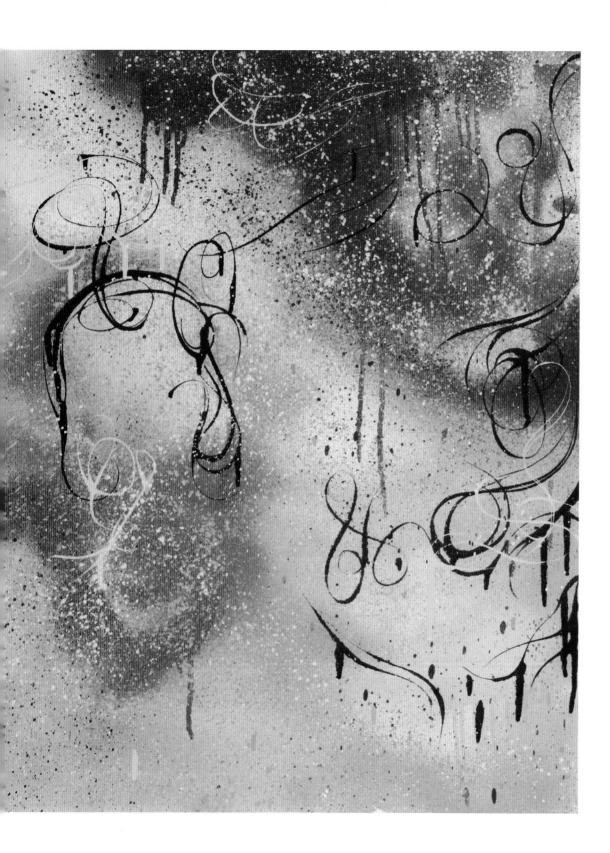

Frequencies 2003
Acrylic, Lettering Enamel, Spraypaint on Canvas
30"x40"

CHAPTER 9
(ART AS THERAPY)

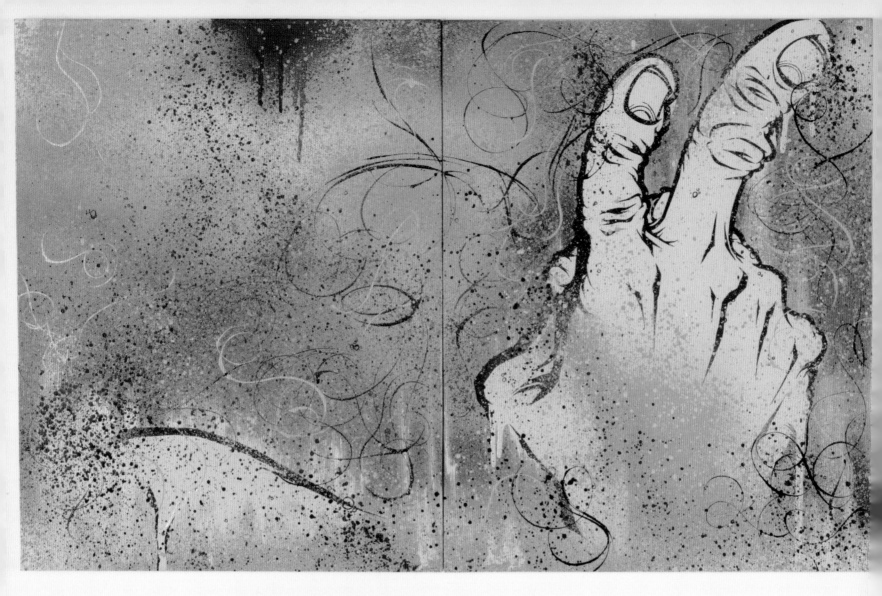

(Art As Therapy) *The Kantor Gallery 2003*

Andy In April '03, I got asked by Neils Kantor and Kent Parker to do a show at the Kantor Gallery in Los Angeles. I was so excited. As a fine artist, it was the ultimate kudos. I got started looking for a theme, and doing these white paper concepts for the show. I had all these different ideas—which I can't remember because they were crap. Frankly, I was trying to come up with a cool theme for a cool show for cool people to look at and say, "That's cool." It was the opposite of why I was doing painting in the first place. So I got stuck and didn't know what to do.

Meanwhile, my dad called me. He was driving to his house in Kitty Hawk, North Carolina and said he was going to stop by the doctor's office on the way, because he'd been having stomach pains. My dad had Hepatitis C from being a dentist in the '60s and '70s, when they never wore gloves. He fought it and it seemed totally under control. I couldn't imagine my dad ever being seriously sick—he was the ultimate understater. So I said, "Shall I come out there?" "No, don't worry about it, I'm fine, I'm just going to stop at my doctor for some tests and drive down to Kitty Hawk tomorrow morning," he told me. I'd heard him say the same sort of thing a hundred times before, so I hung up and I went out that night partying with friends, and came home around three or four in the morning. My phone rang and it was my

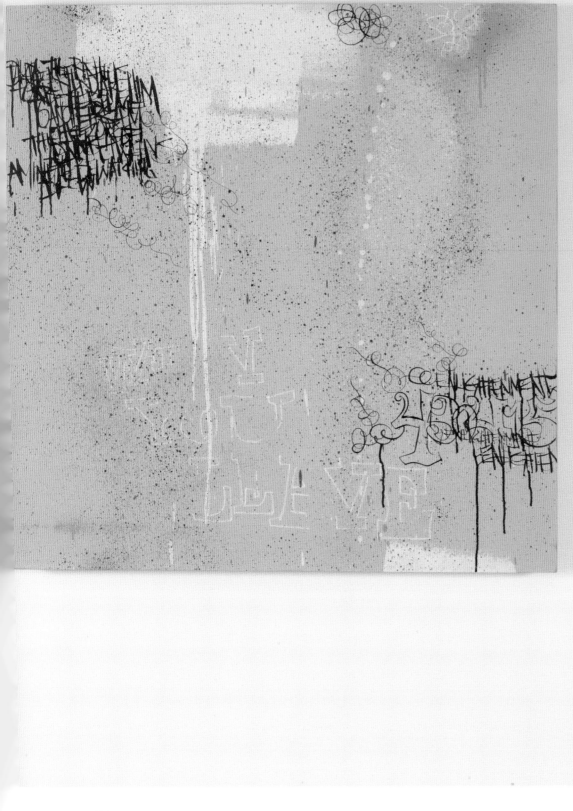

Enlightenment 2003
Acrylic, Ink, Spraypaint on Wood
36"x36"

sister Courtney, in Virginia. "You've got to come out here. Dad's in a coma." I was drunk, spinning, and totally freaked out.

The next day I flew out there, walked into the hospital, and found Courtney sitting with him. My dad was there, but he was gone. I picked up his hand but it was limp. He wasn't moving. I held his hand and thought, "I may never talk to him again."

That first night, I just sat with my dad, holding his hand. The whole time, the big toe on his right foot was the only thing moving, twitching every couple of seconds. Seemingly miraculously, he came out of it a bit. He had a day when he was in this in-between zone. His eyes were open and rolled back in his head, he was staring up into space, and he couldn't talk or communicate at all. He just groaned. He came out of the coma and couldn't talk. He'd been doing this gutteral coughing thing and his voice was gone. He was talking but in a whisper, he could only say three words at a time. That lasted for about four or five days. That's when my sister and I got to have our last everything with him.

It was one of the most incredible experiences of my life. There was no time not to be 100 percent present. When I would start to pull away from it, filling my head with meaningless day-to-day worries or drifting off into a sexual fantasy to escape I'd catch myself and go, "Where are you running to? This is *it*." So I forced myself to face my own fears of losing him to death. My sister and I would see when each other was about to crack and walk out into the hall and explode into tears. And the doctor's going, "Look, don't have hope. He's not going to make it. His liver and kidneys are at 98% failure. He's shutting down." Those doctors in those fluorescent-lit conference rooms were a fucking nightmare. It was the most intense experience to get to a point where we began to let go of him, even though he was still there.

He was hanging on almost for show. For us. At one point he was lying there, my sister and I were each holding one of his hands and I was holding my sister's other hand. And I said, "We're going to be okay, Dad, we're going to make it." And his eyes, which had been almost shut for three days, flew open. Even though he had no strength and was nothing but bones, he sat up on his elbows and looked at me, his face, eyes, and mouth wide open in amazement. I was allowing him to see how much I loved him and he looked at me with this awesome look,

of sheer happiness and amazement. It was *love,* like nothing I had ever felt before. And he looked at my sister too, and we were just crying while he simply smiled. My dad was coming to the realization that he was going to die right there in that hospital. I was so sad, but at the same time proud of how strong he was. It was the ultimate culmination of our relationships. If I'd run away from it, I'd never have been able to experience it.

We said all our goodbyes and he slipped back into a coma. The doctor said, "I think he'll be in the coma for a week and then won't come back." I had already told Dad all the things that bugged me, all I was pissed off about. About five years back, we'd cleared the air when we shared the *Impact* program experience. So I had some peace with it. I told him I loved him, and he said he loved me too, and I thought that goodbye would be the last time I ever talked to him.

So many people came out of the woodwork in those few days—literally 50 people. He was this little guy—just five-foot-six—but he was the basketball and football star of his high school. All these people came to visit him in hospital, like this girl who had had a crush on him when they were teenagers, who came with her husband and told me how in love she'd been with my dad, what a great a man he was, and how much love and real respect she'd always had for him. It's like we were learning all about him for the first time. People and family and old friends showed up to give their respects and share stories with us. I'd never even known he was a basketball star. He never, ever talked about himself. He was the most unassuming person ever.

After I started to travel home, I got a call from the hospital that he was conscious again. I talked to him and I knew the reason he'd woken back up was that he had to talk to Courtney again. To let her say the things she hadn't said to him, just like I had. I said, "Everything's fine, Dad, but you can't leave 'til you talk to Courtney, 'cause she's hanging on to things. You gotta talk to her." And he said, "I know." And then I told him I loved him, and he said he loved me too.

I felt a slight calm, and I said, "I'll see you again." And that was the last time I ever talked with him.

It was the most powerful thing anybody could ever experience. He got to see Courtney and it's what had to happen. And then he did what he always did. He just fell asleep and slipped away when everyone else wasn't paying attention.

I came home from that and went into my studio and started to paint. Everything I painted was everything I'd experienced. The pictures from that show tell you everything. That's all I could do, all I could think about, all I could paint. I was crying in my studio, laughing, listening to music. All these things were coming out. It was therapy—that word became the title of the show. I almost had to be alone in the studio and come to terms with it myself because when it was happening it was the whole family—fifteen people going through it at the same time. It wasn't just my own experience of it. I remembered seeing him just as he came out of the coma, not recognizing anyone. He looked into the sky and said a woman's name in a perfectly clear voice. And none of his brothers or anyone knew who she was. Was he in between something? Was he seeing these other people? Was it someone coming to tell him, it's time to go?

When I started putting this all down, all these images started coming to me. I started seeing these angels, these yellow gangly creatures kind of like my characters, with backpacks on. And the backpacks were helicopters. They had big goggles on, like *Ranxerox* goggles. They had tattoos on their heads and shoulders which were the time and date they were assigned to pick up their dying person. They'd fly down and ease the person out of life—pulling their hair, pulling their face. Many people might have said, "That's gross." But for me, it's what I thought dying must be like.

And a year later after my sister and I scattered my father's ashes from a Cessna over the stretch of beach where he'd taught me to fish on as a kid, I saw the angels again. As we taxied back to the hangar after the flight landed, I saw a sign for a local flight school which read "Yellow Mosquitoes", and had a handpainted graphic of a gangly yellow mosquito with the same goggles as my angel characters. It's like my dad was telling me he had seen the paintings I had done for him.

Playground 2003
Acrylic, Ink, Paper, Spraypaint on Wood
12"x24"

Out Of My Skin 2003
Acrylic, Ink, Paper, Spraypaint on Wood
12"x24"

Zone Of The In Betweens 2003
Acrylic, Ink, Spraypaint on Canvas
72"x72"

Kenton Parker, artist, Curator "Therapy" Making the work for this show was a really, really big step for Andy. It was very deep. The show was all about how you feel when you lose someone—it wasn't for everyone. Andy took a chance, he didn't just put all the colors and characters people know and love out there. He did a lot of abstract paintings and he painted from his heart. It has this drippy gestural style, and when you look at it, you know there's something else going on. It's full of dichotomies. So many people just sell shit they can sell right now, so the biggest joy for me working on that show was seeing someone take a chance, and taking something that really affected him and making art from it.

Andy Patricia Arquette saw one of my works, a twelve foot by eight foot painting called "Tomorrow Never Comes." It's basically those angels pulling this man who is staring off into some other dimension, with his hair wrapped around their arms. They're tiny, and one is reaching into his mouth to take his last breath. Patricia immediately realized what it was about. She had lost her dad a year earlier.

Patricia Arquette, actress I didn't know the show was going on. I was stopped at the light outside the gallery and I looked over and saw the painting I ended up buying in the window. I immediately had an emotional response to it. So I parked and went in. And it was like being in some kind of distorted reality where you're almost walking in to your own life. Because our

dad had died the year before and so much of the show was oddly reminiscent of that. There was this written piece that Andy had done on the wall. And his handwriting looked a lot like my brother David's and it looked like he was talking about his own life, even referring to holding "Courtney's hand," which is his wife's name. The whole thing was really weird and really familiar. I felt a lot of pain in the room that was really familiar. Yet it also was beautiful that creation was coming out of this pain.

There were so many things in the exhibit that I related to. You could feel the painter's age, you could feel he was a young person and it was happening so suddenly, not in the time you'd somehow been prepared for.

Above: view of Kantor Gallery front window, Los Angeles, California 2003

Even the fact that my siblings and I are all artists and our dad raised us in some way to become that. And here is this father who the son is loving and mourning and talking about, and he's even talking about all the weird things happening when someone's dying, like him being horny and feeling bad about that and all these bizarre things that seem so private. He really exposed everything. And it was so raw.

A lot of people go through death and losing parents younger than they ought to, but there's not a lot that rings true when you see it in the world around you, or when you hear it spoken about, or you read about it in books. It just doesn't seem familiar at all. It's like these people had some other experience; whatever you had is something from another planet. Seeing Andy's show it felt like a familiar planet. As deep as death is, that's what it felt like.

I don't know if Andy got this from death, but what I ended up getting from my dad's death that I hadn't got from my mom's death was, how to die. I almost felt like that the second my dad died, he said, "Let's go. Let's go on this adventure. Come on!" And so in a way he taught me to die like that. And in Andy's painting, by turning death into art like that, it felt like he said, "Let's go," too. It's so huge when someone you love that way dies, it could so easily shut you down completely. So it's pretty miraculous when someone actually erupts with all of this work that comes out in such an intimate way.

previous page:
Portrait Of A Spirit 2003
Acrylic, Ink, Spraypaint on Wood
48"x24"

Safe From Your Secret 2003
Acrylic, Ink, Pastel, Spraypaint on Wood
36"x36"

Synchronized 2003
Acrylic, Ink, Pastel, Spraypaint on Wood
36"x36"

Andy I went to Patricia's house in Malibu and she had me take down a huge painting by Robert Williams, which was the centerpiece of her living room, and replace it with mine. I was like "Patricia, I can't take down a painting of someone whose posters I collected since the time I was thirteen, it's sacrilege." But she said, "Just lean that one against the wall over there Andy and put yours up." I had seen her in *True Romance* and thought, "She is such a bad ass. That's someone I'd really like to know." So it was another full circle thing. My art did exactly what I always want it to do: it bridged the gap to someone who'd had a similar experience.

At that show, people came up to me, kind of freaked out. One girl whose dad was terminally ill said she was still hiding from it. She was in tears. Another had lost her father the year before and was crying too. When I was in my studio painting it didn't feel like it was powerful work. But it turned out to be, because it was completely heartfelt. There were no "cool" filters whatsoever, and people could feel that. At the show, I didn't feel the same way as the people who came up to me crying. I had gone through that part already. I just felt satisfied that I had paid this respect to my dad, and it felt complete.

I had this vision about two and a half weeks before my show. I went over to see my friend Gustaf who works with metal, and told him my vision. I wanted to recreate the moment when my sister and I were holding my Dad's hands and sharing our love with him, the moment when he almost rose up out of his bed and he had this huge smile on his face. I wanted to share that magical moment in my show, and add in the other commentary I had about the experience. Like when I was in the hospital room I was looking at all these fucking life support and drip machines and thinking, it doesn't matter how much money you have, none of it can do anything. It felt pathetic. It's like the business of death: doctors have to break the news and

quickly move on to the next one. This is my rebellious side coming out, but it almost felt like we were being shuffled through. "This one's going to die, let's move on to the next."

Gustaf is one of those guys who, when he gets it, it's a mission. He heard me out, and welded my ideas together. We found all these pieces of machinery to make a sculpture. The machines in the hospital print out receipts that say, "Thank you so much for your patronage," along with the list of the drugs that are being pumped into the patient. So I knew the sculpture had to talk. I still had all these phone messages from my dad telling me he was sick and from my sister telling me he was in a coma, so I edited them into soundbites that you could hear from the machines in each corner of the piece. You'd press a button and hear the sound of the angel's helicopters and the radio communication between the angels zooming down to pick him up. It was really overwhelming.

The content was so emotionally charged and so literal. People can't exactly take a picture home of a guy with all these tubes coming out of his arms. It's not necessarily the thing you want over your couch. But the experience I wanted to create was exactly what was created. All this was happening as I was working fulltime at Imagewerks. I was in the studio 'til four in the morning every day. It was the ultimate homage to my dad.

And it confirmed that I should never be trying to make up what's cool for other people when it comes to my fine art. And that if I ever do that, to just stop painting and go do something else, and come back later when I'm inspired to paint. Some of the paintings in the show, like a portrait of Eric Ellington, are pieces I did during that time when I needed a break from thinking and feeling about the death of my

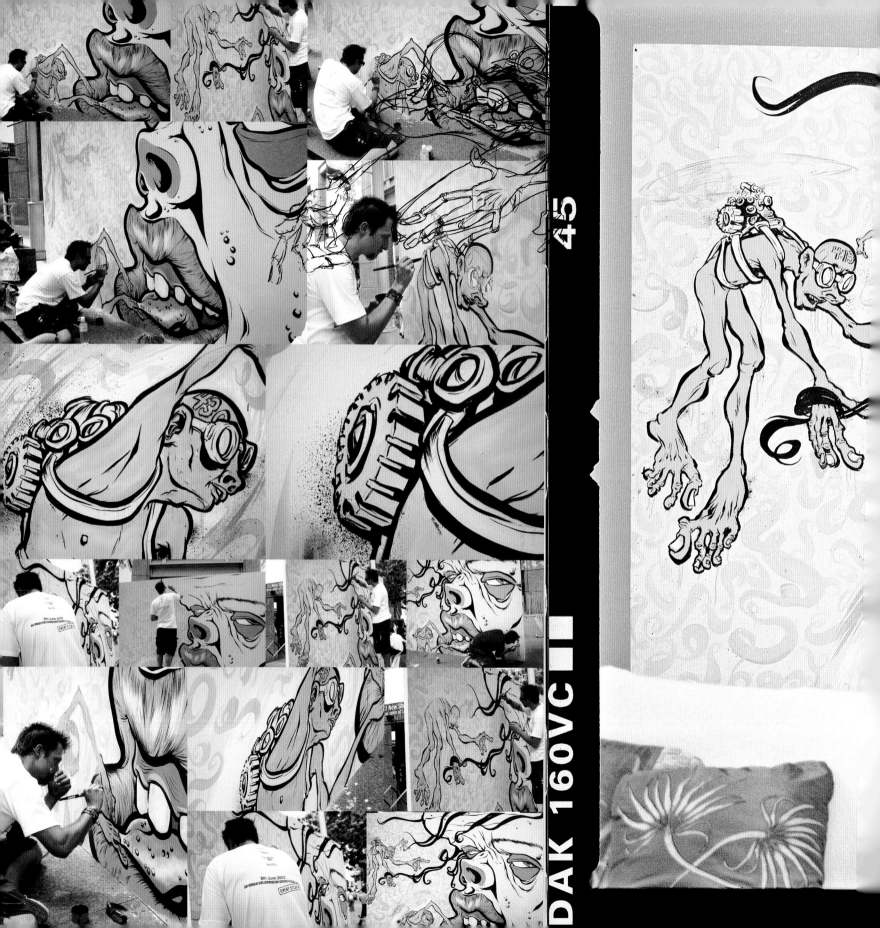

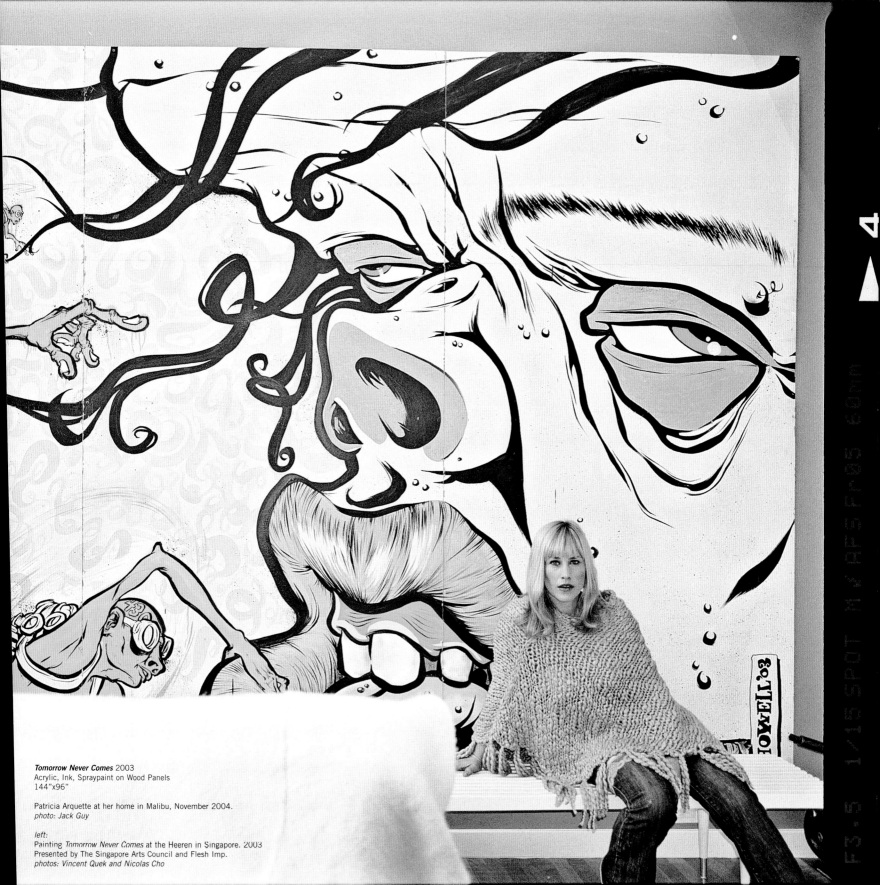

Tomorrow Never Comes 2003
Acrylic, Ink, Spraypaint on Wood Panels
144"x96"

Patricia Arquette at her home in Malibu, November 2004.
photo: Jack Guy

left:
Painting *Tomorrow Never Comes* at the Heeren in Singapore. 2003
Presented by The Singapore Arts Council and Flesh Imp.
photos: Vincent Quek and Nicolas Cho

father. The therapy was getting to be too much, and those kinds of works were like little bright lights in this dark gray zone I was coming through. There was so much positivity in the therapy of the painting experience but it'd get so heavy sometimes, I'd be like, "I can't do it right now! I've got to paint a picture of a chick or a skateboarder!"

Kenton Parker Andy's always moving. You'll look at his work at the end of his life and it'll all make sense. But as you look at the day-to-day stuff now it always changes and evolves and progresses, which is good.

Andy I only have two of my own paintings up in my house. One I did in '98, called "Feed the Family," of a guy holding a fish. It's inspired by the Pablo Neruda story that's in the movie *Il Postino*. And another six-color serigraph called "Disconnected," with all these body parts that are separate from each other. That came about because in 2002 I had this tumor in my back, and for a year I was completely addicted to Vicodin. It felt like nothing fit together and nothing was working in my body. Everything I was doing was influenced by this relentless pain. I painted over a hundred pieces that year, including a massive twenty by eight foot piece I did in Denver called "Veronica's Prescription Dream," which depicts a woman in a drug-induced hallucination, with blue geese flying around her, emptying these multicolored capsules containing all the issues she's ever faced in her life. During that year I felt completely disconnected, and that manifested as all these drawings of fingers and toes chopped off at the bone, or heads cleanly sliced into three pieces like that horse in *The Cell*. It was a really rough time.

The doctors didn't give me an MRI for the first six months. Finally, the MRI revealed a cyst in my lower back, near the spine. I went to see a specialist and he operated on me, cut me open, took the cyst out—this was after a year of being in pain. They said, "You'll feel a lot better in a week." So I laid around for a week—meanwhile my partner, Gregg, at Imagewerks was breathing down my neck to come in to work, that was a bad point between us—but the acute pain didn't go away. I had one insanely painful night, and went back to the hospital in agony. The doctor's in Aruba, of course, so his assistant comes in and says, "This isn't right, the new MRI we just took shows another cyst two and a half times the size in the same spot."

So the doctor comes back and I go under the knife again. Right before he put me under, he let me know that I could become paralyzed from the waist down

and that there was a chance I might lose all feeling in my left leg. This terror came over me—and I fought it as the black closed over me. The surgery was supposed to be an hour, but it lasted three and a half hours and the doctor finally comes out sweating and tells my family, "I think we got it." He told my mom he'd finally removed from my spinal column a marble-sized tumor with a four-inch tail that had wound itself around the sciatic nerve and was pulling it from the stalk. It tested benign. Sixteen staples and a week later I was standing and walking around and it healed right up. I'm not sure who blessed me, but I feel very fortunate. Within a month I was back to normal. It was an intense year-long experience, and then only five months after the last operation on my back, Dad went into the hospital and died within a week.

Like the infected skateboard cut on my shin at eighteen that nearly cost me my leg, and like the chunk of skateboard-wood that was caught in my lip for a year after a botched stitching operation in a third-world Portuguese hospital, the tumor with a tail was another reminder. I am definitely a cat with nine lives, maybe ten, maybe forty three, and the experience with my dad just reminded me of a certain fact: We're only here a short time, make the most of it. It all happens the way it's supposed to, and I always have this feeling it's all gonna be okay. And just like when I was fourteen, hiding away in my room to make *Sic Nature*, art has always been my refuge to get to my spirit, or to work out the puzzles of life. That act of self-expression has been my therapy all along.

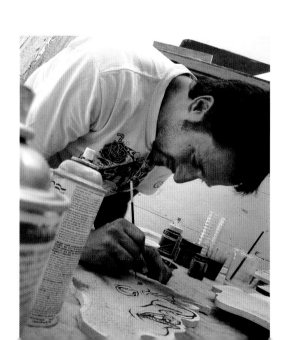

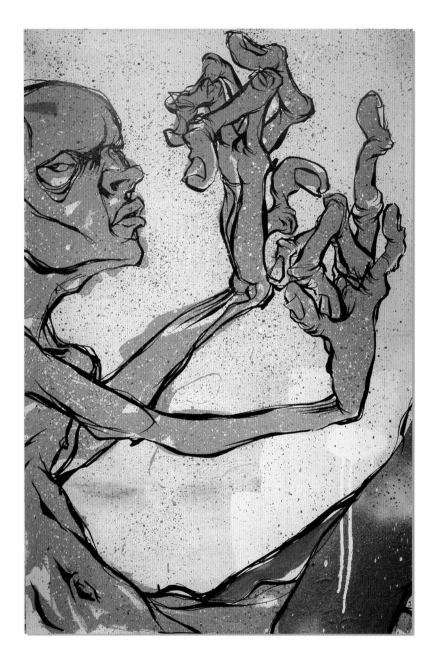

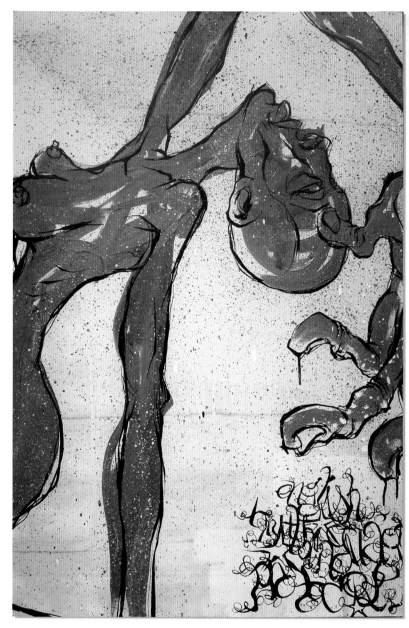

next page:

English Protocol 2003
Acrylic, Ink, Lettering Enamel, Spraypaint on Wood
52"x48"

Strange Angels Like Thieves 2003
Acrylic, Ink, Lettering Enamel, Spraypaint on Canvas
48"x60"

SAFE FROM YOUR SECRIT

I SHALL DRIVE MY CHA
DOWN YOUR STRE
WHEN THE FLYS WITH
THE SWALLOWS TO
SAN JAN CAPISTRAN
JUST RIGHT
SATISFIED
HE BREATHED OUT A
THAT WAS IT

TIME TO
REMOVE SUPPORT
SYSTEMS
THE TUBES

HANG
ON

TAKE IT TO A WHOLE
NOTHER LEVEL

Starcatcher (detail) 2003
Acrylic, Ink, Lettering Enamel, Paper, Spraypaint on Wood
72"x72"

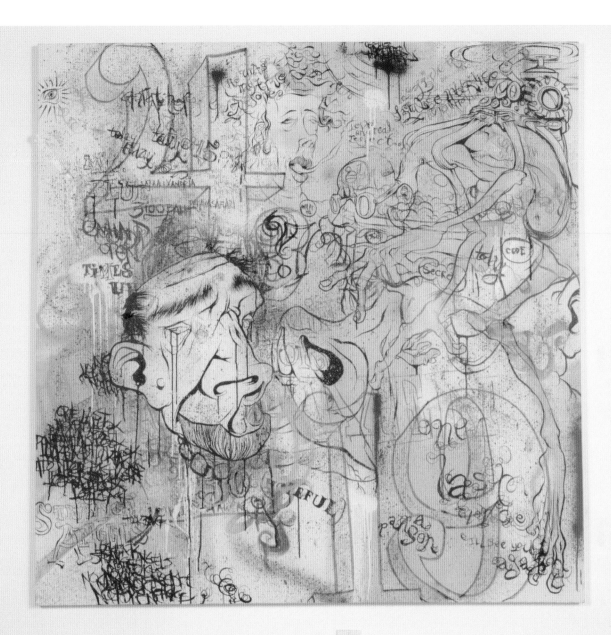
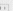

Starcatcher 2003
Acrylic, Ink, Lettering Enamel, Paper, Spraypaint on Wood
72"x72"

Portrait Of Erik Ellington 2003
Acrylic, Paper, Enamel, Spraypaint on Wood
36"x36"

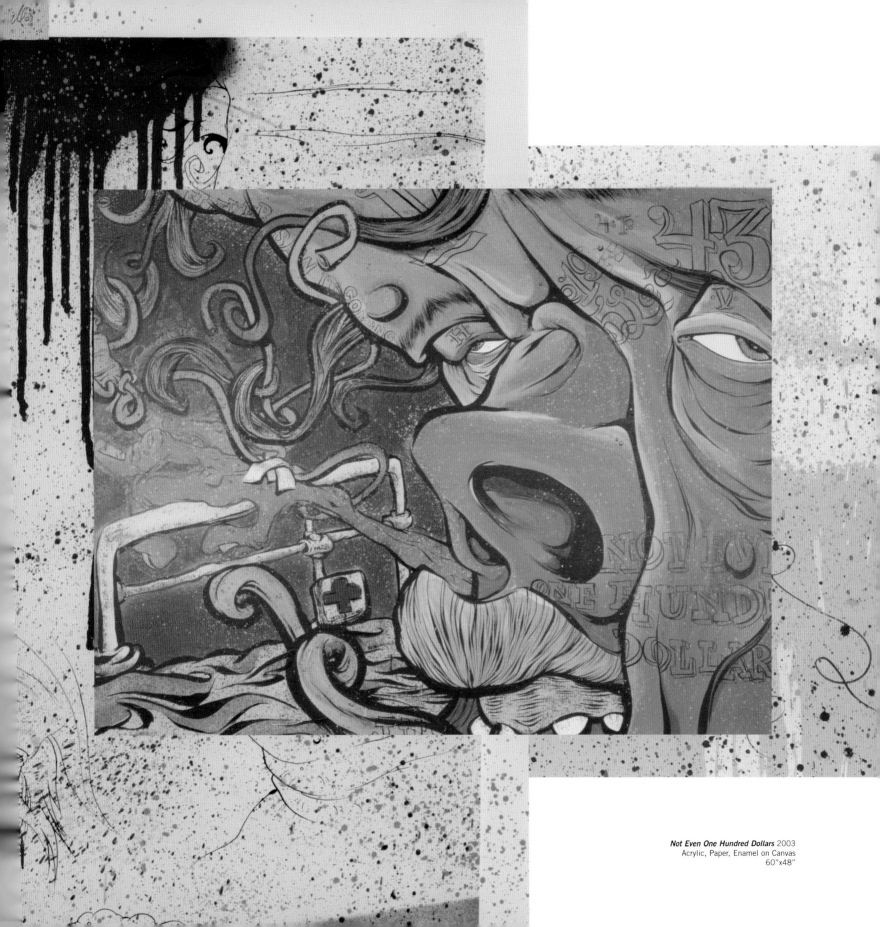

Not Even One Hundred Dollars 2003
Acrylic, Paper, Enamel on Canvas
60"x48"

Raise The Dead With Lactulose 2003
Acrylic, Pastel, Enamel, Spraypaint on Wood
25"x12"

next page, clockwise from top left:

Untitled (Lips and Teeth) 2003
Acrylic, Pastel, Enamel, Spraypaint on Canvas
12"x12"

Syringes 2003
Acrylic, Enamel, Spraypaint on Canvas
12"x12"

Untitled (430415) 2003
Acrylic, Pastel, Enamel, Spraypaint on Canvas
12"x12"

The Tale Of Obici's Yacht 2003
Acrylic, Enamel, Spraypaint on Canvas
12"x12"

following spread:

Various Details
Andy Howell (Therapy) exhibition at Kantor Gallery 2003

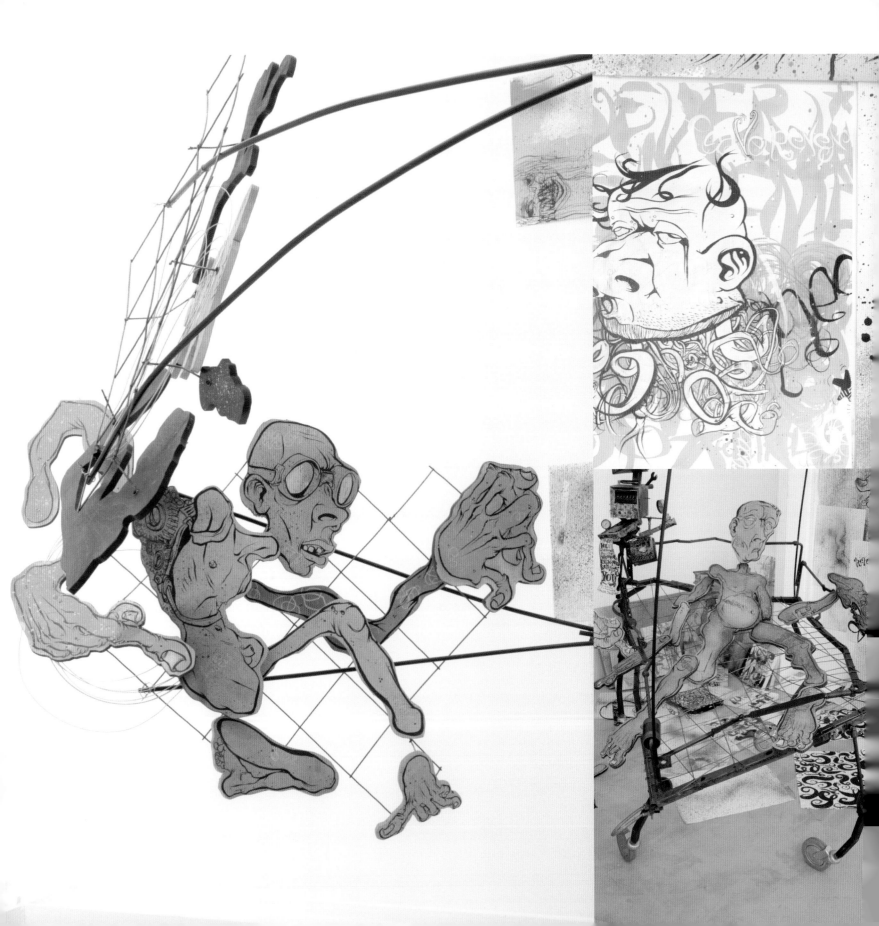

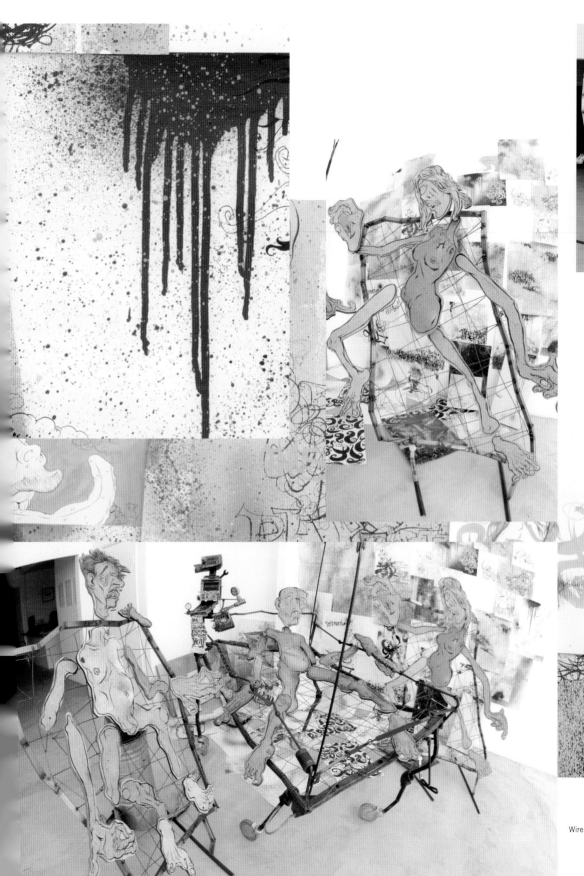

this spread and following 4 pages:
Beautiful Horrible Love Moment 2003
Andy Howell / Gustaf Rooth
Acrylic, Paper, Enamel, Steel, Iron, Antique Gauges, Wood, Canvas,
Wire, Pastel, Chalk, Caster Wheels, Digital Samplers, Speakers, Spraypaint
264"x120"x168"

TODAY I AM HAPPY AND SAD THE MOST AMAZING TIME OF MY LIFE, THE MOST SCARY, THE SADDEST, THE MOST EMOTIONAL. HE LOOKED AT ME, UNABLE TO SPEAK AND HE TOUCHED MY FACE, HE PATTED MY FACE, AS I CRIED.

I LOVE YOU DAD, YOU ARE GONNA BE OKAY, I AM GONNA BE OKAY, YOU HAVE BEEN AN AMAZING FATHER, I AM GONNA MISS YOU SO MUCH, I LOVE YOU, IT HAS BEEN AMAZING TO KNOW YOU, I LOVE YOU...

HE PATTED MY FACE, STRAINED TO PULL HIMSELF UP TO HIS ELBOWS AND BLURTED OUT

I'M NOT GOING ANYWHERE!

LOVE AND FEAR AND SADNESS AND HEARTACHE

I HELD HIS RIGHT HAND. SHE HELD HIS LEFT. WE'RE GONNA BE OKAY DAD, IT'S GOING TO BE FINE, REST NOW I LOVE YOU, THANK YOU.

THE TEARS JUMPED OUT OF MY EYES. THE TEARS OF JOY AND FEAR AND EVERYTHING ALL AT ONE.

MY GOD, SO THIS IS WHAT IT FEELS LIKE. MY WHOLE BODY SCREAMING, A SMILE PEEKING THROUGH RIVERS OF TEARS MY FLOODING FACE, COURTNEY SMILED AND CRIED TOO.

DAD'S FACE LIT UP, THE BIGGEST SMILE I'D SEEN SINCE I HAD ARRIVED AT THE HOSPITAL. HIS EYES OPENED WIDE, HE WAS AMAZED AND LOOK FIRST AT ME THEN

COURTNEY, THEN ME AGAIN.

I'M GONNA MISS YOU SO MUCH, I STUMBLED THROUGH THE TEARS, YOU ARE AN AMAZING MAN.

HE LOOKED HAPPY, A LITTLE CONFUSED TOO MAYBE AND A LITTLE SAD.

WE ALL TALKED SAT LIKE THAT, IT SEEMED TO LAST FOREVER, THAT INTENSITY, THAT ENERGY, ALMOST NO FEAR, SO CLOSE TO PURE LOVE. THE MOST AMAZING MOMENT OF MY LIFE.

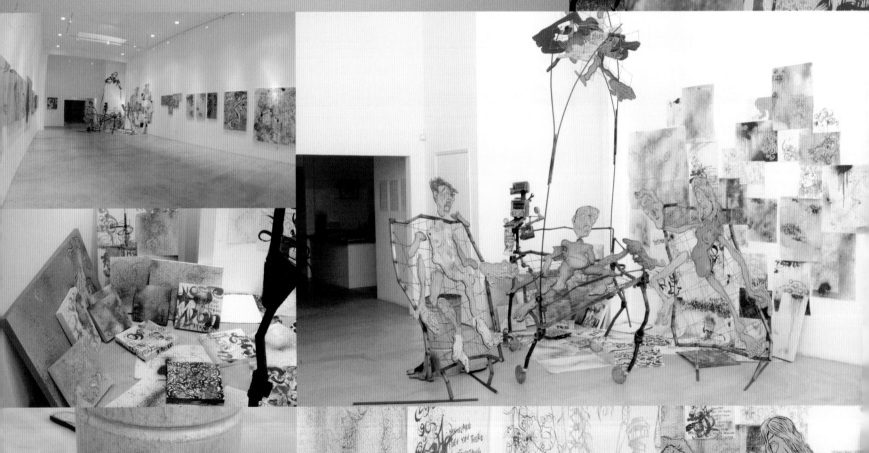

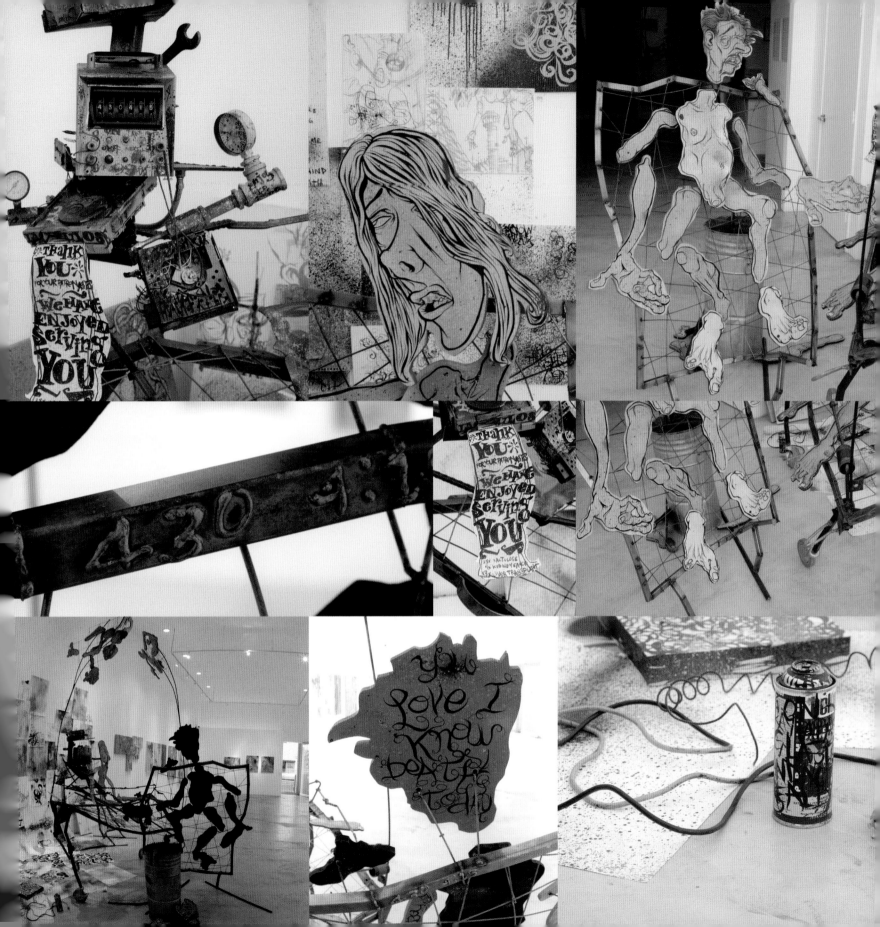

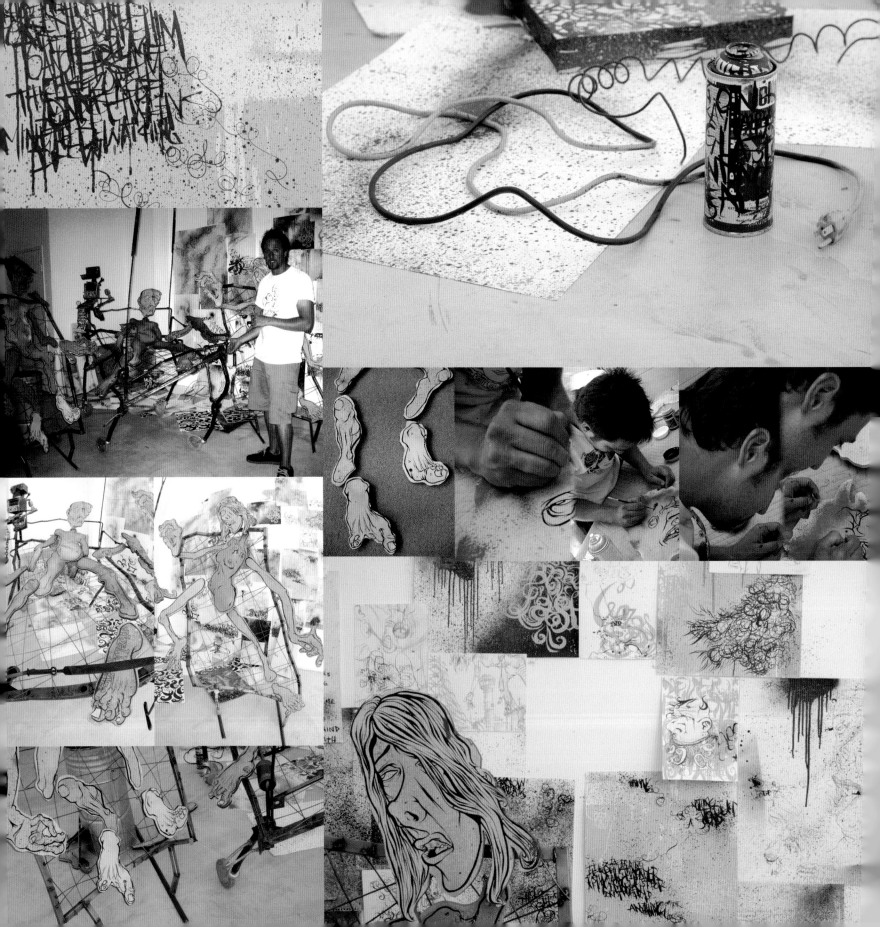

Andy Howell / Therapy

I don't believe this is a "proper" Artist's Statement, but more of a collection of things I have been thinking about recently. Things that will for you scratch the surface of what is in my heart and in my head right now. The work in this show illustrates the following thoughts.

Recently I have experienced the most amazing and the most horrible moments in my life. The death of my Dad has brought out emotions I didn't even know were humanly possible. I could not have imagined what to expect when I flew out to Virginia knowing only what my sister had told me at 5am that morning, that my Dad was lying in the hospital in a coma. I had just spoken to him the afternoon before, and he told me in classic Virgil style that he was fine and not to fuss and that he was heading down to Kitty Hawk in a couple of days to go fishing. I stepped off the plane and into the most intense rollercoaster ride of my entire life. The feelings I went through and am still trying to understand are part of the biggest moment in my life. These are all my feelings, all my fears and all my happiness. The dichotomy of everything I feel, have felt, or imagined recently. My transition and his, thoughts of not knowing to knowing and from knowing-it-all to knowing nothing.

Seeing him helpless and unconscious, I felt the fear and desperation of losing the most important person in my life. That fear turned into sheer joy and unfaltering hope as my father miraculously regained consciousness. Watching him in pain as he pulled through 36 hours of gritting teeth, groans and screaming that one cannot imagine. The anger I felt when I couldn't make him eat, or when he began pulling the feeding tubes from his nose. Holding his hand in the night when every one was gone in the dark and alone. Mortified when he stopped breathing, I shook him and he caught his breath. Then relief and mislead hope when he started to show signs of improvement. Pure love and happiness consumed me to be able to have simple conversations of the best days of my life with him, even for only a few days. Then came the ultimate horror when the doctor told us that his liver and kidneys were at 97% failure, and that there was no chance of recovery. Overwhelming sadness and sheer panic when we took away all his tubes, oxygen and life support lines. TAKE OUT Regret for all the things I took for granted in our relationship. The worst inexplicable feeling when I realized he was going to die. The surreal experience of sitting across from the doctor and watching him fumble through telling Papa's two little children that he wasn't going to make it. And worst of all watching Dad's eventual recognition that this was it, a kind of solemn acknowledgement in a room where there was just love and fear.

I told him good-bye, that I loved him and that we would be okay, trying to hide the uncertainty, sadness and fear that he could certainly feel coming from me.

Me holding his right hand and Courtney holding his left, tears practically leaping out of our eyes. His face lit up, tears rolling down his cheeks, his eyes wide opened and focused for the first time in three days. His voice was a hoarse and barely audible whisper, "I'm not going ANYWHERE!" He looked almost amazed, as if experiencing something he had been waiting for from me, or a feeling never felt before. One last struggle to get out of bed fell victim to the fact that his body lacked the physical strength to pull himself even onto his elbows. I could see it in his eyes. Realization, fear and then the acceptance. The knowledge he gave me with the hope in his eyes. I have complete admiration for him never complaining once of any pain or discomfort. My dad was and still is my hero for that.

I love him more than I can express. I am totally crushed that I will never be able to talk to him, hold him, touch him, fish with him, walk with him, kiss his cheek, hold his hand or even hear his voice while I continue living in this world. I realize how insignificant my "monumental" daily life problems are. So sad that you had to go. I know that you are everywhere now, a part of everyone and a part of me. I have to believe that everything happens for a reason.

Stories, memories and fears. I reminisce about our day's together fishing and our long walks down Kitty Hawk Beach. Separating our love for each other with creative influences and teenage rebellion. I worried as a teenager about what he thought of me. I think about what his experience of transitioning to that other plane could have felt like. Angels coming down, people blind to love, coldness and loss of your body and soul. Does everything become clear? Where are you Pops? Everywhere? A collage of thoughts like everything I am and do. An attempt to hold on to the moment forever. An attempt to hold onto everything. An attempt to let go completely. I accept only to let it all flow, come and go. Water, fire, earth, air, tears, loves and life all swirl around in the massive world, this tiny world. I wonder when they will all come together or fall apart.

It's all too big to comprehend, so we bring in religion and science to help ease our fears and frustrations about the very insignificance that is our existence. I wonder about the thrust of life, the constant flow of energy, heat and mass that drives us to stay in this dimension. A place we fear and dread, fumbling around and bumping aimlessly off one another. I question life and death. What are these states of being and where are they in relation to one another? Does this life of energy really end? Do we just become pure energy, and is that "love"? And then death comes back in to play. My fear of it, my fear of losing him, my complete devastation in this great loss. He is still here. He's in my mind and in my heart. He's with me and I can still feel him. This is my love. And if energy never ends then why am I so afraid of the things I can't see and understand?

I can only share this taste of my experience in the hope that it could serve someone as a reminder that we are alive right now and that we can live by being present in our own life and in the lives of our families. The most important things in life are our relationships and interactions with the ones we love. Now I will never forget that.

It has been amazing to know you dad. You have inspired me, hurt me and loved me more than anyone in my life. I love you too. Only in my dreams now, and only in my mind, but you are never far away. Starcatcher, there's one, there's another star shooting across the sky. I love you always.

Andy

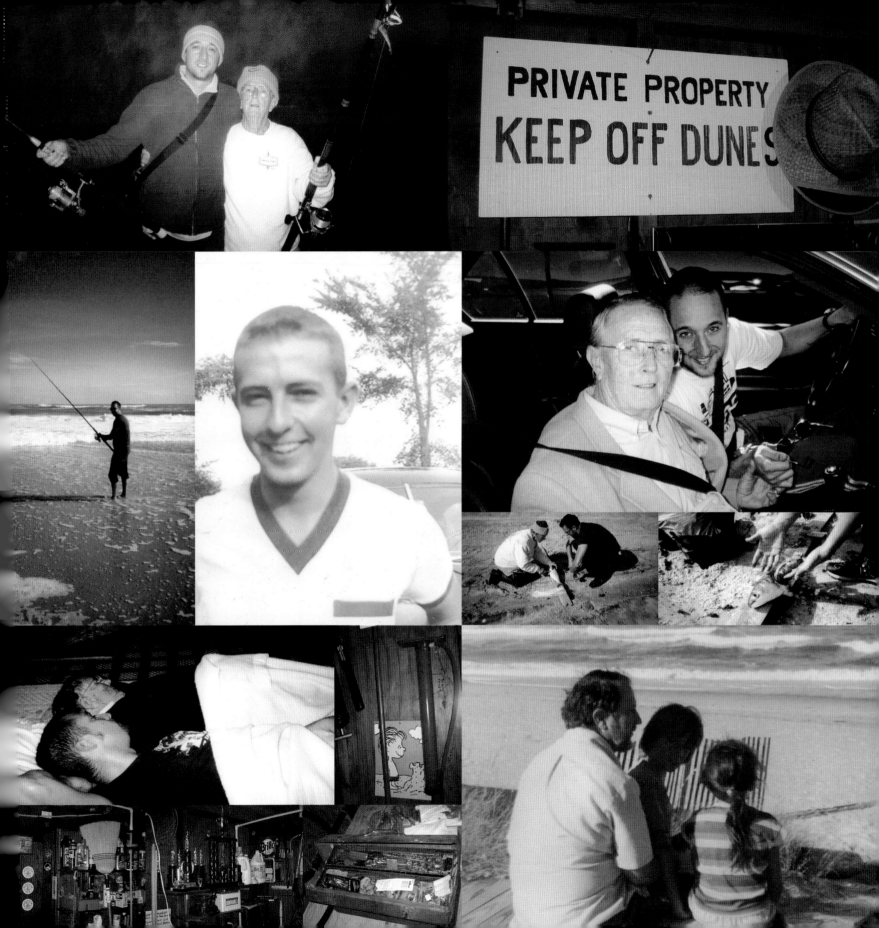

CHAPTER 10
THE COLLABORATIVE EXPERIENCE

The Collaborative Experience
Selected Works 1995-2004

Andy Innovation and inspiration is the master theme behind everything. As long as I am living in spirit, alive, and driven to create, then I'll always be inspired to innovate in some way. Love, inspire, create, and empower: that this is why I am here in the first place, and that's how life makes sense to me. I'm inspired by the innovation and passion around me, and that comes out in my work and my life, and others become inspired as well. Because I think that's the only way people will act: if they're inspired by something. So that's always been my M.O. It's amazing the way inspiration comes around. Things I have said or done in the past have inspired a lot of people to get into art and skating and probably fashion too, along the way. And almost all the people who've come up behind me have turned around and inspired me, too, people like Kinsey, Shepard, Jose, Anthony Yamamoto. The truth is that I caught the escalator going up back in the late '80s, and a lot of my friends caught it either the same time or just a couple of years later. So we're all on this trip, it's a constant cycle of innovation and inspiration, and the people catching up from behind always push me to go farther than I thought I could. Whoever's hot at the moment, whoever's coming up with something new, they make me say, "Yeah man, go, go, go—because that's going to inspire me to push it too."

Kenton Parker said something, "You're inspiring me to go out and do it better, to push myself." It doesn't matter where you're doing it and where it ends up, it matters that you're inspiring someone else to take it to a new level. That's what my mission in life is. I only feel happy when I'm passionate and inspired. The whole world makes no sense to me at all unless I'm coming up with a new idea, or making something, or figuring out a way to do something new from scratch.

I've translated that into a number of things, whether it's creating a business I've never done before, or taking certain graphic vibes and changing them to work for a different crowd of people. There are all these different ways to communicate with people, and to make ideas come across to make people feel something. And that's what I've always wanted to do. Make people feel something. Make them say something—even, "Fuck you, that was the worst thing I ever saw." Be it art or design or fashion or video or a promotion or an idea for a jingle—high or low art it doesn't matter—if you created anything that caused an action in anyone else, or made them for a second feel it was valuable, then that's the point. I've always been comfortable with the so-called dichotomy between commercial and fine art. I don't think that commercial art is not art. I think it's the same as fine art. The same as riding my skateboard. The same as making something with my hands in my backyard. They're all some form of creativity.

I love that I'm a part of this whole culture, this whole crew of people who make art. David Choe and

Giant and Bigfoot ... to have the opportunity to do art with them and to get to go home and look at their art on my walls, is mind-blowing. Joe Soren, Sam Flores, Mark Newton, Shepard Fairey, James Marshall a.k.a. Dalek, Mike Nelson, Kinsey, Jose Gomez, Mambo, Evan Hecox, Ed Templeton. So many ultra-creative people like Jim Hauser, Twister, Andrew Pommier, Otis, Kenton Parker, Martin Ontiveros, Justin Kreitemeyer, Flo Zavala, Becky Wescott, Phil Frost, Moebius, Jeremy Farson, Peter Halasz, Josh Hassin, Keith Haring, Howard Finster, my house is filled with these artists. It's such an inspiring environment. I think mostly I'm just as much of a fan and collector. Any creative person who's genuinely interested in creativity wants to collect what their peers and friends make. Anytime I have the possibility of making money, my first thought is, "What art can I buy now?" I love all of it and I think that's for me one of the most beautiful things.

Collaborations are the ultimate communal experience for me as an artist, a chance for a group of creative people to play together in this open space called art. I mean we are all a bit introverted and individual in almost all of our work and life, yet when I get together with a bunch of artists to do a piece or travel together, something very interesting always happens. I get to push myself, and learn from friends, and reflect on my own creative process, motives, and techniques. And we all get to have a good time together. I started doing collaborations with Jeremy Henderson in '89 or so: he broke out this woodburning kit and we made these plaques out of found woodpieces while his daughter Kaia painted a huge canvas with oils sticks taped to the end of her little umbrella. Ten years later he sent me one of them as a gift, along with a piece he did on an old record sleeve. In the beginning of New Deal, Ed Templeton and I did some collabs of drawings and things for stickers, and Gorm and I actually drew graphics for boards together. God bless the CAP Crew in Atlanta, too, for many many collabs. X-Factor, ZERO, Bust, BaseOner, Verse, Silly Sil, and too many dudes to even list who took part in the first massive wall collaborations.

One of my favorite things is this drawer in my house with a collection of sick prints and drawings from my friends, including Kinz, Mike Nelson, Phil Frost, Joe Sorren, Kozy–n–Dan, Dalek, Gonz, Twister, Ed Templeton, Jose Gomez, and like 50 Shepard Fairey prints—a good scope of work, even ones from way back when he was in art school at RISD. Knowing Shep for a long time, and seeing his whole development from skate kid to icon of street poster art has been incredible because as a pop artist he truly created a cultural phenomenon. We've worked on a lot of projects together: FBI, the first Giant skateboard, and a special one for me that Shep actually pulled the prints for himself, which was a mass birthday celebration we did back in the '90s for Dave Kinsey (Feb 14), Jose Gomez (Feb 15), Shep (Feb 16), and me (Feb 17). All Aquarians and we started this group almost as a joke, but then that started to grow too, and we had these collaborative birthday celebrations with me, Anthony Yamamoto, Kinz, Mike Nelson,

Gregg DiLeo, Shepard Fairey, Steve Saiz, and a bunch more—so many of us are Aquarians, creative and mercurial I guess. In the drawer is also a painting that Phil Frost made for me in '98. He couldn't make it to a show I was having in Philly, and he had a friend drop it off to me. It was Phil's version of my first board graphic for Schmitt Stix, the pyramid one. He did all these cool little parts to it, and included a sticker from the first skate camp I had done in Amherst, Mass called Interskate 91, and the sticker had my name and Eric Dressen's name on it. I was so touched. He had been one of the kids who came to the camp, and had saved that sticker for 10 years then used it to seal a rolled painting he made for me. It was the amazing full-circle experience again.

Just a taste of the collaborative experiences I've had so far: In '98 Jose Gomez and I had a show in Philly at Space 1026; we took this broken deck and each painted one of the broken halves ... Nelson brought in the three-by-three collabs for a whole crew of artists ... Kenton Parker and I did a painting at his studio in Hollywood: lots of blue and feet, are they dangling by a thread or diving into it all? I went to Singapore with Bigfoot and Sam Flores, and we got to paint together a few times—among other activities. One piece we did was a kind of graffiti-style collaboration of small drawings on a four-foot by eight-foot board, all of us going over top of each other over and over and over again. We had a blast. Magazines are a great venue for collaborations. Jeremy Fish and I did one once, his perfectionist style helped reign my drawings in a bit, and totally complimented each other.

"This Is Me" was a sick show Eva Newton did a few years ago. The artists all painted on bags and shoes and Marke Newton and I did a skateboard together. I did a really big piece on the side of my house one time with Persue, Fafi and Tilt. Fafi and Tilt were visiting on tour from Toulouse, the dynamic duo. Swayze always comes off, and I really dig Fafi's sexy little mami's. Then of course Steve Saizmo aka 5412 and I painted a big collab of the feeling of looking up from the noise in the middle of the city, guess it came from a debauclery tour we did in New York the year before. Lots of birds and trees. Recently, I did a big piece with Angry Woebots in Oahu in Feb 2004 and then another one in Dec 2004. I was traveling around the world for the first half of 2004, and had this incredible experience in the mountains of Rwanda with the Susa group of gorillas that Dian Fossey used to research. I actually had one way up in the jungle grab me on my head and run his hand down the back of my head! When I got to Paris a few weeks later, Marke Newton and I painted another piece together.

Manipulating other people's products, like a collab with Yams, Fontes and Natas and the cats at Quiksilver on a series of Howell trunks, as well as a hat and woven shirt, dropping Spring '06, more trees. Nelson Japan threw a bunch of tees my way, so I spraypainted all over them, and at the same time painted Kites flip flops for my friends Carla Manual and Dan Mead. James Barak asked me to manipulate some 686 Snowboarding stuff, got their #1 jacket this

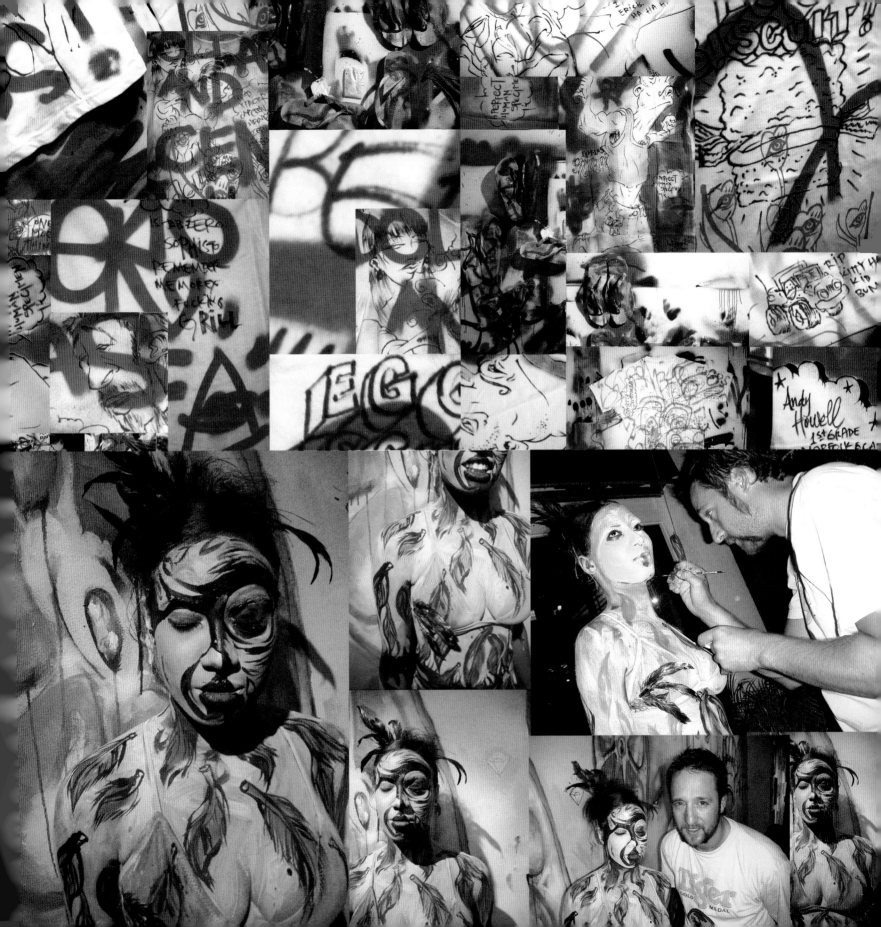

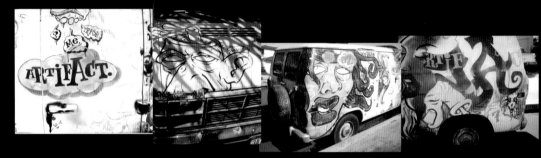

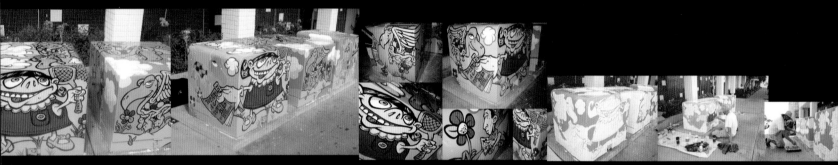

year, a Howell Screen inside, then of course I made my Urban Soldier Peace Protector jacket, in which I inverted the actual production piece by ripping it to shreds and gluing and sewing it all back together, and covering the whole thing in that classic splatter noise I've been spittin' lately. It has a crazy mask and all these badges and plaques glued and woven onto it. I finished it at like 4.00 am one night and my girlfriend Cerissa and I filmed ourselves dancing around half naked with the thing on. Funny as it was I had just painted Rob Dyrdek's AK-47 for a Militree show called Artillery, so it made the perfect prop for our little movies. Jon Phenom, yeah, that kid's always got something going on, my favorite one was a raw-edged denim jacket he sent me in 2003, and I just covered it with this angel flying in to pick up one of his assignments. Painting in SF with David Choe, Jeremy Fish, Biggie (Bigfoot), and Sam Lo-Res (Flores) on a huge canvas while many beers and crazy ideas were flowing. Tagging up with Choe on a piece he was doing for Scion. Busting an eight-foot by four-foot painting of some lips with a tree growing out of them, hanging with Kenton doing that one. So many amazing experiences, just like traveling with friends on skate tours way back in the day. Another means to communicate a new idea, to take something known and make it unknown again. A stretch beyond my comfort zone.

I love the feeling of looking at another artist during a collaboration, and just getting off on watching them go to that place, within themselves but also connected to something all around them too, where they just get lost in it. Or when mine has subsided for a minute, watching them take the torch and come in and completely cover my shit, but make it way better. Watching the organic creative process unfold, amidst the creativity, and passion, and ego, and love that the participants share for making art. I love the organic nature of collaborations, there are some people who can flow with it and just make it up as they go. That to me is what it's all about: okay I literally paint myself into a corner with this character or this color, now I gotta work my way out of it, make it work better this time, make that beautiful line or that hilarious comment, or that trick of light. And it always comes together at the end between artists, and if you see some spot on mine you wanna hit, go with it, that's why we're here. I like the freedom of that, and for a moment when I am painting with other people it's a connection beyond words, as if with paint we are saying, "I understand you, and it feels like you understand me, too." It's an incurable condition.

David Choe Art for most of us is a solitary experience.

It's only in the recent years that I've started to do shows and go on tour with people for art. In the end it seems like we're all out there trying to express ourselves, but it feels like we're all almost the same person. We're all disorganized, can't keep our own shit together, everyone has some kind of addiction ... it's like that. When I do collaborations on a mural it usually doesn't feel like a true collaboration. I really enjoyed painting with Andy on that level because he's more organic. There's a huge group of artists who just do one thing over and over. And even if it is a collaboration it isn't really, you know? 'Cause everyone's like, "This is my corner, I'm going to paint the same thing I paint all the time here." It ends up being such a bummer. You start painting close to them and they get all anal about it. What the fuck— are you a graphic designer or an artist?

Andy We don't want boundaries. Paint all over my shit, it'll probably be better than what I do anyway. Artists like David Choe whose work looks different every single day—that's a major inspiration to me, because it's not stale. It's not cookie cutter. To me it's real art, because by definition it's not pop art, it's not a manufactured look that has become so overplayed and saturated in the mainstream so that now they finally get it. If I'm doing a run of 10,000 T-shirts for

a company, that's commercial art. But when I'm painting, I don't want it to look the same as the last time. And if buyers don't understand it because it hasn't stayed the same for the last fucking fifteen years, who cares, you don't deserve it. The reason I paint and make art is to challenge myself to solve new problem every time, with every show. And being around people who inspire me to do that makes me feel whole. No matter how busy I am with projects or whatever, I always seem to take on another collab show. It's not like I have time, but it so fulfilling to do, like going surfing, or skating, or fishing, it's one of those experiences that makes me feel alive.

David Choe Andy and I started painting and he started making a mess and I was like, "Okay, perfect." He just started right away going, "Let's see what happens from this mess." As opposed to, "Let's map it out." I guess the truth is that we're all so overlapped. Graffiti artists, fine artists, graphic artists, we're all the same person now. I guess with my no-boundaries philosophy I've stepped on a lot of toes and made a lot of enemies but … in the end it's just pigment on paper, pigment on wall.

Angrywoebots, Artist, Hawai'i I met Andy through our mutual friend Jun Jo, he told me Andy Howell was coming to Hawai'i. I was like, "Cool, let me know when." I definitely wanted to meet up. I personally wait until I meet an artist to see how they are in person, then I give them their final respect—especially with all the experience and travels under homie's belt, I wanted to meet homie in person. I hate when you meet someone that helped you build, from watching on the outside it pushes you, but when you finally get in there, meet the person and they're a total asshole, it's a complete shut down. So I meet this laid back, down-to-earth Samurai, and for real, Andy's the coolest fucker I met in this art industry.

So my boy Jun suggested that we get together and paint in their store, In4mation. I was mad down for that, played phone tag between us three and we planned to meet up and get supplies. Andy was staying in Waikiki , so I had to pick him up then head over to the supply store and get paint. I remember rolling up to the corner, stopping and noticing my ex-girlfriends roller blades in the back seat. He was getting in at the same time and in my head I was like, "Fuck he's going to think that those purple and black rollerblades are mine!" It was fucked up! No disrespect, but I hate bladers. As he got in I told him "Don't mind the blades they're not mine!" and he was like, "Don't fuckin' lie, I know you blade." I just remembered being all embarrassed, and shit homie's a skateboard OG and I'm chillin trying to defend my self from these bulky-ass rollerblades in my back seat. Ha-ha. It was really funny at the time. Anyway we rocked a fresh-ass painting.

After meeting Andy in person, it made me respect his creations more. It finalized why homie's art is so fresh, you can be the sickest fuckin' artist in the world, but if you don't have soul in your shit and don't respect the heads that help you build, then it's pretty

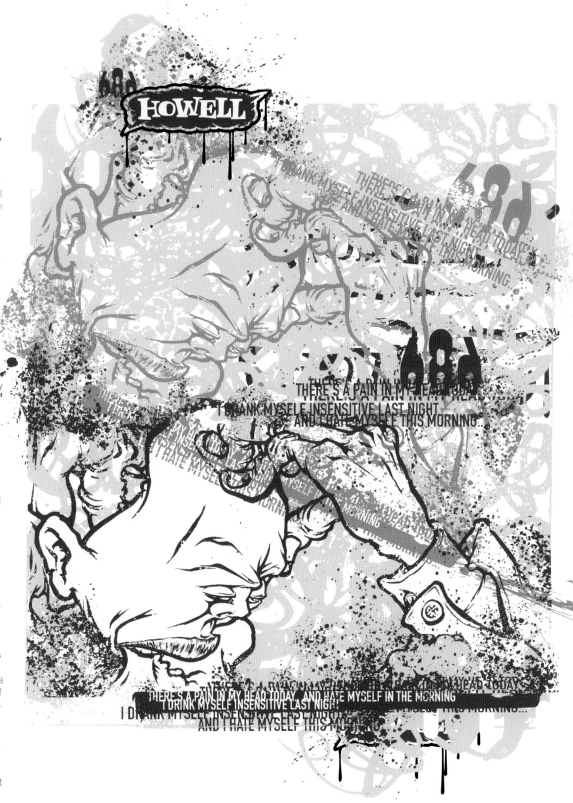

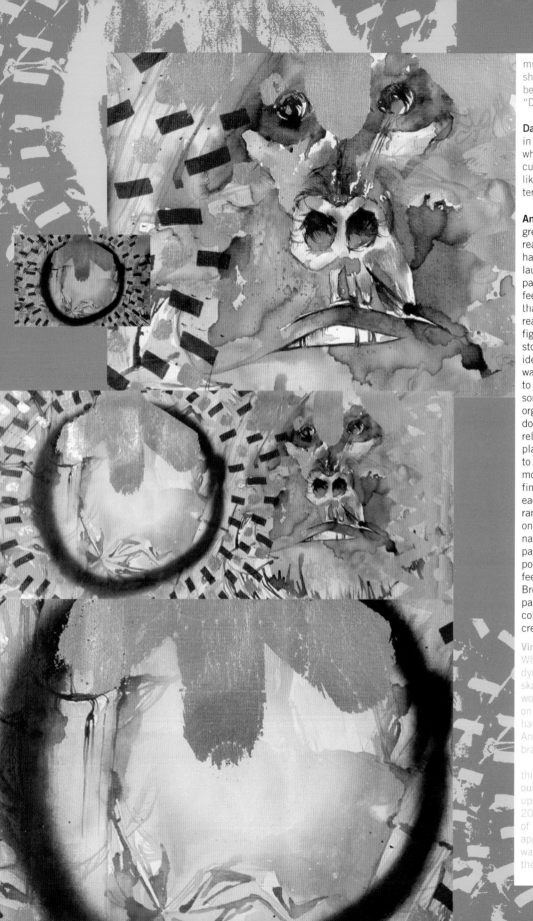

much worthless. I personally feel that it's the fools that love your shit that push you, and I know everyone wants to meet the person behind the images. Andy had nothing but soul and mad respect! "Do what you love and love what you do?" Homie lives by that!

Damon Way I started a program called Artist's Projects for DC Shoes in 2000 and the idea was to do collaborative projects with artists who had some relevance and attachment to skateboarding and its culture. As it evolved, Andy's work evolved as well, and so we were like, "Let's do it." He's in that top tier of artists in skateboarding in terms of talent.

Andy When Damon asked me if I'd like to do a shoe for DC, it was a great compliment to me. And when I was skating professionally I really didn't ever have the opportunity, Natas was the only cat who had a shoe back then. The Howell Modelle DC Artists Project Shoe launched in Fall 2004 and it was probably the first shoe with packaging that features a door and cellophane window, in a way that feels like a collectible toy packaging. We started developing it more than a year before it was slated to come out, and at that time I was really into the packaging that had been done for collectible vinyl figures, mostly in Asia. I had the Doze Travela figure and was really stoked on how he did the package and that inspired me to take that idea into DC, but of course with my own flavor thrown into it. I wanted to take one of their existing shoes that I thought was similar to a runner, and apply my art through a sublimated process, and do some pvc patches and stuff. I had been losing myself in these organic swirls of black, over top of these DNA strands I had been doing, which to me were representations of the transient nature of relationships between people. Like a cosmic trail of attracted planets, their mutual attraction drawing them together close enough to smell and touch and love from a distance, then holding them only momentarily in a delicate balance of mutual attraction and fear, and finally allowing them to break free of that temporary conformity with each other in order to be projected off into another seemingly random encounter down the road. I took all of that and condensed it onto a form of self-propelled transportation, a DC shoe with my name on it. Steve Saiz and I worked on the packaging and a 40-page handbook to be inserted with the shoes. I added stories and poems and drawings all over the actual box, a taste of what I was feeling at the moment. And it came out and we launched it at Brooklyn Projects in L.A., with a big billboard on Melrose, and a party with Arkitip too. It is an amazing experience to be able to collaborate with a company at that level, and with the kind of creative freedom that those guys allowed me. I thoroughly enjoyed it.

Vincent Quek, artist, co-founder of Flesh Imp Brand, Singapore What struck me first when I saw the Kitty Hawk Kid was the dynamism and the versatility he had. HBomb 43 has it all: slick skateboarding moves, captivating paintings, youth culture creative work, and of course impressive shows, collaborations and exhibitions on his ever growing portfolio. He's a legend in his own right. Always having a knack for creating a real impact on today's youth culture, Andy's done more than he should through his progressive art, branding, and contributing to worthy causes.

I got to thank my homey Sam Flores and Bigfoot for hooking up this man who is well respected in the design circuit. It was through our collaboration designing, crazy partying, and some serious uppity ups that we bonded and we never looked back. Our collaboration in 2003 with Andy, Sam Flores, and Bigfoot marked a new era for all of us and we opened the doors to more street, urban, and arts appreciation. Having him here with us is truly something we really wanted and being able to hook up with some sick tips and tricks of the business opened our eyes to many new dimensions.

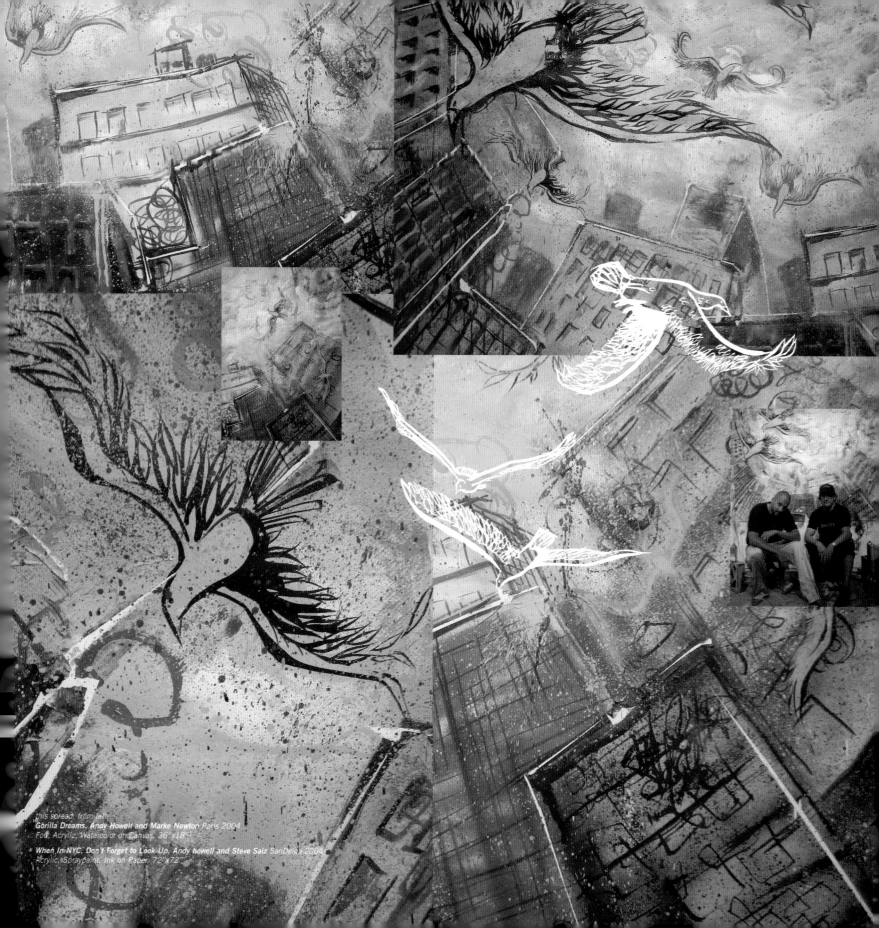

this spread, from left:

Gorilla Dreams, Andy Howell and Marke Newton *Paris 2004*
Foil, Acrylic, Watercolor on Canvas, 36"x18"

When In NYC, Don't Forget to Look Up, Andy howell and Steve Saiz *SanDeigo 2004*
Acrylic, Spraypaint, Ink on Paper, 72"x72"

Dave Kinsey His style hasn't changed much since we were bombing walls in Atlanta. I think actually it's become less refined than it was back then. Now it's a lot more loose, more free, more expressive. I think he had to hone his talents ... or rather, sharpen his ideas and details towards what catered to skateboard graphics, which was not entirely what he wanted to do as an artist. Andy's been an inspiration on my career. He really gave me the opportunity to look at someone who was doing something in the commercial sense but was also supporting what they loved to do on the fine-art end. I related to it and it helped me and helped thousands of artists, skateboarders. Phil Frost talks of it, Jose Gomez, lots of them who got good things from him.

Andy The street art movement, if it's being called that now, has been a kind of springboard for many artists. There are die-hard graff artists and wheatpaster kids, but I think ultimately again that is just one brush in a quiver of modes of expression. Like drawings or sculpting or video, be inspired by what's around and what is being done, we all are, because we live in the world. We live amidst all this amazing street art, and as creative people we are always drawing from our surroundings, translating them onto canvas in a way that they can coexist for us in our own minds. I absorb it all—the stuff on TV, the movies, the people begging me for change on the street while they talk on their cell phones, the love of my family and friends, the fucking meter maid who just gave me a ticket, the death of my father, the beautiful Brazilian girl at the restaurant. The dichotomy or irony of every second I spend here in this place. And I have to take all of them and run them through the filter of my own experience and knowledge and turn that into the work that inevitably comes across in *my* voice.

I don't ask myself if it's cool, I just make it, and a lot of it is complete shit, and some of it feels really good. That is the plight, the process of the artist, right, unless you are just trying to come up with a cool gimmick that people can easily digest? So in collaboration, I like to work with different people, because it's always good to be around someone new who has something new to share. In many cases I have worked with the same people consistently for over ten years too. There are a lot of us like that, and we kind of jump around from project to project, all fulfilling our

desires, but always open to new ideas too.

When you first get on a ride, everything is new and exciting. Because it's your own trip and you are just branching into another realm. And then eventually every incredible visual stimulus and creative impetus that comes in is going to feel old and boring. Every single creative person I've talked to says the same thing. It's like a blessing and a curse. Artists create the voice that tells the culture's stories for the rest of the people. The three percent that makes the stuff the other 97% consume.

As a creative person, I'm always thinking, "What's the next thing I can do?" I have to do it. If I don't do it, I'm wasting my talent. Or I'm stuck to one project or one style for the money. I'm always attracted to that irony, I guess I am a real oxy*moron, every pun intended.* It's the big crazy puzzle I'm trying to work out in my head. How can I possibly work obsessively 24-7 on my art—How dare I do that ... but how can I not do it? If I do it, I'll fuck up the rest of my life; if I don't do it, I'm wasting my talent, my time, my opportunity.

The problem is, can I be an artist and still have this kind of life where I have love and relationships and friends and a community? I go for eight months without seeing my friends sometimes, and they're half the inspiration for everything I do. We all do it, then we look up and say, "I haven't seen you in a while, we gotta hook up." It's a running joke with a lot of us. And when it comes to relationships with women, they always suffer. The thing that attracts people to me is ultimately what drives them away. It's a huge problem. There's always this third party. Nobody wants a menage à trois where you're going to bed with two things—the man and his art. That sounds corny, but it

can be the case, I know so many people who ride the same razor-sharp edge, always getting cut on way or the other. Either the art or the woman's going to get the short end of the stick. I always want to find that balance, but art and creativity can be incredibly extreme. When it comes it comes and you have no choice but to run with it. And my relationships are often extreme as well, the kind of woman I am attracted to comes on so strong, both of us diving in head first, loving completely. Cerissa and I are like that. This ping-pong effect happens, that I am constantly trying to balance out. I need the support when I am working, and sometimes that doesn't correspond with her needs. We clash and are both resentful, but we always hope the love will prevail. It's hard because creativity has no schedule, it's not a 9 to 5 job where you close up shop and go home. It hits randomly and you just have to go full steam ahead with it. And often people closest to us believe the nature of artists is to be self-indulgent and self-centered. It's a misconception people often make, and it becomes a barrier for many relationships. Artists themselves cannot see it that way because it is like a calling, you have no choice. You have to go. It's always been like that. The blessing and the curse.

Courtney Harbison, Andy Howell's younger sister Mainly when I talk to him it's listening to all the things he's doing, that's the way it tends to go. He always says he wanted to be closer to his family but when it came down to it, whenever he was in town he was just so into his artwork it was almost

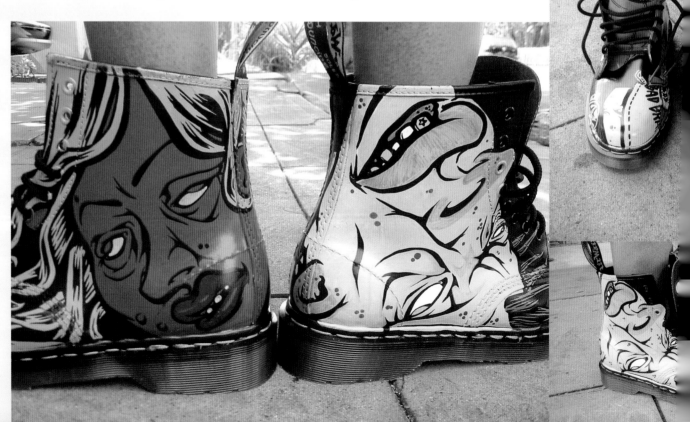

hard to tear him away from it. To hang out and just … chat. When Andy first meets people he'll make such a big tadoo about them, but then the business catches up with him, "Oh god, I've got to get back to my work," and then it kind of goes downhill a little.

Andy It's the same thing whether it's relationships, friendships, business, or creative relationships. They are all collaborations in some way. There's always a huge love and respect that draws people together and then all of a sudden there's not enough time. The fear that I don't have enough time to do everything, underscores my entire life, it's eating at me all the time. I'm always looking at something, going, "What can I do with this and when am I going to do it?" It can't wait until tomorrow. Getting up in the middle of the night to put an idea down on canvas—that actually makes me really happy. But it's the kiss of death on a relationship, it is truly hard on other people. Because the art is such a driving force, because it is paramount to my happiness with myself, to being able to live with myself. So a relationship starts with an explosion of love and lust and passion and then it suffers. And something has to give: either the girl, the art, or the friends. Ultimately, I'm accountable for fucking up relationships with people in my life, or maybe for starting them, I'm never sure;

but it sometimes feels like there's no choice. Ultimately I always have to go back to the work, because it's how the world makes sense, it's a place where things are often intangible, but at the same time crystal clear.

David Choe For me, an artist is somone who travels and does art. That's just how I define it for myself. I would die if I were alone in a studio 24 hours a day. And I think Andy would too. When you're a graffiti artist you paint by yourself in the middle of the night, and when you're a comics artist you're alone all day at your desk. So when you meet some of these guys they're the most introverted, socially awkward people. And people in America, they hardly leave their TV sets. So you have to get out and go to other countries and see how people live. I am an explorer.

Andy You can look back at any of the bohemians, the Beat Generation, the Hippies, at every subculture or thought revolution and all of it said the exact same thing—punk, early hip-hop, too—it said, "Fuck the system, live your life, ignore the heroes, do it yourself,

and do it your own way." That's a universal message. So if that message can be perpetuated in my work and life, that's great. At the same time, I'll get letters from kids in high school that are supposed to do reports on a famous artist, and they're asking my permission to do it on me, and I'm saying to myself, "What the hell is going on? Guys, I said, 'Ignore the heroes!'" But at the same time I want to be an inspiration to them, and to encourage the people to come up too, to push the envelopes, to fly way past where I imagined it could go. Because I feed off of them just like they draw from me. And the inspiration always comes back around.

I've never been a person who wanted to do something so long that I completely perfected it. The life of it for me has always been in its creation, the new idea. I've always wanted to come up with exciting and creative new ways to approach the things I have done. To do what's been done before is redundant and boring. Maybe it makes things kind of crazy; maybe relationships suffer. But that's my message in the collaborative experience, and in life really, inspire people to push through boundaries and fears and setbacks in order to innovate, *and* that it's actually *okay* to be that way. Life and art goes forward and progresses. And ultimately everything makes sense.

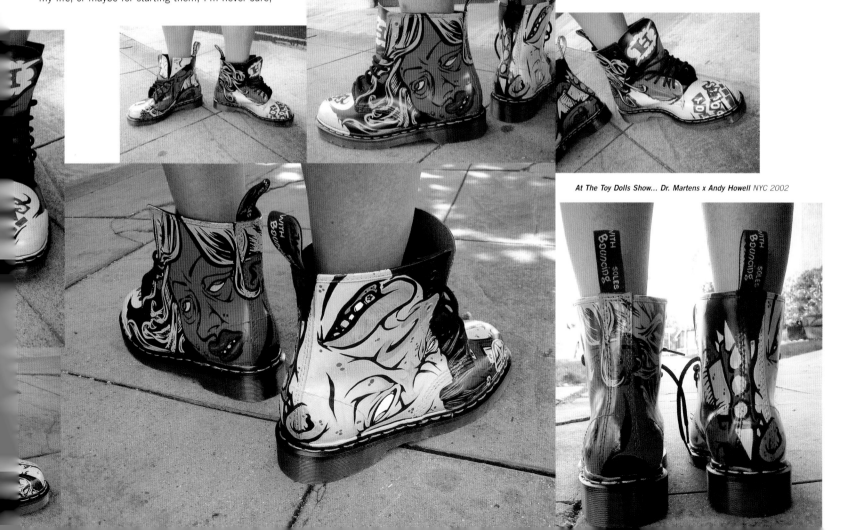

At The Toy Dolls Show... Dr. Martens x Andy Howell NYC 2002

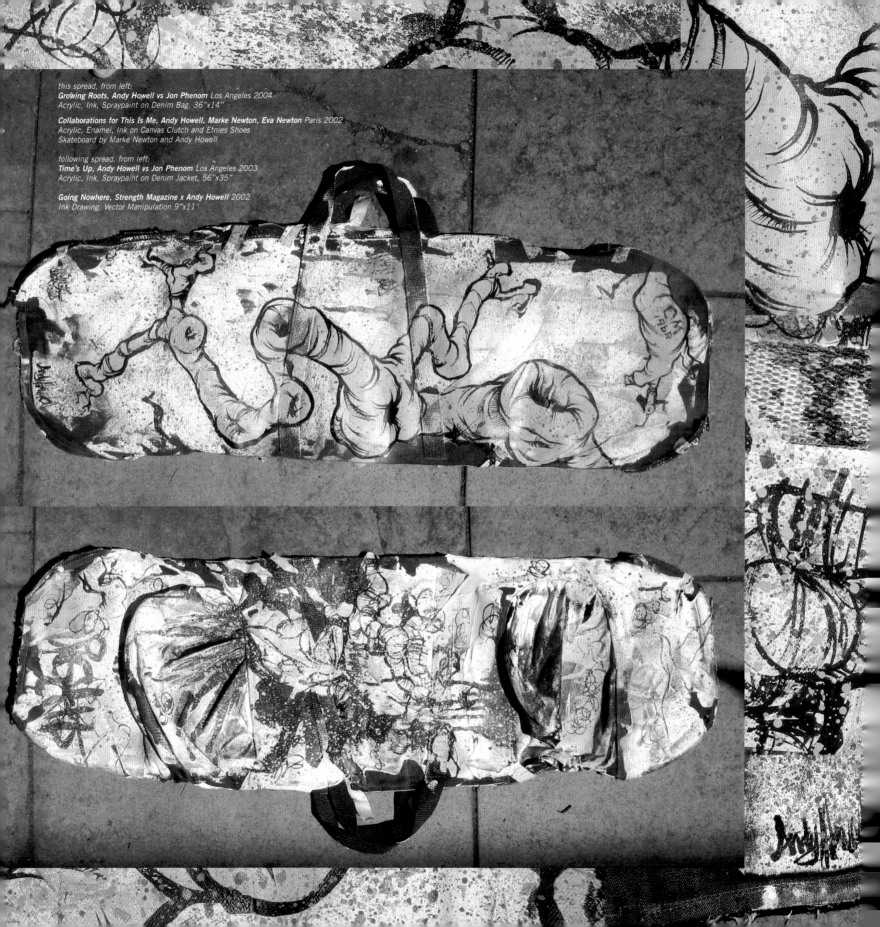

this spread, from left:
Growing Roots, Andy Howell vs Jon Phenom Los Angeles 2004
Acrylic, Ink, Spraypaint on Denim Bag, 36"x14"

Collaborations for This Is Me, Andy Howell, Marke Newton, Eva Newton Paris 2002
Acrylic, Enamel, Ink on Canvas Clutch and Etnies Shoes
Skateboard by Marke Newton and Andy Howell

following spread, from left:
Time's Up, Andy Howell vs Jon Phenom Los Angeles 2003
Acrylic, Ink, Spraypaint on Denim Jacket, 56"x35"

Going Nowhere, Strength Magazine x Andy Howell 2002
Ink Drawing, Vector Manipulation 9"x11"

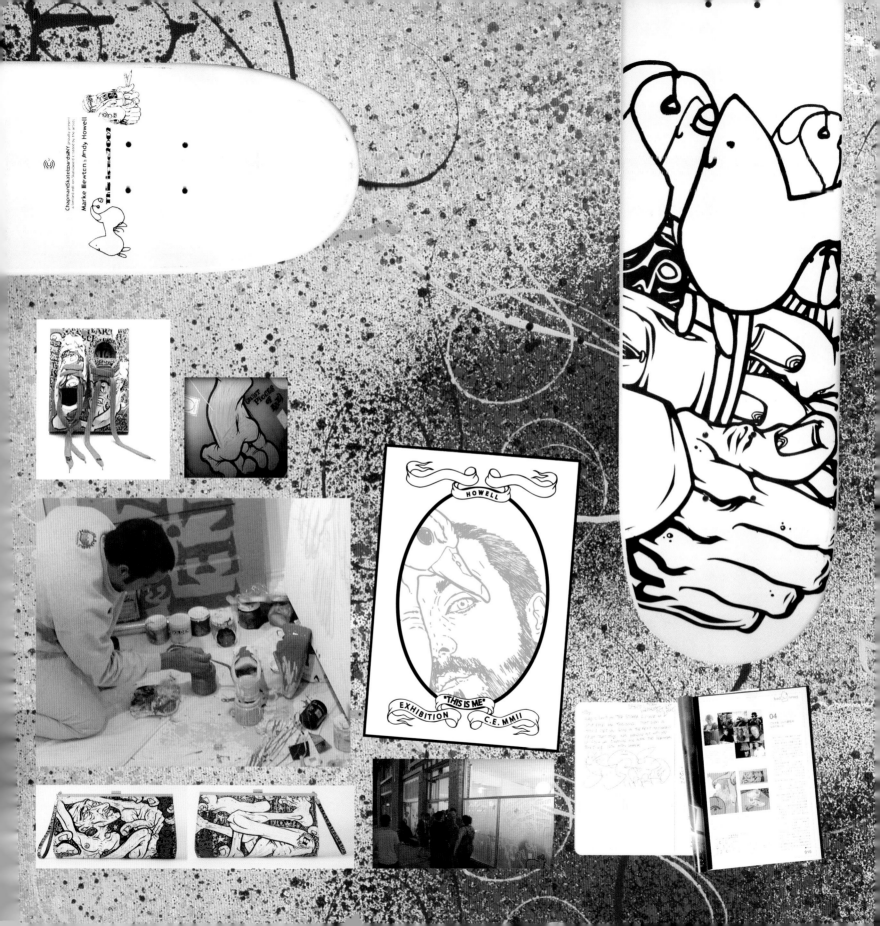

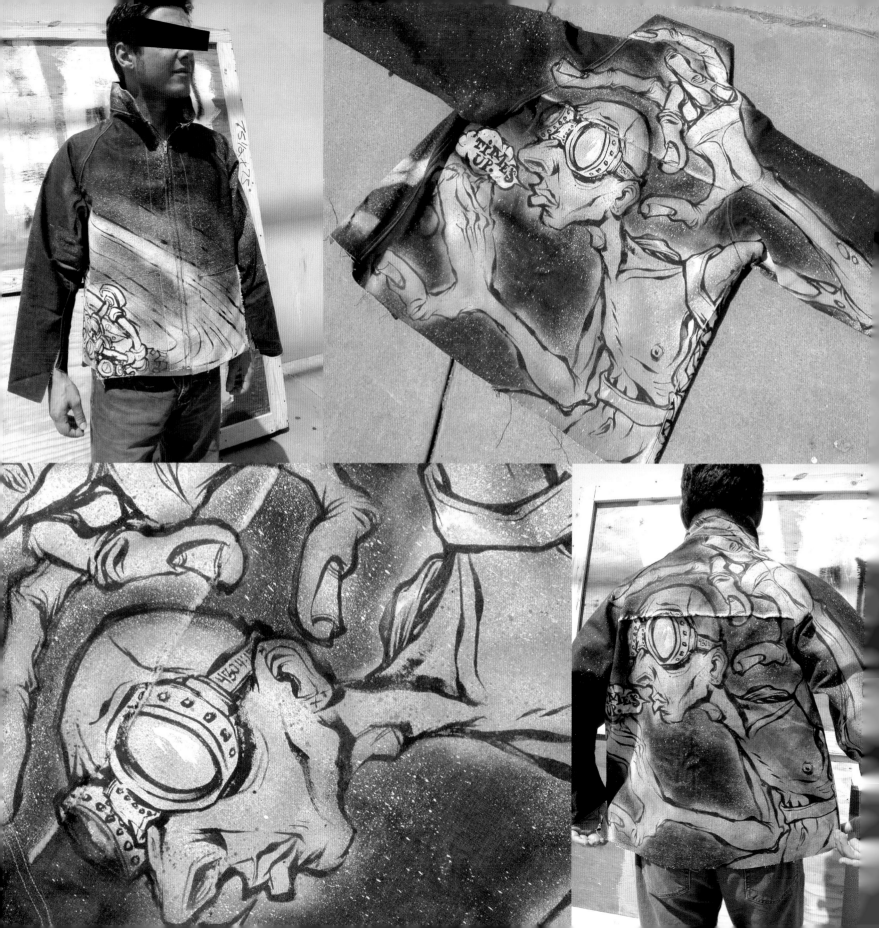

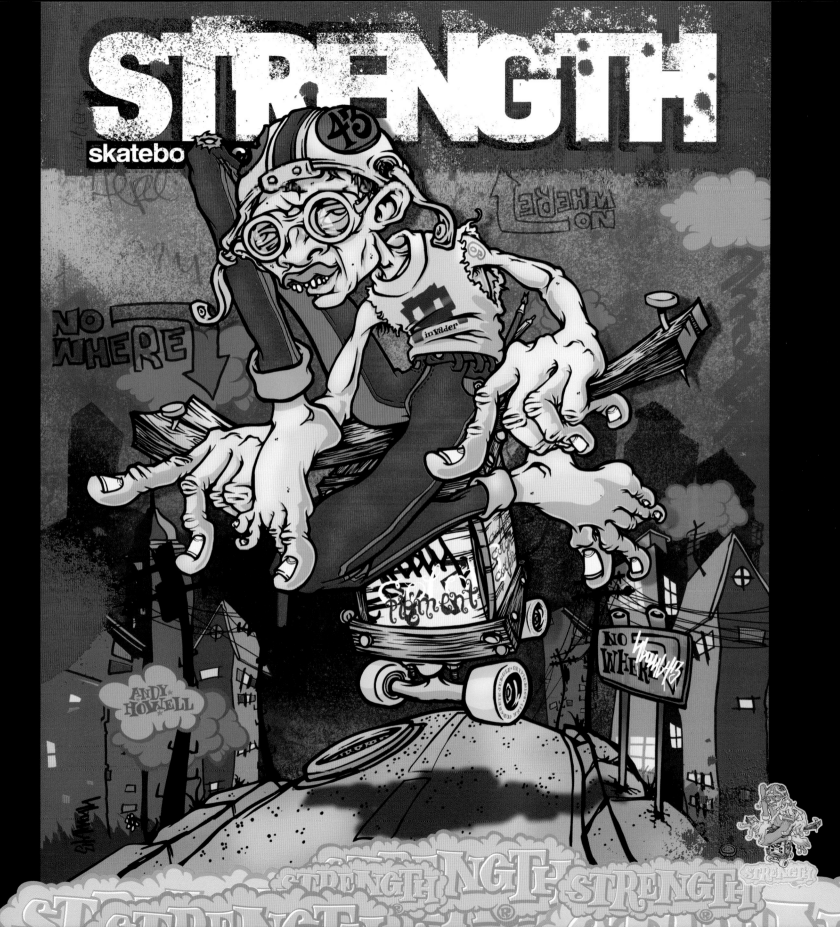

ARTIST PROJECTS™

ANDY HOWELL SHOE
FOR MORE INFO ON SPECIAL PROJECTS,
VISIT OUR WEBSITE AT WWW.DCSHOES.COM

ANDYHOWELL.COM

HOWELL

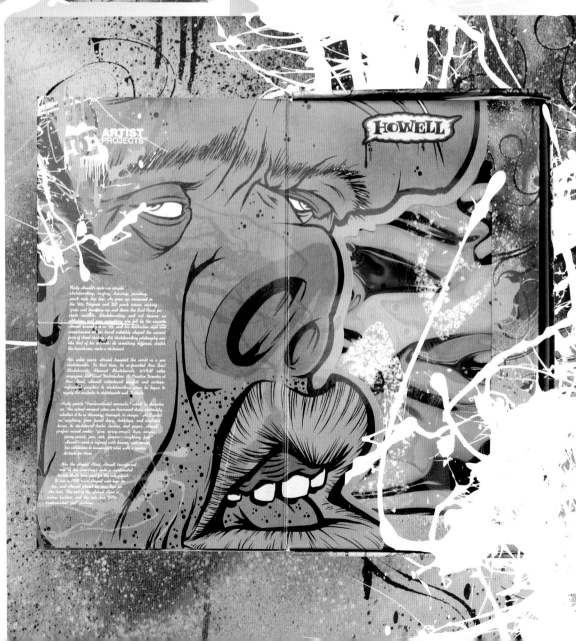

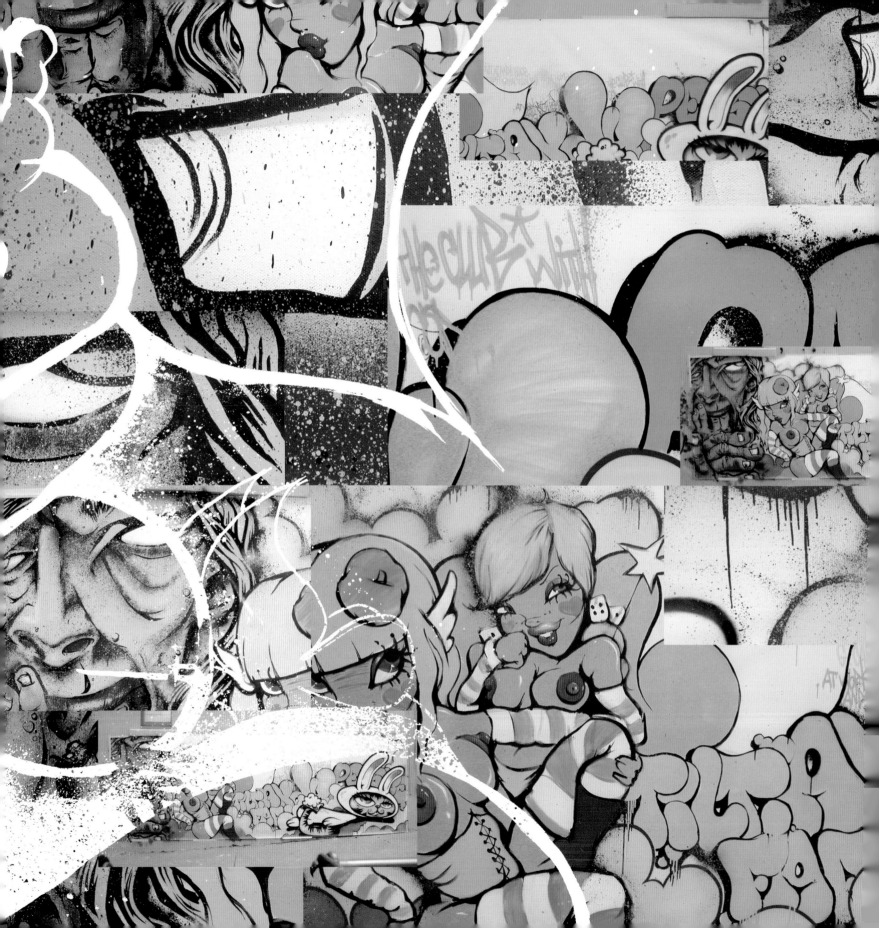

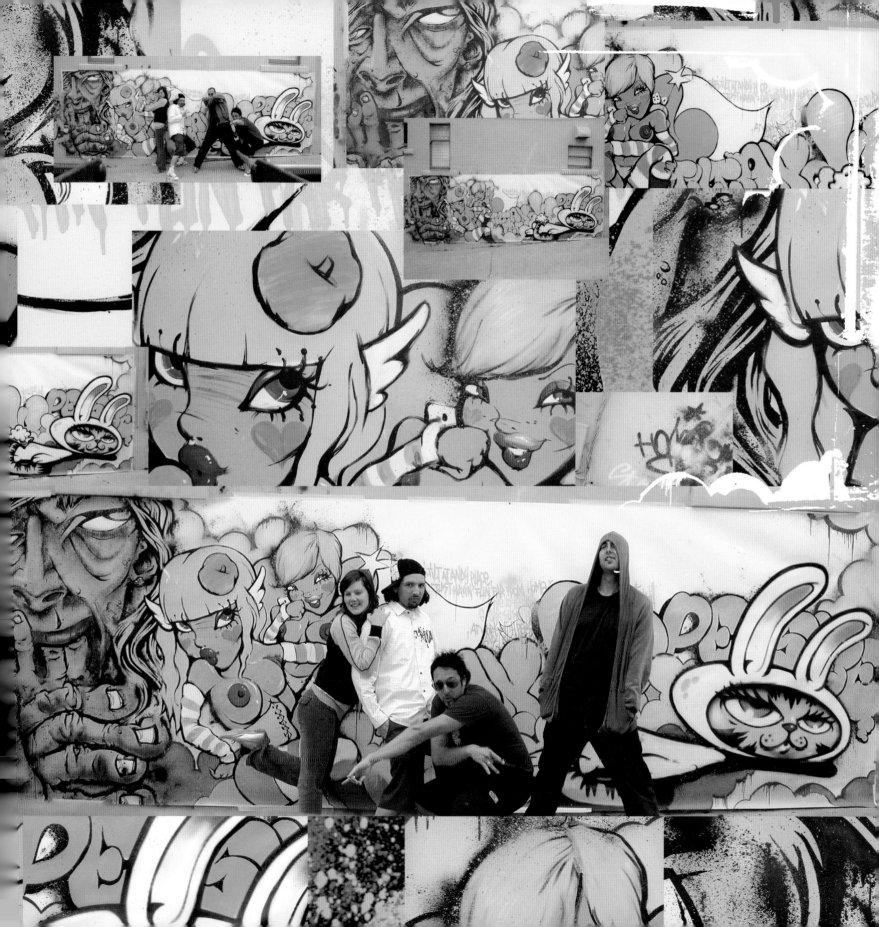

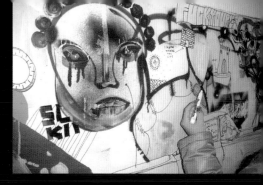

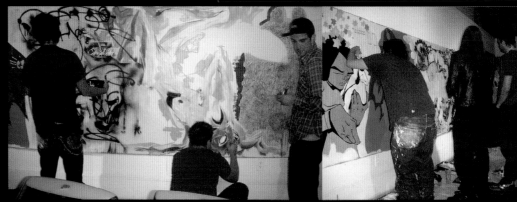

this spread, from left:

Dithers Release Event Collab: Sam Flores, Bigfoot, Andy Howell, David Choe, Jeremy Fish San Francisco 2003
Acrylic, Ink, Spraypaint on Canvas, 216"x48"

Flesh Imp Collaboration: Sam Flores, Bigfoot, Andy Howell Singapore 2003
Acrylic, Ink, Spraypaint on Wood, 72"x48"

previous spread:

Fafi, Tilt, Howell, Persue San Diego 2003
Acrylic, Ink, Spraypaint on Canvas, 120", 72"

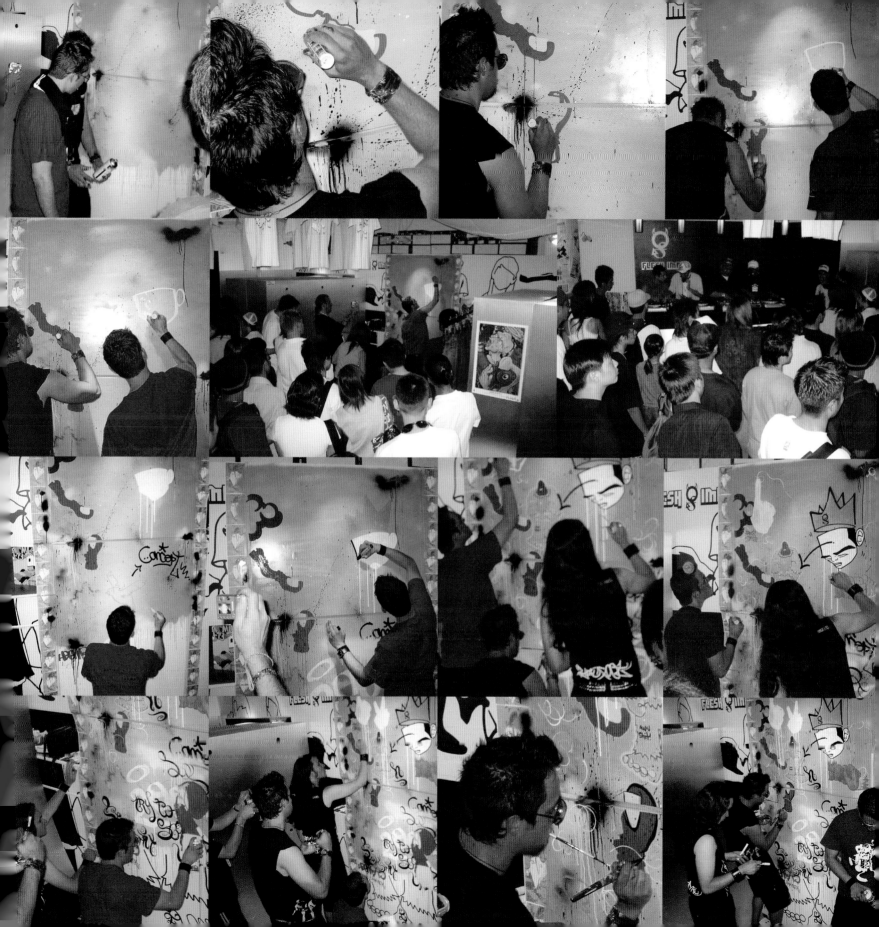

Quiksilver Limited Edition Boardshort x Andy Howell
Roots: Water & Light 2005
Pen and Ink Drawing Colorized as Vector Art, Screenprint and Embroidery Applications

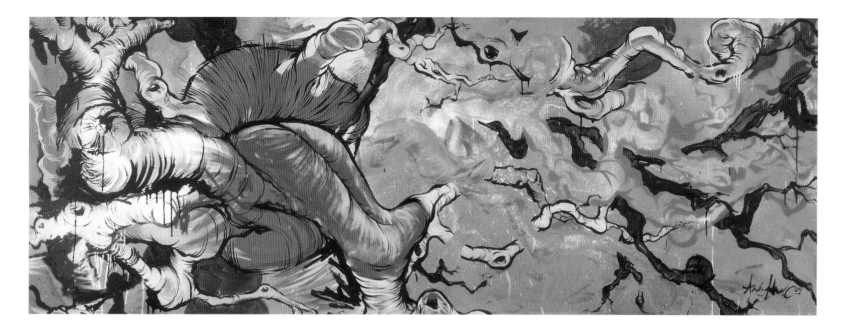

above:
Installation Scion x Andy Howell
Making love In The Orange Grove 2004
Mixed Media on Wood, 96"x36"

right:
Art Covers and Mentions

below:
Nike Dunk Manipulation x Andy Howell
Singapore, 2004

THE BOURGEOIS HAD BETTER WATCH OUT ME FOR

CHAPTER 11
THE FUTURE iS NOW

The Future is Now *Tapping The Un1versal Mind to Find Better Chemistry*

Andy After selling Imagewerks and being bought out at the end of our contracts in November 2003, freedom washed over me. I was tempted to dive back into another venture, but decided it was time to travel around the world. So I bought a *Circle The Globe* multi-destination ticket, and stepped into tour mode once again. I was waiting for my next prompt: Where was life going next? I was open to anything that came my way. I had just met a girl, a wild and sexy and tumultuous girl, but something told me to go it alone, so I got on a plane, and headed west to Hawai'i. In Hawai'i I was still wound up in my monkey mind, caught up in responsibility and guilt and the fear of losing something, or someone, but my friends there helped me unwind a bit, and after a few warm-water surf sessions at Jun's secret breaks, I was starting to come undone ... and back together again. I felt the ocean again, I was breathing into things. I painted a piece with Woebot of a panda in the jungle, then headed out to Tokyo. I went to ancient temples on the coast, saw the Diabutsu (Great Buddha), and got lost in the subway systems. Then on to Singapore to paint and hang out with Vince and Nicholas. And then to Thailand and Malaysia to meet up with Haze out there in Kuala Lumpur.

When we got back to Singapore, my girlfriend came out to join the crusade. We went back to Thailand, and we lived on Koh Phangan for a month, in a little hut on a bay with no hot water and no electricity. It was amazing, like we were completely cut off from real life. There was a certain fantasy element to living that way that I had never experienced before, a complete freedom. Color started to come back very

vividly, and the petty little things in life disappeared. Just the warm water on my skin, and the sounds of waves against the rocks below the cabana to fall asleep to. We were naked most of the time, and made love incessantly, we were just turned on by each other in this fantasyland. We lived by nature's clock, rising when the sun rose and going to sleep shortly after the sun went down. The bug had bitten me, and after that we spent a month in Bali hiking live volcanoes at sunrise, fishing, visiting temples, and surfing legendary breaks like Ulu Watu and Shipwrecks. We stopped in India briefly to visit the snake charmers, then on to Kenya, landing in Nairobi. We went on safari through the Masai Mara, meeting the Masai tribal leader and visiting his mud-walled home, and seeing lions hunt down and devour a giant bull. I was starting to feel creative ideas coming on again, and I was becoming inspired to explore the dichotomy between organic and manmade elements in my own world.

When my girlfriend took off to Florence to visit friends, I continued into Uganda to raft the Nile, and then on to Parc National Du Volcans in Rwanda. My quest was to spend an hour with the Susa Group of Mountain Gorillas, descendants of the same group on the same mountain where Dian Fossey had lived years before. Getting to the base camp took about 36 hours of driving through rough terrain and windy mountain dirt roads, and crossing the border from Uganda into Rwanda at five in the morning. The only Caucasian around, I was quickly dubbed Mzungu by my hosts. After being trained how to react if approached or attacked by a gorilla, I

began hiking with guides through nearly vertical farmlands in order to reach the bordering jungle. Adrenaline was pumping, especially because the dangerous possibilities had been confirmed by the guides who insisted I sign a waiver freeing them from any and all safety responsibility. A number of tourists had already been killed that year, so there was the real possibility of being attacked by terrorizing rebels or poachers from Congo, which bordered Rwanda and was only a few kilometers away. In two trips to see the gorillas I hiked about ten hours straight up into the jungles, the guides using machetes to hack our way in.

My first glimpse of the Silverback was intense, a massive three hundred pound ball of muscle, feeding on three-inch thick stalks of bamboo which he snapped like twigs with his hands. "He's massive!" I thought as I took photos like mad. Then he picked up and eased down through the thick jungle toward us. Crouching in the faux feeding position in order to acknowledge his dominance, we looked down and made no eye contact as instructed. But I couldn't help it, when he passed within two feet of me, I looked up, and straight into his eyes. They were dark brown, I could see the veins in his eyes, and he looked right at me, more dominating and more powerful than I had imagined. His head appeared to be at least two feet from nose to back of neck, his ear maybe the same size as a human's, and I could smell him distinctly. I looked away almost instantly. Then others from his group came down, breaking through the tall bamboo like King Kong and pushing out into the clearing they had all made in the early morning. I spent an hour with them, listening to them talk, watching them play, hearing them call out to others hidden in the jungle. They were naturally free, as fleeting as it has become for them, living in the moment, their moods instantly and obviously changing from playful to serious. A few times I traded glances with the Silverback, who seemed to ask me why I'd come, not where I'd been or what I'd done, just why was I here in his world. There was a connection, eerie and at the same time natural. A slightly smaller male walked up behind me while I was turned away looking at some infants crawling down through the jungle cover. I followed the guide's instruction and as he got close to me I turned my back to him. He dropped a broken branch he was playing with and reached out toward me, putting his hand on my head. I couldn't believe it! I turned the camera on myself and filmed him as he dragged his hand down across my head and then smelled his fingers, as if he was wondering who this new dude was. It was the most incredible experience I have ever had with an animal in nature, with no confines or protection, and any possible outcome. It was unreal.

How could we all connect like that? Why did all the artists I met along the way seem to be drinking from the same well of inspiration? How was nature responding to the dam that man has built to obstruct her natural flow? The ideas were starting to come back, and I realized that my journey around the world was coming to an end. And the traveling had inevitably

led me back home, to Virginia Beach, where my sister Courtney was giving birth to her first son (and my first nephew), Thomas. The spring was bursting with new ideas, new desires, and thoughts boiling inside me like I was ready to explode. I was already moving toward a new adventure.

While I was in Virginia at my Mom's I was watching a lot of old '60s acid-trip movies—*The Trip*, the Peter Fonda and Jack Nicholson stuff. I was projecting myself into that movement and back, thinking that because of all the complete nonsense going on with government and foreign policy today there will be another uprising, another anti-establishment bohemian movement. The street artists were already putting social and political commentary on the walls again. But what is this thing going to look like? How are we going to create it visually? I kept piecing it together in my head—we're technologically advanced, so it's not going to be the '60s tie-dye this time. It's people in the cities, literate and even technologically advanced folks, who are going to be making changes and coming up with whatever this next movement is. Whether it's an art movement, political, literary, or a combination of it all, I was starting to see pictures in my head of an organic vibe meshing together with technologically advanced elements. At that point it was a loose affiliation of vectorized geometric shapes mixed with marbled organic ones. I could see watercolors bleeding around hard shapes.

There always has to be identifiable design elements behind a thought movement for people to identify with it visually and culturally. It gives them an icon, or series of icons and colors to file into their minds. So I started to dismantle and redesign the '60s icons. What's the next tie-dye? What's the next peace sign? Even other kinds of utilitarian housewares are intriguing to me. How can other things have a voice beyond just their structural design? That's exciting for me to think about. I was starting to create concepts for product lines in printed paper goods, accessories, apparel, and to develop housewares designs, using different artists to focus on re-design of other revolutionary eras. What will a lava lamp be in the future? How can technological elements in our homes such as clocks be functional and still utilized as organic pieces of art? It's entertaining to think of the way cycles of culture turn and to try to figure out what's going to be next. It's natural for me to think like that, and it also has an innovative element of prediction. It's so interesting to deal with pop culture in that way.

So in letting that feeling resonate for a while I started to see tangible design and written communication coming out of it. In one part of *The Trip* a hippie bus has a bumper sticker on it that says "Better Living Through Chemistry." I thought we all need a better more organic method of living, and of course there is the technological element of Chemistry, man's ability to manipulate and categorize events through a series of experiments. To me it instantly made perfect sense.

What we really need is a better more natural form of defining the world around us, a Better Chemistry. And so that became the name of a new brand. And it instantly started to build on itself, Better Chemistry could be applied directly to our world's social and economic conditions. It was also a clear solution to the need for a new method of loving between man and woman. In short it was the creative manifestation of my thoughts about life, of my quest to understand myself. A tiny microcosm in the giant scheme of life, and nonetheless a clear picture of how things operate on all levels of existence.

It was feeling very experimental, as if every idea that came out for this brand had to feel innovative in some way. I wanted to challenge people to try something new, not a militant reform, but an enjoyable and positive way to resume the natural flow. It started to feel very psychedelic, organic, and relaxed without borders. The ultimate challenge for a creative person working within the confines of accepted communication. So I called in a bunch of different artists I knew and explained that feeling I was having to them. I asked them to translate: "What do you think this is going to be?" It doesn't have to be political—it's about communicating this feeling. I feel people are going to realize they have to make a stand for things, to secure their own happiness on an individual level, but realizing that even the most singular action affects the greater whole. I prompted the artists with excerpts from poetry I felt was commenting on the same feeling. I encouraged them to take their own trips with it, to get lost in the feeling, and not be restrained by the perceived boundaries.

Japanese artists Toshifumi Tanabu and Takyeshi Yonemochi put together a design we called Teardrop, a fantastic collage of technologically injected vector art combined with manipulated photographs. A detailed eye is pasted together with two hands, which seem to be dancing or flying, and providing wings for the eye. Perhaps to take flight away form all the problems they see, or maybe just to fly a little higher so as to see the bigger picture from above. It reminds me a lot of a child of the future locking his thumbs together and flapping his hands in front of flashlight to make shadow birds dance on a wall.

Designer and painter Josh Hassin took a cue I provided from Anaïs Nin's *Spies In The House Of Love* to create a loosely composed watercolor scene with birds of prey, tigers, and sensually portrayed women existing in a range of bleeding purple tones. His soft and cynical touch aptly describes the artist's feeling about the possible twists and turns in the road of life and love in a fantastic landscape of the future.

I added my own illustration of perfection, a beautiful cloud princess, a mirage of perfection amongst a sea of softly blending colors. I have always been a daydream believer, and love to lie in the grass and stare up at the clouds, finding whatever it is I need at the moment in that constantly bubbling and

Oahu
Tokyo
Singapore
Kuala Lumpur
Bangkok
Koh Phangan
Kuta
Ulu Watu
Nusa Dua
Lembongan
New Delhi
Bombay
Nairobi
Kigali
Kampala
Amsterdam
Florence
Paris
Norfolk
Virginia Beach

UNIVERSAL MIND

WELCOME TO THE REPUBLIC
OF RWANDA.

BIENVENUE
À LA REPUBLIQUE RWANDAISE

NAIROBI YOUTH HOSTEL
SUPERMAKET
NOW OPEN
At affordable price

okay i get it...the journey's the thing...
daybreak, inpenetrable forest uganda

sea. It's all up to my own interpretation of what I think the shapes are forming. My translation was a chance for a simple diversion to anyone's day: look up in the clouds and create your own Better Chemistry with the chance images you find.

Whilst Better Chemistry was starting to solidify as a concept, I was also coming up with a lot of ideas that didn't seem to actually fit into that psychedelic and organic style. Valid ideas, opinions, reactions to what I was seeing and feeling. Un1versal Mind, with the numeral "one" replacing the first "i" in "Universal" appeared to me as the conduit I was using to get to these ideas. Ideas that friends of mine told me they were having too, in another language, and another culture, in another part of the world. I was reading about theories of common thought and shared consciousness, and since I already knew from past experiences that we *are* all absolutely connected, this idea became real in my mind. All these artistic cultural movements, or music, or politics—they're all part of this Un1versal Mind. All these creative people drawing from the energy of inspiration that everyone is absolutely connected to all the time. There are people in London doing things that are very similar to what people are doing in Tokyo, not ideas they are copying because they are reading the same magazine or looking at the same website, but new ideas, reactions to what they are seeing in the world. And through acknowledgement of these shared experiences we start to realize the bigger picture of how these relationships and love energy flow together in this web we call our universe. Since the universe can't lie, we can start to take a cue from its inner workings. From the grandest scale of planets and solar systems operating in harmony, down to the relationships of cells and atoms in matter, everything is already working the way it's supposed to in nature's flow, but man resists the flow, so we suffer. People are beginning to wake up and become aware of this fact, and many of them are becoming frustrated with the results we've gotten so far. Social conflict and greed doesn't work for the overall health of the planet, and many people are deciding to change it. We see it first in the art and social visual communication that is created. So the tree branched out early on, and the twisted winding branch of Better Chemistry took its socially organic and psychedelic route, while Un1versal Mind branched off in a different direction, its many offshoots from artists around the world crossing and twisting around each other in the form of collaborations.

There's my friend Marke Newton in Paris whom I just painted with recently, and there's Thomas Marecki doing his thing in Berlin with *Lodown,* and Luca Ianesco in Australia doing *Refill Magazine,* and Thomas Campbell painting and directing his surf movies, and then there's some guy no one's heard of yet who just came up with a passionate and original idea. We are all part of a visual revolution, and it seems like we're all pulling inspiration from the same place—which I call the Un1versal Mind.

How often have you had this great idea, then two weeks later see it in a foreign mag, made by some cat in Singapore or Paris? A feeling of relief comes over me when that happens, a feeling of relief that we are all connected. And at times when I am competitive with myself the dark side of the artist comes out, and a feeling of fear that I am not fast enough or creative enough. Did they come up with it first? But it doesn't matter, as long as it was my interpretation of that feeling that created it. It's all ultimately positive and I have to deal with my own insecurities and realize that this process it what it is all about. It's all part of the shared consciousness.

We're drawing from this whole cultural experience that we're all having, and every individual experience is interconnected. So UM is based around that. The intention for it is to create this pass-it-along format for creating designs, where I prompt someone in say Singapore, posing a question or a theme, and they work on some form of design, then pass it to someone in Paris, and they work on it. The process creates a collaborative effort going on with a common goal. And the result in the shared application of design is validation of the concept, there is a Un1versal Mind. Even if these people are putting down elements of completely different alphabets or visual language or medium, it's going to end up being harmonious in it's communication, and resonating across all different cultures. That's the basis for the project, I'm open to the possibility that it may grow and change from there.

The genesis for the concept was really my travels during the whole time I was skating and involved with skate companies. I was having a great time, and meeting a lot of creative people I formed relationships with that I still keep in touch with today. That's over ten years ago. I went on a round the world trip again in 2004 for six months and stayed with people I'd known through the art experience, in

WAKE THE TOWN TELL THE PEOPLE

Militree®

WAKING THE TOWN IN 2005 / MILITREE.COM

Singapore, Paris, Amsterdam, and everywhere I went people were experiencing this feeling. It's this common thread that we are in and entering into a global creative community of like-minded individuals, not just people but individuals, where the influences of ten or fifteen years ago from the cultures we were creating with skateboarding and graff have become the culture that a new generation of artists are addressing, shaping, and perpetuating. It's a circle of inspiration that never stops.

The things that we were creating back then caused the influence to spread everywhere, and many new artists who are coming up now at 22 and 23 years old were kids twelve and thirteen riding New Deal and Element Skateboards and rocking Zero Sophisto when we were doing that back in the early '90s. They are music producers and artists and creative people who are shooting videos and directing movies around the world. These were kids who were riding skateboards back then and they were influenced by many of the things we were doing. We planted some seeds back then which grew into trees, and they've climbed to the tops of those branches to see even further than we could have back then. And we are all climbing and nurturing and growing the tree, as its new branches spring up and spread out across the creative landscape. And they are growing and creating the influence—they are the trendsetters. And we are all inspired by each other to take it even further. So that unknown territory that we pioneered through the late '80s and early '90s has become it's own republic, now, and it's always evolving.

This time when I went around the world, all the people I talked to were creating this really powerful art, both visual imagery and sounds. They are just the next generation. For me to be a part of that as well and still being able to do different forms of art as well is like almost an OG status now. That people are like, "Oh I used to see your work, I used to ride your board ten years ago when I was a kid." For me to be able to be a part of that history, and inspire future creativity is just an amazing honor. And it continues on.

I formed a new company, eggprojects, a brand incubator and hatchery, a creative and distribution platform where these new brand ideas could be realized. I partnered with Zach Mandelstein, a friend who came up through the snowboarding world, and together we hooked up a strong team of sales, marketing, manufacturing, and fulfillment professionals to support the creative vision of eggprojects. It's been fun to challenge ourselves with new projects, venture into new industries, and at the same time keep the design and style of what we are doing totally on point. Everyone involved is already successful in their respective fields, and of course that allows me to focus on the area that I'm really passionate about: creative.

So for me the experience of living in this creative vein continues. Through it I address my passions, my questions, my confusion. I feel free when I am doing it, connected. I'm interested in living life to the fullest, in whatever form that may appear. To losing myself in the creative process, and finding myself along the way. The transition to a new idea is always empowering. I embrace the challenge. I listen to the voice inside me, my connection to the Un1versal Mind, my source of inspiration, and I allow myself the freedom to succeed in whatever path I take. After all, I am a loving, inspiring, creative man. And through loving, inspiring, creating, and empowering I bring forth a natural harmonious world of unified conscious spirits. I stay open to new ideas from anyone, open to forming new relationships with creative people and entrepreneurs. Open to being inspired. This is my art, skateboarding and life.

It started with a private school art teacher who encouraged a second grader to take risks with color.

It led to a kid taking risks with a spraycan and a skateboard.

And that led that same child riding his flying paintbox around the world, to make art with friends, or to dance with the gorillas in the jungle, or to paddle out through a raging cave to a perfect left-hander.

And it will inevitably continue.

*Out beyond ideas of wrongdoing and rightdoing there is a field. I'll meet you there...

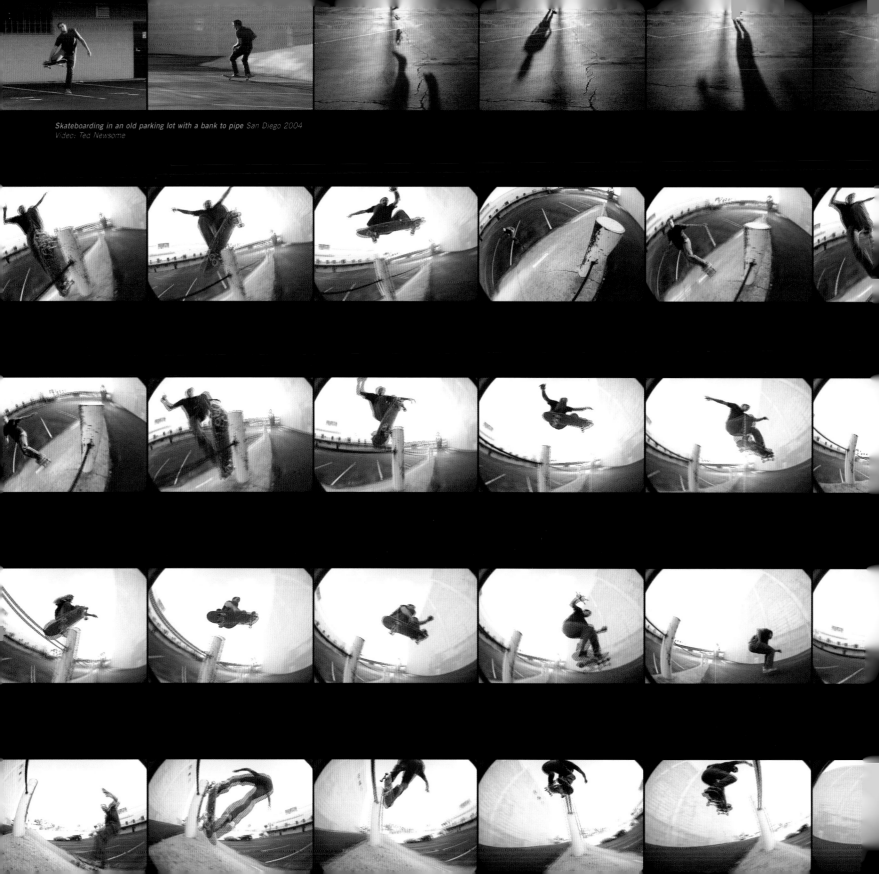

Skateboarding in an old parking lot with a bank to pipe *San Diego 2004*
Video: Ted Newsome

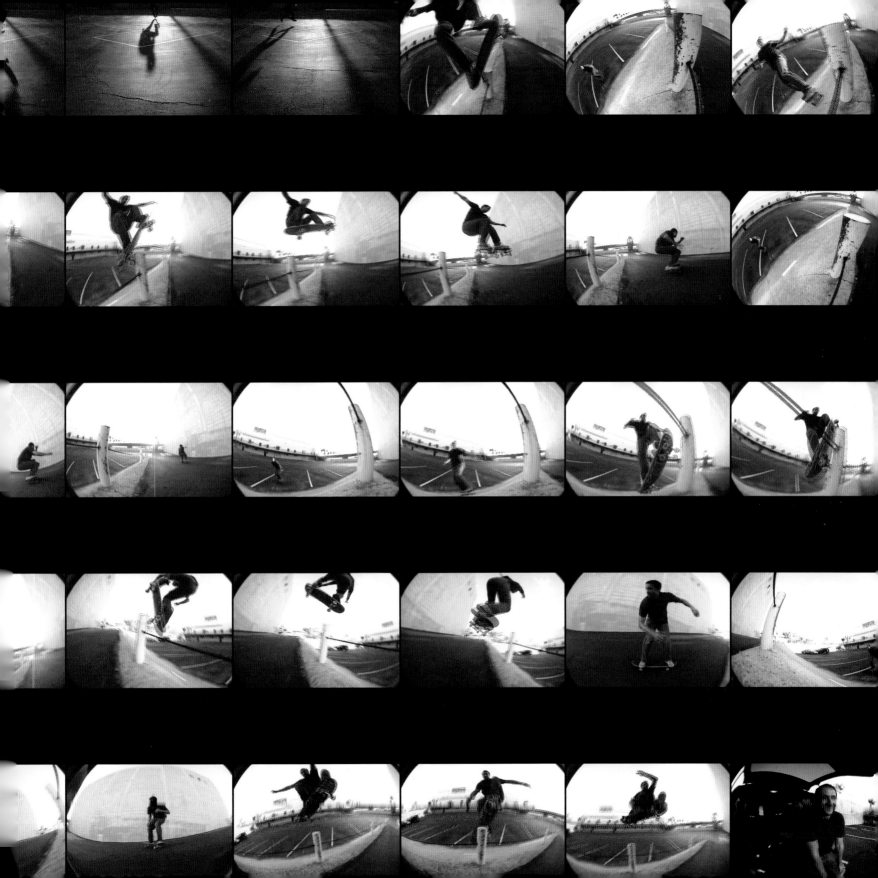

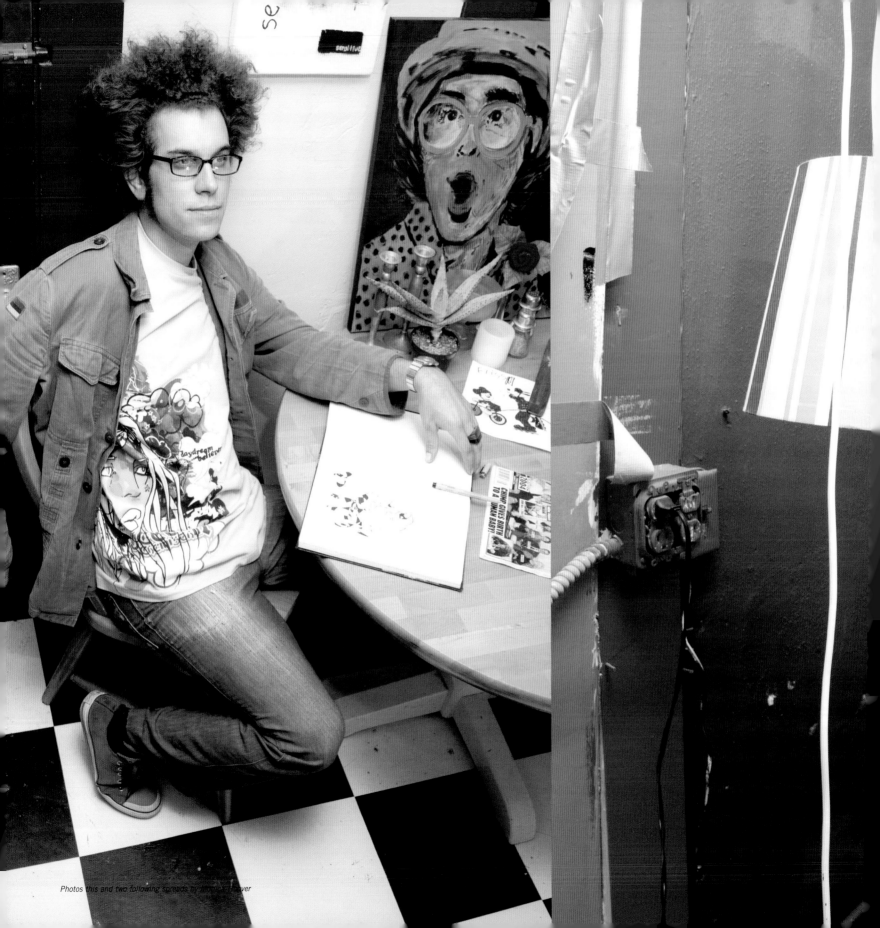

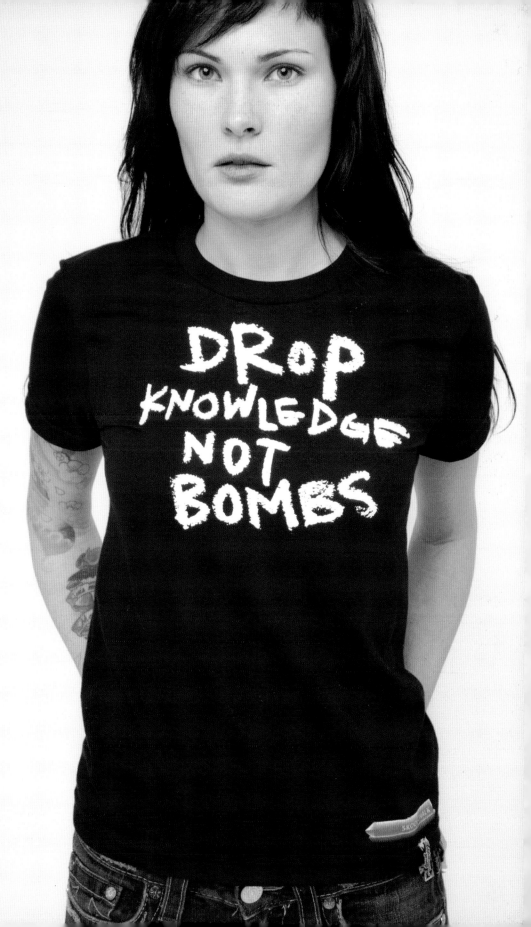

TOD NEWSOME, AMEY GREEVEN, PAUL HUTCHISON, LABAN PHEIDIAS, MIKI VUCKOVICH, SHARON HARRISON, ALY MOORE, DAN MEADE, PAUL SCHMITT, STEVE DOUGLAS, DALLAS AUSTIN, GREGG DILEO, PATRICIA ARQUETTE, NIELS KANTOR, KENTON PARKER, ED TEMPLETON, CHRIS MILLER, JEFF PANG, RODNEY SMITH, PHIL FROST, DAVID CHOE, TONY HAWK, SALVADOR BARBIER, MATT HENSLEY, BRYCE KANIGHTS, JUSTIN GIRARD, SHEPARD FAIREY, BLAKE INGRAM, DAVE KINSEY, STEVE CABALLERO, MOM+DAD+COURTNEY, BRENNAN SCHOEFFEL, TRAVIS PARKER, ANTHONY YAMAMOTO, STEVE SAIZ, DAMON WAY, KEN BLOCK, MIKE NELSON, SAM FLORES, BIGFOOT, GIANT, JEREMY HENDERSON, BRUNO MUSSO, JAMIE THOMAS, MARK GONZALES, HAROLD HUNTER, HARMONY KORINE, LIL STEVIE, PEPE MARTINEZ, ALY MILLS, CHRIS HALL, ANDY STONE, TOMMY GUERRERO, JULIEN STRANGER, JIM THIEBAUD, COCO SANTIAGO, FELIX ARGUELLES, JOSE GOMEZ, FLORENCIO ZAVALA, SCOTTY BOY HERSKOVITZ, GOMEZ BROWN, DANIEL POWELL, FRED REEVES, THOMAS TAYLOR, ALLEN MIDGET, ANDY WARHOL, KEITH HARING, CHARLES HARMON, BRADMANN, OTHA NOWLIN, PAT MCMICHAEL, RON SIEGEL, DARREN JONES, BOBBY LAKE, HENRY EDDIE GLEN GUITIERREZ, BUSHKA VIDAL, MIKE VALLELY, DEREK KIERNER, SENSE ONE, JRE, RANDALL LANE, DAVE MERTEN, JOHNNY SCHILLEREFF, BASE, VERSE, WISAN, PIERRE ANDRE, YOGI PROCTOR, SHANLY JO DARDEN, MONA, TIFFANY NEIDER, ROB DYRDEK, JOSH KALIS, KARMATOSKHEFF RICK, ABU, TOKYESHI YONEMOCHI, GURU, PREMIER, BILLY PEPPER, KENNY HUGHES, JOHN MONTESI, CURTIS MCCANN, AKI NISHIMURA, TOSHIFUMI TANI, ANDREW POMMIER, JOSH HASSIN, JEREMY FARSON, JIM HAUSER, BECKY WESCOTT, GLEN FRIEDMAN, JAMES MARSHALL, OTIS, DAMON SOULE, BARBARA ROURKE, JASON ST. JOHN, PETER HALASZ, FRANCISCO GOYA, BOOBIE, MEL BEND, GSD, NEIL BLENDER, RICK GLENN CHARNOSKI, VICTOR KOONS, JOHN FUDALA, SKIN PHILLIPS, O, GRANT BRITTAIN, MAIN SOURCE, FUTURA, CHESTER HIMES, ALEX GREY VICTOR MOSCOSO, LIBERATORE, COREY O'BRIEN, GAVIN O'BRIEN, AUSTO VITELLO, LARRY CLARK, CRAIG STECYK, FRANK MILLER, MILO MANARA MOEBIUS, LIBERATORE, BAD BRAINS, USLEAD, EGON SCHIELE, ERIK KROLL, OLD CLYDE AND HIS FISHING NETS, KALONJI, TAKASHI MURAKAMI, PASQIAT, JOE SORREN, YOSHITOMO NARA, TIFFANY BOZIC, GUSTAF ROOTH, COOP'S FAT GIRLS, BARRY MCGEE, ESPO, JEAN-MICHEL FRANCIS FORD COPPOLA, THEODORE GEISEL, DAN ELDON, PERSUE, LORD FINESSE, BEATSIE BOYS, THOMAS MARECKI, SAUL BASS, DAVID CARSON, J. KRISHNAMURTI, NICOLA TESLA, BUCKMINSTER FULLER, NABAKOV, PABLO NERUDA, ANAIS NIN, RICHARD BACH, MARIA MCKEE, TONI MITCHELL, NATAS KAUPAS, MICKE REYES, JOEY RAMONE, IAN MCKAYE, HEATH SHAWN, GRANDMASTER FLASH, TFS, KOOL KIETH, LIGHTNIN HOPKINS, DOC WATSON, CHARLES LEONARD, EMMYLOU HARRIS, PAUL SIMON, BELA FLECK, YA'LL SO STUPID, KND, PUBLIC ENEMY, SEX PISTOLS, GERRY LOPEZ, SHAUN THOMPSON, JOEL TUDOR, PETER MAX, TOKE TEAM, RANCHEROS, JEFF KENDALL, JOHN XCERO, RICKY BARNES, JASON JESSEE, SERGIO VENTURA, CHRISTIAN HOSOI, LEE RALPH, TOM PENNY, RODNEY MULLEN, ERICK SERMON, BLACK SHEEP ICE T, NWA, GETO BOYS, COLTRANE, MILES, MONK, MOS DEF, CHRIS JOHANSON, CAROLE KING, PETE FOWLER, MARK EVA NEWTON, STEPHANE LARANCE, ART OF NOISE, KRAFTWERK, RAKIM, BECK, SABBATH, METALLICA, STAN LEE, COURTNEY PINE, JOAO GILBERTO, MANU CHAO, BOBBY MCFERRIN, YOYO MA, TERMITES, JOHNNY WINTER, STEVE ORTEGA, YELLOWMAN, BOB, SPECIALS, TAM PAUL WELLER, MICHAEL HIGGINS, JAMES TAYLOR, ROBERT JOHNSON, HERBIE HANCOCK, NEW ORDER, LEONARD COHEN, KATE BUSH, DAVID BOWIE, JIM HENSON, ELVIS COSTELLO, TRACY THORN, RUSH, JOAN ARMATRADING, FUNKADELIC, CLASH, LYLE LOVETT, BIZ MARKIE, QTIP, JUNGLE FG, MUDDY WATERS, PETE NICE, NAS, CASUAL, PETE ROCK, IRON MAIDEN, PRINCE PAUL, SMITHS, JOHN STEINBECK, KATHERINE DUNN, STONE S, BILLIE HOLIDAY, LEE PERRY, GIL SCOTT HERON, CINDY SHERMAN, SHUT SKATES, AMERICAN DREAM, REAL, INDY, THRASHER, REGGIE BARNES, RIP PARROT, MARK, JOE AND BILLY DUONG, STEVE SOLOMON, CHRIS MOKE, SHANNON RAYLE, STEPHANI HATCH, LAURIE PARISH, CERISSA NC ARTLIN, KINKO'S, SKIP PURING RUD, PAUL NEWMAN IN COOL HAND LUKE, STANLEY KUBRIK, MIKE MILLS, MARTIN SCORSESE, SPIKE JONZE THE UNBEARABLE LIGHTNESS OF BEING, JODIE FOSTER, TOM SACHS, LICHTENSTEIN, POLLACK, MARK TWAIN, SYDNEY PORTIER, COREY ROUP, VINCENT QUEK, FREDDY KRUEGER, SIR GOYA ROCK-N-ROLL MAJESTIC, HOWARD FINSTER MAN OF VISIONS, THE GUSA MARK DAGGETT, KIM CUFFE, JUN JO WOEBOT, MASAI, CHARLIE TRADING, MCCANN ERICKSON, MARK DOWLEY, SCOTT HULTGREN, SCOTT MORA, TRANSWORLD, SKATEBOARDER, THRASHER, GANJA, MATT BOLDING, JASON BUCKNER, H2O, BUCK, LIL JON, D-MONEY, X-MAN, DOZE GREEN, STRENGTH WALL STREET JOURNAL, SPIN, TIME OUT, RESUME, CLARK, LODOWN, SUGAR, HIRO, DOS DE DOS, WARP, CY VOGUE, 1026, KANTOR, HLEGED, CANDIDE, FACE, SOURCE, SUEDE, SIGMUND AND THE SEA MONSTER, PUFF THE MAGIC DRAGON, HONG KONG FOOEY, SCHOOL HOUSE ROCK, TIM BURTON, DANNY EHF MCNT, HOMEBOY, RAD, BIG BROTHER, POWEREDGE, REFILL, RISEN, HAPPY, ARKITIP, CUMMARTS, BAKER, THOMAS CAMPBELL, SEAN PENN, SIDE, THE CYPE, JEN AMERINE, ANDREW JEFFREY WRIGHT, PINERO, IBRAHIM FERRER, CHET

CREDITS

Special Thanks
To all my freinds who contributed in one way or another to this project, your inspiration means the world to me...

Contributors:
Dallas Austin / cyptron.com
Patricia Arquette
Shepard Fairey / obeygiant.com / studionumber-one.com
Dave Kinsey / kinseyvisual.com / blkmrkt.com
Jose Gomez / adiofootwear.com / shilodesign.com
David Choe / davidchoe.com
Josh Hassin / joshhassin.com
Kenton Parker / kantorgallery.com
Marke Newton / www.markenewton.com
Takeshi Yonemochi / geocities.jp/yonetake2001/index1.html
Toshifumi Tanabu / geocities.jp/t_tanabu/
Sean Cliver / disposablethebook.com
Alyasha Owerka-Moore / cleanercorp / fiberops
Angry Woebots / in4mants.com
Tony Hawk / birdhouseskateboards.com / tonyhawk.com
Natas Kaupas / quiksilver.com
Tommy Guerrero / tommyguerrero.com
Matt Hensley / floggingmolly.com
Ed Templeton / toymachine.com
Salvador Lucas Barbier / zooyork.com
Salman Agah / icelounge.com
Jefferson Pang / zooyork.com
Steve Douglas
Chris Miller / earthproducts.com
Steve Caballero / stevecaballero.com
Chris Hall / truemath71@yahoo.com
Blake Ingram / rorret.com
Bryce Kanights / brycekanights.com / skatedaily.net
Damon Way / dcshoes.com
Rodney Smith / zooyork.com
Johnny Schillereff / elementskateboards.com
Anthony Yamamoto / anthony.yamamoto@quiksilver.com /
Miki Vuckovich
Paul Schmitt / psstix.com
Gregg DiLeo
Barrie Bloor / hypebrand.co.uk / hypestore.net
BaseOneRock
Charles Harmon
Oscar Quiambao
Jack Guy / jackguy.com
Matt Revelli / upperplayground.com
Mike Blabac / dcshoes.com
Monica Hoover / monicahoover.com / voice1156.com
Sergio Sandoval
Steven "Bingo" Binks / mischiefskatestore.com
Susan Farrell / graffiti.org

Music:
Monkey Wrench / Alyasha Owerka-Moore
Skip Buringrud / militree.com
Daniel Mead / kitesdesign.com
Greenhouse
The Blowing Rock Triplets
Ulypians featuring HBOMB43
Libido

Featured Film/Video/Commercials:
The New Deal / Promo Video
The New Deal / Useless wooden Toys
The New Deal / 1281
The New Deal / Whatever
Underworld Element / Private Archives
Underworld Element / Promo
Underworld Element / Skypager
Element / Fine Artists Volume 1
Freedom / featuring Sophleto, REN, Girly Thingo

Art Skateboarding & Life
Written by Andy Howell with Amely Greeven
Edited by Amely Greeven, Sharon Harrison, Andy Howell

Art Direction / Design
Paul Hutchison
http://www.hypetype.co.uk
http://www.hypestore.net

HYPE TYPE STUDIO.

DVD Direction / Photography Direction
Ted Newsome
http://www.2headedhorse.com
Additional Interviews by Laban Pheidias

2headedhorse

Publisher
Untitled Publishing, llc
Gingko Press

untitled
PUBLISHING, LLC

ANDY HOWELL WEB LINKS:

http://www.andyhowell.com (fine art, paintings, drawings)
http://www.portfolio.andyhowell.com (commercial portfolio)

eggprojects, inc
http://www.eggprojects.com
http://www.un1versalmind.com
http://www.better-chemistry.com
http://www.militree.com

egg

...Warm heart, cold feet, itchy fingers, heavy lines, careless glances, blurry vision, intoxicating sounds, a dichotomy of fear and passion. I take giant steps in the squeaky white sand, floating above it all, moving like water, distorted. Today I am free, a tattered mind at large, no ceiling in here, walls crumbled and useless. Inky lines, spraypaint, a glued-down sketch, soupy acrylic chased by a sable brush across stretched canvas sealed with white, begging me to ride, manipulated visions of metropolitan mediocrity, my summer, my world, my todays, my tomorrows, my fantasies and my stark reality. Like skateboarding, movement with intention, seeing past the obvious and the taken-for-granted, attracted to the possibilities, a glossy postcard memory of a thousand surreal experiences, perfect in every opposite direction. Like the first time I saw it switchstance, done a different way, the opposite way, like running from the cops with fingers still dripping aerosol, like Tuesday morning rights off a cold SD jetty, like love, rhythmic expression, bringing everything I am to the surface all at once, energy flowing like Fuller's geodesic half-baked visions, perfectly and absurdly abstract. Caricature flaws, anger, lust, forgetfulness, remembering, or maybe just knowing. The good thing is now I know. HBomb43, tiny in the grand scheme, fishing for perfection, lured by rhyme, taunted by reason. To my friends, I love you. Oh yeah here it is again, another skateboard, another spraycan, another creative vehicle, another urban manipulation device, only now with light and color and brushes and fingers and house paint and skinny caps. Another chance to fly, like in my dreams, high as the pines, looking down and choosing every careless step. Random, at ease, above the noise, beneath the surface. Touching down for one second, regroup, reflect, a wreck-less paintbox on wheels with an unlicensed pilot at the controls. Yeah, I remember this, completely off the handle, and I never want to wake up...

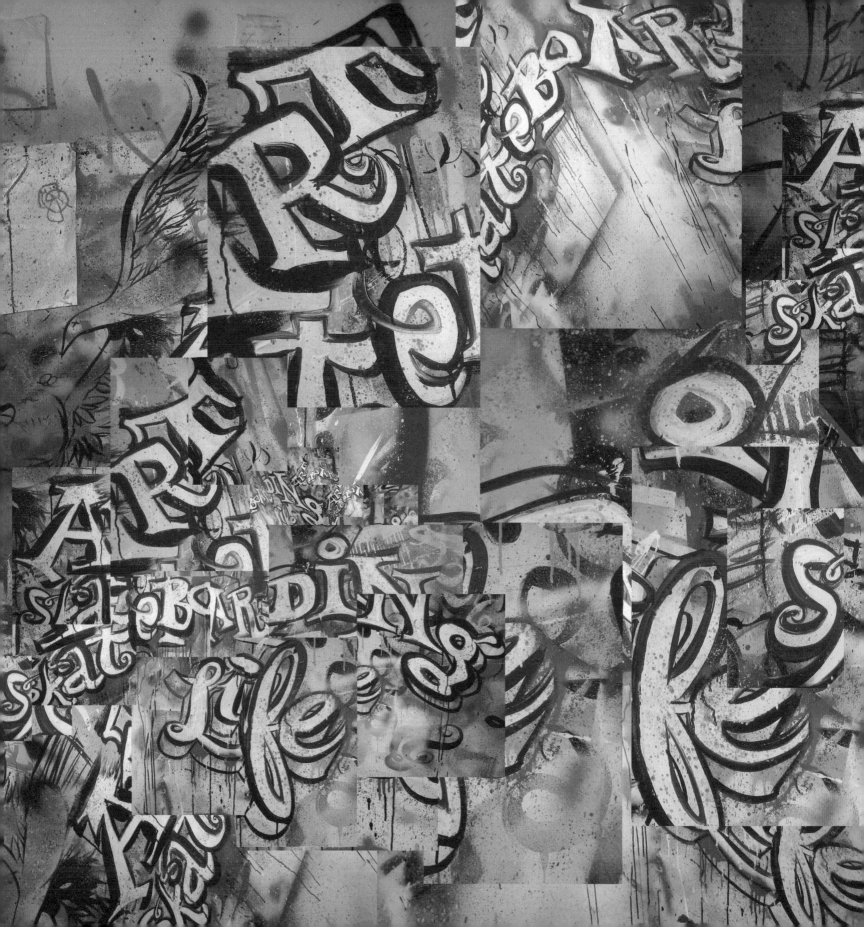